D1229751

Eighteenth Annual Winterthur Conference, 1972

CERAMICS IN AMERICA

WINTERTHUR CONFERENCE REPORT 1972
Dwight P. Lanmon, Chairman

Ceramics in America

Edited by Ian M. G. Quimby

WINTERTHUR

Published for
The Henry Francis du Pont Winterthur Museum
Winterthur, Delaware

The University Press of Virginia
Charlottesville

Copyright 1973

by

The Henry Francis du Pont Winterthur Museum

First published 1973
Second printing 1974
Third printing 1980

The University Press of Virginia

Printed in the United States of America

Cover illustrations: Designs for porcelain objects from
pattern books by Thomas Tucker, Philadelphia, 1832-38.
(Philadelphia Museum of Art: Photos, A. J. Wyatt.)

Library of Congress Cataloging in Publication Data

Winterthur Conference, 18th, 1972.
 Ceramics in America.

 (Winterthur Conference report; 1972)

 1. Pottery--United States--Congresses.
I. Quimby, Ian M. G., ed.
II. Henry Francis du Pont Winterthur Museum.
III. Title.
IV. Series: Winterthur Conference. Report; 1972.
NK4005.W5 1972 738'.09 72-96715
ISBN 0-8139-0870-1
ISBN 0-8139-0476-5 pbk.

NK
4005
.W5
1972

CONTENTS

University of Wisconsin - Eau Claire

455134

INTRODUCTION

A CURSORY inspection of the archaeological discoveries at
colonial American habitation sites reveals immense
quantities of ceramics that were originally an important part
of daily life. The volume of ceramic refuse threatens to
overwhelm the archaeologists charged with their recovery
and restoration. In addition, the wide variety of decorative
and utilitarian wares, both domestic and imported, listed in
newspaper advertisements and merchants' account books
must be correlated with the physical remains of ceramic
artifacts that were used, broken, repaired, and discarded.

In the past the study of ceramics has most often been
approached on the antiquarian level. The questions most
often raised were: Who made it?, Where?, When?, and
sometimes Who owned it? More advanced studies have
considered existing wares in light of technical aspects of
production and the histories of specific factories,
decorators, or potters. Rarely have studies of ceramics
been devoted to enriching social history by examining the
relationship between the craftsman and his clientele, the
wealth and status of original owners, or the original
function of the object itself.

It was the purpose of this conference, therefore, to
bring together students from many areas of ceramic research
to focus on and to interpret the cultural information with
which all ceramic objects are invested. Our aim was:
(1) to demonstrate the wide range of wares used in America,
(2) to ascertain which wares and forms were popular, why
they were popular, and how long their popularity lasted,
(3) to identify contemporary attitudes toward wares and
forms, (4) to analyze the roles of technological innovation
and client taste in shaping the product, and (5) to study
early American manufacturers and their wares to understand
better the determinants influencing both products and
producers.

To accomplish these goals, the ceramic remains found at two separate, relatively urban, areas were studied: Plymouth, Massachusetts, and St. Mary's City, Maryland. For both areas, archaeological evidence and written records of ceramic use were available. The Plymouth studies attempt to explain variations in ceramic forms and materials used by a large number of persons over a period of two hundred years. The St. Mary's City studies are devoted to an examination of the ceramic refuse deposited at one site by the John Hicks family. The ceramics found at Hicks's home site were interpreted in the light of studies of the man and his community during the second quarter of the eighteenth century.

To place these reports in a wider cultural context, studies of Spanish colonial ceramics in the New World and ceramics found at the North American site of a French colonial fortress (Fortress Louisbourg) were included for comparative purposes. The differences and similarities of the evidence reported in these studies are important for what they reveal about manufacturing and trade practices and for what they tell us about standards of living in the colonial period. The technical and historical aspects of ceramic manufactures in both England and America were developed in the studies of English salt-glazed stonewares, cream- and pearlwares, and American earthenwares, stonewares, and porcelain.

It is hoped that students of ceramics and those interested in early American culture will gain a better understanding of the relative roles of manufacturers, merchants, clients, and technology through the papers presented here. It is evident that ceramics--this fragile yet durable material--constitutes valuable cultural evidence that will find increasing use in the study of the American experience.

The papers in this report were delivered at the Eighteenth Annual Winterthur Conference held at the Winterthur Museum, March 22-25, 1972. The accomplishments of this conference are due to the unfailing and brilliant efforts of the authors, who graciously consented to take part in the program, and to the members of the Conference Program Committee, who aided in the organization of the conference, the selection of

speakers and commentators, and the smooth operation of a
complex meeting. Those members due special thanks for
their valuable assistance include Nancy Goyne Evans,
E. McSherry Fowble, R. Peter Mooz, all of the Winterthur
Museum staff; Jane C. Nylander of Old Sturbridge Village,
and J. Jefferson Miller II of the Smithsonian Institution.
In addition, I would like to thank the members of the
Education Division at the Winterthur Museum for their
assistance at all stages of planning and operation.

<div style="text-align: right">

Dwight P. Lanmon
Conference Chairman

</div>

Eighteenth Annual Winterthur Conference, 1972

CERAMICS IN AMERICA

KEYNOTE ADDRESS

THE CULTURAL DIMENSIONS OF POTTERY:
CERAMICS AS SOCIAL DOCUMENTS

Bernard L. Fontana

NOT very long ago, I was walking with some friends over the
surface of an impressive archaeological site, eyes to the
ground, moving slowly in that hunched-shouldered, obtuse-
angled-waist stance characterizing the arrowhead collector
or some other would-be discoverer of artifactual treasures.
We were looking for potsherds, fragments of Piman Indian
earthenware and plain or decorated tin-glazed majolica, the
archaeological hallmarks of Spanish presence in the greater
Southwest. The site was that of the presidio of San Phelipe
de Guevavi, alias Terrenate, a prehistoric and historic
village occupied by Spanish troops between 1742 and 1755.[1]
 Although the outlines of its documentary history have been
published, the site of Terrenate itself is little known and
rarely visited. After its abandonment in the 1770s by soldiers,
and probably by the Indians as well, it has never been
reoccupied. A small house and three or four utility buildings
occupy a lower portion of the old ruins. A cowboy and his
family live there, while he watches over what is now a
portion of a large Sonora, Mexico, cattle ranch. But the
place stands in splendid isolation. The cowboy only rarely
climbs the mesa where most of the presidio was located, and
the road into the area is rocky, dusty, high-centered, and
unpaved throughout its twenty-six-mile length. Although
the cowboy's house has no electricity, the same water runs
today that ran more than two hundred years ago when soldiers
were guarding the Spanish frontier against Apache incursions.
There is a small stream out of which men have run a ditch
for irrigating their pastures and fields as well as for providing

water for themselves. Cottonwood trees more than sixty
feet tall grow along the stream, and centuries of erosion
have cut into the base of the mesa on which the presidio
rests. Walking in this place, or camping here, creates an
overwhelming sense of uninterrupted time, a feeling of
continuity between then and now.

Our archaeological efforts--if making an unmapped
collection of surface finds can be called that--were rewarded
by our gathering more than a hundred sherds of eighteenth-
century Mexican majolica and more than a dozen sherds of
Chinese porcelain. Most Chinese porcelain imported into
Mexico from the Orient came via Manila galleons. Nearly
all the majolica, which was in part Mexico's answer to
Chinese ceramics, had been made in Puebla, far to the
south.[2] These small pottery fragments are pieces in the
jigsaw puzzle of the history of Spain's expansion into what
was to become the North American Southwest. They are a
reflection, however faint, of the relationships between
Indians and Europeans on this eighteenth-century frontier
and even of the legal and political structure of New Spain
with regard to the role of church and state. But potsherds,
like whole ceramic objects or all artifacts, continue to be a
language whose sounds are poorly understood. It is not
that the language of man-made objects is undecipherable.
It is simply that we have not yet cracked the code. The
more minds that are turned to the question, the more likely
it appears we will one day be better able to interpret
artifacts as social documents. In this instance, we will be
better able to appreciate ceramics as something more than
aesthetically pleasing or displeasing objects to be dated
with accuracy, objects whose pastes, glazes, and decora-
tions we can classify in terms of some mutually agreed-upon
system of typology. Brian Fagan argues, "Unless ceramic
studies lead to a better understanding of the cultural context
in which they were founded, [pots] form a sterile record of
very limited historical value'."[3] Some of the different ways
of thinking about ceramics will be considered here.

Pottery in North America is at least four thousand years
old. Pieces of fiber-tempered earthenware found in Georgia

and Florida have been radiocarbon-dated at about 2000 B.C.,
making these wares among the oldest in what are now the
United States and Canada.[4] From then until today, potters
in North America have been busy at their craft, turning out a
bewildering array of products, from the simplest kinds of
politely fired plainware cooking vessels to sturdy ironstone
toilets and brown-glazed electrical insulators. To add to
the confusion, the consumers of these fired-clay objects
have willingly acquired and used those made in foreign
climes, ultimately leaving in American soil or in American
homes and museums ceramics that originated halfway around
the globe. It is no wonder that pottery has attracted a host
of specialists to its study. It is among man's most durable
artifacts. It is crafted by artist, artisan, technician, and
engineer; it is traded throughout the world; it is used by
president and pauper alike. If ceramics could talk there
would be no limit to what they could tell. It is one of the
tasks of the historian of technology to help them speak.

More than thirty-five years ago, anthropologist Ralph
Linton suggested that every element of culture had four
distinct, if interrelated, qualities. These, he wrote, are
form, meaning, use, and function.[5] Applying these concepts
to an analysis of ceramics, the form of a fired-clay object
may be thought of as comprising its tangible and observable
physical attributes. The object has shape, size, weight,
color, texture, and degrees of hardness and friability, clay,
and temper. It may also have different kinds of paints or
glazes on it, not to mention impressed or printed marks and
various kinds of decoration. If it is a container, it has a
measurable capacity.

In short, any study of ceramics begins with a study of
form, a study that is purely descriptive in character. The
attributes of form that the student wishes to regard or
disregard will depend on the kinds of questions being asked.
If one's concern is with the location of the clay deposit
from which the object was made, an analysis of its paste
will yield more information than a study of its weight or size.
But if we want to know to what use the object was put, we
will pay more attention to its shape than to the ingredients
of its temper or slip.

If a study of pottery begins with a formal description of
pots, it moves quickly to an examination of the uses to
which pots are put. Linton defines the use of any cultural
element as an "expression of its relation to things external
to the social configuration."[6] When it comes to ceramics,
Winnie-the-Pooh reminds us that a useful pot is for putting
things in, whether the things be honey for hungry bears or
exploded balloons for Eeyore's birthday. The use of any
ceramic object, if we follow Linton, is defined in terms of
its relationship to the nonhuman environment.

Even so, it is man who determines the uses of ceramics.
In large part, these uses will depend upon the meanings
assigned to them by those who are doing the using. Thus a
fired-clay marble was used by small boys to shoot against
other marbles in an ancient game of skill. But in the 1890s,
manufacturers of wire doormats used identical objects for
spelling firm names in the steel meshes. Marbles were also
used in pump valves and in various kinds of puzzles. It is
clear that marbles meant different things to different people.

Finally, ceramics also have their functions, and Linton
tells us that the function of an artifact is defined by its
relation to things within the cultural configuration.[7] A pottery
candlestick may be used to hold a candle, but placed on the
altar of a church, it functions in the religious realm of
culture. To the potter who fashioned the candlestick and
sold it, it served an economic function. To the priest who
liked it and bought it for his altar, it may also have served
an aesthetic function. In short, it is a consideration of
the function of ceramics that brings us closest to an under-
standing of ceramic objects as social documents. Lewis
Binford, in fact, has proposed three levels of function.
These are technomic, which corresponds roughly with Linton's
notion of use; sociotechnic, the function of artifacts in
social relationships; and ideotechnic, the function of
artifacts in the ideological component of the social system.[8]

In more elemental terms, it can be argued that all human
beings attempt to order the universe, to make it intelligible
in order to deal with it. To facilitate the process, we
apply labels to everything we see, which is to say we give

names to both artifacts and nonartifactual items in our external world. How we perceive an object can be defined as its meaning to us. And the meaning of any artifact is likely to be part of a larger framework of understandings, part of the particular way in which our culture has taught us to arrange the world of external reality. We make unfamiliar artifacts familiar by relating them to the nearest homologue in our own inventory of forms. Thus we see Japanese glass fishing floats as colorful parlor decorations just as Navajo silversmiths see Mexican silver pesos as raw material for bracelets or other jewelry.

It is clear that an object's meaning determines its use. A ceramic stocking darner serves one use to the lady whose culture produced it, but it also well serves the Indian potter who needs something smooth to polish her vessels. If pottery vessels function in the realm of food preparation, stockings function in the realm of clothing and bodily protection. Form, meaning, use, and function are inseparable links in the chain of our need to order the universe, to make sense of it, to cope with it. Whether one prefers Linton's or Binford's conceptualizations is not as important as one's willingness to use whatever ideas one can to contemplate the nature of the relationship between man and artifact, between potter, pot, and consumer.

A decade ago, three fellow students and I applied the ideas of form, meaning, use, and function to an interpretation of modern Papago Indian pottery.[9] We attempted to learn from Papago Indians how they conceptualized the forms of pots; to learn the kinds of meanings attending the forms, meanings that determined their use; and to understand the function of pottery in the economic, religious, social, and political system of Papago culture. The study was fairly successful in setting forth these complex relationships. But I was startled two years ago on seeing a large earthenware water jar lodged on its side in the crotch of a tree in a Papago's yard, for it had become the nesting place of a white leghorn chicken (Fig. 1). There is no term in Papago to denote an earthenware chicken coop as a ceramic form.

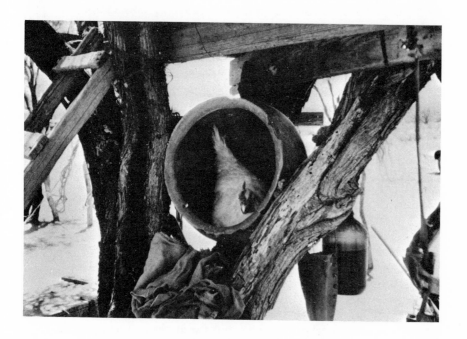

Fig. 1. Earthenware water jar (<u>shuhdagi wa'igkuD</u>) used as a chicken roost, Many Dogs village, Sonora, Mexico. (Photo, the author.)

As a final example of the connection among ceramic form, meaning, use, and function, we might consider the case of a Papago modeled bird effigy vessel made about forty years ago (Fig. 2). There are five small holes in the head of the bird, which indicate that its potter meant it to be a salt-shaker. The small holes were not intended as vents, for Papago effigy vessels have a single large hole to serve as a vent.

The problem, like that of several similar pots, is that the bird vessel has no hole into which to put the salt. The Papago lady who made these vessels came from a part of the reservation where people traditionally used Mexican hard salt that was crushed between the fingers of one's hand as needed. It seems clear that she had seen salt and pepper shakers on the shelves in stores, and she perceived these were objects non-Indians used. She proceeded to copy what she had seen on the shelves, albeit in the manner of a native effigy form, but because its use was not familiar to her, she failed to allow for a way to fill it with salt. The form, use, and meaning of saltshakers in our culture are familiar to all of us. To this Papago potter, the meaning was purely an economic one: something to sell to non-Indians. The ceramic result is that this cross-cultural confusion has been fired into permanent form. It is, indeed, a social document.

I have not spoken here of the language of ceramics as a purely rhetorical device. Several historians of pottery, most notably archaeologists, have turned to the model of linguistic analysis in their search for new ideas. James J. F. Deetz has touched on this in his book, Invitation to Archaeology,[10] but the approach is one that needs far more serious attention from more scholars. In essence, Deetz says:

> Artifacts, like words, are the product of human
> motor activity, made through the action of
> muscles under mental guidance on the raw
> material involved. . . . There may be structural
> units in artifacts which correspond to phonemes

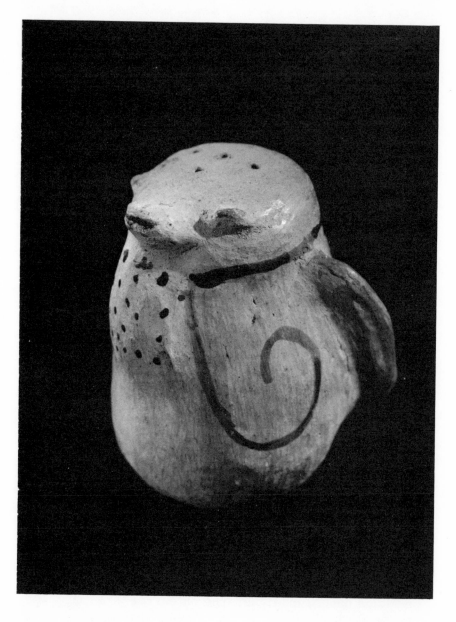

Fig. 2. Chalina (Charlene), Saltshaker, Gu Vo, Papago Indian Reservation, Arizona, ca. 1930. White clay painted red and black; H. 4 1/2". (Arizona State Museum: Photo, Helga Teiwes.)

and morphemes in language, a correspondence
which goes beyond simple analogy reflecting an
essential identity between language and objects in
a structural sense. If this is true, . . . might not
words be one aspect of a larger class of cultural
products which includes all artifacts as well?[11]

There are reasons to suspect that even as language is an
instrument for the expression of meaning, artifacts--whether
ceramic or otherwise--are similarly so. Today's analysts
have innumerable linguistic models on which to draw. Terms
such as generative grammer, phase structure grammar, and
transformational grammar come to mind, to say nothing of
tagmemic and other kinds of structural studies.[12] We can do
no more than to remind historians of the potential.

Less abstract and complex, perhaps, is the approach to
studying ceramics that draws our attention to an inter-
relationship among pots, potters, potting, potteries, and
the eventual consumer or user of ceramics. Beginning with
the pot, we quickly arrive at such questions as when and
where was it made? What was its intended use? What was
its name? Who was its maker and how was it made? What
was the technique of potting? Terms such as wheel-turned,
molded, modeled, coiled, and paddle-and-anvil come to
mind. To what extent are the techniques representative of a
cultural tradition and to what extent are they the reflection
of the potter's inventiveness? Is the grammar of the potter's
gestures apparent in the finished product, or is the pot
ungrammatical? Is it the product of a single potter, of
several, or of an industrial pottery? Answers to these
questions will tell us a great deal concerning human beings
and our societies. To quote again from Brian Fagan:

Surprisingly little attention has been paid to
the social, cultural, and economic settings
of pot-making in modern populations. As a
result, it is difficult to draw meaningful
conclusions [based on studies of ceramics]. . . .
Most descriptions of pottery, both in archaeology
and anthropology, deal with techniques and

processes of manufacture and with the design
elements. They may tell us something about
the division of labor in the making of pots, but
they reveal little about the potters' status in
their own society, their attitudes artistically
and in terms of fashion, the economic role of
pottery, nor the way in which potters are trained.[13]

Where, indeed, do we find ethnographic descriptions of
how potters themselves conceive of their work? What are
their value judgments concerning pots and on what are they
based? What are the reasons they indulge in their craft?
What are the ranges of forms they make and what linguistic
labels do they apply to them?

In Papago the terms for ceramic objects describe the
intended uses of pots rather than their shapes. The label
indicates whether the pot is an instrument for fetching
water or frying beans, but it tells us little or nothing about
form.[14] An example of such a label in English might be
"butter churn," which tells us the use but does not indicate
appearance.

Most common terms applied to ceramic objects in English
describe form rather than use. Etymological studies
indicate that a plate is flat. Jar derives from an Arabic word
for vase, which is related to vessel, and a vessel is a
hollow utensil. A dish is circular and flat, and a bowl is
something that is blown round. Pitcher, which may stem
from an Egyptian word for oil vessel, is one of the exceptions
proving the rule. Why terms for ceramics in English tend to
describe form rather than use would make a worthwhile study.
It is no accident that potters and specialists who study their
wares use a nomenclature that calls attention to the nature
of the clay and its finish. Thus we hear of stonewares,
pearlwares, creamwares, salt glaze, lead glaze, slipwares,
banded wares, polychromes, earthenwares, bone china, and
a host of similar terms all of which tell us nothing about form
or use, but instead describe body, surface treatment, and
decoration. In short, this ceramic terminology indicates
that those who use it attach meanings to the wares

different from those who speak simply of plates, bowls, and dishes.

We need to know the terms used by potters in different places and times. We need to know the labels applied by shippers, importers, wholesalers, retailers, advertisers, and consumers. And what of those who prepared the inventories for probates of estates? Who were they, and what kinds of knowledge of ceramics did they possess? Surely the popular, folk, and academic nomenclature for ceramic objects, in all languages and cultures, is an avenue worthy of investigation.[15]

And at last, we need to turn our attention more seriously to the wide varieties of uses to which ceramics are put. As important and as interesting as studies of potters, potting, potteries, and nomenclature may be, it is a knowledge of the final utilization of fired-clay objects that will enable us best to write human history. Since prehistoric times in America, ceramics have been used primarily in food-getting and food-preparation activities. But American Indians had clay pipes and beads and figurines as well, and the modern, industrial inventory of the uses of ceramics approaches infinity.

To pay heed to the uses of pottery means, too, to broaden our horizons. We should know as much, if not more, about Homer Laughlin's hotel china and the dime-store dishes given away in gas stations as we do about the wares of Rudolf Christ, the master potter who spent his retiring years in the pottery shop at Salem, North Carolina.[16] But where are the books, the studies, and the collections of everyday dishes of America? The fact that these studies are all but nonexistent is itself a kind of social commentary. It tells those of us who are interested in ceramics something about ourselves.

My mind inevitably turns back to that quiet mesa top in northern Mexico where the Spanish presidio once stood. What possible secrets are hidden in those sherds of Mexican majolica, and why would grown and reputedly sane men travel so far and expend so much effort to gather them? Curiosity and hunch send us on our way. Our exertions are

beginning to pay dividends. We were able to find more pieces of tin-glazed earthenware on the ground at the Terrenate presidio in a single day than we have been able to find at any northern Sonoran or southern Arizonan Spanish mission site ever excavated. The reason is now becoming apparent. These particular types of majolica were Mexican-made Spanish ceramics. The people who had them brought such great distances and who preferred them to Indian wares were Spaniards and other Europeans. Presidios were not merely Spanish frontier institutions, they were inhabited by Spaniards and their families as well as by Indian troops.

Missions, on the other hand, although certainly European institutions, were segregated havens on the Sonoran frontier during the eighteenth century. The only non-Indians normally resident in missions were the clergy and occasional Spanish soldiers and artisans. Missions were above all for Indians, and Indians were not in any meaningful way a part of the trade and use of majolica pottery. The relative abundance of majolica in presidios, which we now know to be a fact along the whole Sonora-Chihuahua frontier, and the paucity of majolica in Spanish mission sites are the result of Spanish law and policy as these relate to dealings with Indians in the eighteenth century.

To conclude by presenting a formula for divining from American ceramics the social history of our people would be ideal. As a museum professional, I like to think that this is the goal of our displays and our collections of artifacts. But I have no formula; merely these few suggestions, hints, and leads. If we use our imaginations, there is no doubt we will one day be able to appreciate ceramics in their cultural dimensions as the social documents they are.

NOTES

1. John L. Kessell, "The Puzzling Presidio San Phelipe de Guevavi, alias Terrenate," New Mexico Historical Review 41, no. 1 (Jan. 1966): 21-46.

2. The best source on this subject is John M. Goggin, "Spanish Majolica in the New World; Types of the Sixteenth to Eighteenth Centuries," Yale University Publications in Anthropology, no. 72 (1968).

3. Brian M. Fagan, In the Beginning: An Introduction to Archaeology (Boston: Little, Brown, 1972), p. 213.

4. Ripley P. Bullen, "Radiocarbon Dates for Southeastern Fiber-Tempered Pottery," American Antiquity 27, no. 1 (July 1961): 104-6.

5. Ralph Linton, The Study of Man: An Introduction (New York: Appleton-Century, 1936), p. 402.

6. Linton, Study of Man, p. 404.

7. Linton, Study of Man, p. 404.

8. Lewis R. Binford, "Archaeology as Anthropology," American Antiquity 28, no. 2 (Oct. 1962): 219-20.

9. Bernard L. Fontana et al., Papago Indian Pottery (Seattle: University of Washington Press, 1962), pp. 22-49.

10. Deetz, Invitation to Archaeology (Garden City: Natural History Press, 1967), pp. 83-96.

11. Deetz, Invitation to Archaeology, p. 87.

12. Henry A. Gleason, An Introduction to Descriptive Linguistics (rev. ed.; New York: Holt, Rinehart and Winston, 1961), describes most of these models. Perhaps the best introduction to the ideas of one of the most provocative linguists is John Lyons, Noam Chomsky, ed. Frank Kermode (New York: Viking, 1970).

13. Fagan, In the Beginning, p. 214.

14. Fontana et al., Papago Indian Pottery, pp. 33-49.

15. The concepts of folk, popular, and academic are carefully set forth in Henry Glassie, Patterns in the Material Folk Culture of the Eastern United States (Philadelphia: University of Pennsylvania Press, 1968), pp. 1-8.

16. Stanley South, "The Ceramic Ware of the Potter Rudolph Christ at Bethabara and Salem, North Carolina, 1786-1821," The Conference on Historic Site Archaeology 1968 3, pt. 1 (1970): 70.

CERAMICS FROM PLYMOUTH, 1620-1835:
THE ARCHAEOLOGICAL EVIDENCE

James J. F. Deetz

Introduction

THE holistic view of culture that characterizes anthropology
is particularly crucial in archaeological explanation, since
it is only through treating artifacts as parts of whole cultural
systems that understanding is gained from the material
remains of the past. The use of archaeological data to
explain rather than simply to describe depends on the
effective explication of those critical links that exist
between human behavior and its material products. Any
discussion of ceramics and their use in early America must
therefore consider the place of ceramics in the culture and
their relationships to other aspects of that culture. For the
archaeologist to cite the presence of combed slipwares in
southeastern Massachusetts in the early eighteenth century
is mere description; to determine the significance of its
presence there to our understanding of the life of the people
who were using these artifacts calls for an explanation.
Material culture can be effectively employed in achieving a
better understanding of the American past, but only as long
as the relationship between behavior and its material
products is kept in mind. Such a relationship is not restricted
to the behavior that resulted in the production of those objects.
Their acquisition, use, and ultimate disposal all resulted from
certain aspects of the lifeways of their owners.

This paper will formulate an explanatory model for under-
standing the cultural significance of ceramics in America,
specifically in southeastern Massachusetts between
approximately 1620 and 1835. It should be considered
highly tentative and open to correction, refinement, or

rejection. If it stimulates thought and discussion of the subject along somewhat different lines than those followed in the past, it will have succeeded in one of its prime objectives.

The model will be developed by advancing a number of basic propositions derived from historical data and anthropological theory. These propositions will be used to formulate hypotheses to be tested in turn against the archaeological data from Plymouth representing ceramic use between 1620 and 1835. If the ceramic data support the model as formulated, other material-culture categories should exhibit similarly close agreement, lending further independent strength to the model as it applies specifically to ceramic assemblages.

The Propositions

Ceramics are a functional component of a cultural system. Cultures are dynamic systems used by their members in coping with the world around them. The complex network of any cultural system is such that its component subsystems-- religion, material culture, economics, social organization, etc.--are functionally interrelated. Change in one system usually brings about change in others. The particular subsystem that should be of interest to students of Euro- American ceramics is what Jay Anderson calls "foodways" and defines as "the whole interrelated system of food conceptualization, procurement, distribution, preservation, preparation, and consumption shared by all members of a particular group."[1] While it will be shown that certain ceramics of early America probably belonged partly or wholly in other subsystems, the majority were closely involved with the material aspects of foodways. Changes in the foodways subsystem, engendered by changes elsewhere within the culture, will be reflected in the changing composition of the ceramic assemblage. Given little change in the cultural system, a relatively constant pattern of ceramic use will prevail.

Three successive cultural systems were operative in

New England in the period 1620-1835. While it is quite
possible that any English colony established during the
first half of the seventeenth century would have passed
through broadly similar changes in the cultural systems
involved, the proposition advanced here applies specifically
to New England--the Massachusetts Bay and Plymouth
colonies. Other investigators may want to test the model
in terms of the particular colonial culture with which they
are involved.

The initial cultural system in Massachusetts was the one
brought to the New World by Englishmen and most closely
conformed to the system practiced in their former home.
Since the population of early Massachusetts, particularly
Plymouth, was not representative of the entirety of
contemporary English society, their culture was also not
totally representative. The lifeways transported to New
England in the early seventeenth century were basically
those of the less prosperous Stuart yeoman and husbandman.
Deeply rooted in an earlier medieval tradition, the culture
of the Puritan and Separatist colonist was conservative,
potentially self-sufficient, and greatly influenced by
religious attitudes. Once established in the New World,
this system underwent minor modification as a result of a
somewhat different environment but continued relatively
unchanged for a generation. The Puritan Revolution in
England led to a dramatic reduction in emigration during the
1640s, creating in Massachusetts depressed economic
conditions, a shortage of imported goods, and a cultural
isolation that led to a slow but steady divergence from the
earlier yeoman lifeways. This divergence was reinforced
by the increased presence of individuals born in the
New World.

From this semi-isolated society, a distinctive Anglo-
American culture emerged, one probably less English than
before, and less English than it would become again by the
eve of the American Revolution. This second cultural system
was a typical folk culture, marked by strong conservatism,
resistance to change, and considerable regional variation.
So strong was the conservative nature of this early folk

culture that it continued relatively unchanged in the more
isolated rural areas of New England until well past the
middle of the eighteenth century.

The impact of the Renaissance in the form of the
Georgian tradition was felt at different times in eighteenth-
century colonial America--earlier in the metropolitan
centers, later deep in the countryside. While buildings in
the Georgian style began to appear at the turn of the
eighteenth century in the more elite sectors of society,
for the purposes of the model in question, the key element
is the time when the Georgian culture began to effect
changes on the majority of the society. Henry Glassie has
argued that Georgian is far more than a stylistic category;
indeed it can also apply to a distinctive Anglo-American
mind-set, characterized by symmetrical cognitive structures,
homogeneity in material culture, a progressive and innovative
world view, and an insistence on order and balance that
permeates all aspects of life, from the decorative arts to the
organization of space by society.[2] In these aspects, it
contrasts sharply with the earlier medieval tradition, which
was far more heterogeneous, asymmetrical in its cognitive
aspects, and conservative in outlook. The impact of the
Georgian world view on the older medieval-derived New
England folk culture led to a third cultural system, one that
can be viewed as the first popular culture to appear in
America. Only by the latter half of the eighteenth century
did this new popular culture affect the majority of the
population, particularly outside the cities, and only then
did regional boundaries begin to dissolve, and the overall
rate of culture change accelerate.

Since the immediate origin of the new popular culture was
England, as soon as New England felt its effects, the
colonial society became reanglicized so that the vector of
culture change in colonial New England can be thought of
as a broad, sweeping arc, diverging from its English
parentage and curving back to reunite with English culture
under the influence of the new life-styles appearing in the
mid-eighteenth century and after. By the beginning of the
nineteenth century, even the most remote rural areas of

New England were participating in this new cultural system,
which extended unbroken over all of Anglo-America. In
archaeological terms, this period can be viewed as the
first true horizon in American history.[3]

 In all three cultural systems the presence of ceramics is
a function of four factors: availability, need, function, and
social status. Availability. The artifact must be available
to the members of the culture. While this seems self-evident,
it assumes great importance in an early American context,
since so many of the ceramics used were imported from abroad.
The rise of local potting industries can be viewed as increasing
the availability of ceramics, but local access could have a
negative effect on the use of imported types simply as a
matter of convenience and economics.

 Need. A given kind of pottery might be easily obtained,
yet not be used, if no need exists for it. Functionally
equivalent artifacts in other materials, such as wood or
pewter, could effectively block the adoption of certain types
of ceramics.

 Function. Function is closely related to need; in fact, it
is the specific function of a ceramic item when unfulfilled,
that creates the need. Lewis Binford has demonstrated that
function is far more than simply a matter of technological
efficiency.[4] He discusses three levels of function, each
of which would normally be expected to manifest itself in a
different subsystem of a culture. Technomic function is
strictly utilitarian and directly related to the technology of
the culture. An example would be a candle used as a
lighting device, serving the practical function of solving a
problem directly imposed by the environment. Sociotechnic
function involves the use of artifacts in the context of social
relationships functioning in the social subsystem. A candle,
identical to that mentioned above, when used to enhance a
dinner party is serving a sociotechnic function. Ideotechnic
function entails the use of artifacts in religious and
psychological contexts. The place of candles in the modern
Catholic church is a simple but good example of ideotechnic
function. When function is considered on these three levels,
it becomes obvious that identical artifacts can function in

very different subsystems of a culture. It is most important
that the archaeologist attempt to assess the level of function
served by the artifacts he studies.

Social status. Depending on an individual's place within
the socioeconomic scale, the artifacts with which he
furnishes his household will vary in quantity and quality.
Even if the factors of availability, need, and function were
held constant, some variation in the type and number of
ceramic items in early American households would result
from social factors.

Hypothesis Testing

The three propositions advanced above can be used to
formulate a series of discrete hypotheses for testing against
the archaeological record. In the paper by Marley Brown
in this volume, these hypotheses are similarly tested using
probate data from the Plymouth area during the period in
question. In either case, refinements in the hypotheses
resulting from testing on one set of data render the
hypotheses more useful when tested against the other types
of data.

The archaeological collections that yield ceramic data for
testing are the result of extensive excavation programs
undertaken by Plimoth Plantation over the past several
decades. At this time, a total of sixteen sites have been
investigated, resulting in a collection of over half a million
potsherds ranging in date from approximately 1630 through
1890. Figure 1 is a tabulation of the more important sites
and the ceramics that have been recovered from them.
Relative frequencies of each pottery type are based on the
relative popularity of the type at a given site, with the most
popular receiving a score of 12 in each instance, represented
by a bar 12 units wide, and the others rated on an adjusted
scale ranging down to a score of 1, represented by a bar
only 1 unit wide, denoting the least popular. (The measurement
of 12 units is based on the maximum number of types from one
site.) The type categories have been constructed with a
view to creating approximately equivalent sets; relatively

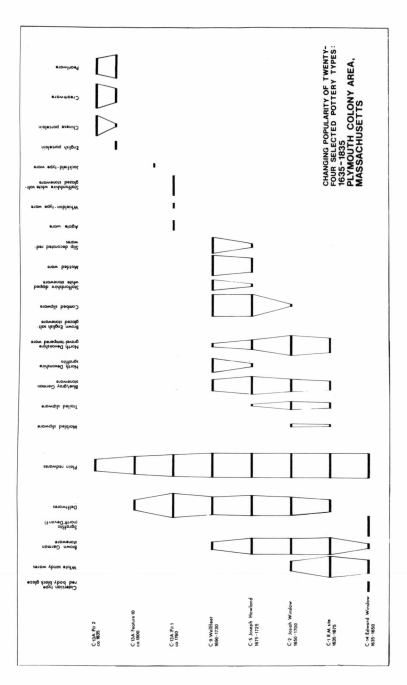

Fig. 1. A tabulation of twenty-four selected pottery types and their changing popularity during the period 1635 to 1835 in eight of the most important sites in the Plymouth Colony area of Massachusetts. (Plimoth Plantation.)

TABLE 1. Sites Excavated in the Plymouth Colony Area

Site Number, Name, and Location	Site Dates	Site Type	Excavator
C-1 R.M. Plymouth, Mass.	1635-1675	Farmhouse and possible garrison house	H. Hornblower
C-2 Josiah Winslow Marshfield, Mass.	1650-1700	Farmhouse	H. Hornblower
C-3 John Howland Kingston, Mass.	1635-1675?	Farmhouse	S. Strickland
C-4 R. Bartlett Plymouth, Mass.	1700-1730	Farmhouse	J. Deetz
C-5 Joseph Howland Kingston, Mass.	1675-1725	Farmhouse	J. Deetz
C-6 William Bradford II Kingston, Mass.	1680-1730, 1840-1890	Farmhouse, later dump	J. Deetz
C-7 Harlow House Plymouth, Mass.	1677-1972	Cellar of standing house	J. Deetz
C-8 Quaker Meeting Hse. Newport, R.I.	1699-1972	Surviving meeting house	J. Deetz E. Ekholm M. Brown
C-9 Wellfleet, Mass.	1690-1730	Tavern, whaling station	E. Ekholm
C-13 Plymouth, Mass.	1620-1972	Town of Plymouth, subdivided into various sections	J. Deetz E. Ekholm
C-14 Edward Winslow Plymouth, Mass.	1635-1650	Farmhouse	G. Moran
C-16 Portsmouth, R.I.	1640-1700	Refuse deposit	M. Brown

general classes are used, and variations within a single
major type are not listed separately. Thus pearlware is
treated as a type, and not subdivided further into transfer-
printed, handpainted, or other varieties. As such, it is
roughly equivalent to creamware as a general type since
creamware could also be further subdivided.

To expedite discussion, relevant data on all of the sites
excavated in the Plymouth area are presented in table 1.
The ceramics recovered from Plymouth sites can be sorted
into three general groups, each of which has some intrinsic
cultural and historical significance. To avoid ambiguities in
the following discussion, the three groups are defined[5] as:
(Group 1) fine imported wares, consisting of Frechen stone-
ware, sgraffito wares, delftware, marbled slipware, trailed
slipware, Westerwald stoneware, English stonewares, combed
slipware, mottled ware, agateware, Whieldon-type wares,
Jackfield-type wares, porcelains, creamware, and pearlware;
(Group 2) coarse imported, undecorated wares, including
white sandyware, North Devonshire gravel-tempered wares,
and undecorated redwares; (Group 3) domestic redwares,
including undecorated types and later slip-painted and -trailed
types. The following hypotheses regarding ceramic usage in
Plymouth are presented with the ceramic data relating to
them, and with a discussion of their coincidence with the data.

Ceramics from Plymouth will exhibit a threefold division
in time, corresponding to the three successive cultural systems
in operation in New England (1620-60, 1660-1760, 1760-1835),
and within each time period there will be greater internal
consistency than between time periods. Figure 1 shows a
strong tendency for the twenty-four types of pottery from
Plymouth to cluster in three chronological periods. This
tendency is somewhat obscured by the fact that the R. M.
site covers a period that includes the first and second
cultural systems (1620-60 and 1660-1760). The R. M.
imported types divide into fine and coarse wares (Groups 1
and 2 above). The fine imported ceramics from the R. M.
site all date stylistically to the third and fourth quarters of
the seventeenth century, while the coarse imported ceramics
from this site are in part earlier. This is particularly true of

the white sandywares, prevalent at the Edward Winslow site,
but waning in popularity at the Josiah Winslow site of the
second half of the century. The Edward Winslow site, the
only one thus far excavated that dates almost entirely to
the first half of the century, almost entirely lacks fine
imported ceramics, the only exceptions being parts of two
Frechen stoneware mugs and parts of four sgraffito-decorated
vessels that probably found their way into the refuse deposit
late in the time when the site was occupied. Of the undecorated
redwares from the R. M. and the Edward Winslow sites, it is
impossible to determine whether they are of imported or
domestic origin. By treating the earlier component of the
R. M. ceramic assemblage and the entire Edward Winslow
assemblage as a unit, the earliest period of Plymouth ceramics
appears to consist predominantly of coarse utility wares with
little decoration. Based on frequency of appearance in the
R. M. and Edward Winslow sites, the following types
characterize the first period (1620-60): Cistercian-type ware,
white sandywares, Frechen stoneware, and redwares. Omitted
from this list is the sgraffito-type ware recovered from the
Edward Winslow site. While it may be identical in many
aspects to North Devonshire sgraffito ware, which reaches
its maximum popularity in Plymouth early in the eighteenth
century, it differs by exhibiting a glaze that is significantly
darker and a different shade of yellow.

The second period (1660-1760), represented most clearly
by the Joseph Howland, Josiah Winslow, Wellfleet, and
later R. M. site materials, contrasts sharply with the previous
period in the marked proliferation of fine imported ceramics.
While a part of this increase is a function of developments in
ceramics in England, their relative popularity and their
apparent sudden appearance is such that this factor alone
fails to account for the difference. While redwares, by now
probably preponderantly domestic, are the most frequent
ceramic type at all sites, delftware, combed slipware, and
Westerwald stoneware account for a large portion of the
assemblage. These are supplemented by mottled ware, dipped
white stoneware, and North Devonshire sgraffito ware. North
Devonshire gravel-tempered ware becomes relatively popular

during this period also. If the increase in North Devonshire gravel-tempered pottery is seen as occurring at the expense of the fading popularity and availability of white sandyware, the two types together exhibit a slow but definite decrease with time, probably the result of increased availability of domestically produced coarse ware.

The third period (1760-1835) contrasts sharply with the previous two. Part of this contrast is due to the nature of the archaeological context of the ceramics in question; they are from a series of discretely separate trash pits in the town of Plymouth, probably of short term use, rather than from farmhouses occupied for as long as half a century. Yet even allowing for this difference, the distinction is genuine. Except for delftware, all of the fine imported ceramics of the second period (1660-1760) are absent. In the seventy years prior to 1730, there was virtually no replacement of types in Plymouth, although their relative popularity changed with time. In just thirty years following the end of the occupation of the Wellfleet site in 1730, a near complete change was worked on the Plymouth ceramic tradition. This third period actually divides further into two subperiods, since by about 1800 yet another ceramic assemblage prevailed, and this was markedly different from that of 1760. The main reason for this difference was the rise in popularity of creamware and pearlware, but there is still a greater consistency within all of the later period in comparison to the earlier periods. It will be shown that a part of this consistency is seen in differences in ceramic forms and functions.

The pattern of ceramic use for the first period (1620-60) will reflect ceramic usage of the Stuart yeoman foodways subsystem as well as that of the first settlers of Plymouth. The preponderance of coarse utility wares in the ceramics of the first period ideally should find some explanation in the role played by ceramics in English yeoman foodways. From conversation with Anderson, and from his detailed study of Stuart yeoman foodways, it is apparent that ceramics played a generally minor role in the entire foodways subsystem. Cooking was done largely in metal containers. The various

lists of items that settlers were advised to bring to the
New World omit ceramics entirely.[6] From our knowledge of
yeoman cuisine, it is apparent that those utensils considered
necessary would accommodate food preparation needs,
albeit basically. The role of ceramics in food consumption
was also negligible; food was consumed from wooden
trenchers, often shared by two or more persons, and
beverages were drunk from common containers. Drinking
vessels were made of ceramic, pewter, leather, or, rarely,
glass. Given both the communal aspect of food consumption
and the variety of materials used for food containers, ceramics
were nonessential to this aspect of foodways.

There is, however, one area in which ceramics appear to
have played a more significant part. Dairy products were of
great importance to the yeoman diet. Cheese was a more
important protein source than meat; indeed it was known as
white meat. The activities centered around milk and cream
storage, and the manufacture and storage of butter and
cheese had greater need of earthenware than did any other
aspect of the yeoman foodways subsystem. The importance
of cleanliness is stressed in early descriptions of dairy
activities, and lead-glazed earthenware containers were
preferred for ease of cleaning.[7] Milkpans, colanders, jars,
and crocks--all might be found in a yeoman's dairy. The
foodways pattern of the yeoman colonists of Plymouth
continued the strong tradition of dairying. That dairy
products were of great importance to the Plymouth colonists
is reflected in the careful apportionment of milk-producing
animals--cattle and goats--on a strict per-capita basis in
the cattle division of 1627.[8] Although it is likely that pigs
outnumbered cows and goats by that date, no such concern
is shown over their equal division.

The pattern of ceramic occurrence in the first period of
Plymouth history is consistent with the data on yeoman
ceramic usage. The shapes of the fine and coarse imported
ceramics from Plymouth throughout the 1620-60 and 1660-
1760 periods are in accord with a function predominantly
linked with dairying. A basic assemblage of coarse wares
continues in Plymouth for more than a century--pans, jars,

pitchers, and crocks. One white sandyware colander from
the R. M. site and a North Devonshire slipware colander
from Wellfleet also fit into this assemblage. While it is
entirely possible that these early ceramics served other
purposes as well, their function is most clearly determined
by dairy activities.

Ceramics of the second period will show differences in
terms of use and type, reflecting divergence from the parent
culture. They will also exhibit strong conservative
tendencies in stylistic and functional trends. The dairying
subassemblage of Plymouth discussed above, continues as
a strong component of the ceramics dating from the 1660-
1760 period. It is joined by a series of new types which
serve to set the later period apart from the earlier period of
colonization. The marked increase of fine imported ceramics
from 1660 to 1760 is certainly a function in part of Restoration
England's renewed interest in her American colonies. The
two decades from 1640 to 1660 were marked in New England
by a dramatic decrease in immigration and imports.[9] It was
in this semi-isolation that an entire population of first-
generation New Englanders grew to maturity, contributing to
the cultural divergence that characterized the period from
1660 to 1760. By the 1650s, there was a shift in the balance
of power in New England, with the merchants gaining
influence at the expense of the clergy, who had dominated
the society of the founding fathers.[10] In such events as the
halfway covenant, we can see the shift away from ecclesi-
astical control of the colonial culture. While this redefinition
of the terms of church membership did not signal a decline in
piety in absolute terms, it can be viewed as indicative of a
growing trend toward secularization of certain aspects of the
culture.[11] With supplies coming in renewed quantities after
1660, the presence of a great variety of finer European
ceramics is no surprise. Yet, for reasons that are not clear,
the manner in which these new ceramics were integrated with
the culture seems somewhat different from the pattern of
ceramic use in contemporary England, and certainly
different from that of earlier Plymouth.

It is necessary to consider the form and function of

ceramics in the period from 1620 to 1660 to appreciate
these differences. The most striking thing about the fine
imported ceramics of this period is the predominance of
hollow forms. The flat-to-hollow ratio at the R. M. site is
roughly one to seventeen, at the later Joseph Howland site,
one to five. The Josiah Winslow assemblage is such that a
reasonably accurate determination of the ratio cannot be
made, but it is of the same order. The absolute number of
plates at each site is significant: R. M. produced 3;
Josiah Winslow, 3; and Joseph Howland, 15. Of the 21 plates,
17 are delftware, 3 are combed slipware, and 1 is North
Devonshire sgraffito ware. Totals for all three sites are
particularly striking in terms of flat-to-hollow ratios, with
21 plates accompanying at least 120 hollow vessels. A few
of the latter are delftware drug and ointment pots, but mugs,
cups, bowls, and jars make up the great majority. The
difference in flat-to-hollow ratios between R. M. and
Josiah Winslow sites and the Joseph Howland site is probably
a significant one, reflecting the growing number of plates
within the ceramic assemblage over a period of time.

　　Although plates had become more common by the end of
the seventeenth century, their occurrence in proportion to
other forms is still quite low. The most reasonable
explanation for this discrepancy would be that plates served
a decreasing sociotechnic function and an increasing
technomic function in seventeenth-century Plymouth. By the
end of the sixteenth century, yeomen in England could afford
to display pewter in an open court cupboard,[12] but such a
display would have been beyond the means of a large number
of Plymouth colonists. If decorated ceramics served as a
functional equivalent to pewter, then one would expect the
presence of such ceramics to be inversely proportional to
social status. Since certain of the more elaborate delft
chargers served a similar sociotechnic decorative function in
England,[13] the same practice could have prevailed in America,
with ceramics replacing pewter in the more modest households.
The extensive use of wooden trenchers made ceramic plates
technomically unnecessary, but they also served decorative
as well as utilitarian functions.

On the basis of the archaeological evidence, there was a
greater tendency to integrate ceramic drinking vessels than
plates into the food-consumption aspect of the foodways
subsystem. Precisely why this is so, it is impossible to
determine at this time, although William Harrison's comment
that the English were quite taken with drinking from Venetian
glass in the late sixteenth century might have some slight
bearing on the problem.[14] In any case, the archaeological
evidence suggests a food-consumption assemblage of
wooden trencher and ceramic drinking vessel as the norm,
with ceramic plates serving as decorative devices that may
at times have been used in the serving of food. Since
wooden artifacts do not survive in an archaeological context,
the increase in absolute numbers of ceramic drinking vessels
could also be an index of a slow trend toward individualized
food serving.

Ivor Noël Hume has suggested that Puritan attitudes toward
decoration of everyday objects might have had an effect on
the delftware industry in the London area in the form of a
reduction of decorated wares prior to the Restoration.[15]
While the subject of Puritan restraint on decorative elaboration
in material culture has been interpreted in different ways,[16]
it is possible that this restraint contributed an ideotechnic
factor that influenced the choice of ceramics used in New
England before the 1660s. While it may be coincidental,
it is of interest that the delftwares from the Josiah Winslow
site have only half as many decorated examples as those
from the later Joseph Howland site. On the other hand,
many of the decorated delftwares from the latter site are
plates. Yet even the use of gaily painted plates as
decoration might have been suppressed in the earlier
years of the colony. The Massachusetts Bay colonists were
concerned with overelaborate decoration, legislating in 1634
against ornate styles of personal dress.[17] A similar
decorative plainness manifests itself in mortuary art in
New England, where decorated gravestones appear only after
1660; the earlier ones are plain, though expertly carved.
This plainness is particularly relevant because a far more
ornate style of gravestone carving had characterized English

culture from a much earlier date. In its religious purity and
cultural homogeneity, New England may have shown the
effects of the Puritan philosophy on the decorative arts
more clearly than Old England, where the Puritans were but
one segment of a larger population.

In a diachronic sense, ceramics from 1660 to 1760 give
the impression of very slow change. New types are added,
simply as a result of their introduction into the English
ceramic universe, but the eleven most common types of
fine imported ceramics are distinctively characteristic of
this period, and less replacement of types occurs within
this hundred-year period than before or after it in any
period of equal length.

Ceramics of the third period will show a greater
homogeneity and will reflect a more structured pattern of
use than those of earlier periods. The period from 1760 to
1835, as seen in the ceramics from three trash pits in
Plymouth, is marked by a major shift in pottery types. Pit 1,
dating from 1760, produced a ceramic assemblage totally
different from those found in sites of the earlier periods.
This trash pit is almost certainly the repository of a single
family's refuse, and it was probably in use for less than a
decade. It contained eight plates, eight chamber pots, and
three bowls in delftware, three mugs, a bowl, a teacup, a
teapot lid, a saucer, and a plate in white salt-glazed stone-
ware, one agateware bowl, a slip-decorated redware pitcher,
four slip-decorated redware chamber pots, three redware
crocks, five smaller redware bowls, and one Whieldon-type
teapot. The most striking contrast seen in this assemblage
when compared with earlier ones is the preponderance of
plates and chamber pots. Not only are plates more common,
for the first time they belong to matched sets (Fig. 2). These
delftware plates show no visible signs of wear on their
cutting surfaces. It is probable that they still had a slight
sociotechnic function and were not used as everyday
utensils. Again, wooden trenchers may well have served in
a purely technomic capacity. Analysis of probate inventories
may provide support to this possibility.

More puzzling is the large number of chamber pots, which

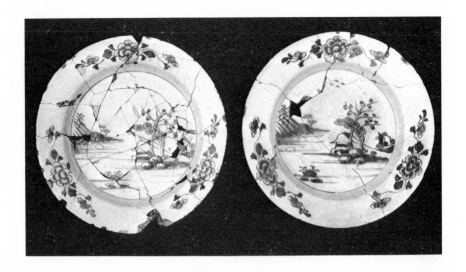

Fig. 2. Matched delftware plates from a 1760 trash pit in Plymouth, Mass. (Plimoth Plantation.)

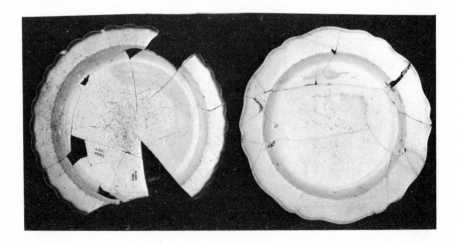

Fig. 3. Wear differences as shown on pearlware (left) and creamware (right) plates from an 1835 trash pit in Plymouth, Mass. (Plimoth Plantation.)

constitute the most common shape in the collection. Chamber
pots are surprisingly rare on earlier Plymouth sites. Only
one Westerwald stoneware chamber pot and two possible
redware specimens from the Joseph Howland site and one
redware example from the William Bradford II site make up
the total number of chamber pots from the earlier periods.
In a single trash pit from the period 1760 to 1835 this total
is exceeded, and chamber pots are just as common in the
other two 1760 to 1835 pits, which produced twenty-eight
examples, in creamware and redware.

It is entirely possible that the earlier chamber pots were
more commonly made of other materials, particularly metal.
On the other hand, it is more than slightly possible that
the increase in chamber pots is directly related to the
increase in plates in this later period. Glassie's argument
that the Georgian mind-set was marked by a bilateral
symmetry visible in architecture, furniture decoration,
gravestone designs, and farm layouts, to name but a few
examples, is an excellent application of anthropological
structural analysis to American cultural materials. The
structure he posits for the Georgian-derived cognitive
system stems from the concept of an ordered universe, which
is in turn an attribute of the new scientific natural philosophy
of the eighteenth century. While rather speculative, it
seems at least reasonable to suggest that such a world view
could lead to a greater concern for an ordered relationship
between man and his artifacts. In place of the older medieval
asymmetrical relationship between individuals and their
material culture, a new one-man, one-plate, one-chamber
pot relationship might have been operative, and indeed, one
in which not only were the members of a social group
rigorously accommodated by their artifacts, but in matched
sets.

The trend to ceramic homogeneity seen in the contents
of Pit 1 is continued in the Feature 10 and Pit 2 assemblages
(Fig. 1). The latter two trash pits, like Pit 1, are clearly
single-family domestic dumps and of equally brief duration
of use. The contents of both pits, taken singly or together,
conform much more closely to our twentieth-century concepts

of the place of ceramics within a culture. Full services
of matching pieces in creamware, pearlware, and porcelain
characterize the assemblages. These sets are accompanied
by matched drinking tumblers. The pearlware plates show
excessive wear on their cutting surfaces, while the cream-
ware plates show relatively little (Fig. 3). It may have
been an idiosyncrasy of a single family, but this difference
suggests the use of creamware as a special-occasion
service, and of edged pearlware for day-to-day use.

The general use of plates as cutting surfaces is probably
related to the introduction of forks and their increasingly
common use. While it is possible to cut meat against a
plate or trencher using only knife and fingers, one of the
prime functions of forks is in anchoring food while cutting
it. Forks appear in the Plymouth archaeological record
around 1730, but they are not common until late in the
eighteenth century. A wooden trencher would have served
as a satisfactory base against which to cut, but the earlier
delftware glazes may have been too fragile. One charac-
teristic of tin glazes is that, once broken, they tend to
flake away from the body. In the later creamwares and
pearlwares, the glaze is so firmly bonded to the body that
flaking is impossible. Thus there may be a direct relation-
ship between the appearance of forks, the persistence of
wooden trenchers, and the final replacement of trenchers
by suitable ceramic plates in the final decades of the
eighteenth century.

There will be a marked increase in the rate of change in
ceramic types during the third period, and domestically
produced ceramics will decrease in relative quantity. It has
been suggested that the period from 1760 to 1835 was
characterized by a popular culture in contrast to the folk
culture of earlier periods. Popular cultures exhibit major
variation in time rather than in space; this characteristic
should be evident in the Plymouth ceramic data in the form
of more rapid replacements of types. This does occur, but a
part of the replacement is attributable to the development of
industrially produced pottery in England. This is relevant,
however, since by this time the American culture system is·

more intimately linked to that of England than before. Thus, whatever the cause, the ceramics from Plymouth by the end of the eighteenth century show a more rapid replacement rate, and also become virtually identical to similar lots from other sites of the period along the entire Atlantic coast. While it is not possible at this time to measure regional variation over such a wide area in the time before 1730 with any accuracy, there is no question that the pottery from Plymouth during the later period is identical to published examples from as far south as Virginia. At the time this material was being excavated and processed two years ago, a visiting archaeologist from Philadelphia was struck by the similarity between Plymouth and Philadelphia ceramics in the post-1765 period and by the dissimilarity between ceramics from the two locations prior to that date.

By 1800 domestic redwares begin to diminish in relative popularity in the Plymouth area. The later component of the William Bradford II site, which dates to the second half of the nineteenth century, produced very little redware. This fading out of the local redwares is not simply a function of more sophisticated ceramics being produced by the local potters. On the contrary, it reflects a larger quantity of imported pottery, predominantly English, appearing in the opening decades of the nineteenth century. English dominance of the American ceramic market continued until the middle of the nineteenth century when various American hard whitewares began to appear. The reanglicization of American culture was virtually complete in the area of ceramics, even though America had become an independent nation after the revolution.

Conclusions

It has been suggested that during the two centuries following the arrival of the first English colonists on Massachusetts shores, ceramics played an increasingly important and changing role in the culture of colonial New England. The increase in absolute quantities of ceramics through time has not been stressed, but it is truly impressive.

The total ceramic collection from the Edward Winslow site represents an occupation by a single family for fifteen years in the first decades of the colony's existence (Fig. 4). The contrast between this sample and that from the Joseph Howland site from the turn of the eighteenth century is impressive, even allowing for a longer period of occupancy (Fig. 5). Both seem slight, however, when compared to the contents of a single trash pit, used by a single family early in the 1830s for only a few years (Fig. 6). Part of this increase is a function of more individualized ceramic use, and part of it is certainly the result of ceramics becoming increasingly available to the society.

If the model postulated above is valid in a general way, it should apply with equal precision to other aspects of the material culture of colonial America. A consideration of two other categories suggests that it does. In architecture, the first houses in New England are very similar to those of the East Anglian homeland of the Puritan and Separatist immigrants. But, like the functions of the ceramics, the houses become less English with time. By the latter part of the seventeenth century they exhibit a number of distinctive attributes such as vertical plank siding, cross summer beams, and shake roofs, as well as a considerable degree of regional variation. More relevant, however, is the continued use of the basic early seventeenth-century house form in rural New England until almost the end of the eighteenth century. The Cape Cod saltbox is the classic example of this later tradition.

The decorative tradition of gravestones also fits into this scheme. As noted above, the earliest examples are plain, and evolve rather rapidly into fully decorated types during the second half of the seventeenth century. During all of the period from 1660 to 1760, the standard decorative motif is the winged death's-head. This design, and an impressive variety of local variations and derivatives, continued until about 1760. At that time, the cemeteries of New England were invaded by a legion of cherubs, a motif that became absolutely universal in all areas by the close of the eighteenth century. Significantly, the cherub design had its

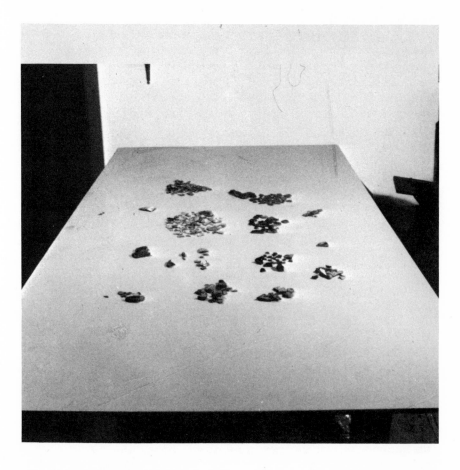

Fig. 4. Total assemblage of ceramic sherds from the Edward Winslow site, Plymouth,
Mass., 1635-50. (Plimoth Plantation.)

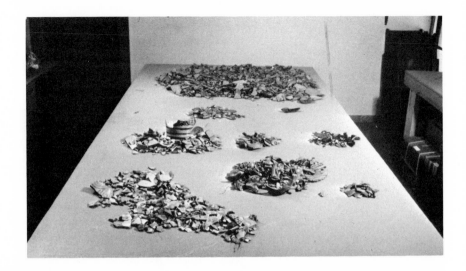

Fig. 5. Total assemblage of ceramic sherds from the Joseph Howland site, Plymouth, Mass., 1675-1725. (Plimoth Plantation.)

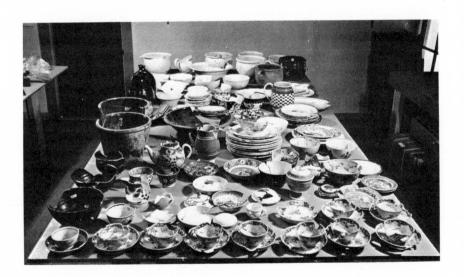

Fig. 6. Total assemblage of ceramic sherds from a trash pit used by a single family, Plymouth, Mass., 1830-35. (Plimoth Plantation.)

beginnings earlier in urban Boston and Newport when the
first Georgian influences were felt by the upper social
strata, and it took over half a century for the design to
penetrate downward in the social order and outward into the
countryside. The spread of the cherub design is perhaps
the most carefully calibrated and measured diffusion in
colonial New England material culture,[18] and if culture is
as integrated as we believe it to be, it may serve as a
more precise indicator of change in other material culture
sets, ceramics included.

This discussion of two centuries of American ceramic
history has been necessarily brief. Indeed, pages could
be written on a number of points discussed in but one or
two sentences. The model that has been developed is
essentially statistical[19] in so far as it is not of the same
scale as the data themselves and represents modal patterns,
i.e. statistical abstractions from all of the data. Not all
delft chargers were predominantly sociotechnic, not all early
coarse-ware vessels were associated with dairying, and not
all unpainted delftware can be seen as reflecting a Puritan
aversion to decoration. On the other hand, on the basis of
available evidence, it would seem that such aspects of
ceramic use may well have been most normal to the society
of the time. It is only this level of specificity which is
suggested. Even if much of what has been discussed and
suggested is wide of the mark, it should indicate directions
to follow in our inquiry into the cultural significance of the
artifacts we unearth, an inquiry which must be undertaken if
we ever truly hope to understand the American past.

NOTES

1. Jay Anderson, "A Solid Sufficiency: An Ethnography of Yeoman Foodways in Stuart England" (Ph.D. diss., University of Pennsylvania, 1971), preface, p. 2.
2. Henry Glassie, "Architecture as Cognitive Process" (public lecture, American Civilization Department, Brown University, Dec. 1971).
3. For a definition of horizon, see Gordon Willey and Phillip Phillips, Method and Theory in American Archaeology (Chicago: University of Chicago Press, 1958), pp. 31-34.
4. Lewis Binford, "Archaeology as Anthropology," American Antiquity 28, no. 2 (Oct. 1962): 217-26.
5. Type definitions follow Ivor Noël Hume, A Guide to Artifacts of Colonial America (New York: Alfred A. Knopf, 1969); and, for white sandyware, Stephen Moorhouse, "Finds from Basing House (ca. 1540-1645): Part I," Post-Medieval Archaeology 4 (1970): 42-59; for mottled ware, Arnold R. Mountford, personal communication.
6. Anderson, "A Solid Sufficiency," pp. 161-62; "The Inconveniencies that have happened to some persons which have transported themselves from England to Virginia" (broadside; London: Felix Kyngston, 1622).
7. Anderson, "A Solid Sufficiency," p. 125.
8. David Pulsifer, ed., Records of the Colony of New Plymouth in New England, 12 vols. (Boston: William White, 1861), 1:9-13.
9. David Hawke, The Colonial Experience (Indianapolis: Bobbs-Merrill, 1966), pp. 154-56.
10. Bernard Bailyn, The New England Merchants in the Seventeenth Century (Cambridge: Harvard University Press, 1955), pp. 91-114.
11. Edmund Morgan, Visible Saints, The History of a Puritan Idea (New York: New York University Press, 1963), p. 137.
12. William Harrison, The Description of England, ed. Georges Edelen (Ithaca: Cornell University Press, 1968), p. 202.
13. Noël Hume, A Guide to Artifacts of Colonial America, pp. 108-9.

14. Harrison, The Description of England, p. 128.

15. Noël Hume, A Guide to Artifacts of Colonial America, p. 108.

16. For a contrasting view, see Alan Gowans, Images of American Living (Philadelphia: J. B. Lippincott, 1964), pp. 64-77.

17. Thomas J. Wertenbaker, The Puritan Oligarchy (New York: Charles Scribner's Sons, 1947), pp. 166-69.

18. James Deetz and Edwin Dethlefsen, "The Doppler Effect and Archaeology: A Consideration of the Spatial Aspects of Seriation," Southwestern Journal of Anthropology 21, no. 3 (Autumn 1965): 196-206.

19. Claude Levi-Strauss, "Social Structure," in Anthropology Today, ed. Alfred L. Kroeber (Chicago: University of Chicago Press, 1953), p. 321.

CERAMICS FROM PLYMOUTH, 1621-1800:
THE DOCUMENTARY RECORD

Marley R. Brown III

ONE of the major tasks facing archaeologists interested in historic sites is that of correlating documentary evidence of material culture with the known archaeological record. Most historical archaeologists employ documentary research in conjunction with excavation, if only as a means of identifying and dating their finds. Historical records should be made to provide the archaeologist with more than answers to the immediate questions of what and when. They can contribute to the interpretation of artifacts in cultural terms by assisting in the formulation and testing of explanatory models. This paper attempts to apply documentary sources to a body of archaeological data in such a way. Plymouth Colony personal-estate inventories from the period 1621 to 1800 have been examined for information about the "technomic, sociotechnic, and ideotechnic dimensions" of ceramics.[1] This information has in turn been analyzed in light of explanatory propositions regarding the archaeological ceramic evidence from Plymouth during the same period.

Although three sets of documentary sources were initially considered--court records, inventories, and newspaper advertisements--inventories were singled out for analysis since they contain the most useful references to material culture. In addition to listing and appraising household goods, these documents sometimes provide information about the status and occupation of the estate holder. The value of these records has long been recognized, though studies of inventories have been pursued mainly by architectural historians and museum specialists with the aim of

establishing grounds for accurate restoration. This purpose
characterizes Abbott Lowell Cummings's study of rural
household inventories from Suffolk County, Massachusetts,
and Barbara Gorely Teller's analysis of Providence inven-
tories from the period 1750 to 1800. Although Cummings
does not specifically discuss ceramics, Teller makes them
her subject. Correlating ceramic possessions with estate
worth, she demonstrates that an awareness of ceramic
styles existed among the population, and that the finer
imported wares were present in large numbers, particularly
in wealthier households. Garry Wheeler Stone offers a
brief analysis of rural and urban inventories of Suffolk
County for the period 1680-1775, concentrating on the
problem of style-consciousness as it differed along a rural-
urban continuum. Paul Chace's study of ceramics in the
Plymouth inventories during the years 1621 to 1675 is a
detailed discussion of the types appearing in these records.
He proposes a "folk taxonomy" of ceramics and investigates
the problems of ceramic use within houses. These studies
go beyond simple description and dating of the types to
make penetrating observations correlating the awareness
and valuation of ceramic types with economic position and
social status. They are not, however, concerned with
explicitly relating their documentary information to the
archaeological record.[2]

In contrast to previous studies, this investigation of the
Plymouth Colony inventories asks questions of the records
that are phrased with specific problems of archaeological
interpretation in mind: namely, the propositions and hypoth-
eses put forth by James Deetz in his paper, "Ceramics from
Plymouth, 1620-1835: The Archaeological Evidence." Further-
more, these questions are asked in a manner that most
effectively complements the archaeological evidence. The
documentary data are treated as a testing ground for hypotheses
drawn from other, independent sources, in this case, inven-
tories from other areas and the archaeological assemblages
recovered in Plymouth. In each instance, the limitations of
the inventory data for archaeological explanation will be
pointed out.

The extant inventory sources from Plymouth Colony for the period covered by this study number approximately forty-one hundred; there are some four hundred for the years 1621 to 1674, three hundred for the period 1675 to 1700, and thirty-four hundred from the entire eighteenth century. The number of extant inventories does seem to correlate roughly with population and its rate of growth in the colony. Chace discusses the ceramics that appear in the inventories during the first half of the seventeenth century, but his study is based only on those inventories coded into the information retrieval system of Plimoth Plantation.[3] Some one hundred ten inventories of the period 1654 to 1675 had not yet been transcribed and coded at the time of his research, and so could not be included in his analysis. These inventories, as well as approximately three hundred from the years 1654 to 1700, were read as part of his study. The result is a total sample of Plymouth inventories from the seventeenth century, analyzed in terms of ceramic content.

Because the number of inventories available from the eighteenth century is so large, it was decided to make a random sample of these records. Some thirty-four hundred inventories from the seventeenth century are contained within thirty-five books now resting in the Plymouth County Registry of Probate. The number of inventories bound within each book was recorded along with the period of time covered by each book. This information allowed both a random and representative sample of 10 percent, or three hundred forty, to be drawn.

A summary of the descriptive information about ceramics appearing in the inventories allows testing of the first hypothesis put forth by Deetz, that ceramics from Plymouth exhibit a threefold division in time. The testing will be accomplished by first establishing the specific types which may be identified from inventory entries to see how these compare with the ceramic groups defined archaeologically, and then by observing the temporal patterning of these types within the inventory sample.

According to Deetz, the period 1621 to 1660 is characterized

by the presence of a large amount of coarse utility wares,
including Cistercian-type wares, white sandywares,
Frechen stonewares, and redwares. In the early part of
the first period, redwares were most likely imported, but
it is impossible to distinguish domestic products from
imported ones.

Turning to the ceramic references, appearing in a total
of forty inventories from this period, there is little straight-
forward evidence regarding individual ceramic types. Many
of the ceramic references occur in the form of lumped
categories, the most common being "earthenware" and
"earthen vessels." More often in this sample, earthenware
is specified as to vessel form, and the inventories mention
earthen pots, pans, a jug, a platter, and a basin. It is
obvious in many instances that these vessels are of a utility
ware, but this represents an inference based on the form
of the objects. There is no way of making certain identi-
fications on the basis of material designation alone.

There is a single occurrence in the first-period inven-
tories of what might be interpreted as domestic redware.
This entry, "It. New England earthen ware seven peaces,"
appears in the 1654 inventory of Ann Atwood of Plymouth.
It suggests that earthenware, most likely red-bodied, was
being produced locally as early as 1654, if not earlier,
and implicitly contrasts the New England material to earthen-
wares both imported from abroad and being made in other
colonial regions. This is the only reference from the first
period that can be identified with any certainty as redware.

With regard to stoneware, entries mentioning vessels of
stone appear in five inventories from the years 1621 to 1660.
In all, five "stone" jugs, two bottles, and one pot are
enumerated. While it is possible that these items repre-
sent the Frechen type, there are no grounds for a positive
identification.

Aside from the distinction between earthenware and the
lone reference to domestic redware, there is one other type
that can be seen in the inventories. This is delft, or tin-
enameled earthenware. There are a total of four entries
from the first period containing ceramic pieces which might

be construed as delft. These are listed in Appendix 1.
The first three examples exhibit modifiers of color and
might be interpreted as painted delft. Stone, in his study
of ceramics in the Suffolk inventories, is willing to positively
identify the label "blue and white earthenware" as delft.[4]
Chace is more cautious in equating references of colored
earthenware with delftware. It is his opinion that "they most
likely are delft, although porcelain or even grayish white stone-
ware may possibly be represented."[5] Acknowledging the other
possibilities, then, these colored items are tentatively iden-
tified as tin-enameled earthenware. The one reference to
"gally pot" seems less ambiguous, and when this term appears
it can be taken to mean a delft ointment pot.

In summary, it may be said that there were earthenwares and
some stonewares present during the first period. Earthenwares
can be divided further into domestic redware and tin-enameled
earthenware, redware being present in the colony at least by 1654
and delft coming in during the latter part of the period. The
earthen vessels specified do suggest a coarse utility ware in
most instances, and the forms mentioned in the inventories do
compare favorably with the basic assemblage outlined by Deetz,
that of pans, jars, pitchers, and crocks. In short, the ceramic
entries found in the inventories suggest that coarse utility
wares did make up the greater part of the ceramic assemblage
during this first period, but the documentary evidence is hardly
conclusive, given the ambiguity of most ceramic references.

The archaeological assemblages from the period 1660 to 1760
reveal a marked increase in the amount of fine imported wares
during the latter decades of the seventeenth century. Included in
in this group are delftware, combed slipware, Westerwald
stoneware, and North Devonshire sgraffito ware. Redwares,
for the most part domestically produced, also increase in this
period, making up the major portion of the ceramic collection
at each site. With regard to the documentation of these changes,
the inventories from the second period contain as little direct
evidence of specific ceramic types as do those from the first
period. In fact, an even greater proportion of the ceramic
entries are now lumped, again either as "earthenware" or "earthen
vessels." These lumped categories are of little value in tracing

the increase in fine imported wares and redwares that can be
seen archaeologically. It is interesting to note, however,
that a few inventories do suggest that a distinction was made
between fine and coarse earthenware. For example, the 1731
inventory of Tomson Phillips of Plymouth contains a reference
to "old coarse earthen," and the 1724 inventory of Captain
Charles Little, a merchant of Plymouth, shows that his parlor
contained "fine earthen and glassware." The latter entry
most likely refers to delft plates, while "old coarse earthen"
is probably domestic redware.

Aside from this one reference to "coarse earthen," there
are two entries falling at the end of the second period that
most certainly imply redware. "Red earthen" and "his Red
earthenware" appear in the 1758 inventories of Benjamin and
Roger Hammond, respectively. This is the first clear-cut
evidence for the presence of redware to be found in the inven-
tory sample from 1660 to 1760. However, a number of ceramic
entries that include color designations might also refer to red-
ware: "Yellow earthen dishes" can be interpreted as redware
or combed slipware; "brown bowls," "a brown pitcher," and
"2 black mugs" likewise suggest redware, but material is not
specified, and for this reason they could also represent stone-
ware pieces. In the case of the black mugs, Jackfield-type
ware is suggested; the brown vessels could be English brown
stoneware of the type often associated with Nottingham.

Identifications of delft, or tin-enameled earthenware, from
inventory entries of this period have been based on essentially
the same kind of evidence employed in the previous period; that
is, references to painted or colored earthenware and gallipots.
There is, however, one example of "Holland earthenware"
appearing in a 1751 inventory, and two specific references to
"delph" or "delf" were found, one in 1756 and the other in
1759. In addition to the entries listed in Appendix 1, a number
of references to earthenware dishes may also be delft, but it
is impossible to make a positive identification. They could
refer to other types as well--combed slipware, North Devon
sgraffito, and, for that matter, redware.

Even though it appears that tin-enameled earthenware was
becoming more popular during the second period, it is difficult

to measure such a trend quantitatively, given the form of the
inventory entries. The evidence there is, within the sample,
suggests that a very gradual increase took place, until the
1740s and 1750s, at which time delft made a definite inroad
into Plymouth Colony households.

The distinction drawn between stoneware and earthenware
continues in the inventories of the second period, and pro-
portionally there is a greater number of stoneware vessels
present in this sample than was contained in the records from
1621 to 1660. This growth in stoneware's popularity is most
evident in the inventories of the 1730s and 1740s, when the
range of vessel forms produced in stoneware becomes greater.
This development closely parallels the pattern reported by
Stone for the occurrence of stoneware in the Suffolk County
inventories.[6]

With one exception--a platter occurring in the 1673 inven-
tory of Thomas Prence of Plymouth--stoneware vessels during
the period 1660 to 1730 are restricted to three forms: the mug,
the jug, and the bottle. Although mugs first appear in 1723,
in a context suggestive of stoneware, the first unequivocal
reference to stone mugs is the 1731 inventory of Tomson
Phillips, listing thirteen specimens, seven large and six small,
probably pint and quart sizes. By this date, stone mugs could
represent English brown salt-glazed stoneware, English slip-
dipped white salt-glazed stoneware, or Rhenish blue-and-gray
stoneware. There are two references that more strongly suggest
the English white salt-glazed type: two white mugs contained
in the inventories of Sarah Cushing of Scituate, dating to 1742,
and Isaac Lathrop of Plymouth, dating to 1751. Since stone
is not specifically designated, they could also be delft. The
two black mugs, possibly of the Jackfield-type, have already
been mentioned.

In 1731 the first definite reference to a stone tea set occurs,
that located in the parlor of Tomson Phillips of Plymouth. While
there are numerous other examples of teapots and teacups during
this period and later, material is not designated. "Flint tea
pots" occur in a few inventories at the very end of the second
period, after 1755, and might be Jackfield or even "Black Ba-
saltes," although it is not likely that this latter type reached

Plymouth Colony households so early. Teller discovered some
"black-glazed" or "Japann'd" ware in the Providence inven-
tories during the period 1750 to 1775, mainly as tea and coffee
sets, but it never appeared as "flint" in her sample.[7]

During the remainder of the second period, in the 1740s
and 1750s, stoneware mustard pots, pickle pots, and vinegar
cruses appear in the inventory sample. What seems to be
enameled white salt-glazed stoneware is found in the 1758
inventory of Benjamin Hammond of Rochester, containing an
entry "To his Red & White Stone Ware." There are no other
definite references to white salt-glazed stoneware occurring
in this period. Of all stoneware vessel forms encountered
in the inventory sample from 1660 to 1760, the jug remains
the most common and can represent either English or Rhenish
types.

The first reference to porcelain appearing in the Plymouth
inventories occurs in the 1735 inventory of Abiel Pulisser, a
Plymouth merchant. His front parlor includes a set of "6
China Plates at 10 shillings and a small China bowl." Also
listed are a "tea pot" and "tea cups and saucers," which are
likely porcelain but which could be stoneware. The entries
containing porcelain during this period are listed, along with
estate values, in Appendix 2. A brief glance at the list makes
clear the fact that, as Stone puts it, "being fashionable was
apparently an important cultural value for the cosmopolitan
seafarer."[8] Over half of those individuals in the Plymouth
sample possessing porcelain were either merchants or mariners,
and even though only a few of them could afford extensive
holdings, they all appear to have made an effort to own at least
a few pieces. Numerous yeoman estates of the same period,
worth more than the average mariner's, exhibited no porcelain.
The pattern of status ownership evident in this sample forms
a striking parallel with the Boston material discussed by Stone
for the years 1730 to 1770.

With regard to the identification of porcelain using these
references to china, Teller has pointed out that, at least in
Providence, appraisers consistently drew a distinction between
earthenware, stoneware, and "cheney," or china, and the
latter does, in fact, refer to porcelain. As the list in Appendix 2

indicates, there were only two large holdings of porcelain
in the Plymouth sample from this period--parts of tea or din-
ner sets. Two styles of surface decoration are present, "Blue
and White" and "Burnt." These same styles were found by
Teller in the Providence inventories from the period 1750 to
1800. The "Blue and White" are almost certainly Ching-te
Chen export wares, while "Burnt China" is more difficult to
identify. Teller does not attempt a specific identification,
except to observe that such a designation is not unusual in
light of the firing process of porcelain.[9] Although this term
can refer to gilded or enameled porcelain, at this point the
label remains enigmatic.

To summarize the ceramic types and their distribution
within the inventory sample of the second period, the gradual
increase in fine imported wares seen in the archaeological
record also appears in the inventories. An increase in delft
is evident during the years 1640 to 1675. Stoneware entries
become more numerous in the final decades of the seventeenth
century. A substantial growth in the popularity of fine imported
wares, however, on a scale comparable to that observed
archaeologically, does not occur in the inventories until the
period 1730 to 1740, with the introduction of stoneware and
porcelain in the forms of dishes and tea sets.

In many respects, the pattern established in the late 1740s
and 1750s continues into the third of the periods defined by
Deetz--1760 to 1835. As he pointed out, this time division is
based as much on changes in the form and function of ceramics
as it is on changes in the distribution of types. Nevertheless,
except for delft, all the types of fine imported ware character-
izing the second period have disappeared archaeologically in
the thirty-year interval separating the Wellfleet site from the
downtown Plymouth trash pits. In their place are agateware,
Whieldon-type ware, Staffordshire white salt-glazed stoneware,
Jackfield-type ware, English porcelain, Chinese porcelain,
creamware, and pearlware. Both delftware and redware remain
in the archaeological assemblages but in decreasing numbers.
Turning to the inventory sample from this period, it is clear
that there are some real gaps in the archaeological record when
it comes to the distribution of the above ceramic types. Although

they do not provide specific quantitative data, the inventory
ceramic entries can at least fill in some of the blanks in a
rough way. The most common categories are "earthenware,"
"stoneware," "China," and "Crockery." The latter designa-
tion did not appear in the earlier periods and seems to be
applied mainly to porcelain, although stoneware is occasion-
ally included under this label. For some reason, those
inventories that are specific as to type make relatively fine
distinctions. This is possibly a result of a heightened
awareness regarding ceramic styles on the part of the
appraisers and the population in general. Such an awareness
is not evident in the earlier periods where fine imported
wares are rarely distinguished.

During the period from 1760 to 1835, the earthenware
category often takes on the meaning of redware. In some
inventories this label is distinguished from "Delph,"
"Stone," and "China." The sample contained only two
specific entries of "Red earthen," but descriptive terms
such as "common," "Coarse," and "plain" are present
which in some instances also likely refer to redware. A
number of earthenware-vessel forms like milk pan, porringer,
and pitcher, and, in one case, "refuse vessel," also point
to redware. In general, it can be said that redware is
becoming less important as a ceramic type during this period,
except as a source for purely utilitarian vessels. Even
though there is evidence of this trend in the inventories, it
can only be impressionistic, given the ambiguous nature
of most ceramic entries.

Archaeologically the popularity of tin-enameled earthenware
peaked about 1760, then declined because of the popularity of
creamwares and pearlwares, and disappeared entirely by 1835.
A similar pattern is evident in the inventories, despite the fact
that delft is present in the records until the end of the sample.
It becomes really noticeable only about 1760, at which time
the first unequivocal references to "Delph" occur. Because
this term, actually a misnomer, does become established, the
identification of tin-enameled earthenware in the inventories
is more certain during the third period. Some confusion remains,
however, since colored items can no longer be assumed to be
delft but can refer to stoneware and porcelain as well. The

same is true for such modifiers as "flowered" and "painted."
Those entries interpreted as delft are listed in Appendix 1.

The first unmistakable reference to creamware appearing
in the inventory sample occurs in the 1777 inventory of a
Plymouth mariner. The entry specifies "1 1/2 dozen cream
colored plates." This reference, along with others, to cream-
ware is listed in Appendix 3. It may be seen that creamware
is identified not only as cream-colored ware but also as
"Queen's ware" and, in a few cases, "yellow earthenware."
The latter designation is found in Teller's sample from Provi-
dence, and she identifies it as "probably unrefined and early
creamware." Ivor Noël Hume has suggested that early examples
of creamware can be distinguished from later varieties on the
basis of their deeper yellow color and that "the difference has
become pronounced by about 1785."[10] It is very likely then
that these inventory references to yellow earthenware represent
early forms of creamware. With regard to the date of cream-
ware's appearance in the Plymouth inventories, it is some
eight years later than that recorded by Teller for the Providence
sample and by Noël Hume for Virginia inventories. In both
cases, creamware was present by 1769. The actual introduc-
tion of creamware into Plymouth households probably took place
in the period following the terminal date of the early trash pit
in downtown Plymouth, about 1760, and the inventory date of
1777.

Only one inventory in the Plymouth sample contained a defi-
nite reference to any of the Whieldon-type wares. Six "tortise
shell" plates occur in the 1770 inventory of William Rand, Jr.
These almost certainly refer to a variety of the cream-bodied
"clouded wares" first developed by Thomas Whieldon. This
type has also been observed in limited quantities within the
Providence inventories from the same general period.[11]

There are several references to "black" and "black stone"
coffee- and teapots that might be interpreted as the products
either of the Jackfield pottery works in Shropshire or of the
Whieldon factory in Staffordshire. Both areas were producing
black-glazed tea wares during the period 1745 to 1790.[12] If,
in fact, these entries do identify Jackfield-type wares, their
relative popularity within the inventory sample parallels the
archaeological distribution.

Aside from a few references to "flowered," "yellow," "green," and "black" plates and teapots, the Plymouth inventories from 1760 to 1835 contain mainly lumped categories of "stoneware" and "stone" plates. Although there are jugs and mugs present in quantity and mention of crocks and pickle pots, plates make up the major portion of specified references to stoneware. They are almost certainly examples of the Staffordshire white salt-glazed type and in many cases are listed as whitestone dishes or plates. These entries are enumerated in Appendix 4.

It is interesting to note that in the assemblage from the first downtown Plymouth trash pit, dating to about 1760, the English white-glazed stoneware appeared to be roughly equal in popularity to delftware, and while delft is present in (Feature 10 of) the same site, dating to about 1800, stoneware has by this time disappeared altogether. The relationship between delft and Staffordshire stoneware at the early trash pit is paralleled in the inventory data, the two types being found together in over three-quarters of those inventories that specify type. This correlation continues within the inventories throughout the last decades of the third period, and while both types are declining in favor of creamware, the stoneware has not disappeared entirely by 1800. Such a survival can, nevertheless, be viewed partly as a result of the fact that inventories are reflecting the contents of "heirloom estates." White salt-glazed stoneware is, in these cases, material that has been around for a long period of time.

Examples of porcelain entries from inventories of 1760 to 1835 are contained in Appendix 2. The two styles of surface decoration encountered in the inventories of the 1750s are still present, and now a distinction is clearly made between English blue-and-white porcelain and Chinese products. In addition, there is one reference to "Liverpool ware," which can also be interpreted as English blue-and-white porcelain, although it may refer to creamware since both types were being manufactured in Liverpool during this period. Of course, it could also be an example of the delftware being produced in that city. The pattern of porcelain ownership observed in the inventories of the 1740s and 1750s continues, and over half of the large holdings remain in the possession of mariners and merchants from Plymouth.

This correlation, however, becomes less striking by the 1770s, since by this time more yeoman estates contain at least some porcelain.

With regard to the archaeological evidence for porcelain in Plymouth, it is surprising that no specimens of this type appear in the first downtown trash pit. The inventories show that Chinese porcelain was present in Plymouth households in considerable quantity by the 1750s, and by the 1760s it is almost as popular as delft and salt-glazed stoneware, at least in the households of Plymouth merchants and mariners. Of course, the archaeological sample from the second half of the seventeenth century is a limited one, being based on the single trash pit dating to approximately 1760. The absence of porcelain in this context suggests that what little archaeological evidence exists is not entirely representative of actual ceramic distribution during the period.

Ceramic types evident in the inventory sample and their temporal distribution reflect a radical replacement of fine imported wares around 1760, the culmination of a twenty-year trend. Leaving out porcelain, the fine imported types that define the last of Deetz's periods are not unequivocally present in the inventories until after 1760. This included Staffordshire white salt-glazed stoneware, creamware, and Whieldon-type ware.

No pearlware was encountered in the Plymouth sample. The absence of this type is possibly due to the fact that it was being referred to in the inventories simply as "cream-colored ware" and so was not distinguishable from earlier creamware. Teller also found no specific references to the term pearlware in the Providence inventories from 1750 to 1800.[13]

The purpose of this section is to test Deetz's second hypothesis, i.e., that the pattern of ceramic use for the first period will reflect that of the Stuart yeoman foodways subsystem as well as that of the first settlers of Plymouth. The hypothesis can also be tested against the documentary evidence. Specifically, it is proposed by Deetz that (1) domestic and imported coarse earthenware, dominating the archaeological sample of the first period, figured mainly in foodways activity related to dairying, and (2) this pattern of ceramic usage in dairying reflects a Stuart yeoman tradition.

The ceramics found in the inventories should, therefore,
exhibit relationships with other objects employed in dairy-
ing and should be located in the dairy or other places where
such activity occurred. Furthermore, this should be the case
for both inventories from Plymouth and those from the rural
farming regions of England, especially those from which the
majority of early settlers came. As a result, the examination
of these hypotheses was pursued through a comparison of the
ceramic content of a body of farm and cottage inventories from
mid-Essex County, England, with the Plymouth data.[14]

Because the great majority of mid-Essex inventories from
the period 1635 to 1749 was explicitly recorded in a room-by-
room fashion, it was possible to correlate ceramic entries
with room placement in nearly every case. Fifteen percent of
the inventories contained in the published volume made spe-
cific mention of ceramics. In 75 percent of these, ceramic
entries are located in the dairy. Earthen pots, pans, and a
few dishes, as well as several lumped references to earthen-
ware, appear in the "milkhouse" or "buttery." These dairy
activity areas are found in the houses of individuals whose
estate values range from £11 to £800. On the basis of the
published sample, it appears that an estate worth over £200
indicates a well-to-do yeoman in the area. Dairy assemblages,
in other words, are not restricted to one economic level but
are part of both wealthy and poor households.

Although a few inventories show ceramics in the kitchen
or hall and parlor, this material is restricted for the most part
to the dairy and dairy usage. This pattern characterizes not
only the early period but continues to the very end of the sample
or 1749. The mid-Essex inventory sample clearly supports the
idea that ceramics were of only minor importance in the Stuart
yeoman foodways subsystem and, where used, were almost
exclusively associated with dairying.

Turning to the Plymouth inventories from 1621 to 1660, the
pattern of ceramic usage closely resembles that found in the
Essex records. The major difference lies in the fact that very
few Plymouth households during this period maintained a sepa-
rate room for dairying activity. Only three room-by-room in-
ventories specify a dairy or its equivalent. As Chace has

pointed out, these occur in estates valued at over £100. Instead, the processing of milk, butter, and cheese took place in the kitchen of most houses. Ceramics are thus found with both dairy vessels, such as churns, tubs, troughs, cheese presses, and cheese vats, and with more general cooking and serving vessels, such as metal pots and pans, and wooden trenchers and platters. In just over half of the sample of forty inventories from the years 1621 to 1660, ceramic pots, pans, and basins are undeniably associated with dairying assemblages located within the kitchen or hall. The remaining occurrence of ceramic vessels may be grouped, following Chace, into two other room complexes: the storage area and the parlor. (This parlor complex and the function of ceramics within it will be discussed below.) The storage area contains pots and basins, probably of a coarse-bodied utility ware, along with barrels, tubs, woodenware, and a variety of foodstuffs.[15]

In general it can be said that ceramics during the first period do indeed serve primarily a purely technomic function, mainly in the context of dairying activity, and that this is a reflection of English yeoman tradition.

Deetz's third general hypothesis can be broken down into several more specific and interrelated propositions. First, ceramic vessels continue from 1660 to 1760 as an important part of dairying activity. This pattern of usage is evident in the inventory sample of the period from 1660 to 1760. References to earthen milk pans and butter pots in association with other dairy vessels occur in a number of inventories. There is, however, a growing tendency for ceramics to be lumped with similar categories of pewter, tin, iron, and wood. This results in less satisfactory evidence for the location of ceramics within the household. While many inventories in the second-period sample exhibit very clear dairying assemblages on their lists, earthenware is usually mentioned in a brief entry on pewterware, brassware, tinware, and so on. For this reason, it is difficult to link ceramics with any one activity set, including dairying.

The second of Deetz's specific propositions is that the flat-to-hollow-vessel-form ratio becomes less pronounced from 1660 to 1760 as plates and dishes increase in number. The latter serve both a decorative and utilitarian function, the

sociotechnic function in time becoming less important. Related
to this is the hypothesis that the presence of decorated ceramic
plates, as functional equivalents to pewter chargers, is in-
versely proportional to social status.

Looking first at the inventory evidence concerning ceramic
vessel forms and the ratio of flatwares to hollow wares, it can
be seen that the inventories corresponding roughly to the later
assemblage of the R. M. site, or approximately 1660 to 1675,
exhibit a ratio of flat-to-hollow forms that is about one to six.
This figure is, of course, based only on ceramic entries which
enumerate quantity. The majority of references to specific
vessels do not provide such information. In any case, the
vessel counts that can be made from the inventory data gener-
ally support the archaeological data. Dishes and plates are
found in greater numbers during the period 1670 to 1735, cor-
responding to the increase observed in the assemblage from
the Joseph Howland site.

The testing of the proposition concerning the function of
ceramic plates from 1660 to 1760 was also limited by the large
amount of lumped entries in the sample. Nevertheless, there
is some inventory data that can be applied to this problem.
The idea that decorated dishes served a sociotechnic function
finds at least a degree of confirmation in the inventories from
the years 1645 to 1675 and those in the period after 1736.
Chace has noticed that several of the ceramic entries within
his sample that seem to be delftware are associated in some
places with a parlor complex. This involves cases where the
parlor is explicity designated in room-by-room inventories and
cases where the parlor complex can be inferred from the distinct
clustering of objects on non-room-by-room lists. These objects
include bedsteads, bedding, drinking vessels, bottles, and
table linen. John Demos, in his study of family life in Plymouth
Colony during the same period, observes that the parlor was
usually the place where wealthier families kept their best and
most valuable possessions, and that, in a sense, the room's
function was mostly ceremonial even though it was often used
for sleeping.[16]

It is probable that these delft dishes located in the parlor
were on display, serving a largely decorative function, but

this can be only an assumption. There is likewise no con-
crete evidence in the inventories for pewter chargers on display
in the parlor. The few definite delft-parlor associations
during the period 1645 to 1675 occur in estates with values
in excess of £150, and one of the estate holders was William
Bradford, first governor of the colony, who left an estate
worth over £900. The next individual encountered in the sample
who kept delft in his parlor is Abiel Pulisser, a Plymouth mer-
chant. He died leaving an estate of £2,458. So, although
these correlations suggest that decorated ceramic plates prob-
ably performed a sociotechnic function, they lend little support
to the hypothesis that this pattern of display was functionally
equivalent to the display of pewter plates and inversely pro-
portional to social status. Rather, they indicate just the
opposite, that this practice was directly proportional to social
status.

As mentioned previously, the first clear association of delft
plates with a parlor complex after the period 1645 to 1674 does
not appear until 1736. In the intervening years, entries men-
tioning ceramic plates and dishes do become more plentiful in
proportion to the number present in the first period. However,
they are designated only as "earthenware." As such, they
can be delft, combed slipware, North Devon sgraffito, or
redware. They are most often grouped with trenchers and other
woodenware. This association does suggest a technomic
function, although it could simply be a reflection of the appraiser's
taxonomy, a logical listing of plates of one material with those
of another regardless of their location in the house.

The increase in the quantity of dishes within the inventory
sample parallels the temporal distribution observable in the
archaeological record. In addition, the fact that these ves-
sels are found in a majority of cases with wooden dishes might
be taken as a very tentative confirmation of the hypothesis that
ceramic plates became more utilitarian with time. Unfortunately
the inventory evidence is by no means conclusive. Less than
half of the sample from 1660 to 1760 contained any ceramics,
and only about one-fifth of these had specified references. As
a result, they cannot offer firm support of Deetz's propositions.
Likewise the inventories provide little ground for negation,

except in the case of the parlor display of delft and its rela-
tionship with social status.

With respect to the proposed normative food-consumption
assemblage for the second period--the wooden trencher and
the ceramic drinking vessel--the inventories contain largely
impressionistic evidence. Two trends evident in the records
from 1660 to 1760 point to this combination in the consumption
of food: (1) the few specified entries to ceramics that do occur
contain a large quantity of stone jugs and mugs, as well as
earthen drinking pots, cups, mugs, and pitchers, and (2) the
majority of lumped ceramic references in this period are found
adjacent to entries containing woodenware glasses and glass
bottles--the association with glassware being particularly
striking. Stone discovered a nearly identical configuration
in the Suffolk inventories of essentially the same period. He
notes that almost all the references are only to earthenware
and are usually lumped with woodenware and glass bottles.[17]
Whether this relationship on the inventory list actually reflects
the consumption assemblage postulated by Deetz is, of course,
open to serious question. The principle of "folk taxonomy"
responsible for this cluster of objects could easily have been
based on some common property other than function. Nonethe-
less, ceramic drinking vessels have definitely increased in
quantity in comparison to the amount present in the inventories
of the first period. This change is particularly visible in the
years 1730 to 1760.

Finally, it is not really possible to measure the degree to
which ceramic dishes and plates were integrated within the
food-consumption assemblage, except to point out that wooden
trenchers and pewter plates occur in much larger quantities than
do their ceramic counterparts, both in inventories that contain
ceramics and those that do not. This is the case throughout
the sample from the second period.

According to Deetz, ceramics of the third period will show a
greater homogeneity and will reflect in certain ways a more struc-
tured pattern of use than that of earlier periods. He offers some
specific propositions for testing in the inventories that are related
to the function of ceramic plates in the late eighteenth century.
The first concerns a relationship between delft plates and wooden
trenchers.

In the first downtown trash pit, dating to about 1760, eight delftware plates were recovered, along with only one example of white salt-glazed stoneware. Since these delft plates exhibited no visible sign of wear on the cutting surface, it was suggested by Deetz that their function remained mostly decorative, although they were perhaps used as table service for special occasions. The technomic equivalent to the ceramic plate was still the wooden trencher, which actually provides a more stable cutting surface than does delftware.

This interpretation is partly borne out in the inventories. Wooden trenchers are present in the majority of inventories during the first half of the third period, and seem to be performing in a technomic capacity since they are never found in the parlor complex but usually in the kitchen area. There is an important point of divergence in the inventories with regard to the sociotechnic function of ceramic plates. Porcelain as well as delft was located in the parlor complex according to many inventories, reflecting a pattern that begins in 1736, with the parlor of a Plymouth merchant that contained both delft and porcelain. It has been pointed out before that the absence of porcelain from the early trash pit is not in keeping with the inventory evidence of ceramic distributions. In any case, the pattern does appear to be similar to that proposed by Deetz, except that both porcelain and delft show up as decorative items in the parlor complex.

The second of Deetz's specific propositions involves the further development of ceramics to the point where they begin to serve a double function; they were valued for their style and novelty and were used everyday rather than only on special occasions. Frequent use of ceramics does not seem to occur until the late 1770s when inventories begin to show more than one set of ceramic plates, with enough pieces for a complete table setting. By this time delft and porcelain appear with sets of white salt-glazed stoneware plates, and in the 1780s some inventories exhibit complete services in porcelain, creamware, and stoneware. Delft is rarely found in the quantities characterizing the above types. In addition, both porcelain pieces and delftware are found broken and cracked, and even though they can no longer be used at the table, apparently they are still on display.

Deetz's third proposition concerns the role of the fork in the development of the ceramic assemblage in the third period. Unfortunately the inventory evidence is not entirely clear. Forks are first encountered in the 1721 inventory of a wealthy Marshfield gentleman whose estate was valued at over £200. Following this first occurrence, forks do not appear in large numbers until the 1750s and 1760s. Only after 1770 do these utensils appear in quantities large enough for complete table settings. Furthermore, sets of knives and forks are found, for the most part in the inventories of Plymouth merchants and mariners, as well as in those of some country "gentlemen." These same estates also show the largest ceramic holdings, and in this sense a relationship does exist between forks and ceramic plates. The inventory evidence suggests, however, that this relationship is limited to the style-conscious middle and upper socioeconomic groups.

In summary, the more structured pattern of ceramic usage proposed by Deetz for the third period is evident in the inventories insofar as porcelain, white salt-glazed stoneware, and creamware are being used as tea, breakfast, and dinner services that come in matched sets. This pattern is most noticeable in the households of Plymouth mariners and merchants.

With regard to the function of ceramics in the foodways subassemblage of Plymouth, it may be said that the inventory data are most conclusive about two of the propositions put forth by Deetz. During the first period, 1621 to 1660, ceramic usage does appear to reflect a Stuart yeoman tradition, and during the second period, 1660 to 1760, the display of decorated ceramic plates does not appear to be inversely proportional to social status. The inventory evidence is unfortunately much less concrete concerning Deetz's other hypotheses, offering no firm grounds either for confirmation or rejection.

APPENDIX 1. Possible Delft Entries in the Plymouth Inventories

Name	Date	Entry	Total Estate Value
Period 1: 1621-1660			
William Swyft of Sandwich	1642	6 blew earthen Dishes 00.03.00	£ -----
Mr. John Atwood gent. of Plymouth	1644	3 blew potts and a bason	-----
Elizabeth Poole of Taunton	1656	earthen ware blew and white 00.03.00	-----
Period 2: 1660-1760			
Samuel House, Sr. of Scituate	1661	(in the outward Rome) Item painted earthen dishes 00.05.00	-----
Thristrum Hull of Barnstable	1666/67	1 white earthen ware 00.06.00 1 painted jug with Cover 00.01.06	-----
John Barnes of Plymouth	1671	(in the little Rome at the South end of the house) Item 2 Venice glasses 3 other glasses 1 stone Jugg 3 earthen potts another little white Galley pott a Drinking pott a pewter tunnel a little white bottle and a white drink-ing cupp and other old earthen ware 00.07.00	-----
Abiel Pulisser of Plymouth	1736/37	(In the front parlor) 3 Earthen Dishes and 2 Plates blue and white	-----
Sarah Cushing of Scituate	1742	White mugg	-----
Samuel Sturtivant of Halifax	1744	Item white Earthen dishes 00.07.00 Red earthen pot	-----
Josiah Thomas	1751	White and red earthenware	-----
Nicholas Davis of Rochester	1755	Earthen white 00.06.00	-----
Thomas Wetherwell of Plymouth	1756	1 White pitcher 00.00.09 1 flowered pitcher 00.00.03 1 White chamber pot 00.01.06 1 White butter dish 0Q00.03	-----

Name	Date	Entry	Total Estate Value
Samuel Curtis of Scituate	1756	3 punch bowls 00.20.00 1 platter & 6 plates Delfware 02.16.00 4 white bottles	£ -----
Benjamin Hammond of Rochester	1758	To his China and white earthen 01.18.00	-----
Roger Hammond of Rochester	1758	To Blue and White earthen 00.18.00	-----
Robert Barker of Scituate	1759	To earthenware & Delph ware 00.04.11	-----

Period 3: 1760-1800

Name	Date	Entry	Total Estate Value
Peter Hayward of Bridgewater	1765	all the Earthenware Plain & Flowered 00.14.00	1587.13.10
Capt. James Carver, mariner of Plymouth	1768	1 Doz. Delph Plates & 3 Dishes 00.06.00 2 Delph Punch Bowls 00.01.00	280.01.10
William Rand, Jr. of Kingston	1770	1 Parcell Blue & White Dishes 00.04.08 1 Parcell Small Ditto 1 crakt 00.02.04 1 Parcell Ditto broke 00.02.00 Sundry articles of China, Glass, Stone & Delph Ware 03.19.01	1209.13.11
Gershom Cobb, Jr. of Middleboro	1771	3 Blue & White Plates 00.01.06	-----
Ichabod Nye, yeoman of Rochester	1771	Blue and White earthen 00.09.06	824.16.04
Silvanus Conant of Middleboro	1778	9 Delph Plates 3 Delph Dishes	4126.05.05
Seth Hayward of Bridgewater	1778	2 Delph Plates & 5 Trays 01.05.00 4 Delph Plates 00.15.00	3094.02.06
Isaac Crooker, yeoman of Pembroke	1779	Earthen ware Delph ware & Glass Bottles 01.05.00	624.09.10
Capt. Josiah Edson, mariner of Bridgewater	1779	3 Delph Dishes 6 Delph Plates	2537.13.06
Benjamin Sprague, yeoman of Bridgewater	1779	Delph Plates	295.07.00

Name	Date	Entry	Total Estate Value
Manapah Tucker, yeoman of Bridgewater	1779	2 Blue & White Plates 00.00.06	£2200.06.06
Margaret Keen, widow of Plymouth	1781	(In the Front Room) 7 Delph Plates blue & white 00.07.00 1 Ditto broken 00.00.06 4 bowls Delphware broken at 00.00.09 1 Pudding Dish such ware 00.01.00	193.11.0½
James Hovey of Plymouth	1781	3 blue & white Dishes 00.02.00 2 White Bowls 00.00.18	1030.06.02
Jeremiah Howes of Plymouth	1783	(Widow's Portion) 2 White Plates & 2 Saucers 00.00.10	220.03.04
Josiah Keen of Pembroke	1784	2 Delph Dishes & 2 Plates 00.09.00	2500.04.00
Ebenezer Simmons of Scituate	1785	Delf Bowls	941.00.01
Capt. Thomas Davis, mariner of Plymouth	1785	4 blue & white Delph platters 00.08.00 4 Delft Scalloped Deep Plates 00.10.00 1 Delft Pudding Dish 00.01.00	3373.05.11
Thomas Mayhew, Esqr., of Plymouth	1785	1 Blue & White Dish 00.02.00	209.12.07
Eleazer Stephens of Plymouth	1786	1 Blue & White bowl 00.21.00	638.05.05
Joseph Joselyn, Esqr., of Hanover	1787	3 Delph plates 00.01.06 2 Bowls 00.01.06 2 Punch bowls 00.01.00 2 butterbowls 00.01.06 3 mugs 00.02.00	3243.00.10
Nathaniel Waterman of Scituate	1787	Delf ware	3842.19.19

APPENDIX 2. Porcelain in the Plymouth Inventories

Name	Date	Entry	Total Estate Value
Period 2: 1660-1760			
Abiel Pulisser, merchant of Plymouth	1736/37	(In the front parlor) 6 China plates at 00.10.00 and 5 blue & white ditto at 00.10.00 7 Tea cups with 7 saucers some crakt & a small China Bowl 00.14.00	£2458.00.00
Benjamin Snow, yeoman of Bridgewater	1743	a China plate	212.00.00
William Wetherel of Plymouth	1748	Two bowls & other small Chaney	-----
Isaac Lathrop, merchant of Plymouth	1751	(In the Front South Room) 1 set Tea cups Bowl &c. on ye Tea Table 08.10.00 1 Doz. Burnt China Plates 08.00.00 1 Doz. blew 06.00.00 2 Deep Ditto 00.20.00 . . . 6 Custard cups China 00.30.00 Japann'd Waiter 00.60.00 3 China Bowls 07.10.00 Small Bowls & plates 02.00.00 . . . 2 China Dishes 08.00.00	23941.06.03
Ancel Lathrop, mariner of Plymouth	1751	Sundry China ware	650.14.13
Lazarus Sampson, mariner of Plymouth	1754	China Glass & Earthenware & Glass bottles phialls	291.01.10
Joseph Shurtleff, mariner of Plymouth	1756	China Plates & Earthenware 02.07.04	281.16.10
John Murdock of Plymouth	1756	To 1/2 Doz. China plates 00.08.00 To 1 China boule 00.01.04 To 1/2 Doz. cups and saucers 00.02.00	933.03.6½
Thomas Wetherwell, mariner of Plymouth	1756	3 China plates 00.08.00 3 Ditto broke 00.04.00 4 Brown Ditto 00.01.09 . . . 1 China bowel 00.06.08 1 small Ditto 00.01.04 & tea cups and 8 saucers 00.06.00 To 1 China butter dish 1 sugar dish 00.01.04	606.18.00
Gershom Randall of Scituate	1756	To a sugar box China ware vial & glass 00.06.00	289.11.10

Name	Date	Entry	Total Estate Value
Benjamin Hammond of Rochester	1758	To his China & White earthen 01.18.00	£ 741.16.04
Roger Hammond of Rochester	1758	To 6 China cups and 3 Ditto saucers 00.06.00	1041.15.00
Josiah Hatch, yeoman of Pembroke	1758	To China, glass, earthenware in the Bofat 00.12.00	433.11.02
Elkanah Waterman of Plymouth	1760	To China Punch bowl 00.12.00	30.19.06

Period 3: 1760-1800

Name	Date	Entry	Total Estate Value
John Wetherwell, trader of Plymouth	1764	China Bowls 00.06.00	27.01.07
Capt. Francis Adams of Plymouth	1766	China, earthen, & Tea pots 08.10.00	508.15.2½
Ephraim Gould, mariner of Plymouth	1767	Glass Bottles China Earthen ware & Phials 01.08.00	214.15.00
Capt. John Stephenson of Plymouth	1767	1 set English China 00.88.00 1 set China cups 00.09.04 6 China plates 00.08.00	459.13.08
Capt. James Carver of Plymouth	1768	2 setts China ware compleat 02.00.00 2 burnt china punch bowls 00.16.00	280.01.10
Samuel Clapp of Scituate	1768	crockery ware	1127.07.30
Samuel Harlow, mariner of Plymouth	1768	a China bowl 00.08.00 (Widow's portion) 4 China bowls 00.10.08 China, Stone, earthenware & glass 00.18.00	826.15.02
Timothy Ruggles of Rochester	1769	To China ware 02.05.00	584.02.08
Samuel Bartlett, Esqr., mariner of Plymouth	1769	China ware 01.12.00	869.16.00

Name	Date	Entry	Total Estate Value
William Rand, Jr. of Kingston	1770	1 doz. blue & white china plates 00.13.08 1 doz. burnt china do. part broke 00.23.04 1 doz. blue & white do. 00.12.08 6 Tortoise shell do. 00.02.08 1 parcell burnt china dishes 00.04.08 1 parcell small do. 00.02.08 Sundry articles of China, glass, stone & delph ware 03.19.01	£1209.13.11
Capt. George Bryant, mariner of Kingston	1770	To earthen stone & china ware 01.16.00	362.05.01
Thomas Clapp, yeoman of Scituate	1771	To China, Glass & Stoneware 03.09.08	1481.11.00
Samuel House, whaler of Abington	1771	Crockery Ware 00.10.00	1244.03.06
Stephen Otis, yeoman of Hanover	1775	Crockery Ware 00.07.04	197.11.04½
John Russell, merchant of Plymouth	1777	1 China Dish & 2 Butter Cups 00.08.00	578.05.07
Samuel Wood, yeoman of Middleboro	1777	a Quantity of Earthen, Crockery, & Glass Ware 01.06.08	347.18.04
Silvanus Conant of Middleboro	1778	1 Large China Bowl- 1 Small Ditto- 17 China Plates 4 Crakt Ditto 22.00.00 2 Pitchers- 1 mug . . . 6 Coffee Cups & Saucers 1 China Tea pott- 1 Cannister- 1 Sugar Bowl 04.00.00 1 China Cream & Slop Bowl- 1 Jappan'd Tea Waiter 02.00.00 1 China Butter Plate 3 China Patty pans 6 China Bowls 10 China Cups & 13 Saucers 2 Sugar Potts- 4 Salt Sellers- 5 Creamers 07.10.06	4126.05.05
John Turner, yeoman of Scituate	1778	Tea Gear & Crockery Ware 03.00.03	3056.16.09
Capt. Daniel Cornell, mariner of Rochester	1779	3 Setts China Dishes 01.12.00	362.11.00
Capt. Josiah Edson, mariner of Bridgewater	1779	6 Plates 3 China Dishes 1 Sugar Bowl 2 Salt Sellers 2 Creamers 05.00.00	2537.13.06

Name	Date	Entry	Total Estate Value
Benjamin Sprague, yeoman of Bridgewater	1779	China Ware	£ 295.07.00
Lurania Fridgham, widow of Plymouth	1779	1 Black Tin Tea Pot & Old Crockery 01.16.00	704.05.02½
Gideon White of Plymouth	1780	6 China Plates 05.00.00 3 China Dishes 02.10.00	25340.15.00
Job Clapp, gent. of Scituate	1781	Crockery Ware 00.06.00	967.01.06
Nathaniel Sylvester, yeoman of Hanover	1781	Tea Pot, Crockery &c.	1214.19.06
Margaret Keen, widow of Plymouth	1781	China Broken 00.02.06 1 Parcell Ditto Whole 00.02.06 3 Small Bowls Liverpool Ware 00.03.05	193.11.0½
James Hovey of Plymouth	1781	6 Blue & White China Plates 00.18.05 1 China Slop Bowl--5 Saucers & 2 Cups 00.06.00 3 Salts 1 Cruet 1 Beaker 1 Tea Pot 00.03.00	1030.06.02
Theophilius Cotton, Esqr., of Plymouth	1782	To 5 China Cups & Saucers 00.06.00 2 Vineagar Cruets 00.03.00 a China Bowl 00.05.00	3395.01.08
Daniel Howard, gent. of Bridgewater	1782	Crockery Ware & 2 Tea Pots 02.15.06	1099.11.10
Thomas Bowland, schoolmaster of Rochester	1783	2 Old China Cups 00.00.19--2 Butter Boats 00.01.06 1 Turene 00.03.00 1 China Mug 00.02.00	44.19.07
Josiah Keen of Pembroke	1784	1½ Doz. China Plates 02.14.00 a Parcell broken China 00.14.00 Small China Bowl 00.06.00 5 China Cups & Saucers 00.05.00 3 Butter Boats 00.03.00 1 Pr. Salts 00.02.00 1 Sugar Canister 00.03.00	2500.04.0½
Ebenezer Simmons of Scituate	1785	To China	941.00.01
Timothy White, yeoman of Scituate	1785	Tea Pot & Crockery Ware 00.13.00	295.02.02
Experience Tiffany, widow of Hanover	1785	1 Black Tin Tea Pot & Crockery 00.06.00	306.19.03

Name	Date	Entry	Total Estate Value
Capt. Thomas Davis, mariner of Plymouth	1785	9 English China Cups & Saucers with Slop Bowl & Cream Pot 00.07.00 1 Burnt China pudding Dish 00.03.00 4 Burnt China Coffee Cups & Saucers 00.03.00 4 Blue & White English China Cups & Saucers 00.01.06	£3373.05.11
Thomas Mayhew, Esqr., of Plymouth	1785	8 Burnt China Plates 01.04.00 1 Blue & White China Dish 00.05.00 1 China Bowl Crakt 00.00.06 Sundry Old Crockery & Glass in the Closet 00.02.00	209.12.07
Abiel Shurtleff of Plymouth	1786	1 Crakt China Bowl 00.02.06	183.04.04
Eleazer Stephens of Plymouth	1786	6 Cups & 6 Saucers China 00.03.00	638.05.05
Joseph Joselyn, Esqr., of Hanover	1787	Crockery Ware on ye Table 00.16.00 Ditto in ye Boufatt 01.04.00	3243.00.10
Capt. Benjamin Lothrop, mariner of Kingston	1787	4 China Tea Cups & Saucers, Creampot & Glass Bowl 00.03.00	807.07.00
Richard Holmes, sailmaker of Plymouth	1787	6 China Cups & Saucers 00.04.00	212.02.03
Capt. Ezra Allen, mariner of Plymouth	1789	Sundry Crockery Viz. 8 China Plates 00.08.00 1 Ditto Bowl 00.02.00 1 Ditto Mug 00.01.10 3 Cups & Saucers 00.02.00 5 Cups & Saucers Burnt 00.04.06	570.16.10

APPENDIX 3. References to Creamware in the Plymouth Inventories of Period Three

Name	Date	Entry	Total Estate Value
John Russell, merchant of Plymouth	1777	1½ Doz. of Cream Coll'd Plates 00.12.00	£ 580.05.07
Silvanus Conant of Middleboro	1778	1 Doz. yellow plates . . . 3 yellow butter plates . . . 6 yellow cups and saucers	4126.05.05
Seth Bryant, blacksmith of Marshfield	1779	2 yellow tea Dishes & Saucers 00.03.00	1990.19.00
Manapah Tucker, yeoman of Bridgewater	1779	Cream Colour Bowl 00.02.00	2200.06.06
Gideon White of Plymouth	1780	1 Dish Cream colour 00.03.00	23340.15.00
Margaret Keen, widow of Plymouth	1781	4 White Plates Queensware 00.04.00 3 Small Bowls Liverpool Ware 00.02.08	193.11.0½
James Hovey of Plymouth	1781	1 Cream col'd Pudding Dish 00.00.06	1030.06.02
Theophilius Cotten, Esqr., of Plymouth	1782	To 8 Queensware plates 00.08.00	3395.01.08
Thomas Bowland, schoolmaster of Rochester	1783	2 Queensware platters 00.02.00 Queensware basons 00.01.00	44.19.07
Josiah Keen of Pembroke	1784	1½ doz. Cream Col'd plates 00.07.00	2500.04.00
Capt. Thomas Davis, mariner of Plymouth	1785	1 Cream Col'd punch bowl 00.02.00 1 Doz. Cream Col'd Plates 00.02.00 3 Ditto oval Dishes 00.02.00 1 Pudding Dish 00.00.08 1 Square Cannister 00.01.06 4 Cream Col'd Cups & Saucers, pot & boat 00.02.06 1 Round Tea Cannister 00.03.00	3373.15.11
Capt. Ezra Allen, mariner of Plymouth	1789	2 yellow plates 00.01.06	570.16.10

APPENDIX 4. Stoneware in the Plymouth Inventories of Period Three

Name	Date	Entry	Total Estate Value
Ephraim Gould, mariner of Plymouth	1767	a White Stone dish 00.02.08 1 Doz. White Stone plates 00.06.00	£ 214.15.00
Capt. John Stephenson of Plymouth	1767	11 Stone dishes 00.02.05	459.13.08
Capt. James Carver, mariner of Plymouth	1768	1 Doz. Stone plates 00.03.01 ½ Doz. White stone plates 00.03.00	280.01.00
Samuel Harlow, mariner of Plymouth	1768	2 White Stone Plates 00.00.08 a Stone jugg 00.04.00 2 Stone dishes 00.03.00 Stone Jugg 00.02.00	826.15.02
Major John Johnson of Bridgewater	1770	Stone jugg 00.01.06	31.07.06
John May, yeoman of Plymouth	1770	A Stone jugg 00.03.00 A quantity of earthen & stone ware 00.17.06	894.19.11
Samuel House, whaler of Abington	1771	2 Stone juggs & Glassware in the barr room	1244.06.03
John Joselyn, gent. of Hanover	1771	1 Stone Jugg 00.04.00	172.08.04
Jacob Bailey of Bridgewater	1773	1 Tea pot 3 Dishes 3 Saucers 6 Bowls 5 Stone Plates & other ware 00.19.04	1228.16.00
Lemuel Thomas of Middleboro	1776	5 Plates of Stone & Earthen 00.04.00 one mustard pot & other Stone Vessels 00.03.10	360.19.03
John Russell, merchant of Plymouth	1777	1 Stone Jug Tea Pot & Sugar Bowl 00.07.06 . . . 1 Gall'n Jam. Rum in the Stone Jug 01.07.00	578.05.07
Silvanus Conant of Middleboro	1778	16 White Stone Plates 1 Yellow Stone Ditto 10 White Stone dishes 2 Brown Ditto 6 Brown patty pans	4126.05.05
John Turner, yeoman of Scituate	1778	Stone Jugs 01.10.00	3056.16.09
Nathaniel Thomas of Marshfield	1779	4 Stone Saucers & Six Stone Cups 00.09.00 1 Black Stone tea pot 00.04.00	660.09.00

Name	Date	Entry	Total Estate Value
Capt. Josiah Edson, mariner of Bridgewater	1779	1 Stone Dish 3 Mugs 2 Creamers 1 Tea pot & 1 Bowl . . .	£2537.13.06
Lurania Fridgham, widow of Plymouth	1779	1 Stone Pickle Pot 00.06.00	704.05.02½
James Hovey of Plymouth	1781	1 Green Stone Canister 00.00.16 1 Green Cream Pot 00.01.00 1 black Coffee pot 00.03.00 Stone Jug 00.06.00 2 Pickle Pots 00.04.00 . . . 1 Doz. White Stone Plates 00.06.00 1 oval Dish 00.00.18	1030.06.02
Theophilius Cotten, Esqr., of Plymouth	1782	6 White Stone Plates & 1 Dish 00.14.00	3395.01.08
Robert Sprout, Jr.	1783	3 yellow stone plates 00.03.00 Small Stone Jug 00.03.00	99.07.11
Stephen Martin, yeoman of Rochester	1783	Stone Shaving Box & brush 00.02.00	280.10.00
Thomas Bowland, schoolmaster of Rochester	1783	1 Gilded Coffee Pot 00.04.00 1 black Tea Pot 00.01.00	44.19.07
Josiah Keen of Pembroke	1784	3 White Stone Dishes 00.05.00 1 black tea pot 00.01.00 5 Stone Jugs 01.06.06 & 3 pickle pots 00.10.00	2500.04.00
Joseph Leonard, gent. of Middleboro	1784	flow'd stone plate 00.00.03	332.00.15
Capt. Thomas Davis, mariner of Plymouth	1785	1 Large white mug 00.02.00 1 Quart White Ditto 00.01.00 1 Black tea pot 00.00.04 1 White Ditto 00.00.06 1 Black coffee pot 00.00.10	3373.15.11
Eleazer Stephens of Plymouth	1786	1 Doz. Stone Plates 00.03.00 4 White Stone Ditto 00.16.00 1 Stone pudding Dish 00.01.04 1 Stone pickle pot 00.02.00	638.05.05
Joseph Joselyn, Esqr., of Hanover	1787	6 old barells in ye Stone 00.02.00 1 Large Stone Jug 00.03.00	3243.00.10
Richard Holmes, sailmaker of Plymouth	1788	10 Stone Plates 00.03.00	212.02.03

Name	Date	Entry	Total Estate Value
Capt. Ezra Allen, mariner of Plymouth	1789	1 White Stone mug 00.00.09 1 Ditto Bowl 00.00.04 5 White Stone Plates 00.01.11 1 Flow'd stone tea pot 00.00.06 1 black tea pot 00.00.06	£ 570.16.10

NOTES

1. Lewis R. Binford, "Archaeology as Anthropology,"
American Antiquity 28, no. 2 (Oct. 1962): 217-26.
2. Abbott Lowell Cummings, Rural Household
Inventories, 1675-1775 (Boston: Society for the Preservation
of New England Antiquities, 1964); Barbara Gorely Teller,
"Ceramics in Providence, 1750-1800," Antiques 94, no. 4
(Oct. 1968): 570-77; Gary Wheeler Stone, "Ceramics in
Suffolk County, Massachusetts, Inventories, 1680-1775,
A Preliminary Study, with Divers Comments Thereon, and
Sundry Suggestions," The Conference on Historic Site
Archaeology Papers 1968 3 pt. 2 (1970): 73-90; Paul Chace,
"Ceramics in Plymouth Colony, Massachusetts, Analyses
of the 1621-1675 Estate Inventories" (M.A. thesis, New York
State University College, Oneonta, 1969).
3. Chace, "Ceramics in Plymouth Colony."
4. Stone, "Ceramics in Suffolk County, Massachusetts,"
p. 76.
5. Chace, "Ceramics in Plymouth Colony," p. 35.
6. Stone, "Ceramics in Suffolk County, Massachusetts,"
p. 77.
7. Teller, "Ceramics in Providence," p. 573.
8. Stone, "Ceramics in Suffolk County, Massachusetts,"
p. 81.
9. Teller, "Ceramics in Providence," p. 572.
10. Teller, "Ceramics in Providence," p. 573; Ivor Noël
Hume, A Guide to Artifacts of Colonial America (New York:
Alfred A. Knopf, 1969), p. 126.
11. Teller, "Ceramics in Providence," p. 573.
12. Noël Hume, A Guide to Artifacts of Colonial America,
p. 123.
13. Teller, "Ceramics in Providence," p. 576.
14. Francis W. Steer, ed., Farm and Cottage Inventories
of Mid-Essex, 1635-1749, Essex Record Office Publications,
no. 8 (Chelmsford, England: Essex County Council, 1950).
15. Chace, "Ceramics in Plymouth Colony," pp. 48-49.
16. Chace, "Ceramics in Plymouth Colony," pp. 46-48;
John Demos, The Little Commonwealth: Family Life in

<u>Plymouth Colony</u> (New York: Oxford University Press, 1970),
p. 48.
 17. Stone, "Ceramics in Suffolk County, Massachusetts,"
p. 75. Another reference to early earthenware is found in
the 1777 inventory of John Russell, a Plymouth merchant,
showing that his kitchen contained "Charlestown Crockery."
Several works on American ceramics have alluded to a
mysterious factory in South Carolina, in existence for an
unknown period of time around the middle of the eighteenth
century. A Staffordshire potter in the employ of Josiah
Wedgwood apparently emigrated to South Carolina and
helped to start this pottery works. If the products of this
factory were called after their port of shipping, then
"Charlestown Crockery" might refer to this South Carolina
ware, about which so little is known. The more probable
source for this ware, is of course, Charlestown, Massachu-
setts.

CERAMICS FROM THE JOHN HICKS SITE, 1723-1743:
THE ST. MARY'S TOWN LAND COMMUNITY

Lois Green Carr

WHO was Captain John Hicks? This is a question that might
never have been asked had the foundations of his house not
been discovered near St. Mary's City, Maryland, in the fall
of 1968. Garry Wheeler Stone will discuss the ceramics
found in and around the Hicks house. I should like to
provide a setting for his discussion by briefly describing
the society in which John Hicks functioned, with some
conjectures about the neighborhood in which he lived and
the role he played in it.

These comments are based on career studies of Hicks and
five other neighboring households and on a study of St. Mary's
County estate inventories for three periods during the years
spanned by these households. Maryland inventories do not
list land or its improvements, but otherwise they show a
man's wealth in considerable detail. They provide rich
materials for study of the economic and social structure of
society and its changes with time.

Hicks arrived at St. Mary's about 1723 and died just
thirty years later. His identified neighbors died between
1732 and 1766. These facts have directed the selection of
the inventories studied. One hundred and fifteen consecutive
inventories for the years 1729-33, 1750-53, and 1760-63--345
in all--have provided data on the distribution of wealth,
including distributions of servants and slaves. Detailed
analyses of forty-two consecutive inventories out of the
115 in each period were made to find the distribution of
assets between income-producing and consumption goods
at different stages of wealth. What was invested, for
example, in bound labor, in livestock, in tools, or in credits,
as opposed to clothing or beds or silver or ceramics? Research

beyond the inventories has identified, where possible, which decedents owned land. All this information allows at least rough definition of economic and social groups and an understanding of where Hicks and his neighbors fitted into the economic and social order.

Several technical problems complicate the use of inventories in analyzing the structure of a society. First, inventories must be tested for fullness of reporting, for the poor are less likely to be inventoried. Some admittedly crude tests suggest that in the inventories considered here, serious underreporting probably appears only in the group for the 1760s. Second, allowances must be made for the fact that men accumulate wealth as they grow older, and at the same time they are more likely to die. Thus even when all estates are reported, inventories are biased toward wealth. Finally, means must be found to allow for inflation of prices and fluctuations of sterling exchange rates in expressing the value of goods; otherwise values of inventories of different periods cannot be compared. In this paper all current money values that relate to goods or tobacco are converted to sterling as valued in current money of the 1730s, using the price of pewter as a measure of inflation. Money debts are converted to sterling at the actual exchange rate current when the inventory was taken. Given this somewhat alarming apparatus, what does it show?

In Hicks's days at St. Mary's about 30 percent of inventoried planters who were heads of households had assets worth less than twenty-five pounds sterling and probably owned no land (Table 1A). In the society as a whole, the proportion of tenants was undoubtedly higher, for young men might start life as tenants but acquire land as they grew older. Thus inventories are biased toward land-owners, even if poor estates are always reported. Most tenants were tenants at will or held short-term leases. Such men had neither freehold nor the forty-pound-sterling visible estate that would have qualified them to vote for delegates to the assembly. However, some tenants had leases for life that were considered freehold.

Seventy percent of inventoried planters were probably

landowners, however poor. Landowners' chances of
accumulating wealth were much improved over that of
tenants, unless the land was heavily mortgaged. The cash
crop was tobacco, and with part-time help from wife and
children, a planter might raise from fifteen hundred to two
thousand pounds of tobacco a year; but except on proprietary
manors, where rents were low, tenants paid six hundred to a
thousand pounds or more of this tobacco in rent.[1] A tenant
farmer thus might have half as much chance to accumulate
capital as had a landowner. In addition, participation in
community affairs--opportunity to sit in juries or hold
office--was, like voting, usually confined to landowners or
freehold tenants.[2] A visible stake in the community brought
political as well as economic status.

Landowners can be divided into two groups: those who
owned land but not slaves and those with capital enough to
own both. In the groups studied from the inventoried
population, planters who ventured capital in slaves were less
than one quarter of the whole in the early 1730s, but had
increased to nearly half about the time of Hicks's death in the
early 1750s, as poorer planters began to risk such investment.
In the population as a whole, of course, the proportion of
slaveholders was smaller. Even among slaveholders, the
majority had no great riches. For the early 1730s and early
1750s, 87 percent of the inventories counted came to less
than two hundred pounds sterling, and for the 1760s the
figure was still 75 percent. Before the 1760s only a small
fraction of the states--less than 2 percent--came to four
hundred pounds sterling or more at death.

Over the first twenty years--those of Hicks's lifetime at
St. Mary's--poor planters may have been becoming richer.
Table 1B shows that the proportion of estates between
eighty pounds sterling and two hundred pounds sterling
enlarged considerably. But such a conclusion needs further
testing. Perhaps more capital was required to establish a
plantation in the 1750s than in the 1730s, forcing an increase
in the number of men who could not afford to be planters and
raising the overall level of wealth among men who did have

TABLE 1

Distribution of Wealth in Inventoried Estates, 1729-32, 1750-52, 1760-64
St. Mary's County, Maryland

A. Inventories without Slaves

Date	Total Inv.	Total House-holds	Probably No Land, No Slaves					Probably Land, No Slaves				
			£0-£24					£25-£54				
			non hh	hh	% total hh	total inv.	% total inv.	non hh	hh	% total hh	total inv.	% total inv.
1729-32	115	96	18	28	29.2	46	40.0	1	29	30.2	30	26.1
1750-52	115	109	4	33	30.3	37	32.2	24	22.0	24	20.9
1760-64	115	102	8	19	18.6	27	23.5	3	23	22.5	26	22.6

B. Inventories with Slaves

Date	Total Inv.	Total House-holds	Land, No Slaves, 1730s Slaves, 1750s, 1760s					Land, Slaves, 1730s, 1750s, 1760s				
			£55-£80					£81-£99				
			non hh	hh	% total hh	total inv.	% total inv.	non hh	hh	% total hh	total inv.	% total inv.
1729-32	115	96	13	13.5	13	11.3	11	11.4	11	9.6
1750-52	115	109	1	13	11.9	14	12.2	1	25	22.9	26	22.6
1760-64	115	102	1	14	13.7	15	13.0	1	18	17.6	19	16.5

Inventories with Slaves (continued)

Date	Total Inv.	Total House-holds	Land, Slaves, 1730s, 1750s, 1760s									
			£200-£299					£400+				
			non hh	hh	% total hh	total inv.	% total inv.	non hh	hh	% total hh	total inv.	% total inv.
1729-32	115	96	13	13.5	13	11.3	2	2.1	2	1.7
1750-52	115	109	12	11.0	12	10.4	2	1.8	2	1.7
1760-64	115	102	17	16.7	17	14.8	11	10.8	11	9.6

Note: The threshold of investment for landowning is estimated from those decedents who left wills and from those in the 1760s who were registered in the debt books. St. Mary's County deeds have been destroyed and debt books do not start until 1753. In the 1730s, 4 estates under £81 had slaves, 3 over £81 had none; in the 1750s, 3 estates under £54 had slaves, 4 over £54 had none; in the 1760s, 6 estates under £58 had slaves, but 3 belonged to nonhouseholding sons or widows; 3 estates over £58 had no slaves.

households. In addition final balances, not yet examined, may show heavier indebtedness than existed in the 1730s. Finally, sons, especially younger sons, of men with more than two hundred pounds sterling may have augmented the group from the other direction.

During the decade that followed Hicks's death, the main change in wealth distribution appears in the estates under £25 and over £399. The number of estates less than £25 declined by 27 percent, but this decline probably reflects underreporting of the poor following the appointment of a new deputy commissary.[3] At the same time, the group worth £400 or more shows a particularly startling increase. It quintupled in size over these ten years and represented about a tenth of the inventories counted for the early 1760s. Such a jump must represent a real increase in the number of planters with large assets in St. Mary's County, even granted the greater underreporting of poor estates. Some of the increase may be the result of the rising value of slaves, which rose 25 percent in price over the period. Whether the increase meant a real increase in prosperity for the rich requires a study of the final balances of their estates after debts were paid. Possibly these will not show a rise in wealth.

What do these categories of wealth mean in the terms often used to describe English society: laborer, husbandman, yeoman, gentleman? These traditional descriptions of classes may not fit eighteenth-century Chesapeake society, at least not in any literal way. Aubrey Land's inventory studies suggest that even the very wealthiest planters, those with one thousand pounds sterling or more, were shrewd entrepreneurs--dealers, as Governor Seymour once called them.[4] They did not live mainly off rents, a distinctive attribute of an English gentleman.[5] Presumably men who worked with their own hands were not considered gentry in Maryland, but this distinction is difficult to determine from inventories and its existence requires proof. As late as 1703 Justice John Hawkins of Prince Georges County, a gentleman by virtue of his office, made shoes himself.[6] Career studies of large numbers of men at various

stages of wealth are necessary to show the meaning of the
title gentleman. Perhaps the appearance in inventories
of silver and ceramics in sizable amounts provides a clue.
If so, the gentry did not usually leave estates that were
less than three-hundred pounds sterling. Probably less
than 5 or 6 percent of the heads of households in the whole
population had personal estates of this amount or more,
although the proportion was increasing by the 1760s.[7] As
for yeomen versus husbandmen versus laborers, these titles
as applied to Maryland heads of households are all absorbed
into the title planter. For social analysis of Maryland, the
distinctions between tenants, landowners, and slaveholding
landowners best describe the elements of society below the
gentry.

Over the whole thirty years, the inventories clearly
demonstrate the economy's dependence upon tobacco. From
the 126 inventories analyzed in detail, it appears that--a
few widows excepted--every household had planters' tools,
but scythes for cutting wheat were rare. Corn is the only
grain crop that appears often. Yet some diversification is
evident and was growing. All estates of householders had
livestock and most had sheep and wool. Spinning wheels
were increasing and appear in nearly three-quarters of the
inventories studied for the 1760s. By then, looms were
also more numerous. In conjunction with these home
industries, planters raised flax and hemp and even a little
cotton. The general absence of skilled craftsmen is
notable, with the exception of carpenters and coopers.
(Of the 126 estates analyzed, only one belonged to a
blacksmith, one to a tailor, and only three to joiners. The
most numerous craftsmen were shoemakers--fourteen in
number.) Most craftsmen found were also tobacco planters.

Although specialized craftsmen were absent, the credits
shown in the inventories suggest that exchanges of services
were creating an increasingly complex network of relation-
ships. Diversification was not making each household more
self-sufficient but more dependent on its neighbors, although
perhaps less dependent on imports from England. In the
1730s just over two-fifths of the 115 inventories counted had

credits, but credits appear in more than two-thirds of those counted in the early 1750s. It is interesting, however, that credits decline by more than half in the early 1760s. The decline may be the result of a change in reporting practice; but it may also reflect increased concentration on production of tobacco as investment in slaves accelerated.[8]

Over all three periods, only four of the 345 inventories counted show merchandise, and two of these cases were men of small estates without households, who were probably peddlers. Of the great merchant planters that Aubrey Land describes, only one appears. There were others in St. Mary's County, of course, but the capital required for mercantile activity was evidently available to very few. Perhaps St. Mary's County was somewhat poorer than other areas of Maryland. Land finds that over the 1750s in the province as a whole, 3.9 percent of the inventoried planters had one thousand pounds sterling or more,[9] whereas only 3.5 percent--a 10 percent difference--appear in the St. Mary's County inventories counted for the early 1760s, when under-reporting of inventories and hence overreporting of wealth was probably similar to that of most other counties. Land points out that planting alone did not often produce fortunes of one thousand pounds sterling. Men of this wealth were usually merchants or other entrepreneurs as well as planters. In St. Mary's County it may have been more difficult than elsewhere to accumulate sufficient capital to enter into the activities that created major fortunes.

By the 1750s, furthermore, merchants from Scotland and the north of England were beginning to dominate the tobacco factorage and storekeeping business along the Potomac, and this was the heart of the commercial opportunity available to Maryland planters.[10] Hicks himself was probably one of these interlopers. His native-born son, William Hicks, who ran a store on the St. Mary's River after his father's death, used the capital of a north of England uncle and eventually moved to Whitehaven, near the Scottish border, and ran the business from there. During the same period, the Glassford Company of Glasgow was operating a store at Leonardtown, the county seat.[11] The fortunes to be made in marketing

tobacco and importing merchandise were not remaining in the county.

John Hicks was a sea captain from Whitehaven, who settled on the St. Mary's town lands about 1723 or soon thereafter.[12] He was then probably in his thirties. He had sailed ships in the Virginia trade and was owner of a ship for a while. In cooperation with his brother, a merchant of Whitehaven, active in the tobacco trade, he probably conducted a tobacco factorage business and store. He was certainly a tobacco planter, and at his death owned nineteen slaves worth nearly three hundred pounds sterling. By 1730 he was a county justice, and two years later, he began a three-year term as sheriff, a lucrative as well as powerful office. From 1738 through 1742 he was a judge of the provincial court. He must have arrived in Maryland with both capital and education, and he quickly achieved social and political recognition.

Of Hicks's personal life, little is known. His wife, Ann Hicks, was a Catholic, but his oldest son William, born in Maryland about 1726, was raised a Protestant. William, heir to his merchant uncle, was educated in Whitehaven, and John Hicks apparently returned there himself to die. He had another son, George, and two daughters, one who married well in England and one who married a ship captain in the tobacco trade and settled on the Virginia side of the Potomac. William inherited the largest share of Hicks's farm, but the father evidently anticipated that this oldest son would not settle in the land of his birth and devised the dwelling house to George.

The farm was about 378 acres of proprietary leasehold, which Hicks held on a freehold lease for three lives. The land was superb, the greater part of it capable of high yields of tobacco, corn, and grain.[13] Hicks owned outright freehold land in addition: 650 acres nearby, heavily timbered, and about 800 acres in Prince Georges County leased out to several other planters. But his slaves worked the leasehold land, and the eight prime field hands he owned at his death were producing nearly ten thousand pounds of salable tobacco a year. At most, 2 percent of all producers could match this output.[14]

By 1749 Hicks had left the house that he had occupied
since his arrival and was living in one nearby. His first
house, which Garry Stone will describe, had been dismantled.
The second house is described in a proprietary record as
"framed" and "large," but little more is known about it.
Newspaper advertisements for the period and descriptions of
improvements on other leaseholds suggest that most houses
were small by today's standards, say sixteen by twenty-four
feet.[15] To be large in comparison to such houses, Captain
Hicks's need not have been a mansion. The furnishings
listed in his inventory do not suggest many rooms, although
some items were valuable. In the entire house, there were
only three complete beds, two tables, six chairs, three
cupboards, a chest of drawers, two other chests, three desks,
and a bookcase. A one-story house of four rooms, an attic,
and an adjoining or separate kitchen could easily have
accommodated all.

Like the house and furniture, other articles of household
use suggest a comfortable although unexpectedly simple
life. Some of the furnishings may have been distributed to
the children during Hicks's lifetime. There was a bookcase,
for example, but only one book, rather inadequate for a
judge of the highest court of common law in Maryland. The
trash pits of his earlier house contained evidence of several
sets of tea ware, delft, and other ceramics, yet the inventory
lists only three pieces of earthenware worth a few shillings.
Even his poorest identified neighbors had more. At the same
time, there were fifty-six ounces of silver plate, an item more
in keeping with the presumed social position of Hicks. Surely
the house at one time was equipped more elaborately. If
Hicks invested only half as much, proportionately, in house-
hold furnishings as did his neighbor William Deacon, about
eighteen pounds sterling is missing.

At his death in 1753, Hicks's assets came to £383 in the
sterling values of the 1730s, and the already distributed
assets would surely have brought the total to over £400. He
was among the top 2 percent of St. Mary's County planters
whose estates were inventoried from 1750 to 1753. If his
landed investments are added, his position on the scale of

wealth might be even higher. Nevertheless, given the
findings of Aubrey Land, his estate appears small for a
merchant planter. Probably he had ended whatever commercial
enterprises he had undertaken some years before, perhaps in
1742, when he purchased the plantations in Prince Georges
County.

Whatever his relative wealth, Captain Hicks did not leave
an estate large enough to enable two sons to attain the
position he himself had held. William Hicks, who returned
to live at St. Mary's from about 1751 until 1759, married well,
was a delegate to the Assembly, and carried on a factorage
business, but he ultimately abandoned his Maryland enter-
prises. He built upon the position his merchant uncle had
prepared for him in Whitehaven rather than the one his father
had bequeathed him in Maryland. George Hicks lived out his
life on the leasehold in obscurity.

Hicks's identified neighbors over his lifetime at St. Mary's
were William Deacon (d. 1759) from Portsmouth, England, a
man of great wealth, who was the royal collector of customs
for North Potomac, and three families of small planters who
carried on additional income-producing activities in varying
degrees. Thomas Ingalls (d. 1752) was a joiner from New
England; he made furniture and even violins. Joseph Taylor
(d. 1732) was a blacksmith and weaver, whose origins are
unknown. He died early, but his family was still living on
the town lands at Hicks's death. Daniel Clocker III (d. 1746)
and his son Daniel Clocker IV (d. 1766) were poor landowning
planters who supplemented their income from tobacco with
yarn spinning and possibly carpentry or more menial labor.
The first Daniel Clocker's career had been a success story
of the seventeenth century; he started life as an indentured
servant and ended as a landowner of about three hundred acres
with a seat on the Common Council of St. Mary's. His grandson
and great-grandson were still living on the lands he had
acquired.

These families lived on the town lands of St. Mary's,
about fifteen hundred acres first settled before 1640 (Fig. 1).
The city itself, then a tiny village, had stood on about one
hundred acres at Church Point, just below Hicks's leasehold,

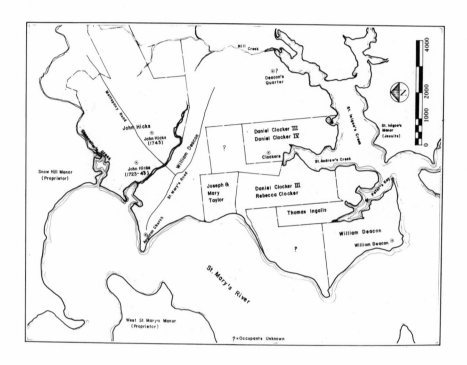

Fig. 1. St. Mary's Town Lands, 1723-43. (St. Mary's City Commission: Photo, Winterthur.)

but by the 1720s most of the structures that had once been
there must have been dismantled. Deacon owned the site,
along with two adjacent tracts, the whole making a parcel
of about five hundred acres. The soil is of the highest
quality for raising tobacco and field crops of all kinds, and
most of it is level and well drained. Deacon's dwelling
plantation was on one hundred acres of far less valuable
land at the mouth of St. Inigoes Creek, but it provided good
pasturage for his livestock and was splendidly situated for
a view of the river and for convenience in conducting his
business as customs collector. The Taylors owned at least
sixty acres of excellent land near the river, but Ingalls and
the Clockers were not so well off. Their lands along two
inlets of St. Inigoes Creek were poorly drained and most of
the soil is unsuitable for tobacco.

When Hicks arrived, Deacon had just settled at St. Mary's
on land that had belonged to his wife's third husband. She
was a Catholic and related to Lord Baltimore. Since she was
then at least forty, it is likely that Deacon was almost the
same age. Daniel Clocker III, his wife Alice, and at least
two children were probably living in the frame, brick-ended
house that still stands at the head of Milburn Creek. Clocker,
too, was about age forty and his wife was ten years older.
Whether Taylor had yet purchased his land along the river is
not certain, but he, his wife, and four children (all minors),
were settled there at his death in 1732. Ingalls was a
latecomer to the area. He may have purchased his land from
Deacon about 1743, but nothing tells how long he had lived
there before he and his wife died in 1752. They left behind
them two children, both minors. There were at least two
absentee owners of town land, and they doubtless had tenants,
but these tenant families have not been identified.

This was a rural neighborhood, but it nevertheless had some
contact with distant parts of the world. Like other sections
of the Chesapeake economy, this area depended on trade with
England for the sale of its cash crop, tobacco, and for the
acquisition of goods that were not produced nearby. Ships
came into the St. Mary's River from time to time with cargoes
from Whitehaven or London or the West Indies, bringing news

from abroad and giving even the humblest inhabitants an
opportunity to talk with people who had traveled to places
that the small planters of St. Mary's would probably never
see.[16] Some of the neighborhood inhabitants themselves
lent a cosmopolitan element to the town. Both Deacon and
Hicks had been born and educated in Great Britain and had
pursued careers there before coming to St. Mary's. "Esquire
Deacon" must once have moved in high English circles, if
his clothing is any indication. It was valued at his death at
sixty-five pounds sterling, a far larger sum than several
contemporary planters of much greater wealth and political
power had invested in their appearance. As a ship's captain,
Hicks had visited other colonies and probably various parts
of Europe. Even Ingalls, a New Englander, had foreign tastes,
for there were barrels of salt cod in his shed. Indeed, only
the Clockers were surely native Marylanders.

On the other hand, St. Mary's was isolated from
Annapolis, the center of political power in Maryland. Even
in the 1750s, John Hicks's daughter-in-law bought her stays
from Whitehaven rather than from a staymaker ninety miles
away.[17] From about 1747, planters could travel to Port
Tobacco, where the naval office for North Potomac was
located, to pick up newspapers and letters sent by post
from Annapolis. But there was no post to St. Mary's County
before 1759.[18] The town land inhabitants did not seek
contact with the capital. John Hicks did not even visit
Annapolis to take his seat in the provincial court.

Most inhabitants of the town lands probably traveled
little, for there was little need, apart from an occasional
trip to the county court at Leonardtown. There was an
Anglican church on the town land to which all could walk and
a Catholic chapel on the Jesuit manor of St. Inigoes just
across St. Inigoes Creek.[19] Two tobacco warehouses were
within easy distance, one on St. Inigoes Manor and the
other probably just across the river from the town land.[20] The
ordinary demands of daily life could be satisfied within a
small area reachable by foot, horseback, small boat, or flat.

For the majority of the inhabitants, the communications of
daily life may have been confined to the east side of the

St. Mary's River. Probably all families had horses to ride;
the poorer may not have had boats. The inventories analyzed
for all three periods show surprisingly few boats, and most
belonged to men whose estates came to at least fifty pounds
sterling, more estate than Ingalls, Taylor, or the Clockers
had. Of the identified town land residents, only Deacon had
boats in his inventory, although evidence from the excavation
of Hicks's house indicates that at one time he did also. Many
of the planters may have had rough flats that could be poled
in shallow water for crabbing, oystering, and fishing, but
such craft could not cross deep water. In the absence of
boats, the St. Mary's River would separate the town lands
from West St. Mary's Manor on the other side and keep the
two areas separate neighborhoods.

The standard of living represented in the inventories of
these families shows no great poverty, but the spread between
the life-style of, say, William Deacon and Daniel Clocker IV,
must have been felt in a thousand details. Only Deacon and
Hicks had slaves, and therefore only they could produce
tobacco or other surpluses that would bring in more than
eight to fifteen pounds sterling a year, depending upon
tobacco prices and exchange rates. These men did not have
to work with their hands. Deacon, whose estate at death
came to more than one thousand pounds sterling gained a
hundred and fifty pounds sterling a year from his post as royal
customs collector,[21] and since he had no children, he could
afford an exceptionally comfortable standard of living. His
house was much larger than Hicks's--four rooms on a floor
and "fully compleat" according to his executor's advertisement
in the Maryland Gazette--and far more luxuriously furnished.
According to the Federal Tax Assessment of 1798, it was one
story, forty-eight by thirty feet, with a separate brick kitchen.
Dr. Henry Chandlee Forman has made a conjectural drawing
based partly on an old photograph, and this shows a frame
house with brick ends and a gambrel roof somewhat similar
to the house of the merchant planter William Hebb, still
standing across the river.[22] Deacon's inventory shows that
he not only had a large amount of good furniture, including
pictures, but also an abundance of linen and good glassware

and china, including ample equipment for drinking tea. His
ceramics were worth eleven pounds sterling, far more than
any other household among those analyzed had invested in
such short-lived items. From kitchen-herb still to silver
punch bowl, nothing appears to be missing that would make
life as comfortable as the time and place would allow.

By contrast, in the households of the Taylors and
Clockers not only did all men labor at planting and other
income-producing activities, but their wives and children
contributed, carding wool or spinning yarn or weaving cloth
and helping on the farm, although the women may not have
actually worked in the fields. Differences between their
life-styles and Deacon's were reflected in every way.
Daniel Clocker IV had a small four-room house about
eighteen by thirty-two feet, with brick chimney and a
separate kitchen; two rooms were in a knock-head garret.
His six children slept three to a bed. Neither he nor Taylor
had fine glassware or tea ware, although household
furnishings were adequate, well above the "rude sufficiency"
Aubrey Land has described for the small planters of the
1690s.[23] Nevertheless, their total investments in household
goods came to no more than £15; Deacon's came to £350.

Although Taylor and Clocker had about the same amounts
invested in consumer goods, the thirty-year span between
their inventories produced a difference of interest. Taylor
in 1732 had no knives or forks or inexpensive luxuries like
sugar or pepper for seasoning food. In his day these items
rarely appeared in inventories, even among far more affluent
households. But Clocker in 1766 had case knives and forks
and a pepperbox. By his day such amenities were often found
even in the inventories of the poor. The investment in such
items was not great, nor were they difficult to transport.
Their higher incidence in the inventories of the 1760s is
evidence of the greater availability of such wares. This
availability produced what has been aptly termed cultural
inflation.

Ingalls's standard of living was higher, indeed too high
for his capital base, although his estate of £126 was twice
that of Taylor or Clocker. He was the only one of the group

whose assets could not pay his debts. He had an indentured
servant, who may have worked the farm, sparing Mrs. Ingalls
more than housekeeping chores. Clothing and household
goods suggest better days, for they came to half the value
of the inventory. Mr. Thomas Ingalls, as he is designated,
owned four wigs, a beaver hat, silver studs, and a watch,
and his wife had a small amount of tea ware. He even owned
a riding chair, an item rarely found even in inventories valued
at £400. On the town lands only Esquire Deacon shared this
distinction.

Despite the enormous discrepancies between the estates
of Hicks and Deacon and those of Taylor, Clocker, and
Ingalls, these small planters were far from the poorest in
the county over these years. At his death in 1732, Taylor's
estate of sixty-five pounds sterling put him just within the
top 30 percent of 115 inventoried estates during the years
1729-33. Clocker's estate of forty-nine pounds in equivalent
money of thirty years later was just within the top 50 percent
of the 115 estates inventoried between late 1760 and early
1764, but a falling off in the reporting of small estates
probably accounts for some of the apparent discrepancy
between his position and Taylor's. Ingalls at his death in
1752 was just within the top 20 percent of the same number
of estates inventoried between 1750 and 1752. These figures
cannot give precise relationships for the economic standing
of these planters in the population as a whole, but they are
sufficient to show that the town land landowners, according
to the standards of the time, were far from poverty-stricken.
The figures probably deflate, rather than inflate, the economic
standing of these planters.

The poorest families on the town land were probably tenant
farmers. There must have been at least two and possibly
more. They may have lived in small houses with wooden
chimneys, such as records of the 1760s show standing on
proprietary leaseholds across the river and elsewhere in the
county.[24] Among the inventories studied in detail, those
valued at less than twenty-five pounds sterling show no bed
linen and fewer beds than are usually found in landowning
households. Little is listed in the way of other furniture.

Everyone had pewter, but such very poor people occasionally
had no ceramics at all. On the other hand, books, probably
Bibles, often appear.

Some aspects of the standard of living enjoyed are not
revealed in inventories. Those studied suggest that any
family, however poor, had milk to make cheese, cornmeal
for bread, and pigs for meat, but other produce goes
unmentioned. Fruits from orchards, vegetables from kitchen
gardens, and even cider do not appear. But cider casks are
sometimes listed, and newspaper advertisements of the
plantations for sale usually mention fruit trees and gardens.
The improvements described on proprietary manors in the
late 1760s show an orchard by almost every dwelling,
including that of Hicks.[25] Chickens also often go unlisted
in inventories, yet even the poorest family probably had a
few fowl. Perhaps such items were omitted because they
were not marketable in an economy where everyone could
supply himself with perishables. Oysters, crabs, and game
were also available to all for the catching. Netting fish
required a seine, however. Few households had these, and
on the town lands only Deacon was so equipped, although the
Clockers had fishing lines.

Deacon, with splendid clothes and well-appointed house,
must have been the grandee of the neighborhood. As collector
of customs for the North Potomac area, he maintained regular
communication with the whole Potomac region, for most ships
did not actually come into the St. Mary's River to make their
clearances.[26] During his fifteen years as justice of the
peace, furthermore, he was the neighborhood authority for
law enforcement. He probably held court in his own dwelling,
where most breaches of the peace would be brought before
him for a preliminary hearing. All neighborhood disputes
over small debts were his to settle, and there was no appeal
from his decision. A man in this position was a key figure
in any neighborhood.

As a county justice on the bench, Deacon not only heard
criminal and civil cases within the broad jurisdiction of the
county court, but he also participated in making decisions
that affected the welfare of all inhabitants of the county:

where roads should lead, who should be guardian of an
orphan, who should receive poor relief, who should have
license to keep an ordinary, who should serve in conscripted,
unpaid local office, what public buildings should be erected,
and above all, what the county tax rate should be. His
neighbors would turn to him for help in procuring favorable
consideration in any business that might come before the
court. In this respect, he was more important to them than
Captain John Hicks, once Hicks had been moved to the
provincial court. Deacon was evidently also a source of
financial assistance. Both debtors of the neighborhood,
Ingalls and Taylor, had borrowed substantial sums from
him.[27]

Captain John Hicks never acquired a permanent patronage
post and died far less rich a man than Deacon, but his small
planter neighbors may not have concerned themselves much
with such differences. Both men represented power and wealth
to which the Clockers, the Ingallses, and the Taylors could
never aspire. If Hicks, as conjectured, was a tobacco factor,
he was of central importance to the economy of a considerable
area, as his son was after John Hicks's death. Small
planters--the great majority--would depend upon Hicks to
buy their cash crop and would have to rely on him for credit.
When yields were poor or prices were low, he would have
power to ruin them, but the insolvency of a large number of
such planters could also be ruinous to him. A man in this
position would feel pressure to extend credit over a consider-
able length of time, and store accounts for other areas show
that factors often carried small planters for years, even as
their debts increased.[28] Such credit was essential to the
survival of small tobacco farmers, though it kept them in
thrall and may have subsidized an uneconomic agricultural
organization.

During his years first as justice and then as sheriff,
Hicks equaled Deacon in the political power he could
exercise within the county. Once he became a provincial
court judge, he was less directly connected with local
administration and decision making. He still had minor
peace-keeping and local administrative duties, but his work

was mainly judicial, and was exercised in a distant court.
Hicks functioned in this last role only a short time, for he
attended only one circuit of the assizes and never joined
his colleagues on the bench in Annapolis. Neither Deacon
nor Hicks seems to have sought the glitter of the governor's
circle or the opportunity for province-wide influence that
their positions might appear to have promised them.

The less wealthy residents of the town lands were very
much more humble, even though their assets put them in
the upper half of the property-owning population. Thomas
Ingalls clearly aspired to higher status than either Taylor
or Clocker in his habits and standard of living, but he
appeared to be losing, not gaining, economic and social
position. At his death, his lands in Maryland were sold,
and had he not had property in New England, his children
would have been dependent on the charity of relatives or
would have had to be bound out to service. They would
have started independent life without capital of any kind.
Taylor and the Clockers were obviously simple, hardworking
people who provided something for their children, but with
difficulty. The status that ownership of land provided could
not be passed along to all their offspring. Taylor could
devise land--about sixty acres--to only one of his sons,
and large debts heavily depleted his estate. Daniel Clocker III
had land enough to divide between his son and daughter, but
most of the soil was poor. When Daniel IV died, he could
leave no real estate to his two younger sons, who must have
started their own households as tenants on the land of others.

Although tobacco was the chief cash crop, there was
considerable diversification on these plantations, including
some raising and perhaps marketing of grain. On cleared
land, tobacco and corn culture required only hoes, but the
soil had to be plowed and harrowed if wheat or other such
grains were to grow. Both Ingalls and Deacon had plows
and harrows, and both had wheat in their inventories,
although how they harvested it remains a mystery; neither
had scythes or sickles. Ingalls's land was poorly suited to
tobacco, and he apparently grew none, but his wheat crop
was worth as much as Daniel Clocker IV's tobacco crop.

Others in the area must also have raised some wheat.
William Hicks in the 1750s kept accounts at his store in
wheat as well as in tobacco and corn, and his father may
have done so before him. Most of the farms also showed a
capacity to produce occasional surpluses of pork. Surpluses
of grain and salt meat could be sold as provisions for ships,
and a wider market was available in the West Indies and
southern Europe.29

Hicks and Deacon had large flocks of sheep and must
have had surpluses of wool. The Clockers and Taylors spun
yarn, using not only wool but cotton and flax that they or
others in the neighborhood grew. The Taylors wove cloth and
ran the forge to keep traces in repair and horses shod.
Deacon's plantation also had a forge--perhaps started after
Taylor's death--and equipment for shoemaking for his house-
hold and perhaps for his neighbors. Deacon operated a corn
mill on the town lands, and he seems to have had a ship
repair business that may have supplied part-time work for
members of other town land families.

Thus diversification led to economic interdependence
among all the town land residents. This interdependence
hinged not only on internal exchange within the neighborhood,
but on external exchange with the major markets. Here John
Hicks, if he ran a store, was in a key position. The town
land plantations had the capacity as a group to be nearly
self-sufficient. Nevertheless, a merchant, whether Hicks or
another, played a necessary economic role in an economy
where markets lay across hundreds of miles of ocean.

Ingalls did not fit well into this neighborhood economy.
He did not produce wool for others to spin or weave. He may
have raised wheat for the market, but otherwise his farm does
not appear to have had surpluses beyond occasional hides.
At the same time the absence of many credits in his inventory
or accounts suggests that the market for furniture, whether
crude or fine, must have been limited in a country neighbor-
hood. On the town lands Ingalls might have done better to
give up his craft and farm more for the market, putting his
capital into better land, more livestock, and servants or
slaves. Even then, he might not have avoided his debts

altogether without lowering his standard of living. He had
only 41 percent of his assets invested in income-producing
goods, whereas Hicks had nearly 90 percent, Deacon
60 percent, Taylor 72 percent, and Clocker 61 percent
(Table 2). It is hard to escape the judgment that Ingalls
could ill afford riding chairs and wigs and other signs of
superior social status. Both Taylor and Clocker, with half
Ingalls's assets, had better balanced economies that
enabled them to leave behind greater estates.

Precedence, based on economic and political position,
undoubtedly governed relationships between town land
residents, but there were occasions on which freeholders,
at least theoretically, met as equals. Until Deacon and
Hicks were elevated to the bench, they occasionally must
have joined their less affluent neighbors on county or
assize juries. Protestant freeholders in an area of large
Catholic population must have been too few to spare many
of those available. The two Clockers very likely served as
constable or highway overseer or both at least once during
their lifetimes, and Ingalls or Taylor may also have contributed
such service. As constables, these men would have served
warrants for both Deacon and Hicks and carried out various
orders; but also as constables they would have responsibility
for seeing that neither Deacon nor Hicks concealed any
taxables. As overseers, these small freeholders could force
their more powerful neighbors to supply labor for work on the
roads. And as jurors a Clocker or a Taylor might be obliged
to determine the outcome of litigation important to Deacon
or Hicks.[30] A network of obligations kept the community
functioning, and even a small planter might sometimes be
in a position to demand that a wealthy and powerful one
contribute his share, obey the law, or pay his just debts.

There is one possibility that might have altered these
relationships. If the Clockers or Taylors were Roman
Catholic--as a New Englander, presumably Ingalls was
Protestant--they would not have been eligible for service on
juries or as constables. Deacon and Hicks had Catholic
wives and surely felt no prejudice towards Catholics, but most
opportunities for sharing community responsibility would have
been missing.

TABLE 2. Distribution of Assets, Five Town Land Families

A. Assets, Excluding Business Credits, Compared with Final Balance of Estate

Name	Total Estate value	Total capital	Total consumption	Final balance	Final overpay
William Deacon	£1306	£777	£530	£1182	
John Hicks	383	339	43	191	
Thomas Ingalls	126	52	74		£44
Joseph Taylor	65	46	18	28	
Daniel Clocker IV	46	28	17	38	

B. Assets and Final Balance as Percentage of Total Estate Value

Name	% Capital	% Labor in cap.	% Livestock in cap.	% Craft in cap.	% Consumption	Final balance as % total estate value
William Deacon	60	48	8	2	40	90
John Hicks	89	72	15	11	50
Thomas Ingalls	41	7	11	21	59	0
Joseph Taylor	72	0	27	42	28	42
Daniel Clocker IV	61	0	42	9	39	82

Note: All the figures in A are equivalent to pounds sterling of the 1730s.

The careers of these six men and their descendants
suggest that by mid-century opportunity at St. Mary's was
not expanding. Deacon and Hicks, especially Deacon,
did well, but their initial capital is unknown, and Deacon
had no children to educate or provide for. Hicks's sons
could not maintain their father's position on the basis of
their St. Mary's inheritance. Ingalls and Taylor could
not hold their own within their own lifetimes, and the
Clockers' position diminished with each generation. Future
research may tell whether this pattern existed in the
community beyond the town lands and thus whether it
reflected overall conditions in a staple economy or mainly
the personalities or luck of these individuals.

What was it like to be John Hicks, or any resident on the
town lands in the second quarter of the eighteenth century?
Help is needed from more than documents. Garry Stone will
discuss the remains of the house on Hicks's land and the
refuse that for us is its treasure. Here is the unwritten
record of human occupation. Once we learn to interpret
it, it can vastly enlarge our understanding.

NOTES

1. Unless he had teen-age sons, a man who could not
hire labor would have to cut his tobacco himself, and even
today in the month available for cutting, a man can cut only
about five acres. In the eighteenth century, three acres
would grow about one thousand pounds of oronoco, the
variety grown in Maryland. See Arthur Pierce Middleton,
Tobacco Coast, A Maritime History of the Chesapeake
(Newport News, Va.: Mariner's Museum, 1953), p. 378.
In 1747 an article in the Maryland Gazette gave fifteen
hundred pounds of tobacco as a fair estimate of what a small
planter might raise in a year. Charles A. Barker, The Back-
ground of the Revolution in Maryland (New Haven, Conn.:
Yale University Press, 1940), pp. 101-2. Aubrey Land has
found that at least 40 percent of producers raised no more
than two thousand pounds per year. "Economic Behavior in
a Planting Society: The Eighteenth Century Chesapeake,"
Journal of Southern History 33, no. 4 (Nov. 1967): 473. For
examples of rents, see Chancery Proceedings IR no. 4,
ff. 23-24, ms., Hall of Records, Annapolis, Md.; Accounts
11, f. 407, ms., Hall of Records, Annapolis, Md.
 2. Lois Green Carr, "County Government in Maryland,
1689-1709" (Ph.D. diss., Harvard University, 1968), pp.
601-9. Research in progress by Russell Menard, University
of Iowa, in the records of Somerset County shows similar
findings for the second quarter of the eighteenth century.
 3. Thomas Aisquith was deputy commissary from 1724
until his death in 1759. A fall in the number of inventories
that appear each year begins with his death.
 4. Aubrey Land, "Economic Base and Social Structure,
The Northern Chesapeake in the Eighteenth Century,"
Journal of Economic History 25, no. 4 (Dec. 1965): 639-54;
William Hand Browne et al., eds., Archives of Maryland,
71 vols. (Baltimore: 1881-), 25:269.
 5. E. I. Mingay, English Landed Society in the
Eighteenth Century (London: Routledge and Kegan Paul,
1963), pp. 6, 10.

6. Carr, "County Government in Maryland,"
Appendix, p. 329.

7. Of the inventories counted in the 1730s, 5.2 percent
came to three hundred pounds sterling or more; 7.18 percent
in the 1750s; 16.5 percent in the 1760s. Part of the increase
in the last group probably reflects increased underreporting
of the poor.

8. Additional credits appear in the administration
accounts. Only those that remain for the 126 analyzed
estates have been examined. These suggest that most
estates had some credits over all three periods, but the
amounts fluctuated as described.

9. Land, "Economic Base and Social Structure," p. 653.

10. Marc Egnel and Joseph A. Ernst, "An Economic
Interpretation of the American Revolution," William and Mary
Quarterly, 3rd ser. 29, no. 1 (Jan. 1972): 25-27.

11. Summaries of William Hicks's so-called factorage
accounts, 1751-61 (mostly 1757-59), are in the Cumberland
County Record Office, Carlisle, England. Xerox copies are
with the St. Mary's City Commission's historian at the Hall
of Records, Annapolis, Md. They are schedules lettered
A through F. Hereafter only the schedules will be cited.

12. Detailed and fully documented biographies of Hicks
and all the people discussed in this paper are provided in
the typescript report by J. Glenn Little III on the excavation
of Hicks's house filed with the St. Mary's City Commission,
St. Mary's City, Md. Evidence is from wills, inventories,
accounts, proprietary records of patents, surveys, quit-rent
rolls and debt books, proprietary lease records, provincial
and chancery court records, commission books, Assembly
proceedings, all at the Hall of Records, Annapolis, Md.;
Port Books, Carlisle, Whitehaven Creek, 1712-19, 1738-42,
Public Record Office, London; Naval Office records for the
South Potomac District, 1725-71 (in the absence of more
than a handful for North Potomac), microfilm, University of
Virginia Library; Lowther Archives, Cumberland County
Record Office, Carlisle, England; Act Books for Copeland
Deanery, Lancaster County Record Office, Preston, England.
Daniel Clocker III left a will, but no inventory of his estate
survives.

13. Information about soils here and throughout is from
soil mapping on aerial photographs undertaken by the U.S.
Soil Conservation Service. I am indebted to John Hall,
Soil Conservation Supervisor for St. Mary's County, for
explaining these materials to me.

14. Land, "Economic Behavior in a Planting Society,"
p. 473.

15. Snow Hill Memorandum Book, ms. in box of
Proprietary Leases, Hall of Records, Annapolis. Files of
the Maryland Gazette, beginning in 1745, are deposited at
the Maryland State Library, Annapolis, Md.

16. Schedule F shows that eight different ships came
into the St. Mary's River during the period 1751-59, several
of them a number of times.

17. Schedule D. The notation is to amount owed for
stays for Mrs. Hicks to Nicholas Wilson. Wilson was
master of the ship Hudson, which was owned by William
Hicks's uncle. Naval Office returns for South Potomac
District, CO 5/1447 f. 55, microfilm, University of
Virginia Library. In 1749 Charles Wallace advertised in
Annapolis as a staymaker; his activities in this trade ended
in 1764. Maryland Gazette, Aug. 30, 1749; Dec. 13, 1764.

18. Maryland Gazette, Feb. 24, 1757.

19. In 1720 the Assembly deeded the old State House to
William and Mary Parish for use as a church. Morris L.
Radoff, Gust Skordas, and Phebe R. Jacobsen, The County
Courthouses and Records of Maryland, Part Two: The Records,
Hall of Records Commission Publication no. 13 (Annapolis,
Md., 1963), p. 158. The Catholic chapel on the St. Mary's
town land was ordered closed by Governor Seymour in 1704.
In 1708 Catholics were finally given permission to conduct
services in private houses, and the Jesuits at St. Inigoes
must have done so. Browne, Archives of Maryland, 26:46,
340; 27:146-48. For Jesuit occupation of St. Inigoes, see
Maryland-New York Province Archives, items 99W, 100N,
100S, 100T, 100W, 100Y, microfilm, Hall of Records,
Annapolis, Md.

20. Schedule D shows dealings with St. Inigoes ware-
house and St. Mary's warehouse. A point across the river
is still called Warehouse Point.

21. Donnell MacClure Owings, His Lordship's Patronage, Offices of Profit in Colonial Maryland (Baltimore: Maryland Historical Society, 1953), p. 100.

22. Maryland Gazette, Oct. 8, 1761; Federal Assessment of 1798, St. Mary's Hundred, Particular List of Dwellings worth more than $100, microfilm, Hall of Records, Annapolis, Md.; Henry Chandlee Forman, Tidewater Maryland Architecture and Gardens (New York: Architectural Book Publishing Co., 1956), p. 97. Dr. Forman did an archaeological probe of the site, but also depends on the description in John Pendleton Kennedy, Rob of the Bowl, part of which was laid in Deacon's house. Kennedy visited the area in preparation for writing the novel. His visit is noted by a Jesuit priest living at St. Inigoes at the time. Maryland-New York Province Archives, 10.6, ms., Baltimore, Md.

23. Land, "Economic Base and Social Structure," p. 640.

24. See, for example, the houses described in the Proprietary Memorandum Book for West St. Mary's Manor, printed in Gaius Marcus Brumbaugh, Maryland Records, Colonial, Revolutionary, County and Church Original Sources, 2 vols. (Lancaster, Pa.: Lancaster Press, 1928), 2:xi-xvi.

25. Brumbaugh, Maryland Records, 2:xi-xvi; Audit Office Papers 12/79 (American Loyalist Claims), microfilm, Library of Congress; Snow Hill Manor Memorandum Book, cited in footnote 15.

26. A customs inspector in 1770 commented that nearly all ships unloaded from twenty to sixty miles away. John Williams to the Commissioners of His Majesties Customs, Mar. 14, 1770, Treasury Papers 1/476, ms., Public Record Office London, xerox copy, St. Mary's City Commission's historian, Hall of Records, Annapolis, Md.

27. For the functions of a county justice, see Carr, "County Government in Maryland," pp. 98-124 and chapters 5 and 6. C. Ashley Ellefson, "Provincial Court and County Courts of Maryland, 1733-1763" (Ph.D. diss., University of Maryland, 1963) discusses the judicial side of the county courts.

28. Edward C. Papenfuse, Jr., "Planter Behavior and Economic Opportunity in a Staple Economy," Agricultural History 46, no. 2 (Apr. 1972): 305.

29. Judgments about surpluses on the town land farms
were formed by estimating the amount of meat and grain the
members of the households and their slaves could produce
and consume as compared to livestock and crops shown in
the inventories. These estimates were based on studies by
Robert E. Gallman and by Richard C. Battalio and John Kegel
of consumption and food production on antebellum cotton
plantations, published in William N. Parker, ed., The
Structure of the Cotton Economy of the Antebellum South
(Washington, D.C.: Agricultural History Society, 1970),
pp. 5-37. James Lemon's estimates for middle-class farming
families of southeastern Pennsylvania in the eighteenth
century were also useful. His consumption figures correspond
with those of Gallman and Battalio and Kegel, but his
estimates for the production of foodstuffs make insufficient
allowances for seed and for fattening, given the weights of
pork and beef. James T. Lemon, "A Rural Geography of
Southeastern Pennsylvania in the Eighteenth Century: The
Contributions of Cultural Inheritance, Social Structure,
Economic Conditions and Physical Resources" (Ph.D. diss.,
University of Wisconsin, 1964), pp. 369-70; James T. Lemon,
"Household Consumption in Eighteenth-Century America and
its Relationship to Production and Trade: The Situation among
Farmers of Southeastern Pennsylvania," Agricultural History
41, no. 1 (Jan. 1967): 59-70.

30. Carr, "County Government in Maryland," pp. 444-47,
601-9, 655-68, shows that in Prince Georges County at the
beginning of the century, service on juries and in conscripted
unpaid local offices was rotated regularly among landowners
and that nearly everyone served. During their lifetime, most
Protestant landowners probably served in other counties.
Unpublished research by Russell Menard in records of
Somerset County of the 1730s confirms such a supposition.
By mid-century, given the increase in population, such
service probably did not touch all landowners in counties
where rotation of office was not a policy, but in a heavily
Catholic area, the chances would be high, unless the
religious requirements were ignored. For duties of these
local offices, see Carr, "County Government in Maryland,"
pp. 198, 207, 227-28, 367-73, 411-15, 483-90.

CERAMICS FROM THE JOHN HICKS SITE, 1723-1743: THE MATERIAL CULTURE

Garry Wheeler Stone, J. Glenn Little III, and Stephen Israel

IN 1969 a notable group of eighteenth-century ceramics was recovered in St. Mary's City, Maryland. The sherds were recovered during three months of excavation at the site of the first residence of Captain John Hicks. The house itself appears to have been quite modest--a post-supported frame structure, sixteen by forty feet, with a brick chimney at each end. Under one end of the house was a dirt cellar hole, and there may have been an addition to the rear. The structure appears to have been extremely unpretentious for a man who was at different times sheriff of the county and a judge of the provincial court. Perhaps the most significant comment about the architecture of this dwelling is that when Hicks was able, he tore it down and constructed another house.

More interesting than the architectural remains, and more indicative of Hicks's economic and social status were the artifacts found at the site. These were found in holes, trash pits, and the rubble-filled cellar of the dwelling. A wide variety of artifacts was recovered. They ranged from boat parts and carpenter's tools to thimbles, buttons, and pins. The quantity was equally impressive. There were fragments of thirteen pairs of scissors, more than three hundred bottles, and thousands of ceramic sherds. Most of the artifacts appear to have been deposited during the relatively short period of time when Hicks's first house was being dismantled. Building debris was found in many of the pits, and it was possible to glue glass and ceramic fragments from some of the pits to other fragments recovered from the cellar hole. The house was torn down and the artifacts buried after 1741 and almost certainly before 1745. At least by 1749, when Hicks wrote his will, he was living in another house about a thousand feet east of the site of his first dwelling.

TABLE 1

Ceramic Forms Excavated from the Site of the First Hicks House
St. Mary's County, Maryland

Function	Form	Earthen	Stone	Delft	Porce-lain	Line Total
Dairy/Kitchen	Pots	23				23
	Pans	30				30
Kitchen	Cooking pots	1				1
	Saucepans	1				1
Kitchen/Dining	Bottles/Jugs	3	4			7
	Serving pans	6				6
Dining	Platters			2		2
	Plates		1	14		15
	Dishes	13		2		15
	Bowls	8		4		12
	Cups	38	4			42
	Mugs	25	24	2		51
	Drinking pots/Jugs	2	3			5
	Pitchers/Jugs	1	1	1		3
Dining/Social	Large bowls			2		2
	Small bowls		3	14	5	22
Social	Teapots		3	1		4
	Teacups		3	3	9	15
	Saucers		2	3	6	11
	Spoon trays				1	1
Medical/Hygiene	Drug jars			1		1
	Ointment pots/Eggcups	2		3		5
	Bleeding bowls			2		2
	Chamber pots			1		1
Column totals		153	48	55	21	277

The ceramic fragments recovered represent a wide variety
of early eighteenth-century types: Chinese porcelain, English
delftware, Rhenish stoneware, and coarse earthenwares from
Staffordshire, Flintshire, North Devon, and Virginia. More
impressive than the variety of types present were the numbers
of vessels represented. As of this writing, 414 possible
vessels have been identified. In many cases it has been
impossible to identify the form of the vessel represented, but
the forms of 277 objects have been identified with reasonable
certainty (Table 1). These vessels, in conjunction with the
ceramics listed in probate inventories of St. Mary's County,
will be the subject of the remainder of this paper.

One surprising result of the archaeological research was
the discovery of the importance of common earthenware even
in a household that contained many fine ceramics. Over 55
percent of the vessels identified (153 out of 277) were of
earthenware. One expects to find much coarse earthenware
used for the storage and preparation of food. Twenty-three
storage jars or pots were identified, most of them in highly
fired black-glazed earthenware. In outward appearance they
were surprisingly uniform, with heavy horizontal rims and
thick black glazes (Fig. 1, No. 1), but the pastes varied
considerably. Besides the marbled red-and-yellow firing
clays from the kilns near Buckley, Flintshire, in northern
Wales, there were also red bodies and an olive-to-purple
gravel-tempered body. Similar black-glazed pan sherds
extend the paste range to buffs and marbled yellow and olive.
The outward uniformity of vessels with such dissimilar fabrics
suggests a large group of potters competing for a market that
included the Liverpool export trade. Comparable sherds have
been recovered from many eighteenth-century sites in Virginia
and North Carolina.[1] In the St. Mary's County inventories
the durable black-glazed wares were sometimes valued as
highly as stoneware. Some of these vessels were undoubtedly
manufactured in Staffordshire where there had been a large
blackware industry since the seventeenth century.[2]

These pots were used most frequently for the storage of
dairy products. The inventories generally refer to pots as

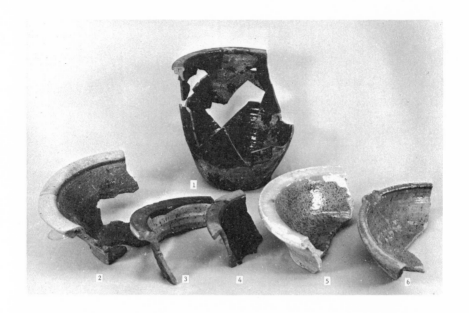

Fig. 1. Fragments of earthenware dairy and kitchen vessels found at the John Hicks site, St. Mary's City, Md. (St. Mary's City Commission.)

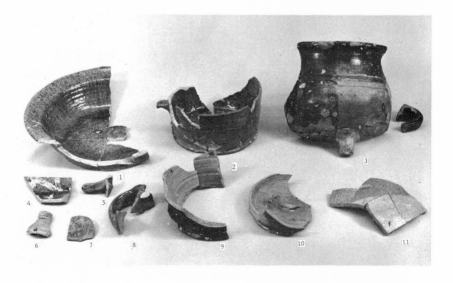

Fig. 2. Fragments of earthenware and stoneware storage, cooking, and serving vessels found at the John Hicks site, St. Mary's City, Md. (St. Mary's City Commission.)

"butter pots" and occasionally as "cream pots." Other storage
functions--for lard or pickles--were only occasionally mentioned.

For storing milk, shallow pans were used, which, when set
in the trough of a springhouse, would quickly cool warm milk
and which would facilitate skimming off the cream as it rose
to the surface. A large variety of pan types was present (Fig. 1,
Nos. 2-6). Besides the black-glazed sherds, there were
buff-colored pans with oxide spatters, a gravel-tempered pan
from North Devon, and fragments of two or three hemispherical
pans from the Rogers Pottery in Yorktown, Virginia. While most
of the large pans were used in the dairy, they also could have
been used as baking pans or washbasins--perhaps explaining
why one has a decorative slip. The smaller pans were probably
used for cooking puddings or pies--"patty pans" as they are
called in the inventories.[3]

For storing and serving liquids, ceramic jugs and bottles
still competed with glass. While jugs as large as four gallons
are listed in the inventories, the vessels from the Hicks site
are much smaller (Fig. 2, Nos. 6-11). Besides three jugs of
earthen and two of coarse gray stoneware, there were sherds
from two Rhenish stoneware bottles. Both are represented by
single sherds only, and it is suspicious that one is a rosette
medallion of a type popular in the first half of the seventeenth
century. Perhaps one of Hicks's children picked up this
rosette at the neighboring seventeenth-century site of St. John's.

Sherds of relatively few cooking vessels were recovered.
This is not surprising since Hicks's probate inventory lists
113 pounds of iron cooking pots and skillets.[4] Besides baking
pans, there were only fragments of a three-legged pot and a
handle that may have come from a saucepan (Fig. 2, Nos. 3,5).
Even more dining than storage vessels were present in earthen-
ware. This is somewhat surprising, since John Hicks's inventory
contains 146 pounds of pewter vessels worth £11 current money.
The earthen vessels may have supplemented pewter for every-
day use, or they may have been used by his servants. Besides
several large serving pans (Fig. 2, Nos. 1,4), there were
sherds from thirteen yellow slipware dishes decorated with
trailed or marbleized slips (Fig. 3, Nos. 1-6). Such plates
are very common in mid-eighteenth-century contexts. Most

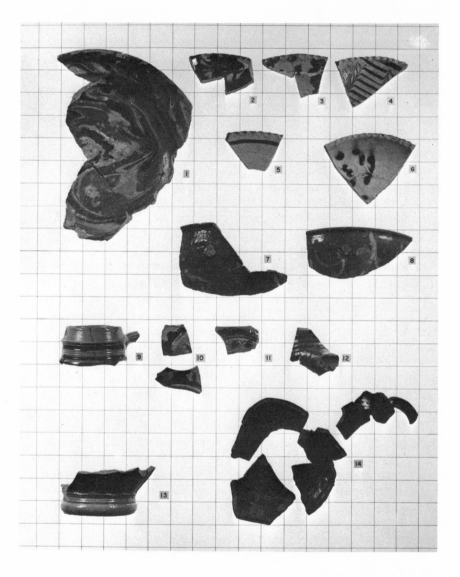

Fig. 3. Fragments of earthenware and stoneware dishes, bowls, and drinking jugs found at the John Hicks site, St. Mary's City, Md. (St. Mary's City Commission.)

of them are thought to have been made in Staffordshire. A number of earthen bowl fragments (Fig. 3, Nos. 7-8) were recovered, one of which shows the attachment for a horizontal handle, and four comparable vessels were present in delft (Fig. 7, Nos. 1-2). Such handled bowls or porringers were used for soup, stew, or porridge--any kind of food which had to be eaten with a spoon.

The presence of only 27 earthen pans, plates, dishes, and bowls is probably a reflection of Hicks's extensive use of pewter. In contrast, the number of earthen drinking vessels recovered was quite staggering--some 38 cups alone. The total of earthen, stone, and delft cups and mugs was 98, so many that at one point the archaeologists thought that they were excavating a tavern.

Most of the cups (Fig. 4) were of combed-and-dotted-yellow slipware, a type made in the west of England as well as in the Staffordshire area. Similar forms were also present in a buff earthenware. These and comparable mugs were sealed with a brown glaze that ran and streaked during firing, creating an attractive grained appearance. The brown cups and mugs are another common Staffordshire product. Redware mugs treated with a brown glaze, or with a clear glaze and yellow slip, were also present. Other mug fragments have a smooth glossy black glaze.

More durable than the earthenware mugs were the 24 stoneware mugs found on the site (Fig. 5). The largest number were of blue and gray Westerwald stoneware. Some of this stoneware is of surprisingly good quality to have been recovered from a mid-eighteenth-century site. The most interesting piece is a quart mug with an applied frieze around the rim and the base depicting dogs chasing deer. Its coloring includes manganese purple as well as the common cobalt blue. English stoneware, more fragile and undoubtedly more familiar to the users, is also well represented. Most of the sherds were from the cheap white-dipped mugs, but there were also fragments from a mug with a refined white body, as well as two mugs elaborately turned and incised with lustrous brown glazes.

For formal dining, the Hickses apparently used tin-glazed earthenware (Figs. 6-7). One dinner service and over a dozen

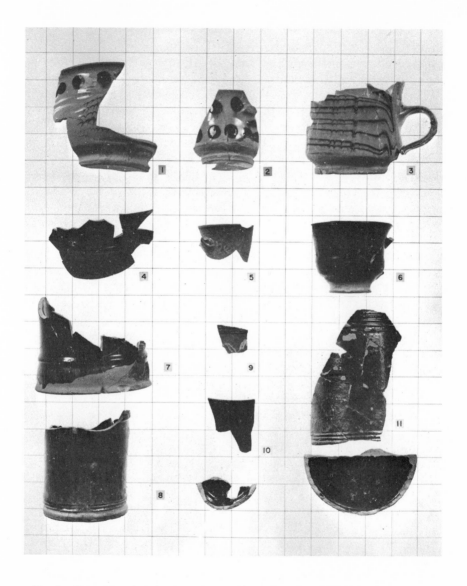

Fig. 4. Fragments of earthenware and stoneware cups and mugs found at the John Hicks site, St. Mary's City, Md. (St. Mary's City Commission.)

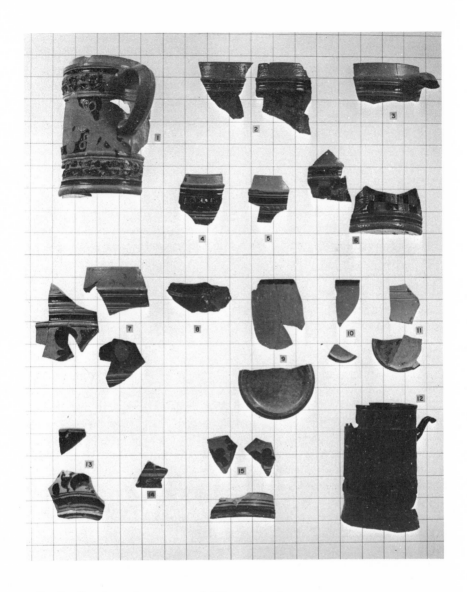

Fig. 5. Fragments of stoneware and delft mugs found at the John Hicks site, St. Mary's
City, Md. (St. Mary's City Commission.)

miscellaneous pieces were identified. The miscellaneous
pieces appear to be a heterogeneous collection of hand-me-
downs and casual acquisitions--a late seventeenth-century
lobed plate; cheap, crudely decorated bowls; and individual
plates from London and Bristol (or Brislington). The dinner
service was quite fashionable and complete. Fragments of at
least three dinner plates, two dishes, and two platters were
recovered. In form and decoration, they are close copies of
contemporary porcelain with Yung-chêng profiles, iron-oxide
brown rims, and elaborate blue floral designs. The sherds
give every indication that Captain John Hicks was responding
to the dictates of Georgian fashion.

Also in delftware were fragments of three large bowls such
as those frequently used for serving alcoholic punch (Fig. 7,
Nos. 3-5). One was decorated in two shades of yellow as
well as blue. It is one of only three pieces of polychrome
tin-glazed earthenware recovered from the site. When not
in use these large bowls may have been used as decorative
centerpieces.

In the eighteenth century the tea ceremony was the cultural
equivalent of the modern cocktail party.[5] The significance of
the ritual to prosperous tobacco planters like Hicks can be
gauged by the fact that his trash included fragments of tea
equipage in delft, white-glazed stoneware, and oriental porce-
lain (Fig. 8). In the delft and white salt-glazed stoneware are
fragments of four teapots, eleven cups and saucers, and fourteen
medium-sized bowls. Some of the bowls must have been used
in the tea ceremony as slop bowls or open sugar dishes. The
floral motif on one bowl matches that on two cups and a saucer--
apparently remnants of a badly battered Bristol set.

Porcelain was the most prestigious and expensive of early
eighteenth-century ceramics. In John Hicks's first dwelling,
its use appears to have been restricted to tea vessels. Parts
of five medium-sized bowls were recovered. They are decorated
in underglaze blue with floral patterns and a landscape scene.
Nine saucers and six cups found at the site are decorated with
typical floral patterns and crosshatched bands and rims. Most
sherds are from individual pieces, but fragments were found of
two cups and a saucer in one pattern and a cup and saucer in

Fig. 6. Fragments of delft plates, platters, and dishes found at the John Hicks site, St. Mary's City, Md. (St. Mary's City Commission.)

Fig. 7. Fragments of delft bowls found at the John Hicks site, St. Mary's City, Md. (St. Mary's City Commission.)

another, the latter decorated with carefully painted bouquets.
These sherds may be the remains of two sets.

The only vessel of gilded or enameled porcelain found in
the excavation was a fragment from a spoon tray. The tiny
sherd shows traces of an elaborate floral and geometric
pattern in gold, black, red, and two other colors that
chemically disintegrated during their stay in the soil.

While forms connected with food preparation and
consumption comprise the bulk of the collection, there are
also fragments from vessels used in the chamber (Fig. 9).
They include a handle from a Rhenish salt-glazed chamber pot,
the rim from a delft drug jar, and fragments from at least five
ointment and cosmetic pots. The most interesting medical
forms found were two small delftware bleeding bowls. Their
actual use as bleeding bowls is not improbable, as part of a
bleeding lance was also recovered in the excavation. Bleeding
appears to have been fairly regularly administered by heads of
households and neighbors as well as by doctors.[6]

The vessels discussed above tell us much about the Hicks
family's tastes and standard of living, but little else about the
people themselves. One sherd, however, is unusually evoca-
tive. It is a tiny fragment of Italian majolica, barely three-
fourths of an inch long. It is far too small to allow identifi-
cation of its form. Comparably molded and painted wares formed
plates, trays, and religious panels. However, the presence
of a piece of Italian majolica on an eighteenth-century English
site is unusual and suggests an unusual use. It may have been
part of a holy-water font, a small hanging vessel frequently
located in the chamber or near the entrance of Catholic house-
holds. If so, this sherd speaks of the unusual circumstances
of southern Maryland in general and St. Mary's City in
particular. Both the Anglican officeholders of the neighborhood,
Hicks and William Deacon, had Catholic wives.

In trying to analyze the social significance of the sherds
found at the site of John Hicks's first house, the major problem
is one of trying to define the relationship between the archaeo-
logical vessel count and the group of ceramics that Hicks had
in his house at any one time. His probate inventory is of no

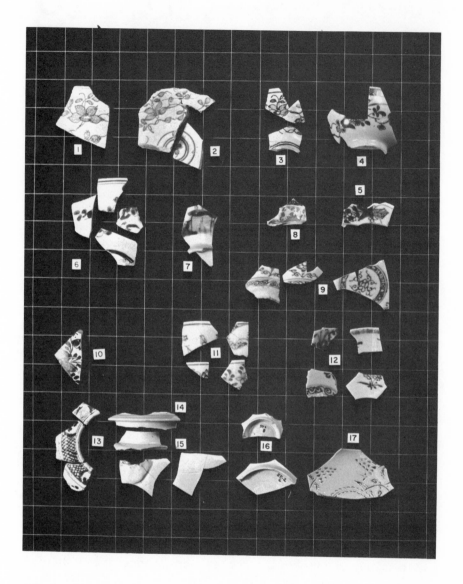

Fig. 8. Fragments of porcelain, stoneware, and delft tea vessels found at the John Hicks site, St. Mary's City, Md. (St. Mary's City Commission.)

help. While it lists his iron and pewter, only three pieces
of earthenware and a punch bowl are enumerated. Hicks
appears to have returned to England shortly before he died.
He may have taken his tea and dinner service with him.

What do the sherds represent? Are they the result of
occasional accidents over several years, or a household
catastrophe, or are they fragments of vessels deliberately
discarded when Hicks moved? The three hundred smashed
bottles clearly indicate that Hicks disposed of some junk
during his move, but would Hicks have discarded a chipped
cup or plate that would have been serviceable to his slaves?
Hicks hardly appears to have been wasteful. Most of the
lumber, bricks, and nails from the house were salvaged for
reuse. Therefore it is doubtful that deliberate discarding
explains much of the collection.

Neither does it appear that the ceramic trash represents a
household catastrophe or commercial breakage. None of the
regularities appear in the artifact distribution that would be
expected from tipping over a cabinet or dropping a shipping
case. The random distribution of vessel forms and types
suggests instead that it is the result of slow household wear.

Thus the critical question is how long a period of breakage
does this trash represent? Presumably it includes the trash
that accumulated just before Hicks moved as well as the trash
from the new house during the period when work crews were
coming back to the old site to dismantle the buildings. Even
if this period was a year long, it would appear to be inadequate
time for the Hicks family and their servants to have broken a
couple hundred pieces of ceramics. A tempting hypothesis is
that the breakage during the moving period was added to a
large trash pile in the back yard that may have accumulated
over two, three, or ten years, and as the site was cleared
this trash was gradually scraped up and buried. But even if
the trash buried shortly after 1741 had accumulated over the
previous five years, it is doubtful that the universe of ceramics
from which it originated could have been smaller than the number
of probable ceramic forms recovered. To hypothesize that Hicks
had less than two hundred pieces of ceramics in his house would
require assuming, first, a tremendous attrition rate, and second,
that none of the vessels found are small fractions of large sets.

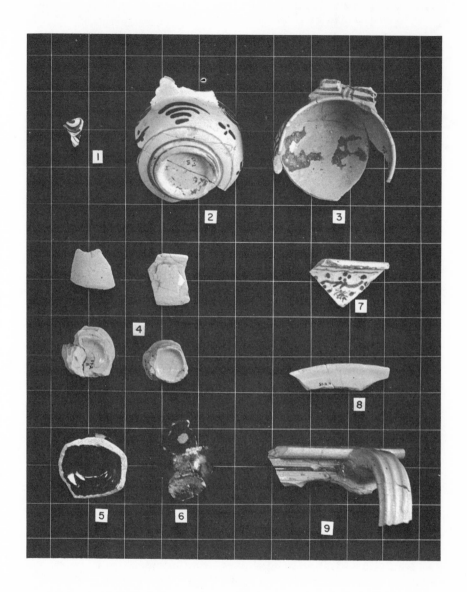

Fig. 9. Fragments of miscellaneous vessels found at the John Hicks site, St. Mary's City, Md. (St. Mary's City Commission.)

If we assume that the group of ceramics in which the arti-
facts originated was larger than the number of ceramic forms
recovered, we can begin to imagine the ceramic furnishings of
John Hicks's home in the late 1730s. In the hall, one or two
sets of oriental porcelain tea ware would have been displayed,
perhaps accompanied by a few pieces of polychrome delft or
enameled porcelain. Odd pieces of porcelain tea ware, white
salt glaze, and relics of old delft sets would have been avail-
able for informal use. The best dining ware was a large service
of British delftware, decorated much like the porcelain tea ware
with blue painted floral sprays. For more serious drinking there
must have been at least a few mugs of Rhenish stoneware left,
now supplemented by lustrous brown English mugs. Most cer-
tain of all, the kitchen and dairy were liberally supplied with
coarse earthen- and stonewares.

This information, while useful in helping us imagine what
John Hicks's life may have been like, does not place Hicks or
his ceramics in any kind of social perspective--a perspective
necessary if we are to understand the man or his furnishings.
By contrasting Hicks's trash with his neighbors' inventories,
it becomes immediately apparent that the quantity and quality
of his ceramics were unusual. Joseph Taylor, the blacksmith,
had only earthenware and glass worth one pound current money
when he died in 1733. Daniel Clocker's inventory lists only
one stoneware plate, three earthenware plates, and a parcel
of earthenware worth 11s. 6d. (probably between one and two
dozen pieces). Thomas Ingalls, the genteel but indebted
cabinetmaker, had bowls and tea ware, but it is improbable
that all his ceramics totaled more than forty pieces. Only
William Deacon, Esquire, had a comparable collection--
some 280 pieces of porcelain, delft, white stoneware, and
coarse wares.[7]

These illustrations, while useful, are too limited to have
any general significance. A better comparison results from
studying the ceramics within the group of 106 St. Mary's
County inventories analyzed by Lois Green Carr for asset
distribution.[8] Almost all the inventories--over 80 percent
at every economic level--contained ceramics (Table 2).

TABLE 2

Percentage of Inventories Containing Ceramics from Sample of
106 Household Inventories, St. Mary's County, Maryland

	1730-32	1749-51	1761-63
Landless	70%	82%	100%
Landowners	85	83	82
Small slaveowners	100	90	94
£300+	100	100	100

Note: Inventories with over £300 constant 1730 sterling.

TABLE 3

Mean Number of Ceramic Items in Inventories Containing Ceramics
St. Mary's County, Maryland

	1730-32	1749-51	1761-63
Landless	9	6	6
Landowners	13	11	14
Small slaveowners	30	14	22
£300+	45	39	41

Note: Parcels have been converted into items, and inventories
for which quantification was not possible have been
omitted.

TABLE 4

Percentage of Inventories Containing Fine Ceramics or Tea Equipage
St. Mary's County, Maryland

	1730-32	1749-51	1761-63
Landless	6
Landowners	33	45
Small slaveowners	20	17	47
£300+	100	100	100

This comes as no surprise since it confirms what we thought we knew about the importance of ceramics in eighteenth-century households. The real shock is how few ceramic vessels are listed in most homes. In the 1730 to 1732 sample, the average small landowner owned only thirteen ceramic vessels. Even if all of these were dining forms, this would not be enough to set a table. Take, for example, the items listed in the inventory of John Newton, compiled in 1762: one stone jug, six earthen plates, one punch bowl, two drinking glasses, one mug, and one earthen cream pot. While the nine ceramic items listed are less than the average number for a small landowner, they do not fall far short. As mentioned earlier, the average for the period 1730 to 1732 was thirteen. For 1749 to 1751 it was eleven, and for 1761 to 1763 it was fourteen (Table 3).

These figures are undoubtedly slightly low. Difficulties in compensating for underreporting, in converting parcels into numbers of pieces, and in interpreting ambiguous entries such as "chamber pot, three shillings," combine to give the figures a conservative bias. We do not think that this bias is large enough to alter the substance of the interpretation. Our confidence in these figures simply reflects the quality of inventories. While not as detailed as urban appraisals, they are far superior to the listings of rural New England.

One of our main conclusions is that ceramics were of only marginal importance to most small St. Mary's County planters. Not only are the average holdings small, but the individual patterns are erratic. Some individuals owned only vessels for dining, others are listed as having only large dairy wares, while still another group of inventories includes only bottle jugs. Iron and pewter were much more important. Occasionally wooden bowls and trenchers are listed, and vessels of tin and wood could be used in the dairy. While these substitutes for ceramics were available, what is really surprising is how infrequently, except for iron and pewter, they are listed. Some households appear to have had no storage containers for milk. Our ancestors were obviously able to make do with very little.

Except for prosperous slaveholders, there seems to have

been a relatively low correlation between inventory size and
the number of ceramic vessels in a household. In 1750, for
example, the houses of tenant farmers within our sample appear
to have contained an average of six pieces of pottery. This
average rose to only eleven for small landowners, and to four-
teen for small slaveholders. The lists make it clear that the
owners of one or two slaves, or the labor of a couple of inden-
tured servants, generally could not or did not try to imitate the
habits of the gentry. Few spent much on clothing or furniture,
let alone conspicuous consumption.

By the 1760's this had begun to change, but only slightly.
Several factors--increasing expectation, more stores, and the
decline in the price of tea--appear to have combined to bring
fine ceramics into the houses of almost half of the small land-
owners and slaveholders (Table 4). The numbers of pieces
that appear in individual households are very small. Their
addition barely increases the average number of ceramic vessels
per household. While a delft bowl or tea set must have provided
an appreciated spot of color in a drab two-room house, there is no
evidence that the small St. Mary's County planter was aggres-
sively investing in porcelain as a cheap status symbol the way
the Boston mariners were doing during the same period.[9]

Fine ceramics were a significant status symbol to only that
group of individuals whose estates were valued at more than
£300 constant 1730 sterling. Generally such individuals owned
the labor of five or more slaves or servants. The values of
their inventories range from about a third less to twice as much
as John Hicks's estate, valued at £383 at his death in 1753.
In the three samples from 1730 to 1763, the inventories of
almost all of this group contained "Holland ware," china,
stone, or fine earthen. An equally high percentage of these
inventories contained traces of ceramic or metal tea equipage.
This is a high correlation between social symbols and economic
status. What is surprising is that in most cases the parcels
of ceramics were quite small (Table 5). Eleanor Gardner,
whose appraised estate of £832 current money was the largest
included in the sample, owned only seven shillings' worth of
tea ware. Mr. James Waughop, owner of twenty-nine blacks,
a silver-hilted sword, six silver teaspoons, and silver sugar

TABLE 5

Ceramic Forms in Thirty-Six Inventories, 1761-1763
St. Mary's County, Maryland

Function	Form	Material						Line total	Group total
		Earthen	Unsp.	Stone	Delft	China	Unsp. fine		
Dairy/Kitchen									87
	Pots	7						7	
	Butter pots	1	9	5				15	
	Cream pots	2						2	
	Fat pots		2					2	
	Pickle pots		2					2	
	Jars			3				3	
	Pans	3						3	
	Large milk pans	5	5					10	
	Small milk pans	1						1	
	Jugs/Bottle jugs		15	23				38	
	Bottles			4				4	
Dining									57
	Platters		7					7	
	Plates	7		4	12	4		27	
	Dishes	1		1	2	1		5	
	Cups		1					1	
	Mugs	5	4	2				11	
	Pitchers	1	1	3				5	
	Mustard pots					1		1	
Dining/Social									19
	Punch bowls				3		2	5	
	Bowls				7	2	1	10	
	Small bowls		3			1		4	
Social									85
	Teapots				2	2		4	
	Teacups					25	4	29	
	Saucers					27	4	31	
	Cream pots				1	2		3	
	Sugar dishes					2		2	
	Slop bowls					2		2	
	Coffee cups					5	6	11	
	Chocolate cups						3	3	
Hygiene									2
	Chamber pots		1	1				2	
Column totals		33	50	46	27	74	20	250	250

tongs, possessed at his death only a parcel of earthen and
glass worth, with three bottles and a sugar box, a mere eight
shillings. Only one of the nine estates in this category con-
tained parcels of fine ceramics comparable to the sherds from
John Hicks's trash.

In contrast to the possessions of even his peers among the
St. Mary's County gentry, the quantity of John Hicks's ceramics
appears to be quite unusual. By investing in large amounts of
dinner and tea ware, John Hicks betrayed his English and mari-
time background. In England fine ceramics became an important
status symbol twenty years before their comparable impact on
the colonies, and when they did become popular in the 1720s
and 1730s, it was through the influence of men such as Hicks--
mariners, merchants, and great planters--men who looked to
England for social standards. Perhaps the rapid elevation of
Hicks into the southern Maryland political elite was influenced
by his obvious compatibility with elitist values.

In contrast, most small tobacco planters appear to have been
preoccupied with the grim business of making a living and pro-
viding for their children. This obliviousness to the social
values of the elite appears to have carried surprisingly far up
the economic scale. Few of Hicks's peers seem to have in-
vested comparably in the equipage for the tea ceremony. The
rural populace appears to have been much more conservative
than many urban classes that more quickly mimicked their
English brethren.

While John Hicks's collection of ceramics was large, it
would not have seemed luxurious to a great planter or wealthy
merchant. Even in St. Mary's County, Nicholas Lowe and
William Deacon owned more porcelain.[10] While these men
fall outside the sample, their inventories provide a glance
into the homes of the wealthy. William Deacon, for example,
owned a porcelain dinner service for twenty and enough white
salt-glazed stoneware to serve thirty. By owning porcelain
tea wares but not owning a porcelain dinner service, John Hicks
indicated that his status fell short of real wealth.

However useful this analysis, it does not explain all the
questions about John Hicks's sherds. Why had he owned and
broken so many ceramic vessels, particularly so many common

wares? Rhenish stoneware, slipware, and ordinary earthen-
ware appear to be far more heavily represented in Hicks's
trash than in any of the inventories. Did Hicks have a per-
sonal fondness for the colorful wares of the English and German
potters, or was his household poorly run; did he entertain
heavily, or was he actually running a tavern? While this last
possibility seems unlikely, an answer may never be found
to any of these questions, particularly since the records of
the St. Mary's County Court no longer exist. However, as
more sites are excavated, especially those for which good
inventories exist, we will be better able to evaluate the ceramic
trash from John Hicks's first house.

NOTES

1. Ivor Noël Hume, "Excavations at Rosewell in Gloucester County, Virginia, 1957-1959," U.S. National Museum Bulletin No. 225, Contributions from the Museum of History and Technology, Paper 18 (Washington, D.C.: Smithsonian Institution, 1962), p. 172; C. Malcolm Watkins, The Cultural History of Marlborough, Virginia (Washington, D.C.: Smithsonian Institution Press, 1968), pp. 126-28.
2. Peter C. D. Brears, The English Country Pottery (Rutland, Vt.: Charles E. Tuttle, 1971), pp. 87-88, 202-11.
3. Good discussions of earthenware forms are contained in Lura Woodside Watkins, Early New England Potters and Their Wares (1950; reprint ed., Hamden, Conn.: Archon Books, 1968) and Brears, English Country Pottery.
4. Inventories, Hall of Records, Annapolis, Md., 55:27-30 (hereafter MHR).
5. Rodris Roth, "Tea Drinking in 18th-Century America: Its Etiquette and Equipage," U.S. National Museum Bulletin No. 225, Contributions from the Museum of History and Technology, Paper 14 (Washington, D.C.: Smithsonian Institution, 1961), pp. 61-91.
6. Personal communication, Patrick Butler.
7. Inventories, 17:166-67 (Taylor), 51:67-71 (Ingalls), 70:72-82 (Deacon), 91:89-90 (Clocker), MHR.
8. Inventories, 16:44-654, 42:4 through 43.392, 78:84 through 79:235, MHR. All subsequent illustrations are drawn from this sample unless noted otherwise.
9. Garry Wheeler Stone, "Ceramics in Suffolk County, Massachusetts Inventories, 1680-1775," The Conference on Historic Site Archaeology Papers 3 (1968): 86-88; see also Barbara Gorely Teller, "Ceramics in Providence, 1750-1800," Antiques 94, no. 4 (Oct. 1968): 570-77.
10. Inventories, 15:110-19 (Lowe), 70:72-82 (Deacon), MHR.

NOTES TO THE ILLUSTRATIONS

DETAILED descriptions of the sherds in each of the nine illustra-
tions are appended below for the interest and convenience
of the reader. More than a third of the ceramic fragments dis-
cussed in the text are illustrated. All of the sherds are thought
to date from before the middle of the 1740s at about which time
they were buried when John Hicks's first house was leveled.
The date ranges given are the approximate time spans during
which wares of these types were being manufactured and exported
to America. Many of these wares were already old fashioned
by the 1740s, while others remained popular long after that
date. These dates are based almost exclusively on the second-
ary sources listed in the bibliography following the descriptions.
The sherds in figures 3 through 9 were photographed on a one-
inch grid.

* * *

Fig. 1. Fragments of dairy and kitchen vessels. (1) Butter pot,
possibly Buckley, Flintshire, Wales, ware manufactured ca.
1720-75. Earthenware; H. 9 1/4", Diam. (rim) 10". Purplish-
red paste with minute yellow veins. Thick black glaze covers
interior and exterior. Reinforced horizontal rim. (2) Milk pan,
North Devonshire, England, ware manufactured ca. 1680-1760.
Earthenware; H. 4", Diam. (rim) 14 5/8". Pink-to-buff, gravel-
tempered body. Brownish-green glaze covers interior. Heavy
horizontal rim with pronounced internal bulge. (3) Washbasin,
Buckley, Flintshire, Wales, ware manufactured ca. 1720-75.
Earthenware; H. 4 1/4", Diam. (rim) 13". Red paste with
yellow veins. Unglazed exterior. Interior covered with a
clear yellowish lead glaze over a thick yellow slip (the unglazed
fired slip appears white) sprinkled with small brown oxide specks.
Heavy horizontal rim. (4) Baking pan, probably Buckley,
Flintshire, Wales, ware manufactured ca. 1720-75. Earthen-
ware; H. 3 1/8", Diam. (rim) 8 7/8". Red paste with minute
yellow veins. Thick black glaze covers interior. Flat hori-
zontal rim. (5) Milk pan, England. Earthenware; H. 3 1/2",
Diam. (rim) 12 5/8". Cream-colored, gravel-tempered paste.

Unglazed exterior. Interior decorated with dark-brown oxide
specks beneath a clear yellowish lead glaze. Heavy horizontal
rim. Comparison with Burslem wasters in the archaeological
collections of Colonial Williamsburg suggests that this pan
may be a Staffordshire product. (6) Rogers Pottery, milk pan.
Yorktown, Va., ca. 1725-45. Earthenware; H. 2 1/2", Diam.
13 3/4". Light-orange paste with ginger-colored specks.
Interior covered with a clear yellowish lead glaze. Unglazed
exterior. Hemispherical form with rim rolled out and tooled
inward; pouring spout.

Fig. 2. Fragments of storage, cooking, and serving vessels.
(1) Serving pan, possibly Staffordshire, England. Earthenware;
H. 3 3/8", Diam 14". Dark cream paste, poorly wedged with
gravel inclusions, appearing light brown under a lead glaze;
exterior unglazed; interior sprinkled with iron or manganese
creating dark brown spots and runs. (2) Single-handled pan,
possibly Staffordshire, England. Earthenware; H. 4", Diam.
8 3/8". Coarse paste, mottled buff-to-light yellow; exterior
and interior glazed light brown with dark brown spots and runs.
A clumsy, poorly potted piece. (3) Cooking pot, England.
Earthenware; H. 8 3/4", Diam. 9 5/8". Orange paste;
interior and most of exterior covered with brown glaze. Flat-
tened protruding rim above a constricted neck. Two U-shaped
handles attached to rim and top of shoulder; flat base stood
on three legs. (4) Serving pan, England. Earthenware;
H. 2 1/8". Pinkish-buff paste appearing light brown under
the clear yellowish glaze; exterior unglazed; interior decorated
with splashes of yellow (white) slip. Rounded rim with incised
line around inside. (5) Saucepan handle, England. Earthen-
ware. Marbled-buff paste; interior glazed in brown pooling
to dark brown in the potter's rising marks. (6) Bottle neck,
Rhineland. Salt-glazed stoneware. Yellow-buff paste; exterior
glazed light brown; interior a thin purple glaze or slip. Cordon-
ing below rim. (7) Rosette medallion from a bottle, Rhineland,
17th century. Salt-glazed stoneware. Gray paste; pale-brown
exterior; gray interior. (8) Bottle jug. Earthenware. Pink
paste appearing light brown beneath a clear yellowish lead
glaze; unglazed exterior. (9) Bottle jug, Buckley, Flintshire,

Wales, ware manufactured ca. 1720-75. Earthenware; Diam.
(base) 7". Pinkish-buff paste marbled with yellow; grit
tempered; unglazed pink interior; black-glazed exterior.
(10) Bottle jug. Salt-glazed stoneware; Diam. (base) 6 3/8".
Gray paste; exterior glazed over brown slip; interior unglazed
light tan. (11) Bottle jug. Salt-glazed stoneware; Diam. (base)
5 5/8". Tan paste; exterior glazed over thin gray slip; interior
unglazed light brown. Neck and upper part of the body deco-
rated with thin brown wash.

Fig. 3. Fragments of dishes, bowls, and drinking jugs.
(1) Dish, probably Staffordshire, England. Earthenware;
Diam. (rim) 10 1/4". Pinkish-buff paste; interior covered
with clear yellowish lead glaze over marbleized white and red
slips appearing yellow, ginger brown, and dark brown. (2) Dish,
probably Staffordshire, England. Earthenware. Pinkish-buff
paste veined with yellow; interior covered with a clear yellowish
lead glaze with marbleized white and reddish-brown slips
appearing yellow, light brown, and dark brown. Notched rim.
(3) Dish, probably Staffordshire, England. Earthenware. Light-
buff paste; interior clear yellowish lead glaze over yellow slip
(white) decorated with trailed squiggles of dark reddish brown
(red) slip. Notched rim. (4) Dish, probably Staffordshire,
England. Earthenware. Light-yellow paste; interior covered
with a clear yellowish glaze over dark-reddish brown and
yellow (white) slips (yellow slip combed to expose brown
stripes). Notched rim. (5) Dish, probably Staffordshire,
England. Earthenware. Pinkish-buff paste veined with yellow;
interior covered with yellow (white) slip, with ring of black
(dark reddish-brown) slip trailed around the edge. Notched rim.
(6) Dish, probably Staffordshire, England. Earthenware. Pink
paste veined with yellow; interior covered with yellow (white)
slip. Press molded with foliate design with applied leaves in
dark brown (dark reddish-brown) slip. Notched rim. (7) Porringer.
Earthenware; Diam. (rim) approx. 6". Pinkish-orange paste
appearing yellow-brown beneath a clear yellowish lead glaze
on lower part of bowl and mottled green-brown (due to reduction
firing or the use of copper oxide) on upper part of bowl. Exterior
and interior decorated with random spots of yellow (white) slip.

Horizontal handle; graceful everted rim. (8) Bowl or porringer.
Earthenware; Diam. (rim) 6 1/2". Coarse red-tan paste
lightened on the surface with a white wash; appearing dirty
greenish-yellow beneath the clear yellowish glaze; exterior
decorated with curving lines of yellow (white) slip. Slightly
everted rim. (9) Drinking jug, Westerwald, Germany. Gray
salt-glazed stoneware. Vertical neck with V-shaped rim above
cordoning accented with bands of blue; bulbous body; reeded
handle with hole for anchoring a metal cover. (10) Drinking
jug, Rhineland. Gray salt-glazed stoneware. Stamped medal-
lion and incised floral decoration against a blue ground; bul-
bous body. (11) Drinking jug, Rhineland. Gray salt-glazed
stoneware. Stamped medallion accented with blue; bulbous
body. (12) Drinking jug, probably England or Rhineland, late
17th or 18th century. Exterior slip freckled brown to yellow.
Vertical, reeded neck. (13) Drinking jug. Gray salt-glazed
stoneware; Diam. (base) 3 3/4". Exterior colored with a thin
brown slip. Body decorated with incised panels above a cor-
doned base; bulbous body. (14) Drinking jug, Buckley,
Flintshire, Wales, ware manufactured ca. 1720-75. Earthen-
ware; Diam. (base) 4". Red paste, fired almost purple, with
fine striations of yellow. Exterior and interior covered with
thick black glaze. Vertical neck; bulbous body.

Fig. 4. Fragments of cups and mugs. (1) Pint cup, Staffordshire
or Bristol, England, ware manufactured ca. 1700-75. Slip-
ware; H. 3 3/4"; Diam. (rim) 5". Yellow paste covered with
brown (reddish-brown) and yellow (white) slips; yellow slip
combed to expose brown slip beneath; brown dots applied
around the rim. Interior and exterior covered with a clear
yellowish glaze. (2) Cup, Staffordshire or Bristol, England,
ware manufactured ca. 1700-75. Slipware; H. 2 1/2", Diam.
(rim) 2 3/4". Yellow body covered with yellow (white) slip
and decorated with dots of brown (reddish-brown) slip. Inte-
rior and exterior covered with a clear yellowish glaze. (3) Cup,
Staffordshire or Bristol, England, ware manufactured ca. 1700-75.
Slipware; H. 3 1/8", Diam. (rim) 3 1/2". Yellow body covered
with brown (reddish-brown) and yellow (white) slips; combed
decoration. Interior and exterior covered with a clear yellowish

glaze. (4) Pint cup, probably Staffordshire, England, ca.
1680-1750. Earthenware; Diam. (rim) approx. 4 1/2". Light-
buff body covered with streaked brown (manganese) glaze.
(5) Cup, possibly Staffordshire, England, early 18th century.
Salt-glazed stoneware; Diam. (rim) 2 3/8". Gray paste
visible through the thin brown (iron oxide) slip. (6) Cup,
England, probably not Staffordshire. Earthenware; H. 2 3/8",
Diam. (rim) 3 1/8". Light-buff paste covered with a thick
dark-brown glaze containing tiny metallic specks. Unglazed
base was pared after throwing. (7) Mug, possibly Staffordshire,
England, early 18th century. Earthenware; Diam. (base) 4 3/16".
Light-buff paste covered with a rich streaked brown glaze.
Staffordshire produced masses of this type of earthenware, ca.
1680-1750, but virtually identical wares were made at Caughley
and perhaps other potteries. (8) Mug, possibly Staffordshire,
England. Earthenware; Diam. (base) 3 1/8". Light-buff body
covered with a streaked light-brown glaze. (9) Mug, south-
eastern England or possibly New England. Red paste appearing
ginger-brown beneath a clear yellowish glaze; yellow (white)
trailed slip decoration. (10) Mug, England. Earthenware;
Diam. (rim) 2 1/4". Light-buff paste heavily tempered with
fine sand; brilliant thick black glaze. (11) Mug, probably
England. Earthenware; Diam. (base) 4 1/8". Pale-orange
paste covered by a dull brown glaze.

Fig. 5. Fragments of mugs. (1) Mug, Westerwald, Germany,
ca. 1675-1710. Gray salt-glazed stoneware; H. 6", Diam.
4 3/8". Capacity about one quart. Hole in handle near rim
to anchor the bracket of a metal cover. V-sectioned rim, short
and narrow, perhaps to facilitate seating the cover. Applied
sprig frieze around rim and base depicts a dog chasing a deer;
sprigs decorated with alternate daubs of blue and purple.
Cordoning around rim and base accented with single bands of
blue. Central portion decorated with an incised floral design
with a blue background and manganese accents. (2) Mug,
Westerwald, Germany, ware manufactured ca. 1715-75. Gray
salt-glazed stoneware; Diam. (rim) 3 3/4". Capacity about
one quart. V-sectioned rim above narrow zone of cordoning.
Body decorated with stamped medallion of rosettes surrounded

by incised foliate decoration against a blue background.
(3) Mug, Westerwald, Germany. Gray salt-glazed stoneware;
Diam. (rim) 4". V-sectioned rim. Heavy cordoning accented
with two bands of blue; pierced hole in handle to anchor the
bracket of a cover. (4) Mug, Westerwald, Germany, ca.
1675-1710. Gray salt-glazed stoneware; Diam. (rim) 3 3/4".
Capacity about one quart. Short V-sectioned rim. Heavy
cordoning below rim with an applied frieze of pyramids alter-
nately colored with manganese and cobalt. Band of cobalt
below rim and traces of a manganese background for the body
decoration. (5) Mug, Westerwald, Germany, ca. 1675-1725.
Gray salt-glazed stoneware; Diam. (rim) 4". Capacity about
one quart. V-sectioned rim; heavy cordoning below rim
accented with two bands of blue and a narrow, molded flower
motif. (6) Fragments of two mugs, Westerwald, Germany,
ware manufactured ca. 1715-75. Gray salt-glazed stoneware;
H. 3 7/8", Diam. (rim) 3 7/8". Capacity about a half pint.
V-sectioned rim. Narrow zones of cordoning around rim and
base accented with single bands of blue; body decorated with
incised checkered pattern of alternate squares filled with
cobalt and a medallion with initials GR. (7) Mug, Westerwald,
Germany, ware manufactured ca. 1700-60. Gray salt-glazed
stoneware; estimated H. 7", Diam. (rim) 4 1/2". Capacity
about two quarts. High V-sectioned rim above cordoning
accented with two bands of blue. Body decorated with incised
foliate design and a medallion or rosette. Pronounced chat-
tering visible on body. (8) Mug, Rhineland. Brown salt-
glazed stoneware; Diam. (rim) 4". Capacity about one quart.
V-sectioned rim above heavy cordoning. Top of handle attach-
ment has shallow punctations, possibly to anchor the bracket
of a cover. (9) Mug, probably Staffordshire, England, ware
manufactured ca. 1730-60. White salt-glazed stoneware;
Diam. (rim) 3 1/2". Coarse yellow-buff paste covered with a
thin white slip or engobe; thick heavily crazed glaze; brown
iron oxide rim. Overall surface appearance is a dirty yellowish
gray. Flaring foot; incised ring 1 1/8" above base. (10) Mug,
probably Staffordshire, England. White salt-glazed stoneware;
Diam. (rim) 2 1/8". Light-gray paste covered with a thin
white slip; brown iron oxide rim. (11) Mug, probably Staffordshire,

England, ca. 1730-40. White salt-glazed stoneware; Diam.
(base) 2 3/4". White refined paste; thin and finely pitted
glaze. Decorated with rouletting and incised lines. Thrown
and turned. (12) Mug, Staffordshire or possibly Derbyshire
or Yorkshire, England. Brown salt-glazed stoneware; H. 5 1/4".
Diam. (rim) 3 1/8". Gray paste covered with a brown iron-
oxide slip. The sides of the mug were incised with alternate
panels of vertical and wavy lines, after which the top and
bottom were lathe turned and a band of rouletting applied
around the top of the panels. Comparable in form to a white
stoneware mug that Mountford dates to ca. 1740. (13) Jug
or mug. Tin-glazed earthenware; Diam. (base) 3 1/2", (rim)
approx. 5". Decorated with cobalt blue. (14) Mug, probably
late 17th century. Tin-glazed earthenware; Diam. 3 1/2".
Decorated with cobalt blue. (15) Mug. Tin-glazed earthenware.
Cordoned, flaring foot. Decorated in cobalt blue with floral
pattern and band.

Fig. 6. Fragments of plates, platters, and dishes. (1) Plate,
part of a dinner service of British delftware, ca. 1735-50.
Diam. (rim) 8 3/4". Also illustrated from the same dinner
service are (2) fragments from the center of another dinner
plate, (3) sherds from a large platter, and (4) a soup plate.
The decoration closely copies Chinese porcelain. Rims are
edged in reddish brown and painted in blue with designs
combining diaperwork panels with wavelike transitions to
floral sprays. The centers of the plates appear to be filled
with blue floral sprays branching from a central flower, but
the platters have more elaborate designs with rooted vegetation.
The backs of the vessels have crude foliate branches around
the shoulders and circular squiggles in the centers. The
closest parallels to these sherds have traditionally been
assigned to Bristol, but most of the British delftware potteries
produced comparable chinoiserie with delicately hatched floral
designs. The vessel shapes (see Garner, shape D; Ray, shape
F) are copied from Chinese export porcelain of the Yung Chêng
period (1723-35) and later. This shape first made its appear-
ance in English delftware about 1730-35. A similar fragment
has been recovered at Williamsburg from the yard of the

Carter-Moir House. (5) Lobed plate, Holland or England,
ca. 1675-1700. Delftware decorated with Chinese figures
and formal rocky landscapes in two shades of blue. (6) Plate,
probably London, ware manufactured ca. 1710-70. Delftware;
Diam. (rim) 9 1/2". Blue bands of decoration. Plates of
this shape (see Garner, shape B; Ray, shape A) and decoration
are attributed to London, and wasters of this type have been
recovered from near the site of the Fore Street Pottery, Lambeth,
London. (7) Plate, probably Brislington or Bristol, England,
ca. 1710-40. Delftware; Diam. (rim) 8". Blue decoration.
Rim design a repeating pattern of dots, scrolls, bellflowers,
and foliate sprays. A sherd, which may be from the central
panel, suggests that it was filled with floral sprays similar
to those on the exterior of a bowl dated 1726 (see Ray, pl. 71).
If the sherds are from the same plate, the rim and center may
have been painted by two different hands, as appears to be
the case with the 1726 bowl (see Ray, shape E). (8) Plate.
Tin-glazed earthenware with blue decoration. Part of a central
scene including a figure; note the human hand on the sherd.
(9) Shoulder fragment of a plate, England. Delftware decorated
with three blue rings and a stylized Chinese bug in manganese
purple.

Fig. 7. Fragments of bowls. (1) Bowl or porringer, England.
Delftware; Diam. (rim) 5 1/2". Vertical sides, everted rim,
and plain white tin glaze. Comparable to sherds recovered
from a 1763-72 context at Rosewell, Gloucester County,
Virginia. (2) Porringer handle, possibly London. Delftware
with greenish glaze, indented outline, heart-shaped perfora-
tion. (3) Body sherd of large bowl. Tin-glazed earthenware
decorated in blue and two shades of yellow. (4) Large bowl.
Tin-glazed earthenware; Diam. (foot ring) 5". Interior floral
decoration in blue and dark blue. (5) Large bowl, London
or Bristol, England, ware manufactured ca. 1700-60. Delft-
ware with poorly sponged and brushed blue decoration. Two
sherds show what may be the end of a bird's tail. Greenish
glaze. (6) Bowl. Tin-glazed earthenware; Diam. (rim) 5 1/4".
Decoration in two shades of blue very carelessly painted.
Exterior border of scrolls above a row of crosses and another

of possible foliate shapes. Interior with one ring 1/8" below
rim. Greenish glaze. (7) Bowl. Tin-glazed earthenware;
Diam. (rim) 5". Dark blue foliate decoration on exterior.
(8) Bowl. Tin-glazed earthenware; Diam. (foot ring) 2".
Blue rings around base. (9) Bowl. Tin-glazed earthenware;
Diam. (foot ring) 3 1/16". Light-blue rings and band around
base above which are traces of a blue floral design.

Fig. 8. Fragments of tea vessels. (1) Bowl (probably a slop or
waste bowl), possibly Bristol, England, ca. 1720-45. Delft-
ware; Diam 6". Decorated on the interior with a circular
band 1 3/8" below the lip. Part of a tea service of English
delftware decorated in blue with stylized flowers and circular
bands. Also found on the site were fragments of a saucer
(2) and two cups, one of which is (3). The central motif of
the saucer, three rings and a flower, matches that on a saucer
that Ray thinks is "probably Bristol." (4) Teacup. Chinese
porcelain; H. 1 7/8", Diam 2 3/4". Decorated in underglaze
blue with an exterior design of floral bouquets and diaperwork
border and interior decoration of central flower within a circle
and cobalt ring below the lip. (5) Saucer. Chinese porcelain,
heavy foot ring. Matches teacup no. 4. (6) Bowl. Chinese
porcelain; Diam. (rim) 4 1/2". Brown iron-oxide rim and
underglaze blue decoration; exterior two rings below rim,
careless floral design in medium blue outlined with dark blue,
with dark blue band above foot ring; interior two light-blue
bands below rim and two light-blue bands around base.
(7) Bowl. Chinese porcelain, decorated in underglaze blue;
exterior landscape in two shades of blue; on the interior a
ring around side and unidentifiable central design. (8) Spoon
tray. Chinese porcelain; interior decorated in overglaze
enamels; black and gold border outlined with red, beneath
which are traces of an elaborate floral decoration in white, gold,
red, and two other colors that have deteriorated. Exterior
undecorated. (9) Fragments of a saucer and one or two
matching cups. Chinese porcelain, decorated in underglaze
blue with stylized floral designs and bands of diaper- and
scrollwork. Cup interior has blue ring around base. (10) Sugar
dish or posset pot, London or Bristol, England. Delftware

decorated in dark blue. Similar floral decoration is common
on London or Bristol tin-glazed earthenware of the period
1700-30. A closed or covered form is suggested by the un-
decorated interior surface that has throw rings visible.
(11) Rim sherds from three cups. Chinese porcelain, decorated
in underglaze blue. (12) Rim and base sherds from three or
four saucers. Chinese porcelain, decorated in underglaze
blue. (13) Teapot. Delftware, decorated around the rim with
diaperwork and floral panels. (14) Lid sherd from a teapot or
similar form, England, ca. 1730-40. Salt-glazed stoneware,
refined white body, thick slightly pitted glaze. (15) Rim and
body sherds from a teapot, England, ca. 1730-40. Salt-glazed
stoneware, refined white body, thick slightly crazed glaze.
Wheel thrown and turned. (16) Cup and saucer base sherds,
England, after ca. 1730. Salt-glazed stoneware, refined white
body, thin finely pitted glaze. (17) Saucer, England, ca.
1740-80. Salt-glazed stoneware with scratch blue decoration.

Fig. 9. Fragments of miscellaneous vessels. (1) Possibly a
fragment of a holy-water font, Italy. Majolica, molded in
relief and painted in blue, brown, orange, and yellow (?) with
black outlines over a thick white glaze. (2) Bleeding bowl,
England. Delftware; H. 1 5/8", Diam. (rim) 3". White glaze.
Undecorated interior; exterior decorated with blue swags,
crosses, and rings. Indented handle with single heart-shaped
perforation combines elements attributed to both London and
Bristol potteries. (3) Bleeding bowl. Identical to no. 2 except
for glaze which has a dirty grayish cast. (4) Fragments of at
least three ointment pots, England, 18th century. Delftware
with glaze ranging from pink to white to pale blue. (5) Ointment
pot, possibly Staffordshire, England. Earthenware; Diam. (base)
1 1/2". Buff paste, lustrous mottled brown glaze on body;
unglazed base. (6) Ointment pot, England. Earthenware;
H. 1 5/8", Diam. (rim) 1 3/4", (base) 1". Buff paste, dull-
brown glaze. Comparable earthen forms have also been identi-
fied as eggcups, but their similarities to the delft forms
(no. 4) suggest that they were meant to contain salves or
cosmetics. (7) Drug jar. Tin-glazed earthenware; Diam. (rim)
4 1/2". Blue decoration on exterior and interior of rim.

(8) Washbasin, England. Delftware glazed white with a hint of blue. Rim everted. Comparable to a restorable basin (diameter of rim 10 3/8") excavated at Rosewell. (9) Chamber pot, Rhineland, ware manufactured ca. 1710-65. Gray salt-glazed stoneware. Reeded handle attached to flattened everted rim; reeding below rim accented with a blue band.

BIBLIOGRAPHY FOR ILLUSTRATIONS

Brears, Peter C. D. The English Country Pottery. Rutland,
Vt.: Charles E. Tuttle, 1971.

Brears, Peter C. D. "Excavations at Potovens, near Wakefield."
Post-Medieval Archaeology 1 (1967): 3-43.

Davidson, W. F. Grant. "Excavations at Caughley." Transactions
of the English Ceramic Circle 6, pt. 3 (1967): 268-83.

Garner, F. H. English Delftware. London: Faber and Faber, 1948.

Garner, F. H. "Lambeth Earthenware." Transactions of the
English Ceramic Circle 1, no. 4 (1937): 43-66.

Kelso, William M. "Excavation of a Late Seventeenth-Century
Domestic Refuse Pit near Lightfoot in James City County,
Virginia, 1964-1965." Quarterly Bulletin of the Archaeo-
logical Society of Virginia 20, no. 4 (June 1966): 103-14.

Moorhouse, Stephen. "Finds from Basing House, Hampshire
(c. 1540-1645): Part One." Post-Medieval Archaeology 4
(1970): 31-91.

Mountford, Arnold. The Illustrated Guide to Staffordshire Salt-
Glazed Stoneware. New York: Praeger, 1971.

Mundy, R. G. English Delft Pottery. London: Herbert Jenkins,
1928.

Noël Hume, Ivor. "Excavations at Rosewell in Gloucester
County, Virginia, 1957-1959." U.S. National Museum
Bulletin No. 225, Contributions from the Museum of History
and Technology, Paper 18. Washington, D.C.: Smithsonian
Institution, 1962.

Noël Hume, Ivor. A Guide to Artifacts of Colonial America.
New York: Alfred A. Knopf, 1970.

Noël Hume, Ivor. Pottery and Porcelain in Colonial Williamsburg's Archaeological Collections. Williamsburg, Va.: Colonial Williamsburg, 1969.

Noël Hume, Ivor. "Rhenish Gray Stonewares in Colonial America." Antiques 92, no. 3 (Sept. 1967): 349-53.

Rackham, Bernard. Catalogue of the Glaisher Collection of Pottery and Porcelain in the Fitzwilliam Museum, Cambridge. Cambridge: The University Press, 1935.

Ray, Anthony. English Delftware Pottery in the Robert Hall Warren Collection. Boston: Boston Book and Art Shop, 1968.

Roth, Rodris. "Tea Drinking in 18th-Century America: Its Etiquette and Equipage." U.S. National Museum Bulletin No. 225, Contributions from the Museum of History and Technology, Paper 14. Washington, D.C.: Smithsonian Institution, 1961.

Watkins, C. Malcolm. "North Devon Pottery and Its Export to North America in the 17th Century." U.S. National Museum Bulletin No. 225, Contributions from the Museum of History and Technology, Paper 13. Washington, D.C.: Smithsonian Institution, 1960.

Watkins, C. Malcolm, and Noël Hume, Ivor. "The 'Poor Potter' of Yorktown." U.S. National Museum Bulletin No. 249, Contributions from the Museum of History and Technology, Paper 54. Washington, D.C.: Smithsonian Institution, 1967.

Watkins, Lura Woodside. Early New England Potters and Their Wares. 1950. Reprint. Hamden, Conn.: Archon Books, 1968.

Webster, Donald Blake. Decorated Stoneware Pottery of North America. Rutland, Vt.: Charles E. Tuttle, 1971.

Personal communications with Norman F. Barka, Dwight P. Lanmon, Arnold R. Mountford, Audrey Noël Hume, Ivor Noël Hume, and the Reverend Alphonus Smith.

THE CULTURAL SIGNIFICANCE OF SPANISH CERAMICS

Charles H. Fairbanks

POTTERY of various kinds plays an important role in the daily
lives of persons living in the more complex cultures of modern
times. This is perhaps especially true of the Spanish and
Portuguese peoples who settled the southern United States and
Iberian America. Following Roman times, where we find abun-
dant ceramics in many varied styles and manufacturing techniques,
there seems to have been no major new development in ceramics
until the end of medieval times. Perhaps the reconquest of Spain
lent an impetus to the development of many arts and crafts in
the area. At any rate, we find that from the earliest Spanish
settlements in the New World there is a wealth of pottery, much
of it of considerable artistic merit. While it shows many parallels
to and many derivations from other European centers, it has a
character of its own and the potential for providing the student
with insights into the cultures involved. The unique nature of
Spanish ceramics, to me at least, lies in its strong Mediter-
ranean and Moorish elements, especially in the ceramics of the
sixteenth and seventeenth centuries. Unfortunately not much
has been written about New World Spanish ceramics. The late
John M. Goggin published on majolica and on olive jars, while
Mexican tiles have been studied by a number of writers.[1] Most
of the other available studies are concerned with museum speci-
mens, which are of marginal help in assessing the cultural
position of those New World peoples with whom we are concerned
as archaeologists. The important pieces found in museums were
major display objects from their inception, carefully preserved,
and thus available today. The storage jars, plates, and bowls
used in everyday life lasted only a short time, contributed their
sherds to the developing midden, and are the basis of much that
we know today about stylistic change, popularity, and evolution
in usage.

The ceramics to be discussed fall into a number of well-
defined groups. Perhaps the most important, at least for sites
within moderate distances of ports, was the olive jar, commonly
used and then reused as a container for almost everything.
The most elaborate and pleasing was the group of tin-enameled
earthenwares commonly known as majolica. It has been pos-
sible to accurately date a number of styles by archaeological
seriation, and we even have a slight amount of information about
its manufacture in the New World. Next in importance must
surely be yellow or red lead-glazed earthenwares, commonly
found but not yet studied in any detail. Closely related to this
last ware are a number of special-purpose groups, imperfectly
understood. There is some evidence for the presence of Indian-
made, Spanish-influenced ceramics from a number of sites.
Although these bear some general relationship to what Ivor Noël
Hume and Stanley South have called Colono-Indian ware in the
Atlantic seaboard colonies, I believe that we can distinguish
differences that are probably related to the differing cultural
processes at work in the two areas. For the last group of
Iberian wares, I will discuss a type I have named feldspar-
inlaid ware, which seems to have escaped notice until recently.
In connection with these wares and types I will comment on the
Moorish, or Mediterranean, influences that seem to distinguish
them from the often comparable technological forms of more
northern Europe. In discussing Spanish New World ceramics,
we must make some mention of the Oriental porcelain introduced
through the Manila galleons and widely distributed among the
Spanish colonies.

While the large jars usually called olive jars share the
general Mediterranean tradition of ceramic storage and water
jars, they seem to differ considerably in cultural role from
anything similar in the English colonies and probably in the
French settlements as well. Large, small-mouthed jars are
quite typical of most Spanish sites in the New World. They
are less frequently described for sites in the American South-
west, and there is thus a suggestion that they were not
transported far from the ports of entry. On the other hand, they
have been found in small quantities rather far north of Spanish
settlements as at Fort Raleigh and Jamestown, Virginia,[2] where

they probably represent sporadic trade from Spanish areas.
Recently they have been identified in some quantity in southern
England, mostly around major ports. In the New World they
occur as far inland as an Indian village dating from about 1685
to 1716 at Macon, Georgia. This, again, must clearly be the
result of trade with Spanish sources.

I have no good explanation for the Spanish cultural bent for
shipping and storing a wide variety of materials in these small-
mouthed jars. It is true that the basic style is very old in
Mediterranean lands, extending back to middle Neolithic times,
about 5000 B.C. The ceramics of northern Europe, however,
drew heavily on southern sources in Roman, medieval, and
postmedieval times. It may be suggested that while the ceramic
technology diffused northward, the associated behavior patterns
did not because of differing facets of the technology. I am
under the impression that even in early colonial times there
was much more glass in English, and perhaps in French, sites
than in Spanish ones. The Spanish did make glass, often very
pleasing, and sometimes quite abundant. But they preferred to
ship many goods in olive jars and subsequently reused these
containers for a wide variety of purposes. I would like to
suggest that perhaps the relatively scarce timber of the Iberian
Peninsula may have been a factor in the persistence of this
pattern. The more northern European countries with abundant
forests developed, probably in medieval times, a heavy depend-
ence on casks and barrels for storage and shipping. This persisted
well into the Victorian era when the ubiquitous tin can of various
sizes and forms became common. Clearly related to a developing
metal technology, terneplate containers continued in popularity
until the middle of the twentieth century when they were replaced
by throw-away aluminum and plastic containers. It may be
argued that the profusion of olive-jar sherds on Spanish sites
is as great a pollution of the environment as are the windrows
of tin cans, poptops, and plastic cups today. To the antiquarian,
however, they are a treasure trove.

Goggin wrote what remains as the definitive study of Spanish
olive jars and my remarks are based largely on his work.[3]
Wine, olive oil, olives in brine, vinegar, beans, chick-peas,
lard, and tar are mentioned in colonial bills of lading as being

shipped in botijas or botijuelas.[4] Recently most of a middle-
period (1580-1800) type of olive jar was recovered from a
coastal sandbar near St. Augustine, Florida, filled with a waxy
substance that upon analysis proved to be soap, modified
somewhat by several centuries of submersion in warm salt
waters.[5] These sturdy jars were usually reused until broken,
probably not a very long time as ceramics characteristically
require loving care if they are to survive long. The average
life span may have been something like ten years. Probably
the most common use was as water jars in homes or barracks.
Because the unglazed specimens are slightly porous, water
could be cooled by evaporation, a welcome aspect in warm
Spanish colonies without any artificial refrigeration. They
surely also served as general storage jars for corn, flour, and
many other products. A highly distinctive secondary use was
in architecture. The roof vaults of an unknown number of
Spanish churches in the New World are composed of empty
olive jars cemented together to form a light, strong arch. The
Conventual church at Convento de San Francisco, and the Church
of San Nicolas in Ciudad Trujillo, Dominican Republic, are
built in this fashion as well as many others in Puerto Rico and
Cuba. In addition the smaller, slender, pointed forms of late-
style (post-1775) jars were often used in inverted position as
finials on buildings, walls, and gate pillars, where they may be
widely seen in Hispanic America today.[6] Occasionally, espe-
cially in the Southeast, we see sherd disks chipped and ground
to shape from olive jar sherds in Indian sites. These olive
jars, among the most sturdy ceramics, were imported in large
quantities and soon emptied. Thus they would find many
secondary uses. Apparently only the Indians found an occasional
use for the broken pieces.

 As Spanish historians and archaeologists have shown little
interest in either the description or investigation of this form,
we know practically nothing of places of manufacture or such
details as types of kilns that may have been used. Goggin
feels that Andalucia was probably a major source. Certainly
they must have been made in many places if the quantities
shipped are any criterion. It is also probable that they were
made near the olive groves and the ports from which they were
shipped. Cazalla, Cadiz, and Aljarafe are occasionally

coupled with the term <u>botijas de vino</u> in some documents. It
is uncertain whether this refers to the jar or to its contents.
I suspect that such a popular form was also made in the New
World at the numerous Spanish kilns known to have been estab-
lished. Unfortunately only one kiln has been investigated.
This Spanish colonial kiln, located in Panamá la Vieja, could
not be excavated because of problems of ownership and per-
mission. Rather extensive collections of kiln wasters were
collected, and these are remarkably free of olive jar remains.
I think that we must conclude that olive jars were not made
there.[7] There is a report of another kiln near the ancient
fortress of Cartagena, with abundant piles of roof tiles and
olive-jar sherds. Perhaps we should expect olive jars to have
been made in coarseware kilns rather than the more refined kiln
at Panamá la Vieja. The whole subject of colonial ceramic
manufacture requires investigation.

Goggin has established three styles and several types for
these jars found in the New World. The earliest is a globular
jar, nearly spherical, with a short, somewhat flaring neck and
two large strap handles. This is dated in the New World from
1500 to 1580, occurring at the Church of San Nicolas, Convento
de San Francisco, Jacagua, La Vega Vieja, and Juandolio in
the Dominican Republic.[8] Cuban specimens came from Pesquero,
Yaguajay, and El Mango.[9] Jamaican specimens occurred at
Sevilla Nueva and were present at Caparra, Puerto Rico.[10]
A few sherds have been found at Panamá la Vieja and as far
north as Mound Key and Safety Harbor in Florida and Parris
Island, South Carolina.[11]

The early style was thrown on the wheel in the form of two
hemispherical sections, subsequently joined by a slip seam,
which runs vertically around the finished pot. The neck and
paired handles were added later as was a fairly frequent green
glaze on the interior and a white slip on the exterior. The
short neck and slightly flaring mouth were usually closed with
either a cork or wooden stopper, a few of which have been
preserved in underwater sites.

After about 1580 the early style is gradually replaced by a
somewhat different middle style. I am not sure whether this
change represents only a change of styles or whether it may

not also represent different sources of supply from which New
World specimens were drawn. The middle style, lasting until
about 1800, has basically the same paste but differs in shape
and method of manufacture. Goggin has distinguished three
types among the slightly varied shapes, all somewhat elon-
gated in form.[12] The nearly spherical shape of early-style
vessels is lacking. All are thrown on the wheel and show
circumferential throwing marks. Most seem to have been
thrown in a basal part up to the shoulder with a second part
added later. The mouth, resting on an extremely short neck,
is always thickened markedly. Handles are never present.
These differences raise the possibility that middle-style jars
may represent another potting mode and thus another center
of manufacture. I know of no specimens that can be consid-
ered transitional from early style to middle style in body
form, neck, handle, and so on. I suspect that the middle
and closely related late styles may represent a shift of manu-
facturing locale brought about by the increased trade to the
New World beginning in the last quarter of the sixteenth cen-
tury. Marks of various kinds do occur on middle- and to some
extent on late-style specimens. These may be impressed,
incised, or engraved. Some are clearly made before firing,
some as clearly engraved after firing. Most of the marks are
rather stylized monograms, usually on the thickened ring
mouth. The marks engraved after firing are more commonly
names, usually appearing on the shoulder. All these seem to
be owners' marks, perhaps the marks of merchants identifying
their trade goods, rather than potters' marks, although so
little is known about Spanish potting that we cannot be sure.
The engraved names on the shoulders seem to be those of
owners or perhaps of secondary users. Subtype C, a variant
of the middle-style jar, is a smaller form with a very pointed
base, certainly necessitating that it be either placed in a ring
stand, probably of wood, or suspended in a net sling.[13]
Specimens seem to have averaged about twenty-five to thirty
centimeters in diameter, with heights up to sixty centimeters.
Capacity varies according to the shape, but will range as
high as 16.5 liters (about 17.5 quarts).

Middle-style olive jars are more widely distributed than

the earlier form, surely due to the spread of Spanish settle-
ments, increased trade, and the longer span of time involved.
They are quite common in Mexico and Mesoamerica generally
and in the Caribbean and Florida. Northward they have been
found as far as Virginia, usually in very limited numbers. The
American Southwest is not heavily represented, probably due
to its distance from major ports, the fragility of even these
sturdy jars, and the availability in the area of Indian ceramics
of large size.

 After about 1775 the middle style is gradually replaced by
the late style, which persists virtually until the present.
This phase sees the appearance of a new finer paste, almost
without temper, which rapidly and nearly replaces the earlier
sandy paste. Shapes remain about the same with perhaps a
greater incidence of small top-shaped specimens with pointed
bases. There is also a general lack of fire clouding, which
was present in early and middle styles. While this may
simply reflect improvement of kilns and greater use of saggers,
it may also represent a change in area of origin. Goggin has
pointed out that after about 1750 the monopoly on trade with
the New World formerly enjoyed by Seville and Cadiz was
ended by the crown. This resulted in the opening of trade
from ports in northern and eastern Spain. Goggin sees the
early and middle styles as forming part of a single ceramic
tradition, apparently based on paste. He relates the late-
style change in paste to a shift to other pottery centers,
perhaps in northern or eastern Spain.[14] On the basis of shape,
I see the middle and late styles forming part of a single tradition.
The use of saggers in firing, the slight changes in mouth form,
and the fairly definite change in paste characteristics could
well relate to changing technology. Probably the answers can
only be found in excavation of kilns in Spain.

 In summary, we can say that the Spanish olive jar represents
a typical Mediterranean pattern of shipping and storing a wide
range of goods, mostly foods. This tradition goes back to the
ancient Near East and includes many elaborate variations,
such as Greek amphoras. It represents a distribution system
somewhat foreign to northern Europe, especially to England.
These sturdy jars were frequently reused as containers in the
household for water and other supplies and sometimes appeared

as architectural elements, especially as roof vaulting and as
finials. I would see the change in styles as reflecting, first,
the increase of trade with the Spanish Caribbean toward the
end of the sixteenth century, and, second, the loss of mono-
poly by the Andalucian cities of Seville and Cadiz toward the
end of the eighteenth century. The quantities represented in
the New World must indicate a considerable stimulation of the
potting craft in Spain, especially after 1600. More work in
Spain and the New World should refine the broad styles
presently recognized and lead to better dating methods.

The second great class of Spanish ceramics is the group of
tin-enameled forms generally called majolica. This series is
closely related in technique, decoration, and appearance to
the types called faience and delft. They all represent an
attempt to make soft earthenwares less porous, to produce a
surface and decoration closer to Oriental porcelains, and to
generally improve the appearance of tablewares or decorative
forms. The majolica of Italy, the faience of France, and the
delft of Holland and England show many similarities aside
from their basic technological resemblances. Due in part to
the movement of artisans from one country to another, these
similarities are also related to the inherent limitations of the
material and to the common copying of Oriental prototypes.
While the discovery of tin oxide as an opaquing material for
lead glazes first occurred in the ancient Near East as early
as 1000 B.C., it fell into disuse and was not revived or redis-
covered until about A.D. 700 in Persia. During the Moslem
conquests, it spread along the north coast of Africa into Moorish
Spain, then to the island of Majorca, and then to Italy. A
vigorous production of majolica began after 1500 in Italy and
rapidly spread to France.[15] Evidence from New World sites
such as Isabela, founded in 1493, strongly suggest that there
was a vigorous Spanish craft in majolica before it became popular
in Italy or France. The early Spanish types differ in a number
of ways from the Italian- and French-influenced types of the
seventeenth and eighteenth centuries. One type, Isabela
polychrome, has debased Arabic script elements on the marly
and clearly represents the strong Moorish tradition in Spain
during medieval times. Although they are technologically

similar, the tin-enameled wares of Western Europe each
reflect local influences.16

Tin-enamel glaze is a device for rendering the almost clear
lead glaze opaque white. As the bodies of these forms are
low-temperature earthenwares, they are porous, often dark,
and inferior for tableware. The lead glaze sealed the surfaces
and made them more watertight, gave them a better cutting
surface as plates, but did little to provide a background for
painted decoration. Powdered tin oxide was added to the lead-
glaze materials and fired at fairly high temperatures to produce
an even, hard, white surface. Generally painting, most often
in cobalt-blue pigment, was done over the tin enamel before
the glaze firing. Somewhat later an additional clear lead
glaze was added to the surface in another firing to further
harden the ware and produce a more vitreous appearance. I
am under the impression that this rarely occurs in Spanish ex-
amples. In the seventeenth century, a new, much broader,
and more and more brilliant range of colors was achieved by
the use of enamel colors. These were painted on the already
fired tin-enamel ground and subsequently fired again. When
dealing with sherd materials, it is often difficult to determine
precisely what techniques have been used. All majolica
seems to have been fired in saggers to protect the vessels from
fire clouds. This fairly sophisticated technology may have
differed in some details from practices in England where the
manufacture of delft has been studied intensively in recent
excavations.

As far as I know, no Spanish kiln has been excavated.
Only one New World Spanish kiln has so far been investigated
although there must have been many, especially in Puebla,
Mexico. Panamá la Vieja, founded in 1519, served as a
crossroads for Spanish exploration and trade until it was sacked
by Sir Henry Morgan in 1671. Unfortunately complications of
anti-United States agitation, private ownership of the site,
and an especially tense election situation prevented our making
a complete study of the two kilns discovered by H. Morgan
Smith just outside the old city. From kiln wasters we were
able to identify two closely related styles of majolica manu-
factured there as well as to describe the type of kiln and give

some details about kiln furniture (Figs. 6, 7). The kiln was evidently of the updraft type, circular, and about eight feet in diameter. Made of brick, it had four stokeholes and showed evidence of rather long use. I suspect that the kiln production began early in the seventeenth century and continued until 1671.

While this kiln resembles the circular stoneware kilns used in Staffordshire at a somewhat later date, it does not compare with the rectangular muffle kiln recently excavated along with considerable delft near Southwark Cathedral.[17] The kiln furniture, however, seems to have a number of detailed resemblances to comparable English delftware materials. Saggers were of two types. The larger ones, apparently for hollow ware, were cylindrical with large, pointed arches, or pointed ovals, for openings and were covered by flat discs. Three-legged trivets were used to support and separate bowls fired within these saggers; they closely resemble delftware trivets found at Southwark Cathedral and Mark Brown's Wharf in the London area. Saggers for plates were pierced and equipped with triangular sagger pins with expanded heads (Fig. 7C). These pins left the characteristic linear mark on the underside of the marly so often found on sixteenth- and seventeenth-century tin-enameled plates from England, Holland, France, Italy, and Spain.

To find great similarity in kiln furniture between England and the Spanish New World was not too surprising since it is known that potters traveled frequently from one country to another. What was somewhat unexpected was the difference in the kilns. Only more work with American kilns and their Spanish prototypes will clear up the questions raised by this apparent variation. The Panamá la Vieja kiln also produced feldspar-inlaid ware and probably lead-glazed earthenwares as well. I believe the biscuit-fired earthenwares that would normally be considered wasters were locally used, as numbers of sherds of this type were excavated from the nearby ruins of Panamá la Vieja. I strongly suspect, on the basis of the designs on some majolica wasters, that Indian labor was regularly used in this colonial pottery.

The literature of majolica is extensive, although it has little archaeological control.[18] The earliest majolica in the New World comes from Isabela (Hispaniola, Dominican Republic), founded by Columbus on his second voyage in 1493. A group of early wares, distinguished by medieval shapes and thin enameled surfaces represent this early material. Goggin classes them as the medieval tradition[19] and gives them the following type names: Columbia plain, Isabela polychrome, Yayal blue on white, La Vega blue on white, Santo Domingo blue on white. There are also some minor occurrences of as yet unnamed types. All are wheel thrown and differ from later types in having generally unsmoothed throwing marks on at least some specimens. By far the most common type is Columbia plain in the form of plates and moderately sized handleless cups or small bowls. The body is thick, the paste even and rather creamy in color. The thin enamel is thus usually not dead white as the paste color shows through. The entire vessel is covered with enamel, usually white although green does occur. A fairly common variant shows half the plate or bowl dipped in green glaze, seemingly over the white enamel. Broad green bands on a white ground, or rarely large green dots are known. Green touches seem to be early as they are more common at Isabela and Juandolio, Dominican Republic, than at somewhat later sites in the Caribbean and Florida. A distinctive feature, especially in earlier specimens, is the hole-base form in which there is no foot ring. Instead there is a pushed-up circular dimple visible in the interior. The type dates as early as 1493 at Isabela and continues in diminishing amounts until about 1650. That it was manufactured in the Seville area, perhaps in the suburb of Triana, is suggested by a few notations in the Registros de Cargos of the period. In 1590 we find a box of Loza blanca de Sevilla and 200 boxes of Loza blanca de Triana; in 1592 there is a listing of 50 vasos loza blanca de Triana and loza blanca hecho en Sevilla.[20] Whole specimens are also fairly abundant in the Museo Arqueológico Provincial at Seville, and generally lacking in other Spanish museums. This form also appears in the paintings of Velázquez, Zurbarán, and Murillo, all of whom painted in Seville early in the seventeenth century. Examples from Velázquez include An Old Woman Cooking

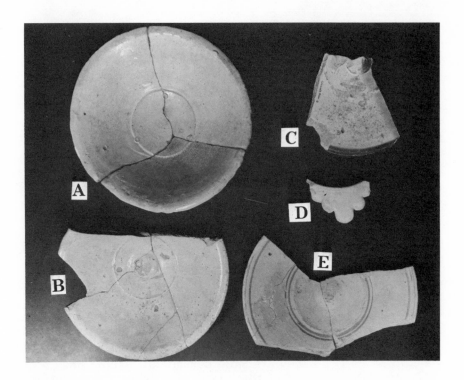

Fig. 1. Spanish majolica types, ca. 1493-1650. A, Hole-based plate, Columbia plain, Fig Springs, Co-1, Columbia County, Florida; B, Hole-based plate, Columbia plain, Convento de San Francisco, Cuidad Trujillo, Dominican Republic; C, Hole-based plate with green lip and broad green line from center to lip, Columbia plain, La Vega Vieja, Dominican Republic; D, Porringer handle, Columbia plain, Nueva Cadiz, Venezuela; E, Hole-based plate, Yayal blue on white, Nueva Cadiz, Venezuela. (Anthropology Laboratory, University of Florida.)

Eggs, Peasants at Table, Two Young Men Dining, The Servant, The Drinkers, and The Triumph of Bacchus.[21]
Two plates have a letter cut through the enamel after firing on the underside. Both are from Isabela while four more from the Convento de San Francisco have similarly cut marks. Represented are an "I," an "A," and several "X" marks. I suspect that these are ownership marks rather than potters' marks. No comparable tile type is known. Specimens come from a number of sites in Santo Domingo, Jamaica, Cuba, Venezuela, rarely in Panama and Mexico, and fairly commonly from early sites in Florida. After about 1650 the Columbia plain type disappears and is replaced by plain white forms showing thinner potting, whiter enamel, and relationships to other decorated types.[22]

Isabela polychrome appears along with Columbia plain at sites dating from the end of the fifteenth to the middle of the sixteenth centuries. The paste is similar to Columbia plain, as is the often rather dull, somewhat creamy or pinkish background. Designs, usually parallel lines on the inside of cups or more complex designs on the marlies of plates, are painted in a rather dull blue and dull maganese purple. On plates a design derived from Arabic calligraphy is found between framing lines. This seems to be a careless form of the Arabic word alafias, which is usually illegible and has become merely a conventional motif. Occasionally a similar design is found in the plate base. The type is of special interest because of its distinctly Moorish character. Some may even have been made in Morocco, although the Seville area is perhaps more likely. Isabela polychrome is not as common nor does it last as long as Columbia plain. Study collections are available from the Dominican Republic, Indian sites in Cuba, Venezuela, Puerto Rico, and Florida.

Yayal blue on white has many similarities of paste and enamel with Columbia plain and Isabela polychrome (Fig. 1). The often dull surface is frequently a purer white than the associated types, and the blue a clear, light-cobalt pigment. Besides plates and small handleless cups, a few specimens, possibly drug jars, of tall cylindrical shape with a tall foot ring are known. The type seems to date from the earliest Spanish settlements, such as Isabela, up to about the early part

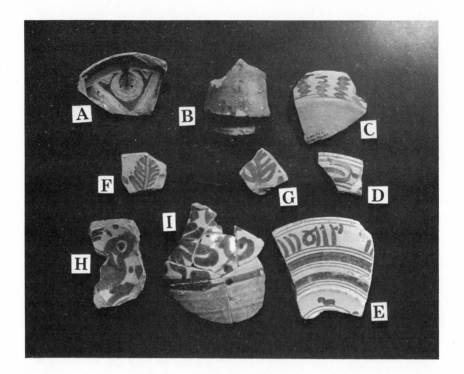

Fig. 2. Spanish majolica types, ca. 1493-1650. A, Cuerda seca majolica, white, blue, orange, green, and brown with unglazed lines, La Caleta, Dominican Republic; B, Drug jar, Caparra blue, Convento de San Francisco, Cuidad Trujillo, Dominican Republic; C, Escudilla or simple bowl, Isabela polychrome, La Vega Vieja, Dominican Republic; D, Plate marly, Isabela polychrome, Juandolio, Dominican Republic; E, Plate marly with alafia design, Isabela polychrome, Isabela, Dominican Republic; F, G, La Vega blue on white, LaVega Vieja, Dominican Republic; H, I, Santo Domingo blue on white, Convento de San Francisco, Dominican Republic. (Anthropology Laboratory, University of Florida.)

of the seventeenth century with a maximum popularity about
1550. It has been found in Santo Domingo, Cuba, Venezuela,
Florida, and South Carolina. Goggin believes it represented
a further simplification of Isabela polychrome since it increases
in frequency as Isabela decreases. It appears in a painting
by Zurbarán, Saint Hugo of Grenoble Visiting the Refectory,
painted in 1633. This may be a record of an heirloom since
most New World specimens are somewhat earlier.

Rather more elaborate is Santo Domingo blue on white,
dating from 1550 to 1630. The design covers the bottom of
plates with a central medallion surrounded by floral elements.
As the marly is usually decorated with parallel framing lines
and a central meander, the whole effect is considerably more
decorative than earlier types. Bowls have a blue dash decoration
on rims as do handles of pitchers. With the appearance of Santo
Domingo blue on white more elaborate decoration begins , at
least as represented by the bulk of sherds in middens. Per-
haps this simply represents greater wealth in the Spanish
colonies as the sixteenth century progressed. Also found in
the first half of the sixteenth century is Caparra blue, which
is seemingly restricted to tall drug jars or albarelos. The
type has a plain white interior and a medium to dark blue
exterior, perhaps sponged.

The love of blue in majolica decoration is supposed to have
derived from earlier Persian prototypes. In Ichtucknee blue
on blue, it is especially evident. Generally better potted and
thinner, this type is covered with an overall light blue ground
on which darker blue designs have been painted (Fig. 3C, D, E).
Plates always show the marks left by triangular sagger pins
on the underside of the marly. The design on the plate interior
consists of a central, usually complex element surrounded by
one or more lines and a decorative, complex band on the marly.
Highly conventional, floral, or animal designs make up the
central unit. The type occurs in Santo Domingo, Venezuela,
Trinidad, Panamá la Vieja, Cuba, a number of sites in Mexico,
Florida, and at Jamestown, Virginia. In Spain the type has been
reported from Barcelona, Málaga, Seville, and other sites.
Goggin believed that it was made in or near Seville.[23] A few
sherds, mostly from the Convento de San Francisco in Santo

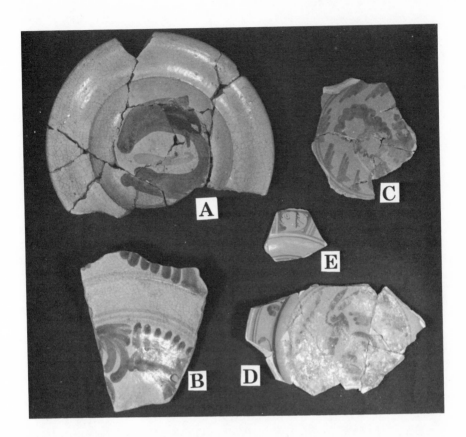

Fig. 3. Majolica types, ca. 1550-1650. A, Fig Springs polychrome, Fig Springs, Co-1, Columbia County, Florida; B, Fig Springs polychrome, Wright's Landing, SJ-3, St. John's County, Florida; C, D, Ichtucknee blue on blue, Convento de San Francisco, Dominican Republic; E, Ichtucknee blue on blue, Malága, Spain. (Anthropology Laboratory, University of Florida.)

Domingo, have the addition of orange or yellow designs. Some of the blue lines on the type are fine, carefully drawn, others are quite bold brush strokes (Fig. 4).

Miscellaneous types belonging to the sixteenth century, known from a few sherds only, are cuerda seca forms in which the design is outlined in wax or grease lines to separate the colors (Fig. 2A). The same technique appears frequently in elaborate polychrome tiles. Very small quantities of Spanish lusterware also accompany these early types. As the luster is often badly decayed in archaeological specimens, I suspect that it may have been slightly more common than our sherd counts indicate.

Tiles of various sorts from the early sites testify to their popularity in Spanish construction. In form they resemble Sevillian types in which the basic design is stamped on the tile outlining depressed areas that are then filled with enamel or glaze.[24] One major style features mainly geometric designs, usually in a fairly bright polychrome palette. While the basic color is usually a blue on white, it is often combined with manganese, green, brown, and yellow. A second form, commonly with deeper impressed lines, is generally decorated by floral designs and deep, rich colors. Many Spanish churches in the Caribbean and Central America still retain spectacular displays of these popular tiles. Flat surfaced, painted tiles also occur in considerable numbers. The cuenca, or stamped and painted tiles, have a very early distribution, being found at Caparra, La Vega Vieja, and at Nueva Cadiz. The flat, painted tiles, often called Pisano tiles, do not seem to have reached the New World until about 1575, after which they are extremely popular.

These early types represent a rather distinctly Spanish constellation of tin-enameled forms. While they are certainly related to the widespread faience and delft groups, as a whole they stand out. In the New World we obviously see the tradition in its later years, in fact almost at the end of its duration. It continued as the dominant style until about 1550, began to decline after 1600, and ended about 1650. While the medieval tradition contains a number of clearly Moorish elements, especially the Arabic-derived marly borders of Isabela polychrome, its major characteristics are medieval rather than Arabic. These

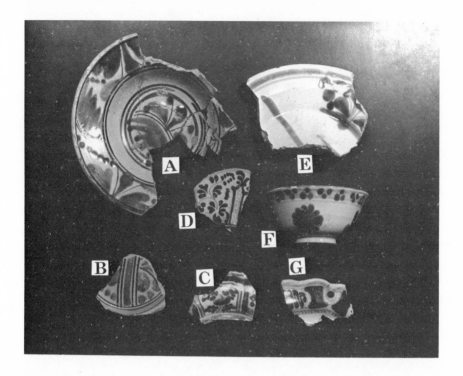

Fig. 4. Majolica types, ca. 1600-1720. A, San Luis polychrome, Zetrouer, A-67, Alachua County, Florida; B, San Luis polychrome, Castillo Fuerza. Habana, Cuba; C, Ichtucknee blue on white, Convento de San Francisco, Dominican Republic; D, Puebla blue on white, Huetjotzingo, Pue-2, Puebla Mexico; E, F, Puebla blue on white, St. Augustine, Florida, Cat. No. B7 L5/ 28; G, Puebla blue on white, Mitla, Oaxaca, Mexico. (A, B, C, D, G, Anthropology Laboratory, University of Florida; E, F, Historic St. Augustine Preservation Board.)

features are the thickness, the hole-based plate, the angled
cups or escudillas, and the overall design plan. I see few
resemblances to British ceramics of the early sixteenth century
as I know it from limited experience. It may be that the white
and green overall color is reflected in English country potting.
But the characteristic tripod pannikin seems totally foreign to
the tradition. I also fail to see any counterpart to the late
medieval pitchers and mugs so common in England. Since the
types of the Spanish medieval tradition, as revealed in the
colonial world, are primarily tablewares, they may not correlate
with English cooking wares in lead glaze. Only Isabela
polychrome displays a blatantly Moorish character.

The tradition is accompanied by very small quantities of
varied lusterware, cuerda seca pottery, and cuenca tiles (Figs.
2, 8). The execution of the types gradually deteriorates during
the later part of the sixteenth century, probably a reflection
of its decreasing popularity. In Spain this has been called
the tradition of ceramica mudejar.[25]

After about 1550, as the medieval tradition waned, the in-
fluence of Chinese blue on white porcelains is seen in the
rise of what Goggin has called the Chinese-Popular tradition.[26]
The first type to appear was Ichtucknee blue on blue, followed
by Ichtucknee blue on white (Fig. 3C, D, E). These may be
more strongly derived from Moorish forms than from Chinese
types. The major characteristics are a change in plate form
to the presence of a foot ring and thin-walled plates with a
nearly horizontal bottom and marly, rather than the sloping
sides of the earlier tradition. The potting is definitely delicate
and fine in comparison with former work. The design layout
also changes to include a central basal medallion with a band
on the marly. All of these traits are found on Chinese porce-
lains, especially the blue on white forms just beginning to be
popular in the West. By at least 1630 these characteristics
appear on types of probable Mexican manufacture such as San
Luis blue on white (Fig. 5C, D), Tallahassee blue on white,
San Luis polychrome, Mt. Royal polychrome, and Aucilla poly-
chrome. These forms maintain the same basic foot ring and
plate features and highly similar design arrangements. The
early colors are blue on white, but green and brown on white

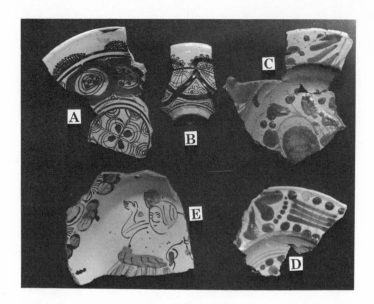

Fig. 5. Majolica types, ca. 1650-1750. A, B, Puebla polychrome, Huetjotzingo, Pue 2, Puebla, Mexico; C, D, San Luis blue on white, Convento de San Francisco, Dominican Republic; E, Aranama polychrome, Caraballeda, Venezuela. (Anthropology Laboratory, University of Florida.)

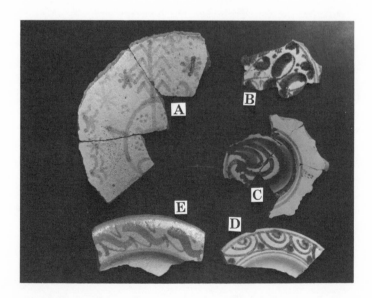

Fig. 6. Majolica, Panamá La Vieja, Panama, ca. 1600-1671. A, Blue on white with design of corn plant; B, C, D, E, Panama polychrome. (Anthropology Laboratory, University of Florida.)

appear in San Luis polychrome; brown, yellow, and blue (San Luis polychrome); or brown (black), yellow, and green (Aucilla polychrome) on white appear. The styles seem to have been very popular, continuing at least to the opening decades of the eighteenth century.[27]

While the tradition clearly owes much to Chinese porcelains, it is recast in a distinctive mold. The presence of brown or black bordering lines and the yellow marly band of Aucilla polychrome are not generally found in Chinese-derived delft in northern Europe. I have the feeling that this tradition owes much to the colonial craftsmen of such places as Puebla, although it is basically an Iberian development. Perhaps it represents a response to New World Indian styles in some way.

A somewhat related tradition, not well represented in our materials, has been called the Italian-Talavera tradition.[28] Vessels include small-mouthed jars of large size and typically footed plates. Decoration is overall, with a central medallion and a fanciful floral surround. The palette is composed of vivid blues, oranges, yellows, purple, and green. In the later and more elaborate pieces, not often represented in our archaeological collections, scenes are derived from contemporary engravings, especially those of Johannes Stradanus. The tradition seems to have been brought to Spain and the potteries at Talavera de la Reina by the same Italian influence and workmen who introduced the Pisano style in tile painting. After 1675 it appears as Abo polychrome, a type probably made in Mexico. After 1800 it declines somewhat in popularity, although the late type, Aranama polychrome, continues into the nineteenth century.

In Mexico, and perhaps in other centers, the Chinese-Popular tradition, as represented by locally made forms such as San Luis blue on white, San Luis polychrome, Tallahassee blue on white, Mt. Royal polychrome and Aucilla polychrome, gives rise to a distinctly Mexican or Puebla tradition. Puebla polychrome, appearing in the last half of the seventeenth century, begins the series with lacy designs in blue and black on a white ground. This was a highly popular and somewhat fragile type, being found throughout the Caribbean, Mesoamerica, and Florida at all Spanish sites occupied during this period. As our archaeological

record is scant for the early eighteenth century, we
cannot define its end with any accuracy. Puebla polychrome
gives rise to a complex series of types (Puray polychrome,
Castillo polychrome, San Augustine blue on white, Puebla
blue on white, and Huejotzingo blue on white) that last into
the nineteenth century. The designs often parallel the influ-
ence of chinoiserie on other European ceramics of the period.
Often figures are partly Chinese, partly European in somewhat
incongrous combinations. Blue remains the predominant color,
although a wide variety of pigments appear. Green and yellow
are more common than red, which is extremely rare. In my
opinion this tradition has more polychrome than comparable
English delft in chinoiserie style. Black lines, either for lacy
designs or as outlining for the blue floral elements and pictorial
designs, are frequent in the early phases but later disappear.
The extraordinary vigor of the Puebla tradition is indicated by
its recurrence in the twentieth century with forms and designs
close to eighteenth-century prototypes. Panama seems to have
shared most of these traditions and styles but locally produced
at least two polychrome types that showed unusual or regional
variations. Kiln wasters at Panamá la Vieja show some unique
designs incorporating blue elements that look like corn plants
and suggest a process of local acculturation (Fig. 6A).

Majolica, then, had a long history in the Spanish New World.
It began early with a medieval element and incorporated Moorish
and Chinese elements. These, however, were usually modified
into somewhat distinctive Spanish forms, especially in the ceramic
center of Puebla and probably also in Panama. Only as we are
able to identify more New World kilns and their wasters will we
be able to precisely define the role of the potters in the New
World. Majolica, whether made in the mother country or in the
colonies, was widely distributed and formed a significant ele-
ment on the tables, in the pharmacies, and in the hospitals of
the colonists. Even at extreme distances it is present in some
quantities. Evidence of the northward penetration of the
Spanish late in the eighteenth century is the recent recovery of
some Spanish majolica from the Nootka Sound area. This dis-
tribution tells us something about the processes of culture in
the Spanish colonial world.

Shortly after the conquest of Mexico a gradual incorporation of Mexican Indian craftsmen into Spanish industry began. Local crafts such as ceramics, weaving, and tanning slowly began to supply some widely used goods imported at great expense. In both Peruvian and Mexican metallurgy native smiths worked under the direction of knowledgeable Spaniards. Gold jewelry incorporated not only some local designs but glass beads as well.[29] Edwin Atlee Barber has shown that the making of pottery and tiles must have begun in Puebla by the end of the sixteenth century.[30] Ordinances for the control of fine, common, and yellow pottery were established in 1653, but Puebla pottery was moving northward to the New Mexico missions as early as 1631.[31] The size of the Puebla industry is indicated not only by the many church facades in and around the city that still show tremendous numbers of tiles but also by the elaborate guild regulations that have been preserved. Other potteries evidently existed at Mexico, Guanajuato, Guadalajara, Oaxaca, Aguascalientes, Atlixco, Pátzcuaro, and Panamá la Vieja. There is evidence of the establishment of a majolica industry in Peru early in the eighteenth century, but it has not been studied in any detail. In all the former Spanish colonies, there is a rich vein of ceramic history to be studied in the future.

The distribution of majolica was rigidly controlled by the fiscal and commercial policies of Spain. As has been indicated, trade with the New World was limited to the southern Andalucian ports of Seville and Cadiz. When the Casa de Contratacion was moved to Cadiz from Seville in 1717, the roles of the two ports were reversed and Cadiz became the busier. This concentration of trade in Seville and Cadiz was supposed to facilitate the collection of royal shares and customs duties by the crown. The effect was to create a monopoly for the merchants of Seville and, to a lesser extent, those of Cadiz. Spanish exports have not been studied in great detail, although some treatment is available. Both majolica and filled olive jars do appear in the few cargo lists available. By the middle of the seventeenth century the flow of Spanish ceramics begins to decrease, to be replaced by a considerably augmented trade in majolica from Puebla and other towns.

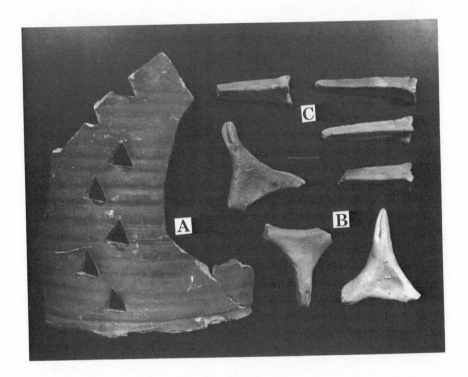

Fig. 7. Kiln furniture, Panamá La Vieja, Panama, ca. 1600-1671. A, Sherd of sagger with triangular holes for pins and large arched opening; B, Three trivets, unglazed earthenware; C, Four sagger pins, unglazed earthenware. (Anthropology Laboratory, University of Florida.)

Some of this went to Peru, where it was often purchased partly
for cash and partly for tin, which was already being mined there.
As tin was the scarce essential ingredient of majolica, this
trade must have been more important than the few available
references indicate. Trade with Venezuela, in exchange for
cacao, also flourished late in the colonial period.[32]

Florida and the American Southwest were also largely supplied
from the Mexican center. Missionaries in Florida were sup-
ported by the king and thus received some part of the annual
situado (allowance). After 1702 the situado was ordered to be
supplied from Puebla.[33] The archaeological evidence suggests
that as early as about 1650 major supplies from that center
were increasingly common in Florida. Supplies to New Mexico
could not travel the relatively easy water route of those to
Florida. As a result we tend to find much less majolica in the
Southwest than in Florida. The missions were provisioned by
means of a wagon train every three years. An excellent study
of this supply system in the seventeenth century indicates
that each supply train was to carry one box of loza de Puebla
for the infirmary.[34] The archaeological evidence supports the
conclusion that majolica originating in both Spain and the New
World was largely a luxury item. Often used in hospitals and
by apothecaries, it was also found as a widespread tableware.
Probably more important in number of pieces were the tiles that
reflect the stylistic changes of the whole group. These decor-
ate the facades of hundreds of colonial churches in the New
World. The major spread was by water-borne trade as is indi-
cated by its abundance in the Caribbean. Away from the ports
it becomes increasingly scarce. But it must be pointed out
that many archaeologists have not been interested in majolica,
or olive jars, and have failed to mention these types in reports.
The rising interest in historical archaeology should do much to
remedy this gap. Culturally, majolica is a luxury item, although
it is found in even the more impoverished sites.

At early Spanish sites in the New World such as those in the
Dominican Republic and at Nueva Cadiz, there is a distinctive
form quite similar to majolica. Goggin has called this the green-
glazed basin. The paste is closer to majolica in texture and
hardness than to other contemporary earthenwares. The flat-

Fig. 8. Majolica tiles, ca. 1550-1700. A, B, Cuenca tiles, colored in polychrome within stamped designs, Convento de San Francisco, Dominican Republic; C, Painted polychrome tile in yellow, green, and black on white, Ixtapalapa, Mexico; D, E, Puebla blue on white tiles, Huetjotzingo, Puebla, Mexico. (Anthropology Laboratory, University of Florida.)

Fig. 9. Spanish ceramic types, ca. 1550-1700. A, Seville honey-colored ware, La Caleta; B, Seville honey-colored ware, Isabela, Dominican Republic; C, Feldspar-inlaid ware, Convento de San Francisco, Dominican Republic; D, E, Feldspar-inlaid ware, Huetjotzingo, Pue-2, Puebla, Mexico. (Anthropology Laboratory, University of Florida.)

bottomed basins are large, often reaching three feet in diameter. Walls are proportionally thick, often reaching an inch or even more. The interior is covered with a rather thick, clear, dark-green glaze, usually having a rather matte surface. This glaze may have dripped down over the thickened rims, but the exterior is not normally glazed. At present in many areas of Hispanic America these forms are called lebrillo, and the name may be rather old. They were used apparently as washbasins. The number is rather surprising since they are quite fragile despite their size. Perhaps the number of sherds reflects their relatively short life as utensils.[35]

Another close relative of majolica is what Goggin has called honey-colored ware, found on the same hole-bottomed plates and the handleless cups known as escudillas (Fig. 9A, B). This form is much like that of the early majolica type, Columbia plain, and the dates seem to be rather comparable. The paste is cream-colored but takes on a honey hue from the nearly clear, brownish, lead glaze. While the paste is usually somewhat harder than Columbia plain, it seems to be very close in paste and form to that type. Lacking any tin-enamel, it sometimes has very simple designs in brown slip under the glaze. This is the only form of slip decoration that I have seen in early Spanish sites. The common early British slip-decorated ware so often made in Staffordshire and other centers seems to be totally absent. Most of our examples date from sites before 1550, and thus the type should tentatively be considered a reliable time marker.

Somewhat later in colonial times, there are several poorly described glazed earthenware forms in Spanish sites. They may be glazed on the interior, totally unglazed, or have a thin whitish slip, perhaps a decayed tin enamel. Forms seem to be handled pitchers or cylindrical jars, usually without handles. Except for the glaze or enamel, these seem to be either influenced by Indian work or perhaps made by Indians influenced by Spaniards. In this respect they resemble the Atlantic seaboard Colono-Indian ware described by Ivor Noël Hume and South.[36] The tall cylindrical jars do not have the composite silhouette of albarelo, or drug jar, so common in majolica. Their whole appearance suggests a strictly utilitarian

form, and some workers have suggested that they may have
occurred mainly as ship furniture. Most examples seem to
date from the early decades of the eighteenth century, and a
number have been recovered from wrecks of the flotas.

Outnumbering majolica and in some sites even olive jars
are numerous sherds of hard red earthenware, mostly in the
form of small cups, small bowls, and _ollas_, or cooking pots.
At Panama la Vieja many were found that seemed to be biscuit
stage from the majolica kiln. Most are completely unglazed,
although on some there may be a clear lead glaze, especially
covering the interiors. Others were slipped with a bright red
iron-oxide wash, sometimes covered with lead glaze. All are
clearly wheel turned and certainly form part of a European
ceramic tradition. They seem to be related to the Rey ware
found by Hale Smith at El Morro in Puerto Rico.[37] These forms
are highly comparable to the usual earthenwares found through-
out Europe at the end of medieval times and cannot yet be
further subdivided without considerable study. That they were
made in the New World is indicated by the presence of kiln
wasters at Panamá la Vieja, and we can presume that they
were made in other ceramic kilns as well.

Occurring widely in small amounts but generally not men-
tioned in the literature is the type I have called feldspar-inlaid
ware. As the name implies, it is characterized by the presence
of inlays of small chips, or tesserae, of white feldspar. These
are set into the surface to form decorative borders or simple
designs. While feldspar chips are the most common, other
minerals are probably represented. From Panamá la Vieja we
have examples of both feldspar and iron pyrites, or fool's gold.
Since we also have kiln wasters from this site we can be sure
the ware was made in Panama. Sherds of this type have also
been found at the Convento de San Francisco, Dominican Republic
(Fig. 9C); at Nueva Cadiz in Venezuela; at Huejotzingo in the
state of Puebla (Fig. 9D, E); Mexico; and from the Portuguese
site of Fort Jesus in Mombasa, Kenya. As late as 1920 fine
examples could be collected in highland Mexico. Especially
elaborate pieces are stamped Recuerdo de Cuernavaca and one
has the Mexican national symbol of eagle and snake in small,
fine, feldspar inlays. The inlaid designs are usually combined

with a wide variety of other decorative techniques not usually
associated with Spanish ceramics. These include incised lines,
stamping, and rouletting with dies much like those used for
elaborate leatherwork. In Mexico black or red paint is often
found on the more elaborate specimens as filling for stamped
outlines. In late examples press-molded raised-relief floral
designs often form a border on saucers or plates. A common
older form at Panamá la Vieja was a tall cylindrical jar with a
separate cover bearing a knop. In later forms a carafe with a
foot ring and a definitely Spanish air was common. Small
pitchers, with matching saucers, were also common and sug-
gest that the form may have been used with chocolate. The
specimens from Panamá la Vieja have a rather rustic flavor, as
do the presumably early specimens from Nueva Cadiz. The
early twentieth-century specimens from Mexico are done with
extreme neatness and clearly represent a major craft effort.
I know of no other ceramic class that combines so many differ-
ent decorative techniques on single pieces.[38] The use of
stamps, rouletting, and pigment is suggestive of Rhenish stone-
ware. Among the stamped designs from the Mexican site at
Huejotzingo is one bearing three nails, an "I," followed by an
"H," and surmounted by a cross. This is surely the common
symbol "IHS" used in colonial times as a signature by the
Jesuits. I have seen no references to this type in the litera-
ture of Spanish ceramics, but suspect that it is an old Iberian
type, perhaps of western Spain, since it is found in at least
one Portuguese site.

This discussion concludes the forms that I can recognize as
being of Spanish manufacture, whether made in the mother
country or in the colonies. Two types rather typical of Spanish
sites remain to mentioned: Oriental porcelains and what Goggin
called Guadalajara polychrome. Oriental porcelain arrived in
the New World through the Manila galleons that plied from the
Philippines westward across the Pacific during most of the
colonial period. Like the flotas from Spain to the New World,
these were usually an annual convoy, arriving in Acapulco
where the cargo of silks, porcelains, and other eastern luxuries
was the main feature of the annual fair. Thence these trade
goods spread throughout the colonies and were even exported

to Spain. Among the materials recovered from the wreckage of
the 1715 flota off Vero Beach, Florida, was a number of Oriental
handleless cups in blue on white, oxblood, and even overglaze
enamels. The cups certainly represent part of a cargo as they
are described as lying in the original packing order, although
the box had long ago been devoured by teredo worms. At the
Higgs site nearby, the camp of Spanish salvors of the wreck
with their Indian workers, large numbers of sherds were recov-
ered. Sherds have been found at most Spanish sites, including
those in the Caribbean, Mexico, Panama, Florida, New Mexico,
and even Drake's Bay, California. The forms date from the
Wan-li period (1573-1620) through K'ang-hsi (1622-1722),
Yung-chêng (1723-35), to Ch'ien-lung (1736-96) reigns.[39]
As in the rest of Europe, the Spanish valued Oriental porcelain
highly. Perhaps the most pretentious example represented
consists of seventeen sherds of one vessel found in a trash pit
near the rectory of the Cathedral of St. Anastasius in Panamá
la Vieja. The sherds represent part of a large vase or perhaps
a wine ewer in the form of a phoenix. The decoration of relief
clouds and featherlike appliquéd strips is highly elaborate and
contrary to most of the style of Chinese export porcelain.
Teacups were not the only forms imported by the Spanish, and
tea very likely not the only beverage used by the rector.[40]

The final type I will discuss has variously been called
Guadalajara polychrome, or Aztec IV pottery, but should properly
be called Tonalá polychrome as the latter town, near Guadalajara,
seems for long to have been the pottery center.[41] In Spanish
times the ware was called bucaro, a term applied by the Spanish
to native earthenwares made of the odoriferous clay called bucaro.
It is a fine unglazed earthenware with a highly polished surface
and buff color. At the beginning of Spanish settlement, or the
end of the purely Indian phase, it was usually slipped in red
with designs in black and white. It became popular in Spain,
reputedly because Spanish ladies fancied that the clay odor of
water stored in it had special benefits for their complexions.
It soon was heavily influenced by Spanish decorative taste with
the resulting floral patterns. Having been recovered in some
quantity from the wreckage of the flotas off the Florida coast,

it was apparently regularly exported to Spain. There are archaeological occurrences of the ware in Spanish sites around the Caribbean and as far north as Darien, Georgia. As the later site was a mission with only priests and a few soldiers, we can presume that it had other desirable traits than the cosmetic ones mentioned. The tradition has remained alive today, especially in Tonalá where it is produced in great quantities. The art form may have reached something of a climax about 1920 with the production of gracefully decorated bottle, tumbler, and saucer sets. Thereafter a decline set in with mass production to meet the rising tourist demand. Decoration was often reduced to mere gaudy bands, although a number of pleasing bird figurines were produced. At present the older earthenware has largely been replaced by much harder earthenware, although it still retains the Spanish Renaissance floral decoration. At their best these floral designs represent a vigorous fusion of the Hispanic and Indian ceramic traditions.

In conclusion, Spanish ceramics shared some technological traits with the rest of the West but retained a characteristic Spanish-Mediterranean-Moorish flavor. The ubiquitous olive jar has no real counterpart in English ceramics. Perhaps more than either the British or French, the Spanish established a vigorous tin-enameled pottery craft in the colonies extending from Mexico to Peru. While some quite plebeian hybrid ceramics appear to parallel the Colono-Indian ware of the North, they also stimulated a vigorous ceramic style in Tonalá polychrome. This may have been the only hybrid ware to be exported to the mother country in any quantity. Much of the vigor of the majolica and Tonalá polychrome work in the Spanish dominions must owe its vitality to the blending of Indian and Spanish traditions. It is in these blended traditions, perhaps, that the distinctive quality of Spanish potters shows most clearly.

172 Charles H. Fairbanks

NOTES

1. John M. Goggin, "Spanish Majolica in the New World;
Types of the Sixteenth to Eighteenth Centuries," Yale University
Publications in Anthropology, no. 72 (1968); Goggin, "The
Spanish Olive Jar, An Introductory Study," Yale University Pub-
lications in Anthropology, no. 62 (1960).
2. J. C. Harrington, "Archaeological Explorations at Fort
Raleigh National Historic Site," North Carolina Historical Review
26, no. 2 (1949): 148.
3. Goggin, "Spanish Olive Jar."
4. Eduardo Arcila-Farias, Economia Colonial de Venezuela
(Mexico: Fondo de Cultura Económica, 1946), p. 68; Arcila-
Farias, Comercio entre Venezuela y Mexico en los Siglos XVI
y XVII (Mexico: Colegio de Mexico, 1950), p. 99.
5. Specimen at Historic St. Augustine Preservation Board,
St. Augustine, Florida.
6. Goggin, "Spanish Olive Jar," pp. 6-7.
7. George Ashley Long, "Archaeological Investigations at
Panamá Vieja" (M.A. thesis, University of Florida, 1967).
8. Goggin, "Spanish Olive Jar," pp. 9-30.
9. Irving Rouse, "Archaeology of the Maniabon Hills,"
Yale University Publications in Anthropology, no. 26 (1942).
10. Adolfo de Hostos, Las Excavaciones de Caparra (San
Juan, P.R.: Oficina del Historiador, 1938), pp. 5-113.
11. Goggin, "Spanish Olive Jar," p. 11.
12. Goggin, "Spanish Olive Jar," pp. 11-17.
13. Both types of suspension have been found in recent times.
14. Goggin, "Spanish Olive Jar," p. 31.
15. Diana Imber, Collecting Delft (London: Arco Publications,
1968), pp. 11-32.
16. Goggin, "Spanish Majolica."
17. Example at City Museum and Art Gallery, Stoke on Trent,
Staffordshire, England; Graham Dawson, "Two Delftware Kilns
at Montague Close, Southwark, Part 1," The London Archae-
ologist 1, no. 10 (Spring 1971): 228-31.
18. Goggin, "Spanish Majolica"; David H. Snow, "The
Chronological Position of Mexican Majolica in the Southwest,"
El Palacio 72, no.1 (1965): 25-35.
19. Goggin, "Spanish Majolica," pp. 207-8.
20. Archivo General de las Indias, Seville, Spain.

Contratacion, 1091: Ship, Santa Catalina; Master, Rodrigo Maders. 1099: Ship, N.S. de la Asunción; Master, Gaspar de Rojas. Ship, N.S. del Rosario, Master, Luis de Herrera.
 21. Walter Gensel, Velázquez (Stuttgart and Berlin: Deutsche Verlags-Anstalt, 1913), pls. 4, 6, 7, 53.
 22. Goggin, "Spanish Majolica," p.144.
 23. Goggin, "Spanish Majolica," pp. 135-41.
 24. Goggin, "Spanish Majolica," pp. 144-46.
 25. Luis M. Llubia Munne and Miguel Lopez Guzman, La Cerámica Murciana Decorada (Murcia, Spain: Sucesores de Nogues, ·1951).
 26. Goggin, "Spanish Majolica," p. 208.
 27. Snow, "Chronological Position of Mexican Majolica."
 28. Goggin, "Spanish Majolica," pp. 208-9.
 29. Miguel Mujica-Gallo, The Gold of Peru: Masterpieces of Goldsmiths' Work of Pre-Incan and Incan Time and the Colonial Period, trans. Roger Pension-Bird (Recklinghausen, West Germany: Bongers, 1959).
 30. Barber, The Majolica of Mexico (Philadelphia: Pennsylvania Museum and School of Industrial Art, 1908).
 31. Snow, "Chronological Position of Mexican Majolica."
 32. Goggin, "Spanish Majolica," pp. 215-16.
 33. Andres Gonzalez de Barcia Carballido y Zuniga, Barcia's Chronological History of the Continent of Florida, trans. Anthony Kerrigan (Gainesville: University of Florida Press, 1951), p. 349.
 34. France V. Scholes, "The Supply Service of the New Mexico Missions in the Seventeenth Century," New Mexico Historical Review 5 (1930): 93-115, 186-210, 386-404.
 35. Goggin, "Spanish Majolica," p. 201.
 36. Henry Alexander Baker, "Archaeological Excavations at Panamá la Vieja, 1968" (M.A. thesis, University of Florida, 1968), pp. 21-30.
 37. Baker, "Archaeological Excavations," pp. 38-40.
 38. Charles H. Fairbanks, "A Feldspar-Inlaid Ceramic Type from Spanish Colonial Sites," American Antiquity 31, no. 3 (1966): 430-32.
 39. Kamer Aga-Oglu, "Late Ming and Early Ch'ing Porcelain from Archaeological Sites in Florida," The Florida Anthropologist 8, no. 4 (1955): 90-110.
 40. Baker, "Archaeological Excavations," pp. 31-33.

41. May N. Diaz, <u>Tonalá: Conservatism, Responsibility, and Authority in a Mexican Town</u> (Berkeley: University of California Press, 1966), pp. 138ff.

COLONIAL LOUISBOURG AND ITS
DEVELOPING CERAMICS COLLECTION

John Lunn

FEW archaeological sites in the world can compare with the eighteenth-century French Fortress of Louisbourg, in Cape Breton, Nova Scotia. A fortified town of some seventy acres, it is unusually interesting for many reasons, not least of which was the hostility of its environment, which caused virtually everything to be imported, and its brief existence during a singularly important period of colonial history. Before 1713, when the first French settlers were brought from the last French settlements of Newfoundland, Louisbourg harbor had been used for two hundred years as a summer fish-drying location by English fishermen. After 1768, when the British garrison was moved to Boston, a protectionist policy discouraged substantial colonization of the coal-rich island of Cape Breton, and as a result the site was pillaged, but in other respects remained essentially undisturbed for almost another two hundred years. Exactly dated sites are rare enough, but a site with half a century's life-span that was a large military and civil complex, with very little to confuse the archaeologist from earlier or later periods, is quite exceptional.

The excavations that form an essential part of the massive restoration program begun in 1961 by the federal government of Canada have consequently produced many hundreds of thousands of significant, though fragmentary, artifacts, the great bulk of which are ceramic. Their potential importance to North American ceramicists is considerable, but unfortunately restoration priorities and a small staff have, to date, limited the amount of research time available for their study. The Fortress of Louisbourg National Historic Park has as yet but one full-time artifact

researcher, and while John Dunton has for some time been
working on a major report on Louisbourg's faience,[1] this
research is of less immediate concern to the restoration
program than his forthcoming study of structural hardware.

Louisbourg's ceramic holdings are therefore more
important for the potential they offer than for the profundity
of conclusions that may be drawn at this time. Ceramicists
wishing to visit Louisbourg and work with its collection are
consequently urged to do so, for few sites offer an equivalent
opportunity.

To the best of our knowledge all Louisbourg's ceramic
wares were imported. Indeed, with the exception of fish
and some timber, virtually everything else--all the ceramics,
glass and metal objects, furniture, cloth, tobacco, wines,
and food--came from Europe, New France, New England,
the West Indies, or from what was left of the French colony
of Acadia. Throughout its fifty-five years of intensive
development and occupation, Louisbourg's ceramics, then,
appear to be unencumbered by wares of local manufacture.
No wasters have been found in the excavations.

The rich variety of Louisbourg's important material is
further accented by shifting cultural patterns, for the town's
brief history was highlighted by the impact of international
conflict. Louis XV spent a fortune in the twenty-five years
it took to build the fortress, with the result that by 1740
Louisbourg had become so impressive that New England took
its potential dangers very seriously. As a result, an army
of New England volunteers, supported by a British naval
squadron, placed the fortress under siege in 1745. With its
capture and the repatriation to France of its residents and
their most valued possessions, Louisbourg became a British
fortress and Boston the main supply port for a massive
reconstruction and redevelopment program. Four years later
a political trade-off returned a strengthened fortress to its
original builders, but in 1758 France lost Louisbourg again,
for the last time, when Wolfe played a prominent part in its
siege and capture. British influence remained substantial
until, in 1768, the garrison was moved to Halifax, and a
decaying fortress town was left to an impoverished and
diminishing population.

The variety of cultural influences thus suggested by
Louisbourg's kaleidoscopic history has not yet been the
subject of specific study, but material from datable
contexts reflects known shifts in the cultural pattern. The
conservatism of French kitchen and commercial wares is
evident throughout the period. Even Louisbourg's faience
reflects this conservatism, for common designs, popularized
by the larger factories, are repeated long after their
introduction by both large and small manufacturers (Fig. 1).

Any review of the ceramic holdings of Louisbourg must
start with coarse earthenwares, by far the most commonly
represented ceramic artifacts (Figs. 2, 3). Curiously,
from a sample check of our inventories, the converse is the
case. These records of the possessions of deceased
persons, made immediately after death for succession
purposes, were in the main compiled under stringent
conditions, since settlement of the deceased's outstanding
debts in the community frequently depended upon the sale
of inventoried effects. Rooms and often complete buildings
were often formally sealed until full inventories could be
made; in those rooms that had to remain open for use by
surviving members of a family quick preliminary lists were
made for verification in due course. Inventories must
today be used with caution because when one of the
partners of a marriage died, often only those possessions
held in common by the couple were subject to inventory.
Many other technical variations exist in the character of a
number of the surviving inventories. Furthermore, few
inventories exist, or perhaps few were made, for deceased
residents at the foot of the social ladder.

One might expect that the ubiquity of coarse earthenware
in Louisbourg's artifactual holdings would be reflected in
the inventories, but, as has been remarked, a sampling
made of four basic social categories--officials, both
civilian and military; merchants; tradesmen or artisans; and
fishermen, normally the least wealthy of Louisbourg's
property owners--fails to support this expectation.

Some inventories of the less wealthy fail, indeed, to
mention ceramics at all, but this is not altogether surprising

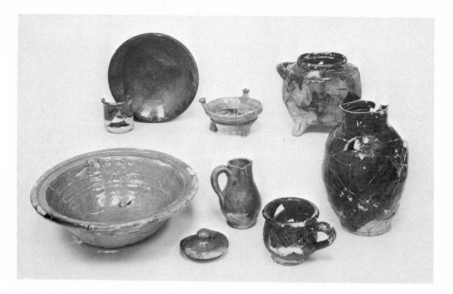

Fig. 1. Kitchen wares, France, 1720-55. Green-glazed coarse earthenware; H. (left-handed pitcher) 5 1/4". The shapes found in this ubiquitous ware seem endless, but the bowl at lower left is very common. Some pieces are given a light-colored slip before glazing, such as the bowl and left-handed pitcher. (Fortress of Louisbourg, Canadian Department of Indian Affairs and Northern Development.)

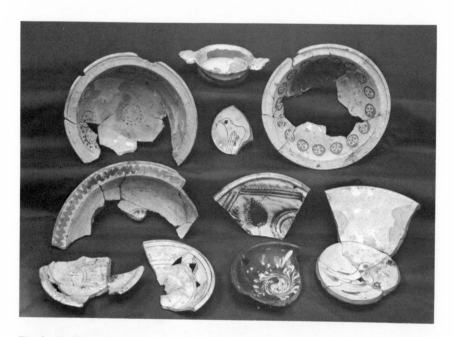

Fig. 2. Kitchen wares, France and other areas, 1720-55. Painted and slipped coarse earthenware; Diam. (bowl at upper right) 11". Upper left and right, slip decoration in a style typical of La Chapelle des Pots, Saintonge; center left, painted decoration, perhaps Saintonge; bottom, right of center, swirled slip decoration cautiously compared to West Indian wares. Those with sgraffito animals resemble some Swiss or Italian pieces; attributions for the remainder are uncertain. (Fortress of Louisbourg, Canadian Department of Indian Affairs and Northern Development.)

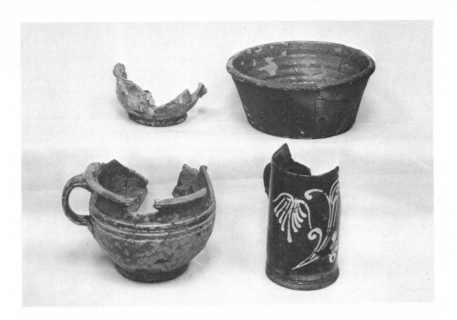

Fig. 3. Household vessels, New England, ca. 1740-55. H. (mug) 6 1/2". These vessels share a number of characteristics which suggest that they are of New England origin. (Fortress of Louisbourg, Canadian Department of Indian Affairs and Northern Development.)

Fig. 4. Tablewares, France and Holland, ca. 1720-55. Faience with blue decoration; Diam. (bowl, bottom left) 9 1/2". The large dish at upper left is probably Dutch; next are a plate in the style of the Le Roy factory, Marseilles, and a Dutch or Flemish plate of common quality. The very large bowl has a red body and a dark brown bottom. The fluted bowl is in the style of Rouen, and the cylindrical vessel resembles common wares of Nevers. (Fortress of Louisbourg, Canadian Department of Indian Affairs and Northern Development.)

since the poorest residents could survive with only an iron
cooking pot, supplemented, if they could afford it, by
plates, dishes, mugs, and spoons of pewter. Since pewter
was more frequently recorded by gross weight than by piece,
often no mention is found of ceramics but merely a record of
a number of pounds of pewter.

At the other end of the social scale porcelain, faience,
and pewter are present in almost equal quantities, while
amongst merchants and artisans pewter and faience dominate
the kitchen inventories (Figs. 4, 5). Coarse earthenwares
are rarely mentioned, and then only in statistically insignifi-
cant quantities.

For example, the inventory of Commandant Duquesnel,
acting governor of Isle Royale (Cape Breton) in the early
1740s, was, at 22,610 livres, some four times as valuable
as any other for which we have record. He left enormous
quantities of porcelain, three-quarters blue, the remainder
gold, including coffee and tea services, butter dishes,
salad bowls, and no less than 348 porcelain plates. His
faience holdings were even more impressive, including
coffee and tea services; wine buckets; tureens; fruit,
mustard, and serving dishes; sauce boats; porringers;
chamber pots; and 346 assorted plates. His pewter alone
weighed over 250 pounds. Only two references to coarse
earthenware have been located in the Duquesnel inventory--a
porringer and eight tureens--and no reference to any other
ceramic wares at all.

Alternatively, Jean-Baptiste Decouagne, an engineer who
died at Louisbourg in 1740, left an estate from which
approximately 950 livres was realized. His possessions
included thirty-one pounds of pewter; three saucers, a fruit
dish, mustard dish, pepperbox, and two goblets of porcelain;
twenty-three faience plates; and a stoneware pot. François
Chevalier, a navigator lost at sea in 1732, left an estate
valued at 413 livres, which included forty-eight pewter
plates and two salad bowls, a plate, and a shaving bowl of
faience. Coarse earthenwares are mentioned in neither the
Decouagne nor the Chevalier inventory, but then other
possessions that might be expected are also sometimes

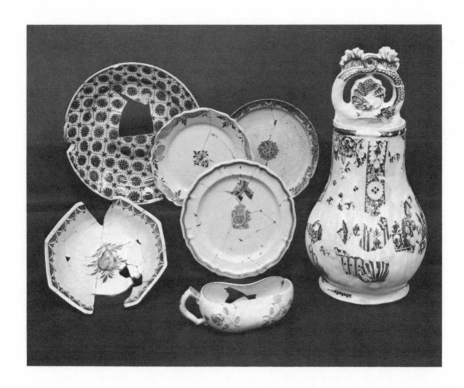

Fig. 5. Household Vessels, France and Holland, ca. 1720-55. Faience, mostly with blue decoration; H. (wall cistern) 19 1/4". The dish and plate at the back of the group are Dutch or Flemish, and the plate between them is in a style of La Rochelle. The armorial plate, probably from the south of France, is from a service of the third governor of Louisbourg. The bourdalou, with overglaze polychrome decoration, probably came from Sceaux, while the octagonal bowl and the wall cistern are in the style of Rouen. (Fortress of Louisbourg, Canadian Department of Indian Affairs and Northern Development.)

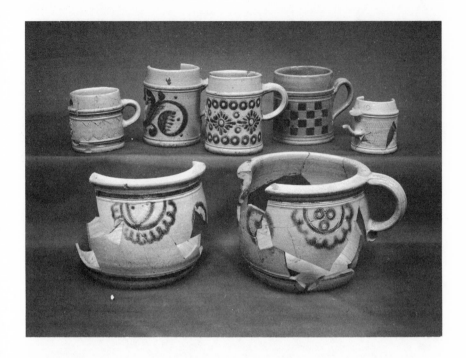

Fig 6. Household vessels, Westerwald, Germany, ca. 1720-55. Salt-glazed gray
stoneware with cobalt-blue decoration; H. (center mug) 4 1/2". The decoration
of mugs was varied. The right-hand example bears a capacity mark and next to it
is a crude piece which might have been made in the Middle Atlantic colonies, since its
form, decoration, material, and firing are distinct from Westerwald although clearly
attempting to emulate it. The chamber pots have the shape and material so familiar
at British colonial sites, but the decoration, though prevalent at Louisbourg, is not
common elsewhere. (Fortress of Louisbourg, Canadian Department of Indian Affairs
and Northern Development.)

absent. Clearly the subject deserves detailed study, but
a few lines of inquiry might be suggested here. Was coarse
earthenware so inexpensive at Louisbourg when new and so
valueless once used as to have been deemed unworthy of
inventory? Was there some local custom that eliminated
some items from assessment? Or was the term faience
sometimes used to describe any ceramic holdings other
than porcelain, as appears to be the case with salt-glazed
wares and perhaps stonewares?

The disparity between archaeological discovery and the
listings of inventories may be approached from another
direction. Coarse earthenware was inexpensive, and
therefore less likely to have been cared for, or repaired,
than most other wares. Its ubiquity may therefore be a
false clue, since much more of the coarse earthenware may
have been thrown out than the finer wares. In addition, the
French may have taken most of their faience, porcelain, and
other ceramics with them when they were repatriated in 1745
and 1758, leaving behind the wares they considered valueless.

At all events, green-glazed bowls by the hundreds were
at Louisbourg throughout its history, making--as John Dunton
has remarked--every kitchen look just like its neighbor.
Except for Whieldon and Wedgwood's finer ceramics, the
English seem to have abandoned green glazes during the
eighteenth century, but the French seem never to have tired
of them. To lighten the color, many pieces were given a
white slip coat under the glaze. Bodies were commonly a
light red, though grayish-white was not uncommon.

Yellow- or green-glazed slip and scratch-decorated
vessels are also numerous at Louisbourg and in seemingly
endless variety. Some appear to be of Swiss or perhaps
Italian origin, and further study may reveal some affiliation
with West Indian wares. Little New England coarse earthen-
ware appeared at Louisbourg before the mid-1730s, but, as
may be expected, substantial quantities were brought in
between 1745 and 1748, and after 1758. English slipwares
are also well represented after 1745, along with a smattering
of other English earthenwares. These, and most other
non-French coarsewares, probably reached Louisbourg via
New England, as did so many other commodities.

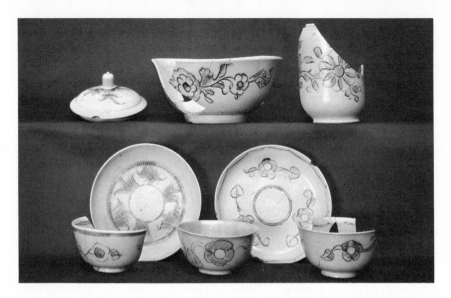

Fig. 7. Tablewares, England, 1740-70. Scratch-blue white salt-glazed stoneware; Diam. (saucer on left) 4 1/2". The decoration is typical of pieces found at Louisbourg. (Fortress of Louisbourg, Canadian Department of Indian Affairs and Northern Development.)

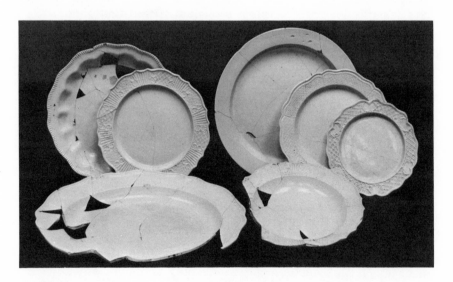

Fig. 8. Molded tablewares, England, 1740-70. White salt-glazed stoneware; Diam. (smallest plate) 7 1/4". These represent the usual types seen at Louisbourg, but fragments of a number of unusual pieces have also been found. (Fortress of Louisbourg, Canadian Department of Indian Affairs and Northern Development.)

Both inventories and archaeological findings suggest
that faience was proportionately more significant at
Louisbourg than elsewhere in New France. The existence of
local potteries in the St. Lawrence Valley, sustained by the
area's larger population, may well provide a reason, and
these could have reduced what would otherwise have been a
dominant import, as it was at Louisbourg. Faience was in
widespread use here, indeed it appears that if Louisbourg's
households had any wares at all, most inventories record
them as of faience.

Dunton, in his excellent introduction to the faience at
Louisbourg, has stressed the variety and number of simpler
forms. This is not to say that fine pieces were not used at
Louisbourg, but simply that they were the exception. The
majority are common dishes and plates in simple Rouen,
Moustiers, or Nevers styles, with Rouen perhaps dominant,
particularly in the red-bodied cooking forms with tin-glazed
interiors and manganese-glazed exteriors. In addition to
French faience, Flemish or Dutch pieces appear occasionally,
as does English delftware.

Stonewares are of course common but receive even less
attention in inventories than coarse earthenwares, raising
the possibility that white salt-glaze stoneware predominates,
and probably reached Louisbourg via New England, although
the quantities exported from England to France raises the
possibility of its reexportation from France to Louisbourg.
Much arrived during the 1745 to 1748 occupation, so that
quantitatively it is more strongly represented than Westerwald,
which has been found in considerable quantity, some, after
1745, with English ciphers (Figs, 6, 7, 8).

French stonewares are less commonly found than either
English or German (Fig. 9). They share with French
coarsewares a conservatism that will make their future
study challenging. Their materials, workmanship, and
decoration in the 1720s are barely distinguishable from
those of a hundred years earlier, and throughout Louisbourg's
existence their marked resistance to change forms a kind of
sluggish undercurrent to the changing styles of other wares.
As a group, the French stonewares of Louisbourg are chiefly

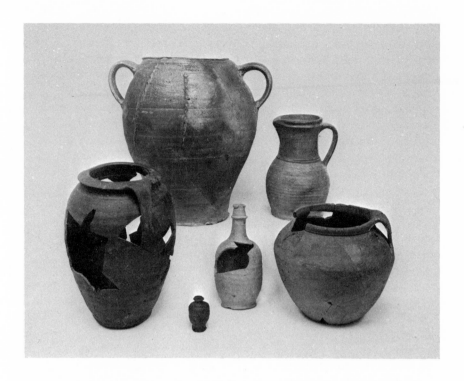

Fig. 9. Commercial and household vessels, France, 1720-55. Glazed and unglazed coarse stoneware; H. (pitcher) 8 3/4", (largest jar) 14 3/16". This group shows the variety of shapes and finishes seen in this ware. Often unglazed, and varying from almost black to light gray and brown, the ware is far from homogeneous and little is yet known of its origins. (Fortress of Louisbourg, Canadian Department of Indian Affairs and Northern Development.)

notable for their variety of shape and lack of glaze. If any wares were made in the Louisbourg area it would likely be these, because although no firm evidence exists for their manufacture, clays found ten miles away, on the Mira River, and experimentally fired recently, exhibit body characteristics closely similar to some French stoneware fragments found in our excavations.

We have also found fragments of a ware much like Westerwald gray stoneware, but more clumsily potted and decorated and with a significantly different body. That these may well have emanated from the Middle Atlantic colonies and from Perth Amboy in the 1750s has been suggested.

Creamware and pearlware are in small supply, because their ascendency coincides with Louisbourg's decline (Fig. 10). Evidence that the remnant population of Louisbourg must have retained some purchasing power, however slight, in the last years of the eighteenth century is suggested by a fragment of a creamware pitcher, commemorating Lord Rodney's naval victory off Cape St. Vincent in 1780 (Fig. 11).

As has been noted, French porcelain occupies a prominent place in certain of our inventories, but it is poorly represented in our archaeological holdings. Chinese porcelain, though in short supply during Louisbourg's earlier years, was on the other hand a common ware in England and her colonies and therefore appears after 1745 in some quantity (Figs. 12, 13). English porcelain is also present in late contexts (Figs. 14, 15).

In general terms, Louisbourg's most important contribution may well prove to be the variety of its common wares--pieces that can rarely be studied in quantity in Europe simply because their original cost was so low that their owners would have paid little attention to their preservation or repair. In Britain, a considerable body of information has been collated on such wares, but such is far from the case in France, perhaps because so much French material of outstanding quality exists that it has, to date, monopolized the attention of scholars in that country.

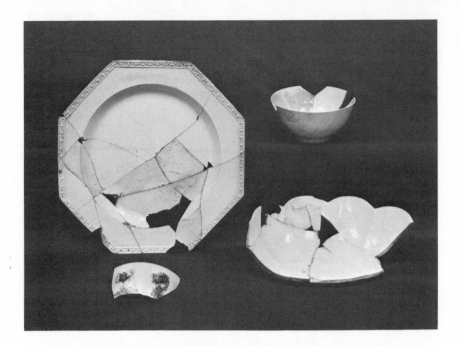

Fig. 10. Tablewares, England, 1760-1825. Creamware; Diam. (plate) 9 1/2". Most, if not all, creamware at Louisbourg arrived during the late 1760s or even later. No notable pieces survive, reflecting the declining prosperity and population of the town. (Fortress of Louisbourg, Canadian Department of Indian Affairs and Northern Development.)

Fig. 11. Fragment of pitcher, England, 1780. Creamware; H. 2 1/8". This pitcher commemorated Lord Rodney's naval victory off Cape St. Vincent in 1780. The background is an orange brown, the figure white on a green base, and the flag blue. (Fortress of Louisbourg, Canadian Department of Indian Affairs and Northern Development.)

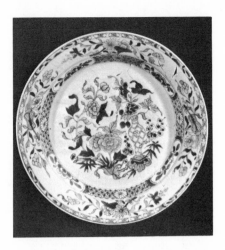

Fig. 12. Plate, China, ca. 1750. Hard-paste porcelain; Diam. 8 3/4". (Fortress of Louisbourg, Canadian Department of Indian Affairs and Northern Development.)

Fig. 13. Plate, China, ca. 1750. Hard-paste porcelain; Diam. 12" (Fortress of Louisbourg, Canadian Department of Indian Affairs and Northern Development.)

Fig. 14. Saucer with Plymouth mark, England, ca. 1760. Soft-paste porcelain; Diam. 5 3/8". Body analysis for this piece suggests Bow or Lowestoft. (Fortress of Louisbourg, Canadian Department of Indian Affairs and Northern Development.)

Fig. 15. Plymouth mark on saucer shown in figure 16. Soft-paste porcelain. England, ca. 1760. (Fortress of Louisbourg, Canadian Department of Indian Affairs and Northern Development.)

It is therefore of the highest importance that Louisbourg's common wares receive detailed study. As Dunton has remarked: "If we are concerned with aesthetics or artistic achievement, we must know the full scale with which we measure aesthetic value; and equally, if we study technical perfection and its advance, we must know the humble sources which gave it birth. . . . Similarly, if the social historian is to draw a realistic portrait of the past, he cannot neglect a thing simply because it cannot claim refinement or other high status."[2] For Louisbourg is, in the ultimate analysis, an attempt to provide the people of Canada with a vital, indeed a living, experience of their past. In this context nothing can be overlooked, and it is hoped that in our future analyses of everything that formed a part of everyday life in Louisbourg in the first half of the eighteenth century a major by-product will be reports illuminating those wares so often overlooked today.

NOTES

1. John V. N. Dunton, "French Ceramics of the 18th Century Found in New France," Cahiers de la Céramique du Verre et des Arts du Feu, no. 48-49 (1971): 12-25.
2. Dunton, "French Ceramics in New France," p. 15.

CERAMICS USED IN AMERICA: COMPARISONS

C. Malcolm Watkins

AS pointed out by Charles Fairbanks and John Lunn, we are
not an island and the ceramics of North America partake of
far more than simply English traditions sprinkled with a few
other North European ingredients. Fairbanks began with the
distinction all of us ought to make in the study of ceramics--
that museum specimens, intended to be preserved from the time
they were made, are only of marginal help in assessing the
cultural position of New World peoples, while, to use his words,
"storage jars, plates, and bowls used in everyday life . . . are
the basis of much that we know today about stylistic change,
popularity, and evolution in usage." I say amen to that.

In reviewing John Goggin's classification of olive jars
into three chronological groups, Fairbanks pointed out that
little is known about the origins of the olive jar and that much
further work is needed in Spanish kiln sites. He stated that
the olive jar represents a Mediterranean tradition extending back
to the Neolithic Near East and that the Spanish preference for
using pottery vessels for transport suggests a cultural distinction
from France and England, where wood and glass containers were
more common.

Fairbanks noted that olive jars were used and reused for many
other purposes than for their ostensible one of containing olives.
The most interesting of these is architectural use in the construc-
tion of walls and vaulted roofs, a classic Mediterranean practice.
He commented on the distribution of olive jars throughout the
Caribbean and Mesoamerica, noting also that they have been
found in the south of England and as far north in America as
Jamestown. He concludes that the contacts with English sites
represent "sporadic trade from Spanish areas." He also states that
the jars represent a "distribution system somewhat foreign to
northern Europe especially England."

I would like to address myself to these statements for a moment. The occurrence of olive jars in non-Spanish areas, particularly English ones, is very frequent and seemingly ubiquitous. In the Smithsonian collections we have olive jars, or sherds thereof, from several places in Virginia. One that was excavated in Charleston was brought to our attention a few years ago. We also have evidence of the presence of olive jars from the Eastern Shore of Maryland and from Nantucket and Newburyport, Massachusetts. From Lunn's evidence we know that olive jars found their way to Fortress Louisbourg. James Deetz has found them in and around Plymouth, Massachusetts. We have a whole one that survived above ground in Newbury, Massachusetts, and I know of other such survivals in New England, including one that descended in the Farrar family in Lincoln, Massachusetts. Both the Farrar jar and the Newbury one were described by their owners as "money jugs," a designation used by New England old-timers. I had always supposed on this account that they were used like the French peasant's sock, but the recovery of a whole cargo of olive jars from a Spanish shipwreck by Mendel Peterson of the Smithsonian, in which one jar alone held a deposit of coins hidden in a filling of pitch, suggests that money may have been transported secure and undetected in this manner and that the term "money jug" might have originated with this usage. In any case, it is clear that Englishmen found the jars useful and that they were adopted in a limited way into our culture. We have also at the Smithsonian an olive jar found in Holland, and I can point to one illustrated in an otherwise very decent book on German folk pottery that is identified as--of course--German! In London the Guildhall Museum has a large variety excavated from within the old City, and I am sure that there is ample evidence to illustrate further the wide distribution of olive jars in northern Europe and British North America.

I think a different explanation has to be given to such distribution than sporadic trade from Spanish areas. I believe it was more than sporadic, that it was a regular thing, and that it was carried on primarily in English ships. English trade laws would have limited the importation of olive jars in the English colonies to English ships, even if we allow for more than occasional illicit colonial contacts by foreign vessels. I think, too, that although

as Fairbanks says, "the olive jar represents a distribution system
somewhat foreign to northern Europe, especially England," it was
adopted by the English and used both for transport and secondary
utilitarian purposes.

The best concrete evidence I can offer to support these ideas
appears in the British Port Book records, where there are numer-
ous listings of both imports and exports of "Portugal oyle." For
example, on January 2, 1682, the ship Concord arrived in Plymouth,
England, from Lisbon bearing "640 jars Portugal oyle."[1] Several
years earlier in 1678, the Nicholas sailed from Plymouth to Jamaica,
carrying "200 jarrs with 1 ton of oyle" assigned to one merchant,
and "400 jars of oyle" to another. In the same year "40 jars oyle"
went from Plymouth to Virginia.[2] There are many references to oil
jars going to Virginia in 1683, some of them described as "6 gallon
jars of oyle" and others as "1 gallon jars of oyle."[3] It is, of
course, the latter size that concerned Goggin and Fairbanks, but
larger-sized standing jars with wide mouths occur archaeologically
as well.

Not only have individual jars survived in the former English
colonies, they were also sometimes recorded in seventeenth-century
New England account books and inventories. In 1659 Samuel Ward
bought from the Salem merchant George Corwin (1610-83) "1 jar oyle,"
as did Christopher Hilliard.[4] In 1669 Edmond Downes, a Boston
merchant, died, leaving in his warehouse "18 small jarrs of Sallet
Oyle," each worth 5s. 4d.[5] Very likely a "small jar" meant the
one-gallon sort we have been discussing.

It would seem from all this that the English were picking up
whole cargoes of jars filled with olive oil, certainly at Lisbon,
and perhaps at other Iberian ports, and shipping them first to
England, as with all foreign imports, then transshipping them to
America. Without disputing what is well proved, it seems probable
that for the purposes of English shipping, the olive jars were
used primarily for transporting olive oil, rather than olives. By
bringing in Portugal, I am perhaps being unfair to Fairbanks, who
was talking about Spanish ceramics. But this opens up questions
of where the Portuguese jars were made and how one tells the
difference, if any, between the Portuguese and Spanish oil jars.
It also reminds us that the British had better trade relations with
Portugal than with Spain and that many of these jars may have

been deposited by Spanish ships in Lisbon and picked up by English ones.

For many of us, Fairbanks's section on majolica opens our eyes to a whole new spectrum of ceramic history. It dramatizes the fact that Spanish majolica was coming to America with Spanish people, notably Diego Columbus at Isabela, Santo Domingo, as early as 1493, 114 years before the first Englishman ever set foot in Jamestown and barely a year after Christopher Columbus's first landing.

Most remarkable was the introduction of majolica manufacture into the New World, first at Puebla in the late sixteenth century and then to such places as Guanajuato, Guadalajara, and Oaxaca, in Mexico, and in the meanwhile to Peru. The distribution of Spanish wares again extended further than the confines of Spanish areas. Fairbanks says that they have been found as far distant as Nootka Sound in the Pacific, and I can add to this the English colonies. At Jamestown, I would note, there are several sherds of Spanish majolica and a comparatively large amount of Lisbon majolica. New England inventories include several references to Lisbon ware and some to Spanish ware, and in 1659 George Corwin sold "Lisburne ware" in his store in Salem, Massachusetts.[6] English postmedieval archaeological collections also include both Spanish and Portuguese majolica. Again, we may safely assume that most of these wares went to England first, then to America.

Fairbanks's discussion and illustration of redware demonstrates well the great difference between those of Spain and Mexico and those of England and the English colonies. Shapes, decorations, and styles are distinct and contrasting.

Lunn's discussion of ceramics found at Fortress Louisbourg also underlines the presence of a distinctive culture on the boundaries of the British colonies. The archaeological discoveries at Fort Michilimackinac, so well evaluated by Jefferson Miller and Lyle Stone,[7] and the remarkable Tunica treasure from Mississippi now being analyzed at Harvard have, with the rich finds at Fortress Louisbourg, given us a new picture of eighteenth-century French faience and utilitarian earthenwares of types that have seldom survived in other contexts. As in the case of the Spanish wares that contrast so notably with the Anglo-American and imported

English wares, these French pottery types provide us with a
perspective on our own culture.

Unlike Fairbanks, who is concerned with the taxonomy,
distribution, and origins of Spanish and Hispanic American ceramics
Lunn is confined to a single dated site and a massive quantity
of ceramics found within it. From his narrative of the history of
Fortress Louisbourg, we have seen how it shifted between French
and English control, with much of the ceramics emanating from
New England. A considerable part of the ceramic evidence reflects
the impact of New England on Fortress Louisbourg rather than
the influence of French-Canadian culture as a whole. Lunn, in
the same spirit as Fairbanks, has stressed the importance of the
common wares.

It is unnecessary to comment on the well-known types of
Staffordshire salt glaze and creamware that demonstrate the vigor
of English trade and entrepreneurship in eighteenth-century
Staffordshire. Almost as productive were the potters of the
German Westerwald whose gray and blue salt-glazed stonewares
were distributed all over England and the English colonies in
America from the beginning to the end of the colonial era. Lunn
suggests that one of the stoneware mugs in his slide may have
been made in New England because the mug is potted more crudely
than the rest. I would respectfully question his criteria until
there is new evidence of colonial stoneware manufacture in New
England. As yet we have no material evidences whatsoever.
Although the Westerwald potters in Germany were probably
unsurpassed as masters of their craft, every pottery there and
in most other places in the world had uneven quality of production;
they all had apprentices who were learners making inferior pots,
and they always produced a few pieces where the body texture
was altered by uncontrollable conditions in certain parts of the
kiln. Such pieces were discarded if they were too bad but others
could pass as seconds, and what better place to dispose of seconds
than some colonial outpost across the Atlantic? I suspect that
this mug may be of that sort.

As to the supposedly New England redware shown by Lunn, I
might take exception to the slip-decorated mug, whose decoration
seems foreign in style to New England. However, there is still
a great deal to be learned through the investigation of New England

kiln sites and through collating seventeenth- and eighteenth-
century archaeological evidence of ceramics occurring in New
England occupancy sites so as to establish types, origins, and
distribution. The great value of the Fortress Louisbourg ceramic
material is its potential relationship to such research and its
ability to enlarge upon it.

The French faience shows, just as at Fort Michilimackinac,
the degree of elegance that was manifested in frontier situations.
I only wish that we could have been shown more of the common
French earthenwares to which we need much greater exposure.

Both of these papers have increased our awareness and our
breadth of vision, and they should make better ceramic historians
of us all.

NOTES

1. "Plymouth, Inwards, 1682." Port Book Records, E190/
1047/13, British Colonial Office (hereafter British Port Book
Records).

2. "Plymouth, Outward, 1667/8." E190/1038/8, British
Port Book Records.

3. British Port Book Records; Plymouth Port Book Records.

4. Captain George Corwin, Ledger; ms. C832, v.1, Essex
Institute, Salem, Mass. (hereafter Corwin Ledger).

5. Suffolk County Court Record Books (Massachusetts Bay
Colony), microfilm, Smithsonian Library, Washington, D.C.

6. Corwin Ledger.

7. J. Jefferson Miller II and Lyle M. Stone, Eighteenth-
Century Ceramics from Fort Michilimackinac: A Study in
Historical Archaeology, Smithsonian Studies in History and
Technology, no. 4 (Washington, D.C.: Smithsonian Institution,
1970).

STAFFORDSHIRE SALT-GLAZED STONEWARE

Arnold R. Mountford

THE northern part of the county of Staffordshire situated in the middle of England has for centuries been renowned for the manufacture of ceramics. Today the city of Stoke on Trent, with its vast industry, thrives as a conglomerate of six townships where the skills of potting, handed down from father to son, testify to the continuance of a long tradition. Ubiquitous bottle-shaped kilns, clay pits, marl holes, sherd heaps, and coal-mine wastes dominate a landscape born out of the industrial revolution.

Easily accessible deposits of clay, marl, coal, lead, iron, and copper in north Staffordshire coupled with an adequate water supply presented an ideal opportunity for exploiting the abundant natural resources of the area while inherent skills and a healthy proclivity for experiment ultimately established the six pottery townships as The Potteries.

The evolution and growth of this famous ceramic center can best be assessed from the seventeenth century onward when the written word supersedes conjecture. Hitherto, an occasional reference in a manor court roll, an indenture or conveyance, gave passing reference to a potter or to a potwork, but from the 1660s certain activities in Staffordshire were being noted in greater detail. Perhaps the best-known account is that found in Dr. Robert Plot's The Natural History of Staffordshire, published in 1686, describing the manufacture of pottery as then practiced in Burslem, the most ancient of the townships.[1] Incidentally, Plot appears to have been the first person to describe a kiln of the period using the term oven, "which is ordinarily above 8 foot high, and about 6 foot wide, of a round copped forme." He has much to say regarding the clays in use for the production of slipware and tells us, "for making their severall sorts of pots, they have as many different sorts of Clay, which they dig round about the Towne, all within half a miles distance." The excellence of

these iron-bearing clays was also known and appreciated outside
The Potteries, not least by the London potter John Dwight, whose
notebook for the year 1691 includes a recipe using "Staffordshire
red Cley."[2] The sales of clay and more particularly the vending
of pots brought Staffordshire men to the metropolis, and it is my
belief that these commercial links between north Staffordshire
and London, 150 miles to the southeast, were directly responsible
for what we should today describe as a successful piece of
industrial espionage.

Legend has it that the technique of salt glazing originated in
a village a few miles to the northeast of the six townships, but
the circumstances attached to this supposed discovery have long
ago been discounted. It has also been claimed that the two
Dutch brothers, John and David Elers, famous for their red stone-
ware, brought the secret to north Staffordshire, but no less a
person than the celebrated potter Enoch Wood, who inspected
the remains of the Elers' kiln, wrote in 1814, "Report says,
Salt glaze ware was made first at Bradwell about the year 1700,
I have seen the foundations of the oven near the west end of the
barn about 20 years since and believe it was built to fire Red
China only."[3] This opinion was supported by a John Mountford,
who demolished the remains of the Elers' oven about 1802, when
he stated "the height was about seven feet, but not like the salt
glaze ovens."[4] The final denunciation can be found in the History
of the Staffordshire Potteries, first published by Simeon Shaw in
1829.

> The Oven itself had five mouths, but neither holes over
> the inside flues or bags, to receive the salt, had any
> been used by them; nor scaffold on which the person
> might stand to throw it in. . . . E. Wood, and J. Riley,
> Esqrs., both separately measured the inside diameter
> of the remains, at about five feet; while other ovens,
> of the same date, in Burslem, were ten or twelve
> feet. . . . We may also mention, that the Salt glazed
> Pottery of that time, was comparatively cheap; and
> the oven, being fired only once each week, required
> to be large, to hold a quantity sufficient to cover
> the contingent expenses. Hence we find the ovens

were large, and high, and had holes in the dome, to receive the salt cast in to effect the glazing.[5]

To discover why the Elers brothers were once credited with the introduction of salt glazing into Staffordshire it is necessary to return to our London potter, John Dwight, who in 1671 had been granted sole use of a patent for fourteen years to manufacture various types of salt-glazed stoneware and redware.. Before the term had expired, he made application in 1684 for an extension of his patent rights to continue for a second period of fourteen years, which was also granted. No doubt John Dwight considered his monopoly inviolate, but this was not to be. Before the second patent had expired, John and David Elers had left Fulham (London) and set up a factory adjacent to the source of the red clay at Bradwell, Staffordshire. Ignoring the patents and risking the consequences, several potters in Staffordshire and Nottingham openly began to manufacture brown stoneware coated with salt glaze. Dwight, on learning that his rights were being infringed, started to collect evidence in support of a series of actions against the offenders, and lawsuits instituted in the court of chancery dragged on from 1693 to 1697. In the first case on June 20, 1693, the Elers brothers were accused of having "for several years past in a private and secret manner made and sold great quantities of earthenware in imitation but far inferior to them . . . the said counterfeits are sold at an under price."[6] On December 15, 1693, permission was granted to attach the names of three more potters to the charge as Dwight widened his search. This trio was the Wedgwood brothers: Thomas (1655-1717), Aaron (1666-1743), and Richard (1668-1718) of Burslem, and it was most likely through these three master potters that the techniques of salt glazing, as perfected by John Dwight, were brought to Staffordshire, the Elers limiting their plagiarism to redwares.

But the story of Dwight and his drawn-out lawsuits is not yet complete. A recently discovered unpublished bill of complaint, dated December 4, 1697, was taken out against three more Staffordshire potters, Cornelius Hamersley, Moses Middleton,

and Joshua Astbury. The charges make fascinating reading,
Dwight claiming that:

> By often intrudeing themselves unknown into
> yr Oratr workhouses to inspect his furnaces and
> wayes of Manufacturing haveing learnt how to
> counterfeit the Said manufactures thereupon they
> the Said Confederates . . . without any lysense
> or authority from yr Oratr have or hath for Severall
> yeares last past in a private and Secrett manner
> made & Sould very great quantities of Earthen
> Wares in immitation and resemblance and counter-
> feiting of the Said new manufactures So invented
> made and Sould by yr Oratr.[7]

The only answer to this charge seems to have come from
Cornelius Hamersley in January 1698, where in an affidavit
he denied:

> He hath often made any Earthen Ware with a
> designe to imitate the complaynants or that he makes
> any other ware than what properly belongs to the
> potters trade but Saith that there hath been a trade
> of potters at Burslem in Staffordshire and at severall
> other townes there about where this defendant lives
> for the memory of man where the potters were never
> confined to any mode or fashion for the makeing of
> their Earthen ware but each potter did from tyme to
> tyme vary and alter the same as he thought good
> And as hee found best pleased his customers.[8]

Alas, the outcome of this particular litigation is unknown but
regardless of the result, Dwight's second patent expired in
1698, which meant that the potters of Staffordshire could con-
tinue to manufacture their salt-glazed stonewares but now
without the fear of court proceedings for infringement.
 Geographically the six townships comprising The Potteries
were ideally situated for supplying the major towns of Great
Britain with earthenwares, and better placed than any other

ceramic center for manufacturing salt-glazed stonewares. The neighboring county of Cheshire had the richest deposits of salt in England, and once the Staffordshire potters had mastered the new techniques of glazing during the last quarter of the seventeenth century a regular trade was established between the two counties.

Utilizing the abundant supplies of locally occurring iron-bearing clays, the north Staffordshire craftsmen produced brown salt-glazed stoneware in which the tankard, mug, and cup predominated (Fig. 1). Indeed, during the early period nothing but hollow ware appears to have been made, the vessels being either completely or partially covered with a ferruginous wash. For this process it should be remembered that there were ample supplies of iron in the immediate neighborhood.

The higher oven temperatures required for firing salt-glazed stonewares not only necessitated changes in the size and shape of the potter's kiln, and the saggars in which the wares were packed, but also in the preparation of the ceramic body where sand was added to the clay as a reinforcement. These and other alterations towards perfection came about only after endless experiment, and it was through these early endeavors that one of the most successful branches of English ceramic art was eventually to flourish.

During recent archaeological excavations in Stoke on Trent, a number of brown salt-glazed stoneware tavern tankards made about the year 1710 were discovered in association with mottled ware and iron-glazed ware. Finds also included tankards that had been partially covered with an exterior freckled ferruginous wash overlying a white pipe-clay slip and squat mugs that had been white-dipped over a darker-colored Staffordshire clay.

What inspired the Staffordshire potter to experiment towards a whiter ceramic body, apart from purely commercial consideration, is not certain. It may have been an attempt to emulate porcelain, following in the steps of Dwight; or, possibly, the influence of Lambeth delft. Whatever the reason, the natural progression during his search for a whiter product must first have involved the utilization of the local lighter-colored firing clays and then the dipping of these, in the leather-hard state, into a white pipe-clay slip. The next innovation was the

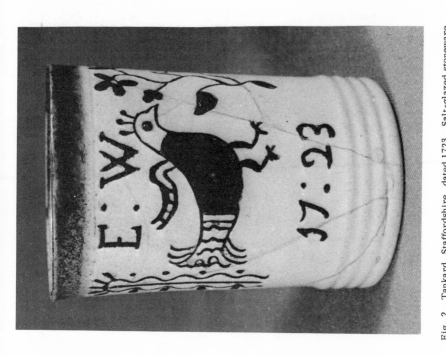

Fig. 2. Tankard, Staffordshire, dated 1723. Salt-glazed stoneware with sgraffito decoration; H. 5 1/4". (City Museum and Art Gallery, Stoke on Trent.)

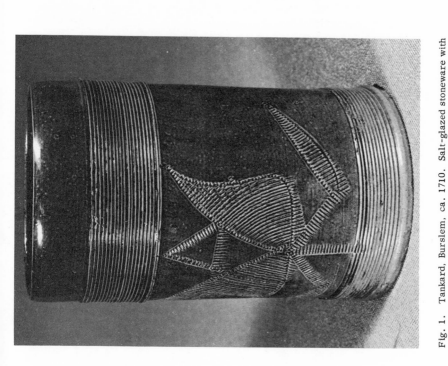

Fig. 1. Tankard, Burslem, ca. 1710. Salt-glazed stoneware with impressed crown and "AR" to left of incised tulip decoration; H. 6 3/4". (City Museum and Art Gallery, Stoke on Trent.)

introduction of calcined flint into the glaze to effect an ever whiter finish.

While north Staffordshire was rich in iron-bearing clays, there were few deposits of the white variety in that area. In the southwest of England, however, in the counties of Devon and Dorset, there were ample supplies of white tobacco-pipe clays that began to be imported into The Potteries about the year 1720.

The price of this clay, coupled with the costs of transport, would obviously have made the importations extremely expensive, and in the early days few potters could have afforded to do more than dip their wares into a white-clay slip. One of the most important specimens of the white-dipped variety, dated 1723, is in the City Museum, Stoke on Trent, and an analysis has established that the white engobe contains flint, while the body composed of Staffordshire clay is flint-free (Fig. 2).

By the 1720s what could loosely be termed a peasant craft was giving way to commercial enterprise as technological advance replaced rule of thumb. Though the two continued for a period side by side, the growth in number and size of manufactories brought about inevitable change not only to the Staffordshire scene but also to the traditional methods of ceramic production. Hitherto, the craft had thrived on easily accessible raw materials, but with the importation of white pipe-clay from the southwest of England, flint from the east coast, and salt from Cheshire, this expanding branch of the potting trade came to rely less and less upon local resources except coal for firing the ovens. The demand for all types of Staffordshire salt-glazed stoneware was great, and potters by the score took advantage of the obvious possibilities by adding stonewares to their output. Expansion was most noticeable in the northern part of The Potteries where the Wedgwood and Wood families predominated. Within twenty-five years, the regular white salt-glazed trade was phenomenal, and by 1762 a case submitted to Parliament by the Staffordshire potters, asking for a certain road to be turnpiked, tells its own illuminating story:

In Burslem, and its neighbourhood, are near 150 separate Potteries, for making various kinds of

Stone and Earthen Ware; which together, find
constant Employment and Support for near 7000
People. The Ware of these Potteries is exported
in vast Quantities from London, Bristol, Liver-
pool, Hull, and other Sea Ports, to our several
Colonies in America and the West Indies, as well
as to almost every Port in Europe. Great Quanti-
ties of Flint Stones are used in making some of the
Ware, which are brought by Sea from different
Parts of the Coast to Liverpool and Hull; and the
clay for making the White Ware, is brought from
Devonshire or Cornwall, chiefly to Liverpool;
the Materials from whence are brought by Water
up the Rivers Mersey and Weaver, to Winsford
in Cheshire; those from Hull up the Trent to
Wellington and from Winsford and Wellington,
the Whole are brought up by Land Carriage
to Burslem. The Ware when made, is conveyed
to Liverpool and Hull, in the same Manner
the Materials are brought from those Places.
Many Thousand Tons of Shipping, and Seamen
in proportion, which in Summer trade to the
Northern Seas, are employed in Winter in
carrying Materials for the Burslem ware. And
as much Salt is consumed in glazing one
species of it, as pays annually near 5000[£]
Duty to the Government. Add to these Consid-
erations, the prodigious Quantities of Coals
used in the Potteries; and the Loading and
Freight this Manufactory constantly supplies,
as well for Land Carriage, as Inland Navigation,
and it will appear, that the Manufacturers,
Sailors, Bargemen, Carriers, Colliers, Men
employed in the Salt Works, and others, who
are supported by the Pott Trade, amount to a
great many thousand People: And every
Shilling received for the Ware at Foreign
Markets, is so much clear Gain to the Nation;
as not one Foreigner is employed in or any

Materials imported from Abroad, for any Branch of
it: And the Trade flourishes so much, as to have
increased Two-thirds, within the last fourteen
years.[9]

Without doubt the foregoing is a most important document,
for on the strength of these facts and figures the Staffordshire
potters were granted permission to turnpike their main road,
facilitating the transport of goods and materials between
Burslem and the port of Liverpool.

As Ivor Noël Hume has shown elsewhere, there is archae-
ological evidence that three different types of white salt glaze
reached the American colonies in the 1720s. As early as 1724,
William Randall, "in the middle of Cross-Street," Boston, was
advertising, "white stone Tea-cups and Saucers."[10] Excava-
tions at widely separated points on the eastern seaboard of the
United States testify to the influx of the Staffordshire ware,
which remained popular for at least half a century.

Until the second quarter of the eighteenth century, pottery
forms and styles of decoration had largely been dictated by
the potter, but then outside influences, including the shapes
of silver vessels, affected output to such a degree that new
techniques had to be evolved to supply the complicated shapes
in which relief decoration was an integral part of the pot and
not merely an addition. The first step was the carving of
alabaster into small trefoil, quatrefoil, triangular, and heart-
shaped molds in order to mass-produce spoon trays, sweetmeat
dishes, pickle trays, and other dishes by pressing thin slabs
of clay into the molds. This innovation was followed by the
making of clay molds, in which painstaking concentration on
detail was of paramount importance, for on the quality and
crispness of the carving would depend the final result. After
firing, the molds (now referred to as a pitcher mold) were used
to manufacture various flatwares by the technique of press molding

One of the most important technological advances that stimu-
lated the manufacture of white salt-glazed stoneware was the use
of porous molds about the year 1740, fabricated from native
gypsum or plaster of paris. The new trade of slip casting was to
become a vital process in the ceramic industry. This is what

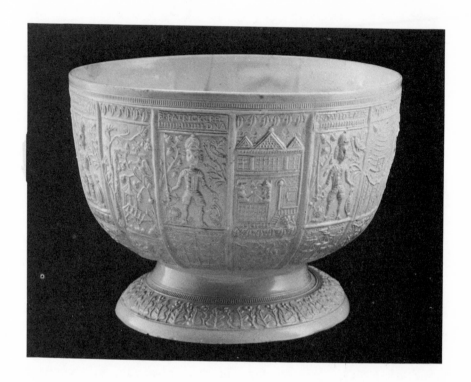

Fig. 3. Punch bowl, Staffordshire, ca. 1745. Salt-glazed stoneware with cast panel deco-
ration depicting The Seven Champions of Christendom; H. 7 1/4", Diam. 10 3/8".
(Colonial Williamsburg.)

Simeon Shaw writing in 1829 had to say on the subject:

> Moulds were now made of all different pieces; for
> complete Breakfast, Dinner, Dessert, and Supper
> Services, and much fancy was exercised in forming
> the Basket-work, Shell-work, Mosaic, Barley-corn,
> and other patterns, with great diversity of shapes
> agreeable to the taste of visitors, and the ingenuity
> of the workman. The specimens are glazed with
> salt; and from the accuracy of the ornaments, and
> the extreme lightness, of Tureens, Dishes and
> Sauce Boats, they are supposed to have been <u>cast</u>
> in the moulds, by pouring in a very thin slip, and
> letting it remain a few minutes, then pouring it out,
> and refilling with a thicker slip which instantly
> assimilates with the former, and more than doubled
> its thickness; a third, and often a fourth dose of
> thick slip was added, until the vessels had the
> required thickness; when the mould and its con-
> tents were placed a while before a fire, and
> afterwards they easily separated, and the workmen
> dressed off the seams where the moulds divided,
> and the spouts, handles, and other appendages
> were affixed, in the process, called "<u>Handling</u> and
> <u>Trimming</u>."[11]

Cast ware is invariably very light in weight, and where
relief decoration is present indentations following the contours
can be seen on the interior (Fig. 3). This process of produc-
tion permitted an almost unlimited variety of forms, especially
in tableware where teapots in particular were made in a bewil-
dering range of shapes and subjects. At this juncture it
should be pointed out that the new technique of slip casting
in no way replaced the process of throwing or press molding,
all three methods being variously used in the manufacture of
the white stoneware.

The earliest method of decoration on Staffordshire salt-glazed
stoneware was achieved by scratching the leather-hard pot with
a sharp pointed implement and filling the scored lines with a
metallic oxide. In the 1720s iron-brown was used, but in the

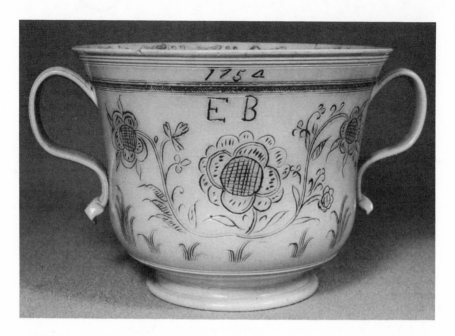

Fig. 4. Attributed to Enoch Booth, Loving cup, Tunstall, dated 1754. Salt-glazed stoneware with inscription "1754 EB" and incised blue floral decoration; H. 7 1/4". (City Museum and Art Gallery, Stoke on Trent.)

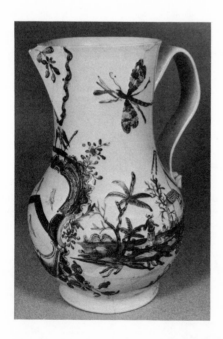

Fig. 5. Jug, Staffordshire, ca. 1760. Salt-glazed stoneware decorated in polychrome enamels and bearing the arms of Walthall of Wistaston and Leek (Staffordshire); H. 12." (City Museum and Art Gallery, Stoke on Trent.)

1740s this was replaced by cobalt blue, which was to remain
in favor for the next forty years. Simeon Shaw tells us "The
Flowerers now scratched the jugs and tea ware, with a sharp
pointed nail, and filled the interstices with ground zaffre, in
rude imitation of the unmeaning scenery on foreign porcelain,
and in this art women were instructed, as a constant demand
was made on the men for the plastic branches."[12] Tea caddies,
mugs, plates, cups, bowls, punch bowls, ale tankards, puzzle
jugs, loving cups, and harvest flasks were embellished with
rather artless stylized flowers, foliage, and, less frequently,
birds. Scratch blue was particularly popular during the first
twenty years of its production as betrothal, christening, and
birthday remembrances, but from the surviving number of pots
inscribed "Ale" it is evident that they were also in demand for
other convivial occasions (Fig. 4).

It is my belief that the richly decorated London porcelains
of the late 1740s had a profound influence on the Staffordshire
potter, which eventually led to the use of polychrome enamels
on the white salt-glazed ground. But the desire to emulate the
more expensive porcelain presented fundamental problems to
the Staffordshire salt-glaze potter--at that date his factory was
not equipped with a decorating shop; more to the point, he had
no employees skilled in the art of painting. Scratch blue
"flowerers" were plentiful, but the freehand painter was as yet
unknown in The Potteries. When enameling was first practiced
in north Staffordshire about 1750, independent decorating estab-
lishments were essential to the potter in order to fulfill an
increasing demand for polychrome ware (Fig. 5). Until he was
in a position to provide accommodation and employ his own
artists, special workshops staffed by painters from porcelain
factories supported by locally trained workmen were set up in
the district. But by the later 1760s certain master potters had
teams of decorators in their factories. As with the earlier plain
salt-glazed stoneware, demand was great and vast quantities
of enameled ware left Staffordshire for markets overseas.

Another method of decorating white salt-glazed stoneware
was the semimechanical process of transferring prints from an
engraved copperplate to the pot by means of transfer papers.
Seemingly confined to octagonal and round plates with a molded

rim of stars and dots within a diaper between medallions with foliate borders in relief, transfer-printed stoneware had a short life, from about 1755 to 1765, and was ousted by transfer-printed creamware (Fig. 6).

Salt-glazed stoneware was made in north Staffordshire for a century, during which time countless potters competed for a living. A few were highly successful, but the majority who toiled with clay, coal, salt, sand, and flint, from the start of their apprenticeship at the age of fourteen often to the time of their death, remain anonymous. A fair proportion of their wares survive, but seldom is it possible to link pot with potter and marked specimens are the exception to the rule. Parish registers, wills, deeds, trade directories, and, rarer still, account books, hiring books, and crate books give the names of some of those connected with the salt-glaze trade, but the overall picture is still far from complete. Fortunately, a selection of fine salt-glazed stoneware and a mass of related documentary material has recently been acquired by the City Museum, Stoke on Trent. This highly important collection, which had been safeguarded by descendants of the Wood family, is concerned with the master potters, Thomas and John Wedgwood of Big House, Burslem.

Thomas (1703-76) and John (1705-80) were born into the trade, their father being the Aaron Wedgwood cited by Dwight in the 1693 lawsuit. Following the order of the day, one may assume that the boys would have been inducted into the "secret art and mystery of the potting business" from an early age. It is evident, however, that both Thomas and John received some formal education, although there is nothing in the Wedgwood documents to indicate where they received their schooling. Instruction in writing, reading, and arithmetic invariably began (when parents could afford it) at the age of six, and it was usual to be "set on" as an apprentice potter at fourteen for a term of seven years. The foregoing was no doubt the path followed by the Wedgwood brothers.

Sometime before 1740, Thomas, an excellent thrower, and John, a skillful fireman, left their father's service to commence business for themselves in the manufacture of white stoneware. But three years later, on the death of their father, they succeeded to his manufactory in the middle of Burslem. There is no reason

to suppose that the family business taken over by the brothers in 1743 could in that day have been classed as unique; it was probably one like many others with its new owners competing for trade alongside fellow craftsmen who manufactured and sold their wares in the manner of their fathers. It is evident that John Wedgwood was the more ambitious partner, his energies being directed to the end of establishing himself as the foremost potter of Burslem. By a combination of forward planning, astute investment, and endless hard work, he became one of the most influential men of his day.

The obvious limitations of the ubiquitous single-oven factory inspired him to cogitate on factory planning of a different dimension. It was fortunate that the plot of the land on which his late father's potworks stood was large enough to accommodate new buildings. In 1743 he and his brother Thomas launched a revolutionary scheme that was to capture the imagination and no doubt the envy of their fellow townsmen--but let Simeon Shaw tell the story: "They erected a new manufactory, and incurred general censure because of their extravagance in erecting so large a manufactory and covering it with tiles (all others being covered with thatch) and for erecting three ovens (subsequently increased to five)."[13] Several years later, in 1751, they caused another sensation when they built the Big House, the first residential brick building erected in Burslem. Whatever else can be said of the Wedgwood brothers, no one can deny their role as pioneers.

Before discussing the products of Thomas and John Wedgwood, the point should be made that their sales account book, compiled by John, covering the period between 1745 and 1776, and the crate book, itemizing the wares that left the district in the 1770s, are two of the most important documents connected with the Staffordshire pot trade to come down to us. Even casual analysis proclaims that in every sense of the word, the Big House Wedgwoods were the leading master potters of their day. Discovery of these manuscripts, with their wealth of detail, throws new light on the early history of pottery making in Staffordshire and violently contradicts the long-held belief that no industry as such existed before the time of their famous relative, Josiah Wedgwood.

I submit that any "pot-bank" (to use the local term), which

Fig. 6. Plate, Staffordshire, ca. 1755. Salt-glazed stoneware decorated with red overglaze transfer print of "Le Marchand d'Oiseaux" after Boucher, engraved by J. Daullé; Diam. 9". (City Museum and Art Gallery, Stoke on Trent.)

Fig. 7. Thomas and John Wedgwood, Cream jug and block, Burslem, ca.1750. Salt-glazed stoneware; H. (jug) 4 3/4". (City Museum Art Gallery, Stoke on Trent.)

could offer for sale over a period of thirty years hundreds of different lines, varying from a humble pickle pot to an extensive range of tablewares, from twenty-eight sizes of porringer to twenty-five variations of teapot, was obviously a commercially successful establishment.

Historians have rightly presented Thomas and John Wedgwood as the supreme manufacturers of salt-glazed stonewares in Burslem, their products embracing every category from the cheap brown to the more expensive polychrome decorated. But the documents referred to are more specific and show that the brothers catered to the tavern and kitchen at one end of the scale and to the tables and drawing rooms of the rich at the other. Wares were supplied not only to the shops and warehouses of the London retailers or "chinamen," but also to the houses of the nobility. In short, there is ample evidence of a universal market including overseas trade via the ports of Liverpool, Bristol, and Hull.

Collectors of salt-glazed stonewares will be familiar with a feature which might be best described as notches, seen on some handles, where small pieces of clay have been removed with a sharp tool to expose two flat faces. Teapots and cream jugs displaying this characteristic, together with their associated block molds, are to be found in the Thomas and John Wedgwood collection and correspond with descriptions of "white natched teapots" listed during the period 1740 to 1750 in the sales account and crate books. Another interesting link is a "block" in the Victoria and Albert Museum, which matches a cast cream jug in the City Museum, Stoke on Trent, made by the Wedgwood brothers and inscribed "R.W. 1749" (Fig. 7). From other evidence there is proof that another famous Staffordshire potter, Ralph Wood, was responsible for some of the blocks used by the Wedgwoods. This is one of the few occasions on which, with some certainty, a pot can be linked with a potter.

The only direct reference in the Wedgwood papers to pots leaving Burslem for America is as follows:

Sent to Mr. Brindley for his son to take to America in Mar. 1772
1 Doz. Meat Spoons & 6 Pierced

6 Doz. Tea Spoons Two Sizes
1/2 Doz. narrow mouthed spoons
1 Doz. Short Mustard Spoons
Nest Starr pettys
Nest double Starr pettys
Nest double Starr Cups nest treble do
Nest Custerd Cups
Nest Puding nest Do
3 Ash Flowr Pots & Stands
Ash Pint & Qut. Jug Do

(The last two items were not salt glaze.)
But the number of customers of Thomas and John Wedgwood
in the port of Bristol indicates that their salt-glazed stoneware
was shipped abroad in quantity. Of particular significance in
this connection are references in the documents to the partners
Wraxhall and Flower; Nathaniel Wraxhall is listed in a Bristol
directory for 1775 as "American merchant," and Joseph Flower
is the potter of tin-enamel fame. This speaks for itself and
identifies with reasonable certainty a man who was instrumental
in shipping consignments of wares made by Thomas and John
Wedgwood to the colonies. There must of course have been
other merchants similarly engaged in the salt-glaze trade.

The wealth of information already gleaned from the Wedgwood
documents makes one regret that similar records compiled by
their contemporaries have long since disappeared. Our picture
of eighteenth-century Staffordshire ceramic production and export
will never be complete, but it is certain from the countless
number of potters engaged in the manufacture of salt-glazed
stoneware that there must have been many who were, to a large
extent, dependent upon markets overseas for their living.

During the third quarter of the eighteenth century, there was
a marked decline in the quantity of stoneware leaving The
Potteries. It had nothing to do with recession in trade or compe-
tition from an outside source. Quite simply, another class of
ware was taking its place--the new fashion was for the perfected
lead-glazed creamware, or, as Josiah Wedgwood was eventually
to rename it, "Queen's Ware." It was only a matter of time
before his contemporaries, conscious of his unqualified success,

abandoned the old method of salt glazing as yet another out-
standing Staffordshire ceramic achievement was about to capture
world markets. But that is another story.

NOTES

1. Plot, The Natural History of Staffordshire (Oxford:
Printed at the theater, 1686).
2. See Arnold R. Mountford, The Illustrated Guide to
Staffordshire Salt-Glazed Stoneware (London: Barrie & Jenkins,
1971), p. 4.
3. Mountford, Staffordshire Salt-Glazed Stoneware, p. 2.
4. Mountford, Staffordshire Salt-Glazed Stoneware, p. 2.
5. Shaw, History of the Staffordshire Potteries (1829; reprint
ed., London: Scott, Greenwood & Co., 1900), p. 121.
6. Mountford, Staffordshire Salt-Glazed Stoneware, p. 5.
7. Dwight's bill of complaint against Hamersley, Middleton,
and Astbury, dated December 4, 1697, Public Records Office,
London C6/524/37, as quoted in Mountford, Staffordshire Salt-
Glazed Stoneware, pp. 6-7.
8. Affidavit by Cornelius Hamersley sworn at Newcastle
under Lyme, January 1698, Public Records Office, London C6/
404/24, as quoted in Mountford, Staffordshire Salt-Glazed
Stoneware, p. 9.
9. Case of potters to Parliament, 1762, as quoted in
Mountford, Staffordshire Salt-Glazed Stoneware, pp. 11-12.
10. Ivor Noël Hume, "The Rise and Fall of English White
Salt-Glazed Stoneware," Antiques 97, no. 2 (Feb. 1970): 248.
11. Shaw, History of the Staffordshire Potteries, p. 146.
12. Shaw, History of the Staffordshire Potteries, p. 177.
13. Shaw, History of the Staffordshire Potteries, p. 161.

CREAMWARE TO PEARLWARE:
A WILLIAMSBURG PERSPECTIVE

Ivor Noël Hume

COLONIAL Williamsburg in 1971 officially extended its
research interests from its Revolutionary War cutoff date
forward to 1830. The decision mirrored a policy already
adopted by its Department of Archaeology, which had long
been treating the material remains of the nineteenth century
with the same respect it afforded those of the colonial period.
Since ceramic fragments are among the archaeological
historian's principal means of dating the ground in which
they are found, it was inevitable that the common wares of
the late eighteenth and early nineteenth century should merit
intensive study, particularly in view of the fact that they
had hitherto enjoyed little popularity or attention among
ceramic historians. The product of some of Colonial
Williamsburg's preliminary work to obtain a better under-
standing of domestic ceramic wares in the early Federal
period provides the basis for this paper, which reviews the
evolution of British creamware and pearlware in an American,
and where possible a Williamsburg, context.

When considering creamware and pearlware, we normally
think of British imports, and it is only reasonable, therefore,
that much of the information coming to light concerning
these wares is also of British origin. It is equally reasonable
to expect that the best ceramic data will come either from
documentary records or from the kiln sites of the potters.
Consequently, archaeological excavations on creamware
manufactory sites can be expected to be more informative
than can digging on American domestic sites where the
product was finally interred. Similarly, the potters' written
observations describing the names, distribution, and
popularity of their wares are likely to be a good deal more
accurate than are, say, the advertisements of American

china shops whose proprietors bought from middlemen and had no contact with the factories.

Unfortunately, few documentary records survive from the many British factories producing creamware during the seventy-year period from the late 1750s to the 1820s; this is one of the reasons we tend to think of the relatively well-documented Wedgwood enterprises and the Leeds Pottery whenever our thoughts turn to English creamware. Realizing that I may be guilty of compounding the problem by using Josiah Wedgwood as a cornerstone of my discussion, I propose to do so nonetheless, not to laud him, but rather to place his factory in an American perspective--specifically, a Williamsburg perspective.

There is a very real danger that we who study in a relatively small corner of a field may tend to assume that the deductions we make up on the hill must be equally true down by the stream. But just as Wedgwood's records cannot speak for all creamware potters, so archaeologists digging in Williamsburg cannot draw conclusions about Wedgwood's wares that can be applied in blanket fashion to Charleston, to Philadelphia, or to Spanish Town, Jamaica. But when archaeological evidence from Spanish Town, Boston, New York, Michilimackinac, and forty or fifty other locations is available to be analyzed together, then resulting generalizations may have some validity. In the meantime, in spite of more than a century of scholarly (but more often dilettantist) interest, the study of eighteenth- and nineteenth-century ceramics is still in its infancy. Although archaeological data is pouring in almost daily, the sum of our knowledge is but a drop in the bucket compared with the amount of unknown, but potentially contradictory, evidence that is still down the well.

Before going any further, it is important to establish what is meant by creamware. I am not referring to the cream-colored earthenwares whose extant examples seem to have begun with the alleged Enoch Booth bowl of 1743,[1] nor do I mean the wealth of so-called Whieldon-Wedgwood, tortoiseshell, and other clouded-glaze wares of the 1750s and 60s that preceded and then paralleled the manufacture

of creamware, employing both its pattern molds and those used for salt-glazed stoneware. For the same reason, I am not including Wedgwood's classic, fluid green-glazed ware whose body certainly closely paralleled that of his first creamware. In short, I am commencing with the development of the yellow lead-glazed ware that subsequently came to be called "Queen's ware," though not, I think, until 1767. It should be explained, too, that this paper is confined predominantly to the useful wares: the plates, the dishes, the washbasins, and the chamber pots, and not the splendid but often anomalous pieces that so often represent the ware in museum collections.

In its earliest form the cream-colored body was the same as that used in the manufacture of white saltglaze, but fired at a lower temperature and dusted with a dry, galena glaze derived from oxide of lead and ground flint. It was Enoch Booth who has been credited with inventing a fluid glaze into which the once-fired biscuit ware was dipped, and which protected the glazers from inhaling either the lead or the flint, the former producing lead poisoning and the latter causing something rather picturesquely known as potter's rot.

In the early 1750s, John Warburton of Hot Lane refined his cream-colored ware in a manner that remains unclear; and ten years later, after Wedgwood had ended his partner-ship with Thomas Whieldon, Wedgwood was working on his own improvements. All these changes were brought about by experimenting with both clay and glazes and resulted from the increasing availability of the new china clay and china stone from Cornwall. But exactly who did which, when, and to what, has never really been established. In truth, nothing short of an analysis of the bodies and glazes of a large number of marked and dated pieces, as well as wasters from numerous kiln sites, will provide firm answers to such questions.

Nine out of ten of all the creamware pieces manufactured were unmarked, and probably fewer than one in a thousand were dated, though such ratios are not reflected in most museum collections. But one has to remember that the

Fig. 1. William Bacchus factory marks; <u>left</u>, on a biscuit sherd from the kiln site, Fenton Vivian, Staffordshire, 1770-85; <u>right</u>, on fragment of a creamware plate found in Williamsburg, Va. (6395-28.A.). W. (Williamsburg sherd) 1 3/4". (Colonial Williamsburg.)

dated pieces were special to start with, and they survived because their antiquarian interest was self-evident. Similarly, collectors normally seek marked pieces while rejecting those that are not. By this refining process, the unmarked and undated specimens are weeded out, and as most of the desirable pieces that come on the market have been released from collections rather than pantries, it is understandable that the ratio of surviving marked to unmarked pieces should be so high in museum and private collections. Similarly, hideous ceramic objects that nobody liked when new were made only in small quantities, but their present rarity and high salesroom prices are mistakenly believed to reflect original worth or desirability.

Although thousands of fragments of creamware have been recovered during more than forty years of Williamsburg excavations, not one specimen is dated, and only thirty-five sherds are marked. Only eight marks are identifiable: two bear the name of Wedgwood, one of E. Mayer of Stoke, and five of William Bacchus, the owner of a creamware manufactory at Fenton Vivian, in Staffordshire from about 1783 to 1787 (Fig. 1). On this evidence, Williamsburg would seem to have been better served by factories other than Wedgwood's. But here again, the proportion of unmarked specimens found in Williamsburg, coupled with the fact that much of Wedgwood's useful-ware output was unmarked, makes such a conclusion of little value.

The dearth of identifiable Wedgwood fragments is only exceeded by the apparent absence of the name from surviving Williamsburg records. Indeed, it is ironic that the only reference to a named Staffordshire potter making Queen's ware is not to Wedgwood, but to Warburton--probably Ann Warburton of Hot Lane, Cobridge. The Virginia Gazette for June 30, 1768, quoting a letter written in Burslem on September 5, 1767, states the following: "Though our stone ware has been universally used, yet until our turnpikes were made few people ever saw our manufactures, but now they are gazed at as a novelty. The ladies go to Warburton's to buy the Queen's sets of cream coloured ware; and the gentlemen come to view our eighth wonder of the world, the

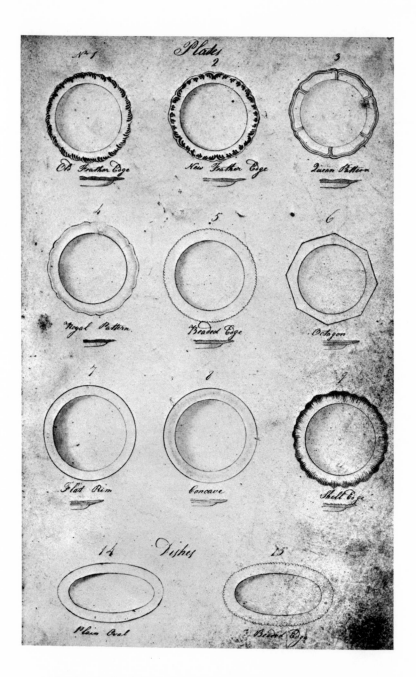

Fig. 2. Catalog drawings of Wedgwood plate shapes on paper bearing an 1802 watermark: (1) Old Feather Edge, (2) New Feather Edge, (3) Queen Pattern, (4) Royal Pattern, (5) Beaded Edge, (6) Octagon, (7) Flat Rim, (8) Concave, (9) Shell Edge. (Archives of Josiah Wedgwood Ltd.)

subterranean navigation which is cutting by the great
Mr. Brindley." Brindley was the engineer in charge of
digging the canal between the rivers Trent and Mersey, the
completion of which, in 1777, was to make such a
difference to the transportation costs of the Staffordshire
potters. Wedgwood himself was honorary treasurer of that
project and had ceremoniously cut the first sod in July 1766.
But here, in this curious letter, we have no mention of him;
instead "the Queen's sets of cream coloured ware" are
associated with the firm that is credited by Simeon Shaw
with refining the ware back in 1751.[2] One wonders,
therefore, whether the letter was written by someone with
an ax to grind.

It may be that others are acquainted with earlier
references to Wedgwood's American exports, but the first
that I know of was found by my wife among the Wedgwood
papers at Barlaston, and it occurs in a letter written by
Thomas Bentley to Josiah Wedgwood on September 25, 1764.
Bentley there passed on "a small Order which we have just
rec[eive]d from Boston in New Engl[an]d from a very careful
Man, who has sent us Cash to pay for them." The order
listed flint whiteware (common salt glaze), pineapple
teapots and coffeepots, cauliflower canisters, black coffee-
pots, cream-colored mugs, and "small ware of several
colours such as pickle leaves."[3] The bulk of these items
belong to that all-encompassing category we call Whieldon-
Wedgwood. But that is not the salient factor here. The
point is that in reading this order, we can very easily be
trapped into using it to show that as early as 1764 the
citizens of Boston were aware of Mr. Wedgwood and the
quality of his products, and so wrote to Bentley specifically
for them; yet this may not have been the case at all. Thomas
Bentley was originally in business in Liverpool as an agent
and merchant. But soon after Wedgwood first met him in
1762, he became the potter's representative overseeing the
shipments of raw materials arriving in Liverpool en route to
Burslem. It was not until late in 1766 that the Wedgwood-
Bentley partnership was established, and therefore it is
quite possible that the "very careful Man" from Boston simply

knew Bentley as an exporting factor, or agent, and so asked
him for a shipment of earthenwares in the popular styles,
without knowing who made them, or that Bentley was connected
with one of the factory owners.

I am not suggesting that Wedgwood was an unknown name
in the American colonies; I am merely voicing the possibility
that to the general storekeeper and to his average customer,
Queen's ware was Queen's ware, and cauliflower ware was
cauliflower ware, no matter who made it. Wedgwood's
promotion was aimed at the nobility, at people of taste and
discernment. One recalls the reference quoted by Wolf
Mankowitz in his book Wedgwood, from a letter of 1772 by a
Miss Hulten of Brookline, Massachusetts, to a Mrs. Adam
Lightbody of Liverpool, saying that her sister liked a crate
of "Yellow Ware" that she had received sometime earlier,
and "desires to have another crate, if I could trouble you to
buy 'em, but she says if there's any new fashion or invention
of Mr. Wedgwood of this kind of ware, that is approv'd,
Shod prefer it to the yellow over again, but chuses the
usefull & neat, rather than Ornamental, as they are for
Common Service, therefore, nothing Gilt & no matter how
few Tureens."[4]

This letter is of major importance, first, because it is a
rare documentary record of American colonial appreciation of
Wedgwood as the continuing inventor of new styles and
fabrics, and, second, because it shows that among colonists
of sensibility it was thought desirable that even the purchase
of a "Common Service" should be in Mr. Wedgwood's latest
fashion. Clearly Wedgwood had snob appeal, as, of course,
he intended. Indeed, poor, uncertain Miss Hulten was so
eager to be in vogue that after asking for Wedgwood's latest
creation she hastily added that it must be of an "approved"
sort.

At the other end of the stick we have the evidence of a
letter from Jonathan Jackson in London to the firm of
Thompson and Gordon regarding a proposed cargo of goods
to be traded in Boston in 1784. In it Jackson suggested that:

After the other Goods you propose to send I can

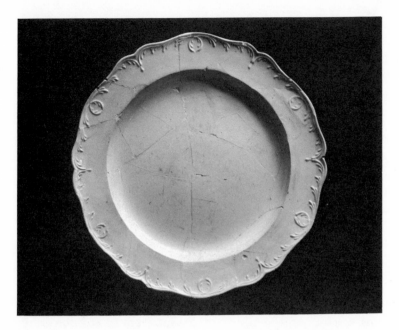

Fig. 3. Creamware plate, New Feather Edge pattern, recovered from a Williamsburg archaeological context of ca. 1775-80. Diam. 9 1/2". (Colonial Williamsburg 6394 E.R. 1638Y-2.H.)

Fig. 4. Creamware plate sherds, feather edge patterns, ca. 1770-85. Top, attributed to Wedgwood; bottom, attributed to the Melbourne factory, Derbyshire. (The pin measures one inch.) (Colonial Williamsburg 6396 E.R. 1578C-2.H., 6398 E.R. 2375-28.D.)

think of nothing better to fill up your Vessell
with than Liverpool Salt & Earthen Ware--but if
you pay money for both those Articles you will
have greater advantages in the purchase, & as
to the kinds of Ware Cazneau & Marlin or any
good House [interlineated: at Liverpool] in
the American Trade can give you sufficient
Information I suppose--the most Saleable is
the Queens Ware--Tea Cups & Saucers Tea pots &
Cream Jugs & Table plates Mugs & Bowls are most
in Demand--have few Dishes Tureens or any fancy
Articles for they are heavy & order chiefly the
lowest priced.[5]

Here we have echoes of Miss Hulten's emphasis on the
"useful wares" and her lack of enthusiasm for tureens. But
more significant is the fact that Jackson was writing in
England, and yet he made no reference to Wedgwood or his
agent, and inferred that his correspondent could be equally
well served with Queen's ware by almost any export house
dealing with the American trade.

I have tried elsewhere to demonstrate that although
Wedgwood was making cream-colored dinner services
before he obtained the commission to make the controversial
tea service for Queen Charlotte, it was not until he had
fulfilled the royal order in 1765 and accepted another for a
dinner service, probably early in 1766, that the design
called "the Queen's shape" came into being.[6] There is no
need here to review the sometimes contradictory documentary
history of the creation of the pattern. It is enough to say
that it was simply the old white salt-glaze barley border
with the barley-corn element removed. Subsequently,
allegedly at the command of George III, a simpler rim form
was devised and dubbed the Royal Pattern, and it was this,
incidentally, that was employed for the great "frog" service
made for Catherine of Russia in 1773. The first surviving
reference by Wedgwood to Queen's ware--as opposed to the
Queen's Pattern--occurs in 1767, probably in September,
when he wrote to Bentley telling him that "The demand for the

said creamcolour, alias Queen's Ware, alias Ivory, still
increases,"[7] and it is my contention that he would not have
spelled out all three terms to his own partner had they been
in common use for two or three years. Furthermore, it was
not until that same year, 1767, that we have the first extant
example of Wedgwood's styling himself "Potter to Her
Majesty," and it was not until January 1768, that we first
hear of Wedgwood's London showroom being identified by
the sign of the Queen's arms. It seems likely, therefore,
that it was late in 1766 or early in 1767 before Wedgwood
first began to call his cream-colored ware "Queen's Ware."

The first reference to Queen's ware so far discovered in
Virginia, dates from August 14, 1769, when Martha Jacquelin
of Yorktown ordered from London "2 Sets Compleat for a
Table of Queens China with Mugs &ca."[8] A month later
storekeeper John Greenhow of Williamsburg advertised that
he had in stock "Queen's china" and "blue and white china
of most sorts."[9] Thereafter, such advertisements become
relatively common. In 1770 we find Mann Page of Fredericks-
burg ordering, through his British agent, "1 Dozn. Tea Cups
1 Dozn Saucers, 1 Dozn. Coffee Cups & 1 Dozn. Saucers,
[and] 1 Slop Bowl of Queen China."[10] In the same year,
when the landlord of Williamsburg's Raleigh Tavern died,
his possessions included 139 Queen's-China plates, 4
Queen's-China butter boats, 3 Queen's-China tureens and
dishes, 2 fruit baskets and dishes, 34 other unidentified
Queen's-China dishes, as well as 2 fish strainers, 9 coffee
cups, and 10 saucers.[11] One might be tempted to assume
that the Virginia evidence is governed by the vagaries of
accidental survival or destruction of documents were it not
for the fact that the evidence is drawn from the court records
of York County whose microfilmed inventories are complete
from 1637 to 1862. Had the ware been in Williamsburg
households, and thus named, much before about 1770, one
would have expected it to appear. The possible explanation,
therefore, is that the ware was here, but not the name, and
this may be the reason we cannot identify it in the inventories
and advertisements. The latter supposition is severely
undermined when one remembers that the term "cream coloured"

Fig. 6. Pearlware pitcher, an example of the "Batavian" ware generally attributed to Leeds, ca. 1790-1800. Coated with brown slip, reserves painted in underglaze blue; H. 7". (Author's collection.)

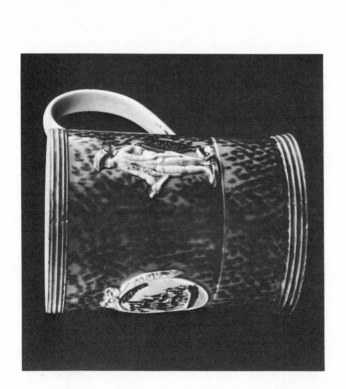

Fig. 5. Creamware mug, 1782-83. Body coated with brown-spattered, orange-brown slip, rim and foot reeded and painted green; H. 4 11/16". The medallion showing the Ville de Paris, the flagship of the Comte de Grasse captured by the British Navy under admirals Rodney and Hood, is flanked by labeled figures of Lord Rodney, each touched with blue as is the ship. (Author's collection.)

was in common use in England before 1765, and, indeed,
occurs in Henry Barnes's Boston Evening Post advertisement
of March 11, 1751--long before Josiah Wedgwood was in the
creamware business.[12] Be that as it may, there are no
references to cream-colored ware in the Williamsburg-York
County inventories in the 1760s, and Barbara Gorely Teller has
noted that the first inventory reference in Providence, Rhode
Island, occurs in 1769.[13] Support for this late date for the
widespread appearance of creamware in America is provided by
the admittedly selective, contemporary newspaper source
material assembled by Messrs. Prime and Dow, wherein, with
the exception of the 1751 references, there is no mention of
either cream-colored Queen's china or Queen's ware until
1770, and then only one Boston reference to "cream-colour'd
coffee and tea pots."[14] However, as previously noted, we
know from the Bentley letter of September 25, 1764, that he
then had an order for cream-colored ware from a very careful
but anonymous Bostonian. In July 1766, we find Wedgwood
asking Bentley: "What do you think of sending Mr. Pitt upon
Crockery ware to America?"[15] There can be little doubt that
Wedgwood was thinking of transfer-printed portraits of Pitt,
and we know that Sadler of Liverpool was offering Wedgwood
a Pitt print as early as 1763,[16] but it is far from clear what
was meant by "crockery ware."

It seems rather unlikely that Wedgwood would have
referred to his cream-colored mugs, jugs, and plates as
mere crockeryware. Could he have been referring to the
status of the objects rather than to the ware itself? Had
he not been a supporter of American aspirations and rights,
and had he not spoken in apparent sincerity of "that great
man," one might suspect that he was thinking of putting
Pitt's portrait on spitting pots or chamber pots. Oddly
enough, there is evidence to suggest that he did just that.
Samuel Smiles, quoting an unspecified contemporary writer,
observed that "a scoundrel of a potter, one Mr. Wedgwood,
is making 10,000 spitting-pots, and other vile utensils,
with a figure of Mr. Pitt in the bottom. Round the head is
to be a motto: We will spit on Mr. Pitt, and other such
d----d rhymes suited to the uses of the different vessels."[17]

If one accepts the thesis that the term "Queen's ware" was not used until 1766 or 1767 in England, and that neither it nor "cream coloured" were generally used in this country until 1769, how then did anybody identify the creamware that got here in the 1760s? A possible clue may be found in the previously quoted letter from Miss Hulten to Mrs. Lightbody in 1772. She wrote, "I sent a crate of the Yellow Ware from thence which cost about £3 to my Brother and they are now demolish'd. My Sister liked them much and desires to have another crate."[18] Earlier in the letter, Miss Hulten had made it clear that the original crate of yellow ware was of Staffordshire origin though acquired in Liverpool. Nevertheless, one wonders whether yellow ware did not describe cream-colored ware. One wonders, too, whether or not a reference in a Boston ad of 1763 to "yellow Liverpool Ware" refers to the same product.[19] By extension, "crates of flat and hollow Liverpool Ware"[20] might also be the same, though, admittedly, Liverpool ware could equally well refer to salt-glazed stoneware. We do know that cream-ware was being manufactured in Liverpool by, and probably well before, 1773, when the factory known as the Flint Mug Works was offering "a large assortment of cream colour or Queensware, manufactured at the said work."[21] The name "Flint Mug Works" suggests that, like most other creamware manufactories, it had previously produced white salt glaze. I am tentatively suggesting, therefore, that by the 1760s, "yellow Liverpool Ware" could have been creamware and that the term "yellow ware" could also have been used in the same way. I hasten to add, however, that the latter occurs in the records long before cream-colored wares were invented. To be specific, "yellow ware Hollow and Flat by the Crate" was being offered in Boston in 1733.[22] One assumes that the reference then was to yellow slipware, for a similar ad of 1744 stated that a supply of yellow ware was lately imported from Bristol,[23] and it is known that Staffordshire-type slipwares were produced in Bristol at that time.[24]

Unfortunately, even the simplest terms were used by knowledgeable authorities in the most confusing way. Thus, for example, the word "china" was frequently used to describe

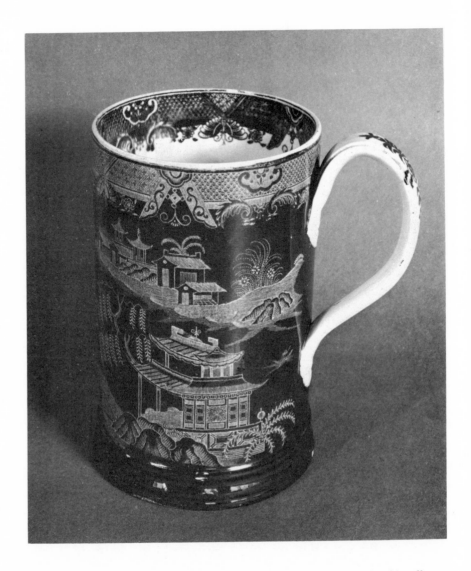

Fig. 7. Creamware mug, 1790-1800. Coated with brown slip, transfer-printed in yellow on exterior in imitation of Portobello ware with same moth border print applied in blue on rim interior; H. 5 3/4". (Author's collection.)

not only porcelain (to which Chambers's Encyclopedia of
1737 had confined it), but also to describe creamware,
pearlware, and even the dry-bodied redware, which Wedgwood
referred to in 1772 as "a qu[anti]ty of common red China
Teapots."[25] The redware had, of course, been originally
copied by the Elers brothers from Chinese Yi-hsing red
stoneware (at first called "red porcelain" in England) and
thus the "china" appellation might have stuck, yet it is
well established that Wedgwood himself used the term to
describe wares that had no oriental characteristics or origin.
Thus, in 1765, he wrote to his brother John telling him that
the Duke of Bridgewater had "shewed us a Roman urn, 1500
years old at least made of red china, & found by his workmen
in Castlefield near Manchester."[26] There can be little
doubt that Wedgwood had been looking at a piece of Gaulish
Samian ware or Terra Sigillata, a slip-glossed, red earthen-
ware having not the slightest oriental association.

This question of interpreting the word china becomes
increasingly troublesome as we leave creamware and venture
into the even less clearly charted seas of pearlware
evolution, for the latter first appears along with creamware
as "china glazed ware." When William Tunnicliffe made
his survey of the counties of Stafford, Chester, and Lancaster
in 1787, he listed eight Burslem factories making or
decorating "china glazed" wares, one in Cobridge, another
in Stoke, and another at Lane End.[27] There may also have
been others in this relatively small area, for the descriptions
of the potters' products are often vague, and instead of
saying "china glazed ware," Tunnicliffe sometimes wrote
only "blue painted" or "blue printed," which could refer to
creamware, pearlware, or, conceivably, to porcelain.

Wedgwood is credited with the invention and naming of the
bluish-white ware that we call pearlware. In March 1779,
he wrote to Bentley asking him to suggest a name for a new
whitened body that would not have the translucency of
porcelain. By August, Bentley or someone, perhaps Wedgwood
himself, had come up with the name "pearl white," but it is
evident that Wedgwood was none too impressed with the ware,
referring to it as "a change rather than an improvement" on

creamware, and adding that he must have something new to follow it "when the public eye is palled."[28] In fact, the public eye accepted pearlware for some fifty years, largely, one supposes, because it took blue painting and blue printing much more attractively than did creamware. Blue decoration on creamware was just that, but blue on pearl was visually close to porcelain, and its emergence in step with the development of underglaze-blue transfer printing (originally, of course, used on porcelain) gave pearlware an added boost. The new glaze involved the use of a small quantity of cobalt to negate the inherent yellowness of the clear lead glaze, a difference most easily seen where the glaze piles up in crevices under rims, handles, and within foot rings. But it was not only a whitening of the glaze that made the difference, for the body had been lightened too, though not originally to create pearlware. In 1772 Wedgwood wrote to Bentley discussing the introduction of Derbyshire churt:

> It whitens the body exceedingly, more even than flint ground with flint would do, and this I suppose is occasioned by a small quantity of limestone which is intermixed with all this Chert, so that the Pottery in general will now make their Cream-colour nearly as white as the white stone-ware, . . . if it is not superior to our white stone-ware in whiteness, it would be esteemed a degradation of cream-colour into white stone ware, rather than an improvement of it into Porcelain.[29]

So it seems that potters in general were developing their own whiter bodies, and this would explain why so many of them embraced pearlware or china-glazed ware so quickly. I should note, however, that Wedgwood had been playing with the idea of a whitened creamware seven years before he wrote so scathingly about his competitors' churt-rich bodies. On March 6, 1765, he had written to his brother saying: "I have just begun a Course of experiments for a white body & glaze which promiseth well hitherto."[30]

Fig. 8. Creamware teapots, attributed to the studio of David Rhodes, ca. 1775. Overglaze decoration in red, green, and yellow; H. (of intact example) 6 1/2". The fragmentary specimen was found on the Ravenscroft Lot in Williamsburg in a context of uncertain date. (Colonial Williamsburg 1819-28.F.4. and Author's collection.)

It is important to remember that, like creamware, pearl-
ware was not a term used in the eighteenth century. As a
rule, the ware appears in American records as "Blue and
White Ware," and it is often only its juxtaposition to cream-
colored or Queen's ware that tentatively identifies it as
pearlware rather than Chinese or English porcelain. In
earlier contexts blue and white ware could equally well
relate to delftware. Because the most common pearlware
varieties were blue or green shell-edged forms borrowed
from creamware, the references are sometimes simply to
"Blue and Green-edge Table Services" such as William
Absolon of Yarmouth announced in the Norwich Mercury for
July 10, 1784, stating that he had just returned with them
from London.[31] This is one of the earliest references to
what I assume is pearlware, but we know from the Tunnicliffe
survey that the ware was in widespread production before
1787 and archaeological evidence indicates that it was
reaching America by about 1790 at the latest.[32] The
documentary sources are full of later references, but a
typical example, if to a supply of large size, will suffice.
It is the advertisement of John Black of New York in the
New-York Daily Advertiser of April 11, 1796: "For Sale, two
hundred and eight Crates Staffordshire Earthenware, assorted,
consisting of cream coloured, blue and white cups & saucers,
bowls, plates, dishes, tureens, chambers, wash basons,
teapots, mugs, jugs &c.: green edged table services compleat,
suitable for genteel, private families."[33]

The advent of pearlware did not herald the demise of
creamware, as the latter had of white salt glaze. Pearlware
was, as Wedgwood had prophesied, a change rather than a
substitute, and the two wares continued to be made together,
sold together, and used together through the second decade
of the nineteenth century. Thus, for example, we have
Wedgwood's catalog of about 1810 dealing primarily with
cream color (as it was still called), but also listing blue-
printed wares that could hardly have been applied to a yellow
ground and yellowing glaze.[34] A later catalog of shapes,
intended only for use in the factory, possessed illustrations
by William Blake of the wide range of creamware forms being

made in 1817.[35] Nevertheless, it should be remembered
that Wedgwood chose what he called his "New Pearl White"
for his Royal Jubilee service of 1809,[36] while his price list
for 1810 listed "New White ware."

The parallel production of both pearlware and creamware
is very evident among the products of Liverpool's Herculaneum
factory. One tends to associate the name primarily with
creamware, but, in fact, the American archaeological evidence
so far available shows more Herculaneum marks on pearlware
than on creamware. From Williamsburg have come six
Herculaneum marks on pearlware and none on creamware. In
all, the Williamsburg archaeological collections include
thirty-nine identifiably marked pieces of pearlware as against
eight in creamware. One cannot draw too firm conclusions
from these figures, however, as much more pearlware was
marked than was creamware. Prior to the 1780s, very little
creamware seems to have been marked, and it was not only
the plain and cheap that went forth incognito. Even Wedgwood's
famous Russian service is not all marked. Some plates bear
both the factory mark and the painted design number, while
others apparently carry only the painter's identification.

In spite of the continuing production of creamware into
and through the 1820s by an uncertain number of factories,
archaeological evidence suggests that, by about 1810 pearl-
ware seems to have become America's dominant common
tableware. The point is strongly made by the contents of a
cellar found in Williamsburg, whose conversion to a rubbish
hole seems to have occurred in about 1820--a <u>terminus post
quem</u> arrived at on the evidence of two coins of 1816 and 1817
found in the deposit.[37] With the coins were fragments of
418 identifiable ceramic objects. Of these, 51 percent were
of pearlware and 13 percent of creamware, the latter trailing
Chinese export porcelain by 1 percent. The remaining
22 percent was divided among nine other wares: British
brown stonewares accounting for 4 percent, white salt-glazed
stonewares surviving from the eighteenth century 3.5 percent,
American coarse earthenwares accounting for 3 percent, and
the final 9.5 percent being distributed through delft, Rouen
faience, black basaltes, lead-glazed redware, yellow ware,

Fig. 9. Pearlware plate with blue-painted shell edge, ca. 1810-20. Underglaze-blue transfer-print decoration including lines from <u>Irish Melodies</u> by the poet Thomas Moore, first published in 1808; Diam. 6 1/2". (Author's collection.)

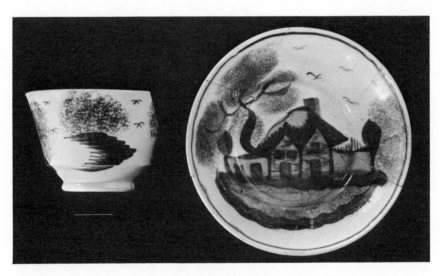

Fig. 10. Pearlware saucer and fragmentary matching cup, excavated in Lancaster County, Virginia, probably deposited ca. 1825. Hand painted in underglaze blue; Diam. (saucer) 5 1/2", H. (cup) 3 1/2". Both pieces are in the London shape first used by Spode in 1813. The saucer bears a painter's blue-painted "N" or "Z" on the base. (Courtesy of Mrs. Nina Mann and the Mary Ball Memorial Museum and Library.)

scratch blue, and German stoneware. It should be noted
that the group included no English porcelain, no bone china,
and no stone china.

It is true that to some degree the waters are muddied by
the uncertainty of survival, for we know that plain and black
transfer-printed creamwares having strongly eighteenth-
century characteristics were in production through the second
decade of the nineteenth century. Nevertheless, there were
recognizable evolutionary trends.

The Leeds Pottery's design book of 1783 put the basic
eighteenth-century creamware dinner shapes in the following
order: Queen's, Feather, Shell Edge, and Royal.[38] However,
figure 2 illustrates Wedgwood's plate shapes as listed in
1802, wherein we find the first pattern being styled Old
Feather Edge, the second New Feather Edge, Queen's Pattern
the third, and Royal Pattern the fourth. The Shell Edge is
here relegated to ninth place, although it is unlikely that at
this date Wedgwood's order has any significance. Accumu-
lative archaeological evidence suggests that the Queen's
shape had lost popularity by 1785 or 1790, that the Old
Feather Edge was fading at the same time, that the Shell
Edge for creamware was never common in America, but the
Royal Pattern was to continue into the second decade of the
nineteenth century along with the plain flat rim, a shape
that Simeon Shaw says was sometimes called the "Bath or
Trencher" design.[39] The first Wedgwood reference to the
Feather Edge seems to be a letter of February 18, 1767, when
Wedgwood wrote to Bentley, saying that he could not then
supply him with Feather Edge dishes, adding that he would
be sending "a service of feather edge En[grave]d soon as
almost all the best now ordered are of that pattern."[40] The
New Feather Edge was developed by Wedgwood late in 1773
when he listed it among the new designs that he had "thought
of."[41] However, it is extremely rare from archaeological
sites, and only three examples are recorded from Williams-
burg, one of them from a Revolutionary War context (Fig. 3).
The Shell Edge appears as no. 83 rim design in Wedgwood's
first pattern book, which was begun in about 1770, but as
designs continued to be added to it over many years, it is

impossible to be sure whether or not this was among the
first.[42] It was firmly established by the 1780s, as the
Leeds design book shows, and the style is to be seen much
earlier on European porcelain. Nevertheless, the thousands
of fragmentary plates found in Williamsburg include but
two shell-edged creamware sherds.

Again, one must remember that although the accident of
survival has forced us into linking most of our documentary
evidence with the Wedgwood and Leeds design books, and to
Josiah Wedgwood's catalogs and correspondence, one must
not lose sight of the fact that there were scores of contem-
porary factories making creamware; indeed, in 1775,
Wedgwood spoke of "one hundred manufactories of Queen's
ware."[43] I have found sherds of excellent quality on the
site of the Indeo Factory at Bovey Tracey in Devonshire, and
Donald Towner has a biscuit fragment of the New Feather
Edge design from the same site. Then again there is the
Melbourne manufactory site in Derbyshire which, according
to Mr. Towner, was in operation between about 1760 and
1785, and one of whose ware's principal characteristics
was a feather edge having an eight-fronded feather broken
in the middle (Fig. 4).[44] A preliminary check through rim
fragments in the Williamsburg collection has yielded at
least sixty-eight examples. I should note that Mr. Towner
arrived at his date brackets, not on documentary evidence,
but on the basis of the color range represented by the
fragments. But, while it is true that early creamware is
richly yellow and that later specimens are much whiter,
that does not mean that this was true of all factories or even
all batches. Indeed, we find that there can be variations
even from side to side on a single piece, the differences
resulting from the object's placement in the kiln. Further-
more, the thickness of the glaze can affect the color, and
thus an object may be much more yellow in areas where the
glaze has run down and pooled. Consequently, caution must
be employed when using color as a dating characteristic.

The sudden diversity of colored decoration on creamware
in the late eighteenth century can be explained in part by
the fact that the public had tired of the once attractively clean

appearance of Queen's ware, and, in part, by the growing
popularity of blue printing on pearlware. Although blue
printing on a yellow ground was not as reminiscent of
porcelain as the public desired, creamware did lend itself
to the use of strong greens and browns that were less happy
on pearl. Among the earliest datable examples of color-
slipped creamware are the mugs made to commemorate the
victory of admirals Rodney and Hood over the Comte de Grasse
at the Battle of the Saintes in 1782 (Fig. 5). One would
hardly expect there to be any American interest in commemo-
rating this French debacle; nevertheless, a fragment of one
such mug has been found in Alexandria, Virginia. Almost as
surprising was the discovery of another fragment on the then
virtually abandoned fortress site at Louisbourg in Nova
Scotia. These mugs invariably have a green, grooved, or
chevron band at the rim, but the body may be marbleized,
splashed with metallic oxides, or merely slipped a plain,
reddish brown. Similar colors were often used in combination
with lathe-turning in a great many variations, from checker-
boards, to simple banding, the latter generally known as
banded, or annular, ware, and nearly all dating in the period
from about 1790 to 1815. Particularly distinctive is the
so-called Batavian creamware that is generally attributed to
Leeds, and which is usually decorated on the outside with a
brown slip, save for reserves painted with chinoiserie scenes
in blue, a combination comparable to that of the pearlware
example shown in figure 6. A dramatic variation (Fig. 7)
employs the same Batavian brown ground over creamware, but
is transfer-printed in yellow, in the manner of the red-bodied
ware loosely known as Portobello, after the Scott Brothers'
factory in the village of that name outside Edinburgh. However,
such pieces are rare, certainly more so than is the true
Portobello ware, but it is interesting to note that the only
example in the Victoria and Albert Museum is not on cream-
ware but on pearl and for that reason is aesthetically
distinctly less successful.[45]

Nothing has been said about early transfer printing on
creamware nor about the use of oil gilding, or, for that
matter, about the use of pastel overglaze enameling, all of

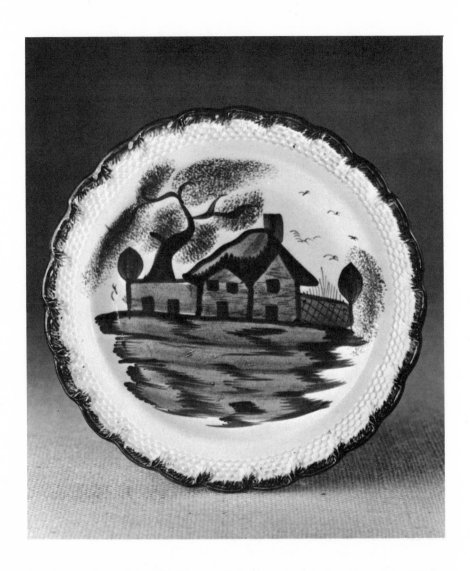

Fig. 11. Pearlware plate, 1815-30. Overall decoration in underglaze blue; Diam. 7 3/4".
The central painted motif parallels that of the Millenbeck saucer (Fig. 10). The late feather
relief on rim is accompanied by scale molding over much of the marly. Painter's number
"7" on the back. (Winterthur 59.1260.)

which are common in museum collections. But I will note
that such decorated creamwares represent an extremely
small proportion of the total recovered from Williamsburg
sites, probably something less than 1 percent (Fig. 8). This
again emphasizes the fact that one cannot expect to gain a
fair impression of the contemporary place of creamware, or
any other ceramic form, by simply looking at museum collec-
tions where the objects have invariably been acquired as
objets d'art, are studied as such and displayed as such.
Alas, the restorers and furnishers of historic places are all
too often similarly misled, and thus the distortion of the
truth is compounded.

The same problem besets our understanding of the place
of pearlware in the British and American home. Most of the
common tableware was virtually undecorated save for a
blue or green ornamenting of the shell edge. Lacking any
aesthetic appeal, very little of this has found its way into
museums and private collections. Instead, we are left with
the idea that a large percentage was decorated with American
eagles and other such collectible and eye-catching devices.
The manufacture of shell-edged plates went on into the 1830s
or even the 40s, until the ware had been converted to a hard
white fabric akin to granite china, and the rim painting had
been reduced from careful strokes brushed outwards to the
edge, emphasizing the shell pattern, to no more than a
painted lateral stripe. Once again, a word of warning:
there was some poor painting at early dates, and some good
work relatively late. Thus, in figure 9, a delicately molded
and painted plate rim suggests a date of manufacture no
later than about 1800, while the transfer-printed center is
decorated with a verse by the Irish poet Thomas Moore,
which was not published until 1808.

Like slip-decorated creamware, pearlware can only be
identified as such when a substantial area of the vessel,
be it in the interior or the underside of the base, exhibits
the unadorned body and glaze combination. Indeed, in the
absence of the glaze, the pearlware body is visually
indistinguishable from that of late creamware. Although
pearlware is generally thought of as being decorated solely

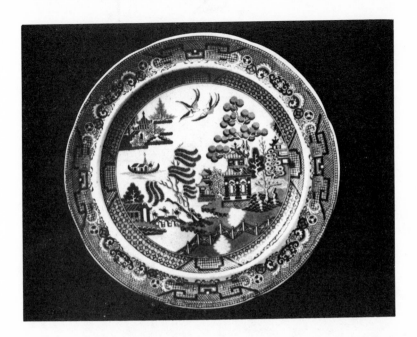

Fig. 12. Pearlware plate in standard willow pattern, ca. 1810-20. Underglaze-blue transfer print; Diam. 8 1/2". Concave rim, three triangular (triple) stilt marks on underside. (Author's collection.)

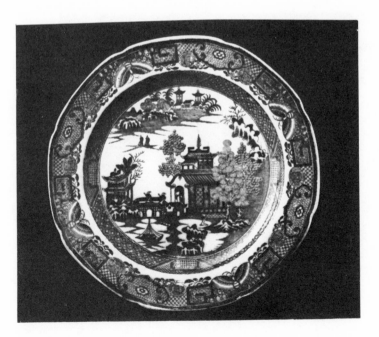

Fig. 13. Dillwyn and Company, Pearlware plate, Swansea, 1811-17. Underglaze-blue transfer print; Diam. 9 3/4". Flat rim with moth border, stilt marks on underside similar to those on plate in figure 12. Marked "DILLWYN & Coy." (Author's collection.)

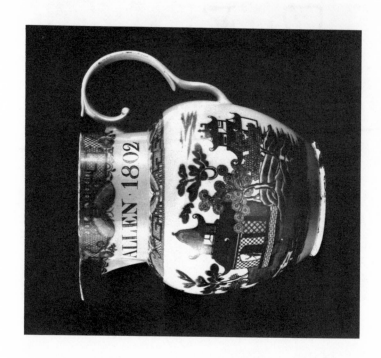

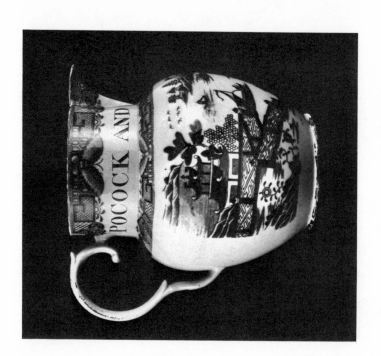

Fig. 14. Pearlware jug, possible Swansea, ca. 1802. Underglaze-blue transfer print, traces of oil gilding on rim and foot ring; H. 8". Inscribed on neck in overglaze black "POCOCK AND ALLEN 1802." (Author's collection.)

in blue (either hand painted or transfer printed), there are
numerous exceptions, among them the molded and brightly
enameled jugs in the so-called Pratt colors, though Felix
Pratt was but one of numerous makers of these patriotic
pieces so characteristic of the era of the Napoleonic Wars.
All in all, it is safe to assume that pearlware was capable
of being decorated in just about every manner known to
earthenware potters in the late eighteenth and early
nineteenth centuries, from classical sprigging à la Turner
out of Astbury to Portobello-style printing.

The most common hand-painted pearlware decoration of
the eighteenth century was, of course, what I term the
Chinese house design to distinguish it from the various
pagoda motifs that one sees on Chinese export porcelain
and subsequently on English transfer printing. The house
pattern, with a stylized rendering of water in the foreground,
occurred on creamware by about 1770 and was quickly trans-
ferred to pearlware where it came in a wide variety of
deteriorating styles. It is uncertain just how late the house
pattern runs, but it is clearly to be seen on the trade card
of Messrs. Ring and Carter of Temple-Backs, Bristol, which
Geoffrey Godden attributes to the period from about 1793 to
1813.[46] In the previously discussed Williamsburg post-1817
cellar, the house pattern is still strongly represented by
tea bowls, teacups, saucers, slop bowls, and a teapot.

Hand-painted decoration on pearlware, both in under-
glazed blue and in polychrome colors (also generally
underglaze) came in an infinite variety of patterns and
pictorial designs, and it would be a simple matter to devote
an entire book to them. The illustration of but one example
does this broad class less than justice, yet the saucer
and fragmentary cup shown in figure 10 are important in that
they were found in excavations at Millenbeck Plantation, the
William Ball family home, in Lancaster County, Virginia,
and were hitherto thought to be unparalleled and to date
within the second decade of the nineteenth century. It has
since been found that Winterthur owns a pearlware plate
painted with a comparable rustic house motif (Fig. 11)
within a blue-edged and scale-molded marly. The latter

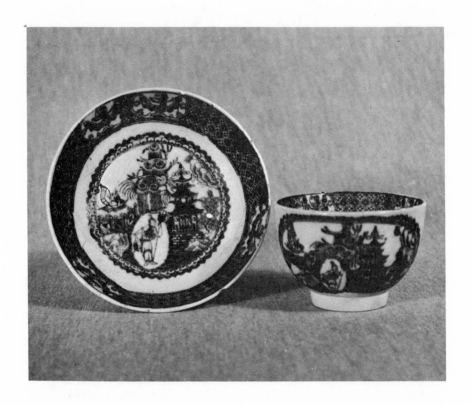

Fig. 15. Pearlware cup and saucer, found in James City County, Va., ca. 1790-1800. Underglaze-blue transfer print; H. (cup) 2 1/8". Diam. (saucer) 4 13/16". (Colonial Williamsburg TL 807C.)

detail also occurs on another pearlware plate in the
Winterthur collection, apparently commemorating the visit
to America by the Marquis de Lafayette in 1824/25. The
tortuously arrived at relationship between these unpublished
specimens and the important dating evidence to be derived
from them emphasizes the amount of work that remains to be
done before pearlware can take its proper place in the
lexicon of British ceramics.

Transfer printing on pearlware was to dominate the useful
wares in the 1820s; but the technique had taken the best
part of thirty years to win out even though mastery of the
new stone chinas seems to have been instantaneous. I
cannot conclude without saying something about the
development of the various chinoiserie transfer prints that
preceded and paralleled the standard "blue plate special"
willow pattern whose continued production today serves as
pearlware's rather dubious memorial. The general disdain
with which blue-printed willow-type pearlwares are treated
is a measure of the gulf that exists between curators of art
objects and those of us who are oriented toward the study of
pottery and porcelain as sociological documents. It is true
that the willow designs were mechanically produced and at
first sight appear to be numbingly repetitious, yet their
place in American life throughout the nineteenth century,
from the Boston merchant's mansion to the Indian's grave,
established the ware as one of the landmarks of European
civilization.

The term "willow pattern" has been used so indiscriminately
by ceramic historians that it is now virtually impossible to be
sure what they were, or are, describing. But if (as I am
convinced we must) we reserve the term to describe the
pattern that contains the elements of the apocryphal legend,
then we limit ourselves to the design generally called the
standard willow[47] that was first used about 1810 (Fig. 12).[48]
In this pattern the legendary lovers flee across a bridge to the
gardener's cottage, pursued by a whip-wielding father; a
boat waits to carry the fugitives to the young man's island
home, and when retribution catches up, the lovers are
transformed into two doves that fly away to eternal happiness.

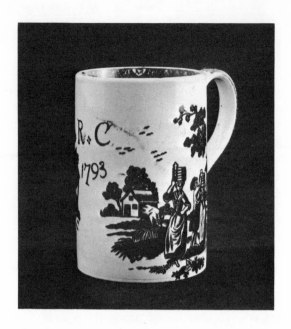

Fig. 16. Pearlware mug. Dark underglaze-blue trans-
fer print; H. 4 1/16". Inscribed "R.C. 1793."
(Author's collection.)

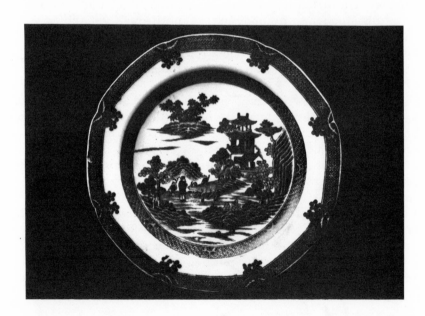

Fig. 17. Pearlware plate in buffalo pattern, ca. 1790-1805. Dark underglaze-
blue transfer print; Diam. 8". (Author's collection.)

Oddly enough, the willow tree is simply part of the setting
as is the so-called apple tree. Anyone who knows anything
about Chinese porcelain knows that the willows turn up on
just about every river bank. But for the standard willow
pattern one needs the bridge, a cottage or mini-pagoda at
the far end of it, three figures, a boat, and two birds.
Without these elements there is no story. Thus, for example,
the plate similar to the willow pattern by Dillwyn of Swansea,
illustrated in figure 13, should not be described as willow
pattern, for it has but two figures on the bridge, three boats,
and no birds. It does, however, possess a good diagnostic
characteristic of its own, and that is what I term the staple-
roofed pagoda, a feature that is present on at least one of
the chinoiserie engravings reputedly made for Thomas Turner
at Caughley by Thomas Minton in about 1780.[49] It is an
essentially early feature that never occurs on the standard
willow, and which seems to have ended by about 1815. The
Dillwyn plate, whose mark puts it between 1811 and 1817,
possesses another key feature that is absent from the standard
willow pattern, namely the moth element in the border, a
detail originally borrowed from the Chinese and first painted
in Britain on delftware and cast in relief on white salt glaze.
The moth or "bug" detail is common on specimens attributable
to John Davenport of Longport, and also to the Cambrian
Pottery at Swansea.

The pitcher shown in figure 14 would seem to be the
earliest surviving dated example on pearlware of transfer-
printed "punt and pagoda" chinoiserie. The jug possesses
both the moth and the staple-roofed pagoda and was inscribed
in overglaze black to promote the 1802 reelection of George
Pocock and Jeffreys Allen as members of Parliament for
Bridgewater in Somersetshire. Although the jug is unmarked,
the same chinoiserie pattern occurs on Davenport pieces
attributed to a date eight years later.[50] However, the
design also occurs on a number of fragmentary plates,
excavated at the Wythe House in Williamsburg, bearing
impressed diamond marks that are usually attributed to
Swansea.

Going backward in time to an even earlier form of transfer-

printed blue chinoiserie pearlware, figure 15 shows a cup
and saucer recently found at the William Trebell site near
Carter's Grove Plantation outside Williamsburg. The
print's important and diagnostically early characteristic
is the figure whose presence is spotlighted by being placed
in a reserve. Normally there are two figures in the reserves,
and no published parallel has so far been found for this lone
Chinaman. Nevertheless, the reserve technique is one that
was common in the 1790s.

The earliest transfer-printed decoration on pearlware was
not confined to oriental patterns; English rural or pastoral
scenes were almost as popular and many examples have been
found on early American sites from Massachusetts to Virginia.
The small mug seen in figure 16, with its milkmaid print and
hand-painted "R.C.1793," belongs to this class and is the
earliest dated example known to me. Also belonging to the
1790s and very evidently early in character is a group of
designs known as the buffalo pattern which, according to
Jewitt, was engraved for the first Josiah Spode by Thomas
Minton and used on the factory's first tea ware (Fig. 17).[51]
The characteristic density of the color and the slightly lobed
edge, plus a stylized version of the moth, are all indications
of early date.

No fewer than twenty-eight items printed with the buffalo
design have been found in Williamsburg excavations on
seventeen different sites. There can be no doubt, therefore,
that this was a popular and much used pattern; yet the fact
that it is so rarely seen in museum collections and its name
is so unfamiliar to curators and collectors demonstrates
how little attention has been devoted to early transfer-
printed pearlwares in general. It is to be hoped that as the
supplies of eighteenth-century ceramics diminish, this
vastly underrated ware will elsewhere enjoy the attention
that it is now receiving in Williamsburg.

NOTES

1. Donald C. Towner, English Cream-Coloured Earthenware (New York: Faber & Faber, 1957), pls. 1A, 1B.

2. Simeon Shaw, History of the Staffordshire Potteries (2d ed.; London: Scott, Greenwood & Co., 1900), p. 177.

3. Bentley & Broadman, Sept. 25, 1764, Wedgwood Archives, Barlaston, England.

4. Wolf Mankowitz, Wedgwood (London: B. T. Batsford, 1953), pp. 53-54.

5. Jonathan Jackson to Thompson and Gordon, Newry, Dec. 30, 1784, as quoted in Kenneth Wiggins Porter, The Jacksons and the Lees: Two Generations of Massachusetts Merchants, 1765-1844, 2 vols. (Cambridge: Harvard University Press, 1937), 1:366.

6. Ivor Noël Hume, "The What, Who, and When of English Creamware Plate Design," Antiques 101, no. 2 (Feb. 1972): 350-55.

7. Eliza Meteyard, The Life of Josiah Wedgwood, 2 vols. (London: Hurst and Blackett, 1865-66), 2:56.

8. Frances Norton Mason, ed., John Norton & Sons, Merchants of London and Virginia (1937; reprint ed., New York: Kelley, 1968), p. 103.

9. Virginia Gazette, Sept. 28, 1769.

10. Mann Page to John Norton, Feb. 15, 1770, as quoted in Mason, John Norton & Sons, p. 125.

11. York County Records, Wills, Inventories, Book 23, Jan. 21, 1771, p. 19.

12. Quoted in George Francis Dow, ed., The Arts & Crafts in New England 1704-1775 (1927; reprint ed., New York: Plenum, 1967), p. 98.

13. Barbara Gorely Teller, "Ceramics in Providence, 1750-1800," Antiques 94, no. 4 (Oct. 1968): 570-77.

14. Boston News-Letter, Nov. 8, 1770, as quoted in Dow, Arts & Crafts in New England, p. 93.

15. Meteyard, The Life of Josiah Wedgwood, 1:468.

16. Sadler to Wedgwood, Mar. 27, 1763, as quoted in Samuel Smiles, Josiah Wedgwood (New York: Harper, 1895), p. 61.

17. Sadler to Wedgwood, Mar. 27, 1763, as quoted in
Smiles, Josiah Wedgwood, pp. 61-62.

18. Mankowitz, Wedgwood, pp. 53-54.

19. Boston Gazette, June 6, 1763, as quoted in Dow,
Arts & Crafts in New England, p. 92.

20. Boston Gazette, July 16, 1764, as quoted in Dow,
Arts & Crafts in New England, p. 93.

21. Liverpool Advertiser, Oct. 29, 1773, as quoted in
Alan Smith, The Illustrated Guide to Liverpool Herculaneum
Pottery, 1796-1840 (London: Barrie & Jenkins, 1970), p. 10.

22. Boston Gazette, Apr. 16/23, 1733, as quoted in
Dow, Arts & Crafts in New England, p. 84.

23. Boston Evening Post, May 7, 1744, as quoted in
Dow, Arts & Crafts in New England, p. 85.

24. Philip L. White, ed., The Beekman Mercantile
Papers, 1746-1799, 3 vols. (New York: New-York Historical
Society, 1956), 1:115. Gerard G. Beekman to Thomas
Gilbert in Philadelphia, August 27, 1750: "I am Sincable
it Cost 8/6 in Bristol but the Same Sort of Yeallow ware with
Small black dashes on it Comes also from Liverpool."

25. K. E. Farrer, ed., Wedgwood's Letters to Bentley
1762-1780, 2 vols. (London: Privately printed by the
Women's Printing Society, 1903), 2:2.

26. Meteyard, The Life of Josiah Wedgwood, 1:385.

27. Josiah C. Wedgwood, Staffordshire Pottery and Its
History (London: Sampson Low, Marston & Co., 1913),
pp. 119-22.

28. Wedgwood to Bentley, Aug. 6, 1779, as quoted in
Ann Finer and George Savage, eds., The Selected Letters
of Josiah Wedgwood (London: Cory, Adams & Mackay,
1965), p. 237.

29. Wedgwood to Bentley, Apr. 18, 1772, as quoted in
Finer and Savage, Letters of Josiah Wedgwood, p. 121.

30. Josiah Wedgwood to John Wedgwood, Mar. 6, 1765, as
quoted in Finer and Savage, Letters of Josiah Wedgwood, p. 30.

31. A. J. B. Kiddell, "William Absolon, Junior, of
Great Yarmouth," Transactions of the English Ceramic Circle
5, pt. 1 (London, 1960): 55.

32. There is a pearlware mug in the Glaisher Collection

(Fitzwilliam Museum, Cambridge), no. 1068, painted in underglaze blue and inscribed "DRINKING GREEN TEA" and "NANNY HARTLEY 1780."

33. Rita Susswein Gottesman, comp., The Arts and Crafts in New York, 1777-1799 (New York: New-York Historical Society, 1954), p. 99, no. 301.

34. This unpublished catalog in the Wedgwood Company's archives is dated on the evidence of the paper's 1809 watermark. The printed price list is dated 1810.

35. Mankowitz, Wedgwood, pls. 14-29.

36. Mankowitz, Wedgwood, p. 44, fn. 1.

37. "New Post Office Site," Colonial Williamsburg Excavation Register 417.

38. Donald C. Towner, The Leeds Pottery (London: Cory, Adams & Mackay, 1963), Leeds design book, 1783, nos. 22-25.

39. Shaw, Staffordshire Potteries, p. 186.

40. The reference is derived from notes taken by the author in the Wedgwood archives. The letter does not appear to have been published.

41. Finer and Savage, Letters of Josiah Wedgwood, p. 156.

42. Mankowitz, Wedgwood, facing p. 58, pl. 5, no. 83.

43. Llewellyn Jewitt, The Wedgwoods: Being a Life of Josiah Wedgwood (London: Virtue Brothers & Co., 1865), p. 244.

44. Donald C. Towner, "The Melbourne Pottery," Transactions of the English Ceramic Circle 8, pt. 1 (London, 1971): 21, fig. 2.

45. Victoria and Albert Museum 37-1904.

46. Geoffrey A. Godden, An Illustrated Encyclopedia of British Pottery and Porcelain (New York: Crown, 1966), p. 278, fig. 487.

47. A. W. Coysh, Blue and White Transfer Ware 1780-1840 (Rutland, Vt.: Charles E. Tuttle, 1971), p. 42, fig. 50.

48. That is not to say that the term "willow" was not used earlier, but simply that it was employed then, as it has been since, in such an indiscriminate way that its descriptive value has been lost. A printed billhead from the London

pottery and glass sellers, Elizabeth North and Son, dated
April 25, 1799, lists the sale of a half gross of tea ware
printed in "bro[wn] edge Willow." Winterthur Museum
Libraries 56x5.49b.
 49. "The Coalport Story," Wedgwood Review 4, no. 4
(Sept. 19, 1967): 2.
 50. Coysh, Blue and White Transfer Ware, p. 26, fig. 27.
 51. Leonard Whiter, Spode: A History of the Family,
Factory and Wares from 1733 to 1833 (New York: Praeger,
1970), p. 152, no. 20.

THE MORAVIAN POTTERS IN NORTH CAROLINA, 1756-1821

John F. Bivins, Jr.

THE MORAVIAN settlers of North Carolina were only one of many groups of German settlers who moved south and west from Pennsylvania during the eighteenth century. Their principal motivational drive toward settlement was, like that of a number of other German religious sects of the same period, evangelical. However, Moravian settlements tended to be considerably more cohesive than other German groups, since the Moravians had brought with them from Europe the concept of a <u>Gemein Ort</u>, or congregation town, wherein the citizens, all members of the Unity of Brethren, were sheltered under the gentle but firm umbrella of the various governing boards of the church itself. The church was the town, for it owned all the property, leasing the land only to members of the congregation. Its boards administered both the material and spiritual affairs of the town, and saw to it that the basic <u>Gemeinschaft</u> ideology of the community remained unbroken by intrusions of the <u>Fremden</u>, or strangers--the outside world, in short. Yet the Moravian <u>Gemein Ort</u> was a paradox in its very makeup. The major congregation towns built by the Moravians in North America were intended as manufacturing centers, not agrarian communities. A broad base of crafts was intended to stimulate intensive trade with the English communities, trade which in turn would provide the funds to support Moravian missions on the frontier, such as Gnadenhutten in Ohio. Ultimately, it was the Moravians' highly successful trade with outsiders that led to the general breakup of the social isolationism of the congregation towns during the early nineteenth century.

The North Carolina settlement was a major one in terms of planning. The Moravians had purchased almost 100,000 acres in the central piedmont from Lord Granville. The tract, called Wachovia after Nikolaus von Zinzendorf's estate in Saxony, eventually embraced three major communities--Bethabara, Bethania, and Salem--as well as a number of smaller satellite

communities settled by both Moravians and Fremden.
Bethabara, the first of the congregation towns in North
Carolina, was settled in 1753, followed six years later
by Bethania. Salem, the carefully planned central town of
the tract, was surveyed and begun in 1766. Salem became
the major trade center in piedmont North Carolina; the
quantity and complexity of its craft system was virtually
unparalleled in any southern piedmont town during the
eighteenth century.

In the settlement of new towns on the frontier, which were
intended to be self-supporting through trades, the Moravians
were faced with the problem of finding a sufficient number of
master craftsmen, and directing the men to areas where they
were most needed. Bethlehem became in effect a huge
clearinghouse for craftsmen destined to serve frontier
congregations. Each congregation requested the number and
type of craftsmen needed in the community. Potters, quite
naturally, were always high on the list of tradesmen needed.
In North Carolina the trade was considered so important
that the church designated the pottery a congregational
business owned by the church rather than the pottery master.
However, the new residents of Bethabara were forced to wait
two years before welcoming a master potter who could supply
them with the necessary household wares. It is the wares
made by this man, Gottfried Aust, and by his principal
apprentice, Rudolf Christ, that concern us here.

Aust was born in Heidersdorf, Silesia (now a part of
Czechoslovakia), in 1722. He had been apprenticed to one
Andreas Dober in Herrnhut, the central town of the Brethren
in Germany.[1] In 1754, Aust was sent to Bethlehem,
Pennsylvania, where he worked in the pottery under master
Michael Odenwald.[2] Some ten months after his arrival in
Bethlehem, in October 1755, Aust set out for the new
settlement in North Carolina with a group of other Brethren
and Sisters also destined for Bethabara. After a four-week
trip, the group reached the boundaries of Wachovia, Aust
and another man riding ahead "blowing on their trumpets the
verse 'Peace and health and every good be with you.'"[3]

Aust lost no time in setting up his trade in Bethabara. By

the middle of December, he had located flint for glazing and had begun to throw wares on the wheel.[4] The pottery shop was not actually completed until March 1756, and Aust did not make his first glost firing until the following August. The event was cause for considerable elation in the community, as noted in the Bethabara diarist's account: "Br. Aust has burned pottery today for the second time--the glazing did well--and so the great need is at last relieved. Each living room now has the ware it needs, and the kitchen is furnished. There is also a set of mugs of uniform size for Lovefeast." Two months later, the diarist was able to record that "Br. Aust burned stove tiles, and when they were ready he set up stoves in the Gemein Haus and the Brothers House, probably the first in Carolina." Despite continuing problems on the frontier arising from Indian raids during the Seven Years' War, trade in Bethabara was undamaged. By the early 1760s, Aust's wares were evidently well known in the outlying settlements: "June 15th people gathered from 50 and 60 miles away to buy pottery, but many came in vain, as the supply was exhausted by noon. We greatly regretted not being able to supply their needs."[5] Aust took advantage of the great need by selling to merchants southwest and west of Wachovia, who transported wagonloads of the pottery to Salisbury, North Carolina; Camden, South Carolina; the Waxhaw settlements in South Carolina; and the Watauga settlements in what is now Tennessee.

In 1771 Aust left his log pottery in Bethabara for a large new half-timbered shop in Salem, constructed for the purpose in 1768. The new building also incorporated living quarters in the north portion. Aust brought with him from Bethabara a twenty- by twenty-two-foot frame wing which he attached to the rear of the Salem pottery; inside this wing he built his kiln.[6]

During this period, Aust's most promising student was one Rudolf Christ (pronounced Krist) who was born in Württemberg, Germany, in 1750 (Fig. 1). Christ came to Wachovia from Bethlehem in 1764 along with a number of other boys who were to be bound out in the trades, and was apprenticed to Aust some time in 1766.[7] Christ's

Fig. 6. Tile stove, Salem, 1770-1800. H. 63", D. (at base) 21 1/16", W. (at base) 46 7/8". (Old Salem: Photo, Bradford L. Rauschenberg.)

Fig. 1. Artist unknown, Rudolf Christ, Salem, ca. 1825. Oil on canvas; H. 5", W. 3 1/2". (Courtesy Mrs. Marie Crist Blackwood.)

apprenticeship was a stormy one, and repeated conflicts with Aust caused concern among the members of the Aufseher Collegium, the board responsible for the operation of the pottery. At one time Aust branded Christ a "silly ass, like many other children of this community." Christ, in turn, asked frequently for permission to leave Aust's employ. In 1771 he was sent on trial to the shop of Valentine Beck, the gunstocker, where he remained a year before returning to the pottery.[8] It may have been here that Christ learned the carving skills which later enabled him to prepare master patterns for press-molded wares.

After repeated applications to the Collegium, Christ was permitted in 1786 to move to Bethabara, where he set up his own pottery in the former blacksmith shop.[9] Christ remained in Bethabara until early 1789, when he elected to return to Salem to take over as master of the Salem pottery. Aust had gone to Pennsylvania several months earlier to be cured of a cancer on his face, and had died in Lititz.[10] Christ was to work "on the same terms" as Aust had done; a contract drawn up by the Collegium specified that he was to receive as salary one half of the annual profits of the pottery, or sixty pounds if the profits were low. From Christ's salary was to be taken rent, interest on the inventory, and wages for the journeymen. The new master was counseled to "work said Pottery according to his best knowledge and ability as its head and master and to seek to get out of it all the profit consonant with good business practices and good conscience, responsible to God and man." Christ was also to "serve his customers modestly and with good wares at a fair price, without bargaining or selling at one price to one and a different price to another."[11] This last phrase evidently refers to problems that Gottfried Aust had caused in the past. Christ, however, was a less choleric man than his former master; he managed to serve the people of piedmont North Carolina with sensitivity and to run the Salem pottery efficiently. When Christ retired in 1821, the Collegium noted that he had "served in the pottery for many years faithfully and enrichingly for the whole community." Christ was given an annual pension of $150 as well as free firewood

in recognition of his services. He died in 1833, the "oldest
member of the congregation."[12]

Watercolor views showing two of the three pottery
buildings used by Aust and Christ survive today. A View of
Bethabara, now in the Moravian Archives in Herrnhut,
Germany, was painted about 1761 and depicts the town from
the southwest. Aust's small story-and-a-half log pottery,
constructed in 1756, can be seen in a corner of the palisade
that surrounded the town at the time (Fig. 2). Today only an
excavated cellar exists on the site. Fortunately, the large
half-timbered structure in Salem, which housed both the shop
and dwelling of Aust and Christ, is well described pictorially
and in the records (Fig. 3). As it stood in 1768, the Salem
pottery was twenty-six feet deep and fifty-six feet long;
the southern half of the building, its space augmented by the
small wing that Aust erected in 1771, constituted the pottery
shop. In 1797 Christ decided that the shop was no longer
large enough for "the strong sale of pottery"; consequently,
a half-timbered addition twenty-three feet across the front
was attached to the south end of the building. In a rough
floor plan of the new wing, Christ made notations for the
location of his four potter's wheels and the two bins used
for storing both processed and raw clay.[13] The rear yard
of the Salem pottery was cluttered with drying sheds,
woodsheds, and the area used to wash the raw clay.
Although no description remains of the method used by the
Wachovia potters to wash their clay, it is probable that
some form of settling tank was used. A cistern located
above the pottery lot provided water through underground
wooden pipes.

Although Aust housed his beehive-type kiln in the rear
wing of the pottery, the fire-conscious Collegium had never
been in favor of firing wares inside the building. An
inspector noted in 1780 that "the chimney in which the potter
burns his ware has holes in it . . . it is sometimes red hot,
so that flames shoot out above." No doubt the children of
the community were well pleased by the spectacular event
of firing the kiln, but the Collegium was horrified. Finally,
in 1791 Christ agreed to construct a new kiln in the rear yard

Fig. 2. Artist unknown, A View of Bethabara, 1761-63. Watercolor. (Moravian Archives, Herrnhut, Germany.)

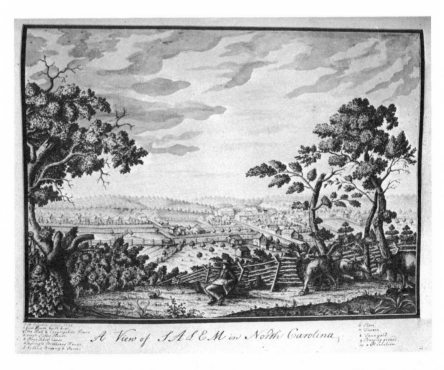

Fig. 3. Ludwig G. von Redeken, A View of Salem in North Carolina, 1788. Watercolor. The pottery is the third building from left. (Moravian Archives, Herrnhut, Germany.)

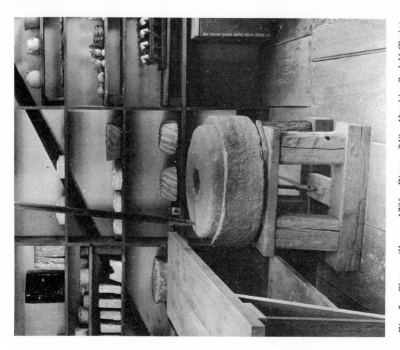

Fig. 5. Glaze mill, ca. 1786. Diam. 24". Used by Rudolf Christ and subsequent Salem potters. (Old Salem: Photo, Bradford L. Rauschenberg.)

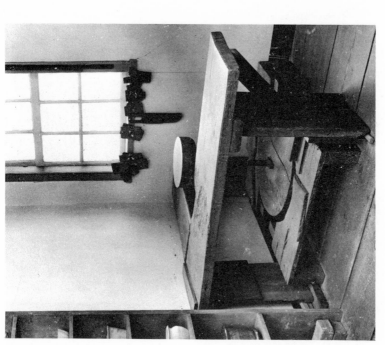
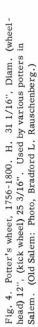

Fig. 4. Potter's wheel, 1756-1800. H. 31 1/16", Diam. (wheel-head) 12", (kick wheel) 25 3/16". Used by various potters in Salem. (Old Salem: Photo, Bradford L. Rauschenberg.)

of the pottery. The expenses in constructing the kiln amounted to £164.[14] A third kiln was built across the street from the pottery in 1793 for the purpose of firing faience pottery, and in 1811 the kiln in the rear yard of the pottery was dismantled and rebuilt next to the faience kiln.[15] After 1811 all Salem pottery was fired on the lot across the street facing the pottery.

Old Salem is fortunate in having a number of potting tools used by both Aust and Christ. When the pottery ceased to operate as a congregation business in 1829, the pottery implements were sold to Christ's apprentice, John Holland. The tools were subsequently passed along to Heinrich Schaffner and Daniel Krause, the last potters working in Salem. Many of the extant tools were listed on the meticulous inventories kept by Aust and Christ, although some items made in the shop such as slip cups and kiln furniture were never listed.[16] The more important items appeared regularly on the annual inventories; these included the "3 wheels" listed on Aust's inventory in 1780 at a value of £1.10 each. Christ subsequently added a wheel to the pottery after 1788. For use in throwing, Aust listed "4 shapes," or ribs, in 1776, several of which have survived (Fig. 13), along with "brass wire" and "1 pair nippers" for making cut-off wires. Buckets, hoes, shovels, "clay beetles," wheelbarrows, and wedging blocks, all for processing clay, are listed. For making glaze, a mortar, glaze spoons, and one scale with iron pans are listed, along with an extant glaze mill valued in 1789 at £7.8 (Figs. 4, 5). Flint, red lead, manganese, iron, and copper--ingredients of the primary lead glazes used by the Wachovia potters--are regular yearly entries. During the 1790s, listings of tin, soda, lead antimony, and silver litharge, along with cobalt and salt, correspond with the manufacture of both faience and salt-glazed stoneware in Salem.

One example of a tool for making press-molded articles is the pipe press listed in 1793 at twelve pounds, in which three pipe forms of pewter and brass were used to form the exterior surface of the pipe heads. Tile stoves required a

considerable number of molds for body tiles and for bed and
cornice moldings; five sets of stove molds were listed on an
inventory as late as 1829 (Fig. 6). Press-molded plates
figured heavily in Christ's production during the 1780s;
forty plate molds, valued at two pounds, may be found in
the pottery inventory for 1789 (Figs. 7, 8). Many of the
molds were bisque-fired clay, although plaster was the
preferred medium due to its more hygroscopic nature. Gypsum,
used in making plaster molds, occurs frequently in the
inventories, and all the press-molded bottle and figure forms
made in Salem after about 1780 were made in plaster molds.

The pottery made by Gottfried Aust and Rudolf Christ may
be divided into two fairly distinct periods, allowing for a
certain amount of chronological overlap in technique and
design. The first period, 1756 to 1773, embraces wares
based largely on European types. The second period extends
from 1774 to 1821, the year in which Christ retired. The
pottery of this period is characterized by a combination of
strong English influence and continental forms and decoration.
A third period can be identified in the wares made by the
potters who followed Christ, but these wares are beyond the
scope of this paper.

Identification, attribution, and typology of the earthen-
wares produced by the North Carolina Moravian potters has
been carried out by the correlation of existing whole
specimens, archaeological specimens, existing molds for
the press-molded pottery, and manuscript inventories
prepared by Aust and Christ for the <u>Gemein Diaconie</u>, which
owned the pottery. Archaeological studies pursued in both
Bethabara and Salem over the past decade have been most
helpful to the author. Three major pottery sites associated
with the Moravian potters are yet to be excavated, making
a quantitative study of the production of stoneware, faience,
and English-type forms impossible at this time. Excavation
of two of these sites must await the acquisition of
properties by Old Salem.

Utilitarian Pottery

Gottfried Aust's pottery production in Bethabara represents

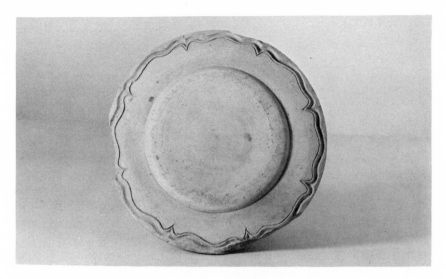

Fig. 7. Rudolf Christ, Plaster mold for a queen's-ware plate, Salem, ca. 1790. Initials "RC" scratched on back. (Old Salem: Photo, Bradford L. Rauschenberg.)

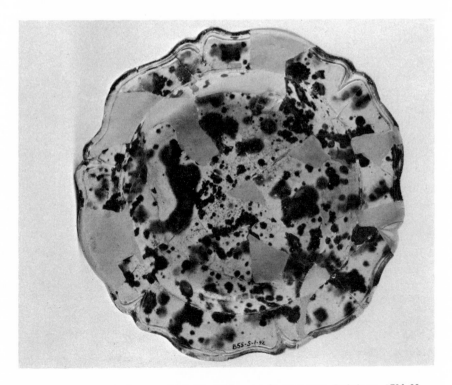

Fig. 8. Rudolf Christ, Press-molded plate of the queen's-ware type, Bethabara, 1786-89. Clear glaze with underglaze sponging of manganese and copper over white slip; brown glaze on back; Diam. 9 7/8". (Old Salem: Photo, Bradford L. Rauschenberg.)

a good cross section of the quantity and type of wares that
may be classified as utilitarian. These wares represent the
bulk of the production of both Aust and Christ, since any
earthenware potter quite naturally received the greatest
demand for kitchen and tablewares. Over one hundred
distinct pottery forms made by the Wachovia potters are
known; consequently, only a few of these can be discussed
here. Slip-decorated pottery will be discussed below.

In the typology of the Wachovia pottery, the potters'
inventories have proved valuable. The inventories compiled
by Rudolf Christ after 1789 are the most complete, and they
list a highly diverse number of forms. Fortunately, the
prices given in the pottery inventories are retail. The potters
made a practice of deducting 33 percent of the total valuation
of wares on hand to arrive at the cost price. This indicates
that retail prices represented a markup of 50 percent.
Categories of wares derived from the inventories include
bottles, jugs, jars, drinking vessels, bowls, pans, pots,
plates, lighting devices, and miscellaneous forms.

Although the term "bottle" could apply to several
different shapes, the standard form in Wachovia follows
European precedent in its squat, flat, circular form. Many
bottles are provided with a foot, and some are thrown as a
ring, not unlike the so-called harvest jugs common in this
country in the mid-nineteenth century. The finish of these
pieces may be a standard green or brown glaze, or they may
be slip-decorated with a clear glaze. One such example in
the Brooklyn Museum is dated 1800; its form is identical to
one recovered in the biscuit state at the Aust pottery in
Bethabara, 1756-71. Footed bottles of the ring form were
also made with a faience glaze during the 1790s in Salem
(Fig. 9). Bottles are listed in the 1789 inventory at prices
ranging from one shilling to 2s.6d.; another inventory lists
"sack bottles" at similar prices. Variously listed as
"rundlets" and "little barrels" at 1s.6d. and 3s., the small
barrellike bottles made by Christ after about 1795 have
ample precedent in both the northern states and Europe.

Until about 1815, the notation "jugs" in the Wachovia
pottery inventories refers to pitchers. The latter term was

Fig. 9. Rudolf Christ, Footed ring bottle, Salem, ca. 1794. Green faience glaze with brown glaze inside; H. 7 1/16", Diam. 5 1/2". (Old Salem: Photo, Bradford L. Rauschenberg.)

Fig. 11. Rudolf Christ, Coffee urn, Salem, ca. 1821. Brown glaze inside; H. 14 11/16". This jar was not fitted with a spout. (Old Salem: Photo, Bradford L. Rauschenberg.)

Fig. 10. Gottfried Aust, Narrow-neck jug in the biscuit state, Bethabara pottery site, 1756-71. H. 8 11/16". (Old Salem: Photo, Bradford L. Rauschenberg.)

not used until after 1815, and before that time storage jugs were referred to as "narrow neck jugs" to distinguish them from the pitcher forms. Jugs were made in varying sizes, from small cream jugs to large water and milk jugs with domed lids. The 1806 inventory lists them at prices ranging from 16s. to 32s. per dozen. At about the same time, narrow-neck jugs are listed at 1s.4d., 1s.6d., 1s.8d., and 2s.4d. (Fig. 10). After 1800 a separate listing for "stone" jugs--gray salt-glazed stoneware--shows correspondingly higher prices of 5s. to 7s. Surprisingly, none of the stoneware jugs survive.

Of clear European precedent are the articles listed in the inventories as "apothecary jars," "doctor bottles," and "gallipots," although the latter term is a misnomer. These jars, priced at sixpence each in 1789, followed the typical European _alboretto_ form with a string rim and rebated foot; some of them were finished with a white slip and clear glaze, probably to give the impression of delftware. Storage jars, some of them quite large in size, were often fitted with domed lids. The purpose of one jar in the Old Salem collection is made clear by Rudolf Christ's incised inscription on its bottom (Fig. 11).

> Today we celebrate Lovefeast.
> That you can tell by the good turnout.
> When this urn is full of coffee.
> How few here will be missed.
> And when it's full, then I'm right there.
> And when it's empty, then we'll sing Hallelujah.
> March 12, 1821.

Both Aust and Christ offered mugs for sale in quart, pint, half-pint, and gill sizes, ranging in price from 4d. to 1s.2d. Aust's mugs of the early period show strong English influence in their quasi-architectural forms (Fig. 12). The coved foot and medial bolection moldings on some pieces suggest parallels to English agate and salt-glazed examples of the mid-eighteenth century. It remained for Christ, however, to employ the full English form, complete with ribbed,

Fig. 13. Brass ribs, 1780-90. H. (left) 6", (right) 7 1/4". Used by Rudolf Christ in making pint and quart mugs of the creamware type. (Old Salem: Photo, Bradford L. Rauschenberg.)

Fig. 12. Rudolf Christ, Quart mug, Bethabara, 1756-89. Brown glaze outside, clear glaze inside; H. 6 1/4". Although the scrolled terminal of the handle resembles the work of Aust, the English form of this piece is typical of the work of Christ. (Old Salem: Photo, Bradford L. Rauschenberg.)

extruded handles with pinched terminals. Glazes on mugs,
irrespective of size, were usually brown or green, with
clear glaze and white slip inside, although not a few
excavated sherds indicate that the Whieldon-type underglaze
mottling of brown and green was also popular. Tumblers
and teacups were also included in the category of drinking
vessels. The teacups, made with or without handles in the
form of a typical Oriental tea bowl, were thinly potted and
had (as did the matching saucer) a foot ring finished by
turning. The cups commonly had a manganese glaze on the
exterior, with clear glaze over white slip inside. A more
unusual form is a piece recovered at the Aust pottery in
Bethabara, which probably takes its form from the knopped
wineglasses of the period. Possibly the expense of
importing glass into piedmont North Carolina motivated
Christ in his copying the form.

Numerous bowl forms were produced by the Wachovia
potters. Among the smallest was a relatively conventional
porringer made in several sizes, ranging in price from
5d. to 8d. A more unusual form, probably of European
derivation, was a lidded porringer with two press-molded
rococo handles (Fig. 14). Sherds from one example of this
type show the use of mottled brown and green glaze, which
was also occasionally used on the standard porringer. Bowls
intended for kitchen use ranged in price from 6d. to 1s.6d.,
depending on size and glaze variations. The unusual rim
forms of these pieces belie European influence; some of the
bowls were fitted with either lug or strap handles and
probably correspond to the term "hand basin" found in the
inventories. Smaller bowls, especially during the middle
period in Salem, often reflect the influence of pewter basins
in the architectural nature of their rims.

Pans differed little from bowls except for their straight
sides. They were more often slip-decorated than bowls, one
1792 inventory notation listing "decorated pans" at 5d., 8d.,
1s., 1s.4d., and 1s.6d. Skillets, also in the category of
pans, are listed as late as 1808 at 1s.4d. and 1s.8d.; Aust
made skillets in Bethabara with three legs and a socket for
a wooden handle (Fig. 15). Of similar form, but evidently

Fig. 14. Gottfried Aust, Lidded porringer, Bethabara pottery site, 1756-71. Brown glaze inside and out; Diam. 7 1/2". (Old Salem: Photo, Bradford L. Rauschenberg.)

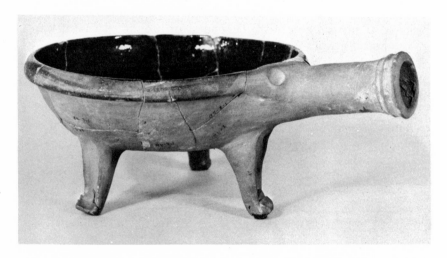

Fig. 15. Gottfried Aust, Skillet, Bethabara pottery site, 1756-71. Brown glaze inside; H. 4 1/8", Diam. 8 1/2". (Old Salem: Photo, Bradford L. Rauschenberg.)

not used with a wooden handle, were the deeper saucepans
also listed in the inventories. Like much utilitarian ware,
these pieces had a glaze inside and no glaze on the exterior.
Lack of exterior glaze lessened the problems of stacking the
kiln for a glost fire.

The form found in greatest numbers in the pottery waster
dumps is the ubiquitous crock, called cream pot and milk pot
by the Wachovia potters and made in several sizes. They are
listed at prices from 5d. to 5s., the latter price describing
the large stoneware crocks made in Salem after 1800. Cream
and milk pots follow no unusual form in Wachovia; the
earlier examples tend to have bulging sides, while the later
ones are straight-sided.

Teapots made in Wachovia show both European and
Oriental influences in their form. Christ lists them in his
1790 inventory at 1s.4d., 1s.6d., and 1s.8d. Aust had a
predilection for shaving the spouts in the leather-hard state
to produce a faceted effect (Fig. 16). Kettles made for use
with the teapots were fitted with lugs at the rim for a wrapped
wire handle, such as those found on the sherds of a finished
example excavated in Bethabara. "Cook pots" were fitted
with a lid and resembled the typical New England bean pot.

The Wachovia potters apparently used the terms plate and
dish interchangeably. They were cheaply priced at two-,
three-, and fivepence each in 1791. Most plates undoubtedly
had a simple brown glaze, although the identical form was
also slip-decorated. The sectional form of thrown plates
provides certain clues for dating, since there is a definite
stylistic development. The early plates, through approximately
1790, have a rolled, everted rim, a double booge, and a
well-defined foot. Later examples, the result of a gradual
transition in the late eighteenth century, tend to have a
squared rim, a concave booge, and no foot.

Lighting devices made by Aust and Christ are unique in
form. Although wheel-thrown lamps and candlesticks are not
listed on the inventories, they were evidently made in some
quantity, judging from the Bethabara wasters. The fat lamps
were true betty lamps, since they were fitted with a wick
tube; their delicate baluster form and drip pan rank them high

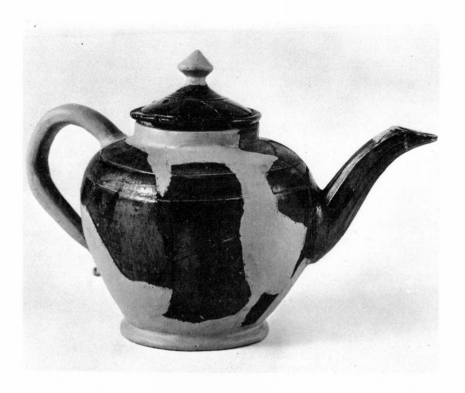

Fig. 16. Gottfried Aust, Teapot, Bethabara pottery site, 1756-71. Brown glaze outside, clear glaze inside; H. 5 15/16". The handle is a conjectural restoration. (Old Salem: Photo, Bradford L. Rauschenberg.)

among American earthenware lamps (Fig. 17). Baluster
candlesticks show a great diversity of form, apparently
since none were rib-thrown (Fig. 18). Two sherds from the
Aust pottery at Bethabara are decorated with shaved facets,
not unlike certain forms of the so-called Cistercian ware.
The complexity and height of these pieces amply demonstrate
the great technical ability of the Moravian potters. A smaller,
equally baroque form of saucer-base chamber stick was also
popular; one complete specimen is in the Old Salem collection.

Among some miscellaneous forms excavated at Bethabara,
is a brazier obviously intended for use at the table (Fig. 19).
In making the brazier, three separate pieces were thrown on
the wheel: the body, the foot, and the handle. A small
open chamber under the body received ash filtering down
through piercings. Other miscellaneous forms include
funnels, sanders, standing salts, and crucibles, as well as
marbles, churns, and even ceramic water pipes, both
earthenware and stoneware. Rudolf Christ began producing
pipes about 1806, when it was discovered that the old
wooden ones in Salem were rotting out.

In 1773 an English journeyman potter visited Salem for
five months. During his brief stay he managed to alter
radically the nature of earthenware production at the Salem
pottery. This potter, one William Ellis of Hanley,
Staffordshire, had come to Salem in one of the Brethren's
wagons from Camden, South Carolina. He was evidently
destitute, having been without regular work for over a year.
Ellis had come to America to work in the shop of John Bartlam
in Charleston, South Carolina, who had proudly, if pre-
maturely, announced to the public that he had opened his
"Pottery and China Manufactory in Old Church Street,"
where he made "what is called Queensware, equal to any
imported." Bartlam's attempt to compete with imported wares,
however, was short-lived. Somewhat later, none other than
Josiah Wedgwood attributed this failure to the environment,
noting that the "change of climate and manner of living,
accompanied perhaps with a certain disorder of mind . . .
carried [the pottery workers] off so fast, that recruits
could not be raised from England sufficient to supply the

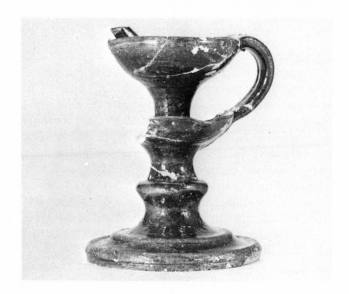

Fig. 17. Gottfried Aust, Betty lamp, Bethabara pottery site, 1756-71. Brown glaze overall; H. 4 3/4". (Old Salem: Photo, Bradford L. Rauschenberg.)

Fig. 18. Gottfried Aust, Baluster candlesticks, Bethabara pottery site, 1756-71. Brown glaze on both; H. (left) 3 3/16", (right) 3 7/8". (Old Salem: Photo, Bradford L. Rauschenberg.)

Fig. 19. Gottfried Aust, Brazier in the biscuit state, Bethabara pottery site, 1756-71. H. 4 5/16". Major portions of this piece are restorations based upon existing sherds of other braziers bound in the same context. (Old Salem: Photo, Bradford L. Rauschenberg.)

Fig. 20. Attributed to William Ellis, Teapot of the queen's-ware type, Salem, ca. 1774. Clear glaze with underglaze sponging of copper and manganese; H. 3 7/8". (Old Salem: Photo, Bradford L. Rauschenberg.)

places of the dead men."[17] This shrewd statement was
meant by Wedgwood to discourage any of his own people
from leaving his employ for America. Ellis, however, had
escaped the miasmal fevers of the Low Country, and the
Collegium in Salem agreed to hire him as a day laborer.
Aust was interested in learning the art and mystery of
glazing and burning queen's ware, a skill already familiar
to Ellis. In return Ellis was promised "food and clothing,
and a doceur for his work." Under the supervision of the
English potter, Aust immediately built a small experimental
kiln on the south line of the pottery lot. Ellis probably
brought with him certain tools of his trade, such as sprig
molds and roulette wheels for the decoration of creamware,
since the Salem potters immediately set to work learning the
new forms. The Collegium watched the experiments with
interest, noting that "all the vessels had to be made by
hand on the potter's bench, instead of with instruments on
a potter's wheel."[18] The pottery from Ellis's experimental
kiln must have startled the people of Salem, who were
accustomed to the simpler forms made there during almost
two decades. The waster dump associated with this kiln
mutely attests the nature of the Salem experimental
queen's-ware forms. The major pieces from the experimental
kiln include a delicate teapot and a magnificent quart mug
with gadrooned rouletting and extruded, sprigged, double-
entwined handles, as well as several smaller forms of mugs,
all of which follow English production in Leeds, Staffordshire,
and other districts (Figs. 20, 21). The waster pieces had
been greatly overfired, having reached stoneware quality,
although Ellis obviously had intended to duplicate creamware.
Some of the pieces distorted and liquefied in the kiln,
sticking to their setting tiles, although the lead glazes
survived the high firing remarkably well. By May 1774
Ellis had achieved a more successful firing of the queen's
ware, and, evidently satisfied that his students would be
able to carry on the work, left with a ten-pound fee in his
pocket. The Brethren noted that "the good man found our
town too narrow for him, so for the present has bid us a
friendly farewell."[19]

Fig. 21. Attributed to William Ellis, Quart mug of the queen's-ware type in the biscuit state, Salem, ca. 1773. H. 5 15/16". (Old Salem: Photo, Bradford L. Rauschenberg.)

Fig. 22. Rudolf Christ, Sprig mold in the biscuit state, Salem, 1773-90. Initials "RC" incised on back. H. 1 3/8", W. 1 7/8". (Old Salem: Photo, Bradford L. Rauschenberg.)

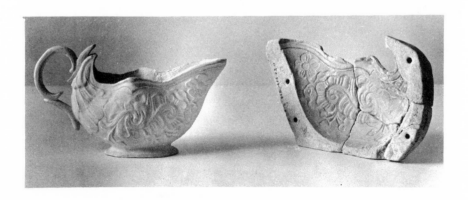

Fig. 23. Plaster sauce boat mold, Bethabara pottery site, 1773-89. Mold cavity 6 3/4" long. (Old Salem: Photo, Bradford L. Rauschenberg.)

The main impact of queen's-ware production in Salem
seems to have been on Aust's chief journeyman; this
chapter in Salem ceramics might well be called "the
Englishing of Christ," so avidly did he seize upon the
manufacture of the new pottery. Aust was more interested
in the standard production wares, and even the Collegium
considered queen's ware as a sideline. A very real
dichotomy developed in the production of pottery, for
Christ had learned from Ellis that "the fine pottery cannot
be manufactured together with rough pottery, because the
finest grain of sand that comes into the white clay, will do
great damage, and as concerns the drying, just the opposite
has to be done with one then with the other." At one point
Christ, in a fine fit of artistic temperament, walked out of
the pottery with several molds used in making "flowers for
the fine pottery" (Fig. 22). The Collegium resolved this
bickering by assigning Aust to make only the regular pottery
and Christ to "make no other kind of pottery than that from
washed clay"--queen's ware.[20] Christ continued in this
line until he left to open his own pottery in Bethabara in
1786. After that date his wares are a mixture of both
German and English forms. Although it is not known to what
extent Christ worked with the more elaborate sprig-decorated
pieces, archaeological evidence of his simpler creamware-
type pieces is ample, particularly at his 1786-89 Bethabara
pottery site. We have seen English-type mugs with extruded
handles that may be attributed to Christ; the sectional profile
of the handles of the small half-pint mugs is identical to
that on the extruded handle of the bisque quart mug attributed
to Ellis's experimental work in Salem. In addition to mugs,
Christ produced bowls, tumblers, and numerous other forms
of hollow ware that are close to English prototypes in form
and glaze. Press-molded pieces include at least two forms
of gravy boats (the molds for which survive and which Ellis
may have brought with him) and a host of molded rococo
plates that differ not at all from the simpler versions of
English creamware (Figs. 8, 23). Among the forty plate molds
owned by Christ in 1789 were designs for at least five
border patterns and a number of sizes. Several of the original

plaster molds are initialed "RC," and some are dated as well.
In use, the molds were placed on the wheel, and the back of
the plate was finished with a jigger to insure uniformity.
Although the mottled glazes that Christ used on these plates
are conventional, his use of rouletting on the backs seems
to follow no English precedent.

After his introduction to foreign forms, Christ was ready
to undertake new types of pottery. The business manager of
Wachovia, Frederic William Marshall, noted that experimen-
tation was good for business. "Usually each new line draws
new customers, and there are potters enough around us where
they would otherwise go." Marshall wrote this in 1793,
shortly after Carl Eisenberg, a German journeyman potter,
arrived in Salem with a manuscript entitled "A Collection of
Faience-China Glazing Formulas: and also, All Sorts of
Painters' Colors and How Such are to be Treated."[21] Although
Christ's ventures into decorated faience pottery cannot yet
be completely examined, it is quite evident from a number of
sherds that both plain faience and brush-painted wares were
being produced in Salem during the 1790s. The ceramic
chemicals listed on Christ's inventories during this period
bear this out, since they match the formulas called for by
Eisenberg in his recipes. Christ also undertook the manufacture
of gray salt-glazed stoneware during this period. Although
the stoneware kiln site has not yet been excavated, evidence
is strong that the ware was cobalt decorated.

At the end of the eighteenth century, Christ began pro-
duction of yet another type of press-molded pottery, in
addition to the pipes, stove tiles, and queen's-ware forms
that had probably gone out of style in Salem by that time.
From about 1800 until 1821, the year of Christ's retirement,
innumerable molded animal and human figurines issued from
the Salem pottery. Although some of this ware resembles the
molded figures made in Staffordshire during the eighteenth
century, Christ's pieces combine the folk characteristics of
realism and stylized details. To my knowledge, few other
American potters during the period produced molded earthen-
wares of the quality and detail of Christ's work; his collection
of molded bottles and toys represents American folk art at its

best. Many of these pieces were complex and expensive,
requiring the use of as many as six individual molds for one
figure. The preparation of the master patterns was often
ingenious; the turtle, for example, was actually molded
from the shell of a box turtle (Fig. 24). The problem of
providing a head large enough to take a bottle spout was
solved by carving a master pattern in the form of a snapping
turtle's head. The turtle first appears in Christ's inventory
for the year 1800. It was quickly followed by a host of
companions: toy birds, chicken casters, toy dogs, doll
heads, duck tureens, foxes, geese, Indians, lions,
mushmelons, toy sheep, turkeys, and bottles in the shape
of bears, crawfish, eagles (obviously taken from a mold-
blown glass flask of the period), fish, owls, and squirrels
(Fig. 25). Christ made some of the pieces in several sizes,
and they ranged in price from fivepence for a small fish
bottle up to ten shillings for an Indian. Although no intact
figure exists in the collection, Old Salem owns the original
plaster molds for most of the thirty-odd molded figures
(Fig. 26).

Decorated Pottery

The European tradition brought to Wachovia by Gottfried
Aust is more apparent in the slip-decorated pottery than in
all other types of earthenwares made by the Moravian potters
in North Carolina. The European nature of this pottery
remained unaltered under the hand of Christ and testifies to
the strength of the European cultural ties that influenced
Wachovian artisans in several craft fields in the eighteenth
century. Surprisingly, the Moravian potters in Pennsylvania
seem to have been quicker to shrug off European details than
their contemporaries in North Carolina, although a compara-
tive study cannot be completed until the early pottery shop
in Bethlehem is excavated.
 Slip-decorated pottery was made during the earliest
period in Bethabara, and production probably did not decline
until shortly after 1820. Although pans, jugs, sugar jars,
and other articles were decorated, the decorated pieces most

Fig. 24. Attributed to Rudolf Christ, Turtle bottle, Salem, 1800-21. Brown glaze overall; L. 7 1/8". (Old Salem: Photo, Bradford L. Rauschenberg.)

Fig. 25. Attributed to Rudolf Christ, Fish bottle, Salem, 1810-21. Green glaze; L. 6 1/8". (Old Salem: Photo, Bradford L. Rauschenberg.)

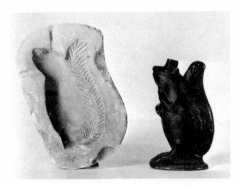

Fig. 26. Attributed to Rudolf Christ, Squirrel bottle (shown with half of an original plaster mold), Salem, 1810-21. Brown glaze; H. 6 5/16". A third mold was required for the foot. (Old Salem: Photo, Bradford L. Rauschenberg.)

often appearing in the inventories are plates of various
sizes. In his inventory of 1794, Christ listed 454 "decorated
dishes," most of them with a retail price of over one
shilling. Some pieces were as expensive as two shillings,
the same price noted for 150 dozen glazed pipes during the
same period. The number and types of decorated forms
other than plates is difficult to determine from inventories.

Archaeological evidence for identifying intact specimens
is ample, particularly at the Salem pottery site and at
Christ's pottery in Bethabara (Fig. 27). In addition to the
sectional form of plates previously discussed, several
important slip-trailed motifs common to both excavated
sherds and intact pieces serve to identify Wachovia
decorated pottery. Some of these details are overtly
European in origin, particularly the motif that English
ceramicists call the vandyke after its obvious similarity to
the pointed lace collars found in the seventeenth-century
Flemish portraiture. Not unlike a sectioned seed pod in
appearance, this device appears both on plates and on
hollow ware with great regularity (Fig. 28i). The same
device may be found on eighteenth-century faience from
Moravia (now Czechoslovakia) and on slip-decorated
pottery of the same period from Romania and probably from
other eastern European countries as well. In fact, the
vandyke also occurs on seventeenth-century decorated
earthenware from Staffordshire.[22] A slip-decorated plate
in the Philadelphia Museum of Art, as well as a press-
molded plate in the Winterthur Museum, both bearing the
same motif, indicate that the vandyke was not unknown in
Pennsylvania, although it appears to have been rarely used.

An important key to the study of decorated pottery in
Wachovia is the immense trade sign of Gottfried Aust,
actually a large plate some twenty-two inches in diameter
(Fig. 28e). It was made in accordance with a directive
from one of the boards in 1773 that trade signs be placed
on shops in Salem "in order that strangers could find them
easily." The signs were required to have "the name of the
master and the trade."[23] Aust's elaborate plate was fitted
with two lugs at the back for hanging. Although the vandyke

Fig. 27. Plate in the biscuit state, Salem pottery site, 1771-90. Slip decoration; Diam. 9 1/4". Note the use of vandykes on the marly of this plate. (Old Salem: Photo, Bradford L. Rauschenberg.)

Fig. 29. Attributed to Rudolf Christ, Sugar jar, Salem, 1789-1821. Brown, white, and green slip over the red body; H. (with lid) 7 1/2". (Old Salem: Photo, Bradford L. Rauschenberg.)

Fig. 28. Plates. a, Attributed to Gottfried Aust, Salem, 1771-88. Green, gray, brown, and red slip over a white slip base; Diam. 13 5/8". b, Friedrich Rothrock, South of Salem, 1790-1800. Initials "FR" on back. Green, red, and brown slip over a white slip base; Diam. 11 1/2". Rothrock evidently was an apprentice of Aust, although he is not recorded as such. c, Attributed to Gottfried Aust, Salem, 1771-88. Red, green, and brown slip over a white slip base; Diam. 13 13/16". The realism of this decoration resembles overglaze enameling on European faience pottery. d, Attributed to Rudolf Christ, Salem, 1789-1821. White, green, and red slip over a dark-brown slip base: Diam. 10 1/8". e, Gottfried Aust, Salem, 1773. White and green slip over red body; Diam. 21 11/16". This plate was used as Aust's trade sign. f, Attributed to Rudolf Christ, Salem, 1789-1821. White, green, and red slip over a dark-brown slip base; Diam. 10 1/8". g, Attributed to Rudolf Christ, Salem, 1789-1821. White and red slip over a dark-brown slip base; Diam. 10 5/8". h, Attributed to Rudolf Christ, Salem, 1789-1821. White and red slip over a dark-brown slip base; Diam. 15 1/4". i, Attributed to Rudolf Christ, Salem, 1789-1821. White and red slip over a dark-brown slip base; Diam. 12 5/8". (Old Salem: Photo, Bradford L. Rauschenberg.)

does not appear on this piece, several unusual details do,
such as the incised schnörkel, or frakturlike calligraphic
strapwork, which is actually inlaid with white slip. This
technique does not appear on other surviving pieces, but
the crosshatched lozenge on the marly of the plate is
similar to a crosshatched fish on a plate attributed to Aust
in the Henry Ford Museum. Highly characteristic of the
work of Aust is the elaborate plant form with heavily lobed
leaves that appears repeatedly on other pieces (Fig. 28a, c).
But by the end of the eighteenth century, Aust's plant designs
had degenerated into leaves formed by a single trail of
slip (Fig. 28i). Christ clung to many of the European
details shown in the work of Aust, such as the frequent use
of dark slip washes under trailed motifs of lighter slip
(Fig. 28d, f, g, h, i), the use of more than two colors of
slip in decoration (occasionally as many as four colors as
in figure 28f), and the tendency toward sophisticated
abstraction in trailed motifs (Fig. 28g). Christ made heavy
use of the vandyke and other motifs, such as large lunettes
with a dotted outline and a type of polychrome "grass"
found on the marly of plates and at the shoulder of sugar
jars (Fig. 29). Simpler pieces are often decorated with
brushed and trailed banding that differs very little from the
plain slipware made in other parts of the country. Often
these pieces must be identified by potting techniques, such
as the form of an extruded handle or the shape of the back
of a plate. Trailed inscriptions and dates are rare on the
work of Aust and Christ, although they do occur.

That earthenware pottery of such sophistication, both
decorated and utilitarian, could be produced on the
Carolina frontier at an early date should not be considered
a mystery. The Moravians were a pragmatic sect; they set
out to erect craft-oriented communities on the frontier,
where virtually no trades existed, and they gave little
thought to the odds against success. They sought the best
craftsmen available within their Unity of Brethren, and
these men set to work in the new towns with the full
knowledge that the integrity of their work would be in part
a measure of the success of the Gemein Ort as a whole.

Certainly, the work of both Gottfried Aust and his apprentice, Rudolf Christ, amply illustrates the Moravian ideal of craftsmen "responsible to God and man," who took the fullest advantage of the skills of their hands and minds.

NOTES

1. "The Memoir of Br. Gottfried Aust, Who Fell Asleep in Lititz on October 28, 1788." Typescript, Archives of the Southern Province of the Moravian Church, Winston-Salem, North Carolina (hereafter ASM).

2. Miscellaneous entries, Bethlehem Diary, Archives of the Moravian Church, Bethlehem, Pennsylvania.

3. Wachovia Diary, Nov. 4, 1755, ASM.

4. Wachovia Diary, Nov. 28 and Dec. 1, 1755, ASM.

5. Glazes can be fused to a piece in the first firing or in a second, or glost, firing. "Memorabilia of Outward Affairs, 1756," Bethabara Diary, Aug. 23 and Sept. 10, 1756, June 15, 1761, ASM.

6. Minutes of the Helfers Conferenz, Nov. 9, 1767; Wachovia Diary, June 3, 1768; Bethabara Diary, June 17, 1771, ASM.

7. "Catalogue of the Inhabitants of Bethabara in Wachovia, 1766," ASM.

8. Minutes of the Aeltesten Conferenz, June 16, 1772, ASM.

9. Minutes of the Aufseher Collegium, Dec. 20, 1785, ASM.

10. Salem Diary, Nov. 17, 1788, ASM.

11. Contract between R. Christ and the Salem Diaconie, Feb. 1, 1789, ASM.

12. Minutes of the Aufseher Collegium, May 14, 1821 and Nov. 14, 1825; Salem Diary, July 28, 1833, ASM.

13. Minutes of the Aufseher Collegium, Nov. 21, 1797; undated drawing by Christ, ASM.

14. Minutes of the Aufseher Collegium, Nov. 21, 1780; miscellaneous materials, ASM.

15. Minutes of the Aufseher Collegium, July 2, 1793 and June 11, 1811, ASM.

16. Inventories of both the Bethabara and Salem potteries, compiled by Gottfried Aust and Rudolf Christ, may be found in ASM.

17. South Carolina Gazette (Charlestown), Jan. 31, 1771; Josiah Wedgwood, An Address to the Workmen in the Pottery, on the Subject of Entering into the Service of Foreign Manufactures (Staffordshire: J. Smith, 1783).

18. Frederick William Marshall, "Report to the Unity Elders Conference, 1773"; Minutes of the Aufseher Collegium, Dec. 8, 1773; Marshall, "Report to the Unity Elders Conference, 1774," ASM.

19. Marshall, "Unity Elders Conference, 1774," ASM.

20. Minutes of the Aufseher Collegium, Sept. 12, 1780, Jan. 27, 1779, and Aug. 1, 1782, ASM.

21. William Marshall to Unity Vorsteher Collegium, 1793; Eisenberg's manuscript is found under miscellaneous materials, ASM.

22. J. Vydra and L. Kunz, Painting on Folk Ceramics (London: Spring Books, n.d.), several examples, especially pl. 62; see also Burlington Fine Arts Club, Early English Earthenware (London: Chiswick Press, 1914), pl. 15 and p. 35.

23. Minutes of the Helfers Conferenz, July 1773, ASM.

THE KILN AND CERAMICS OF THE "POOR POTTER" OF YORKTOWN: A PRELIMINARY REPORT

Norman F. Barka

THE POTTERY manufacturing industry was both essential and widespread in the colonial past, since pottery was one of the main materials used for containers and a variety of other products. It is estimated that nearly three hundred potters were at work in the New England area alone prior to 1800.[1] It therefore seems remarkable that so little information concerning local potters has survived to the present.

Historical documentation is rarely available, and that which is usually yields very limited data. It remains for archaeology to make the industrial past live again through the excavation of pottery factory sites. Only in this way will it be possible, in most cases, to obtain detailed information about the location and distribution of potteries, the characteristics of their kilns and the varieties of ceramics produced. Archaeology can greatly broaden our knowledge of this important segment of America's past. Up to the present time, relatively few factory sites have been archaeologically located and investigated, and these have generally been found in a poor state of preservation.

The discovery of a colonial pottery factory in Yorktown, Virginia, is therefore of utmost significance. Excavations to date have uncovered possibly the best-preserved eighteenth-century kiln of its type. Indications are that skilled potters operated a substantial business in Yorktown from about 1720 to 1745, producing a large variety of earthenwares as well as the earliest, or among the earliest, stonewares made in North America. A kiln and portions of an adjoining factory building have been excavated, with indications that several additional structures, and possibly another kiln, are close by. Over 250,000 pottery fragments have been recovered from a relatively small area.

This paper is an introduction to and a summary presentation

of the findings, with approximately 30 percent of the site having
been excavated thus far. The final report, to be written upon
completion of the archaeological excavations and study, may
alter and will certainly add to the information presented below.
An in-depth study of a colonial American potter and his works
based on well-preserved and abundant archaeological remains
will be possible in the near future.[2]

Very limited documentary information is available on the
Yorktown pottery industry.[3] William Gooch, Virginia's royal
governor, mentioned an anonymous "poor potter" of Yorktown
in his annual reports on manufacturers to the Lords of the Board
of Trade during the 1730s. Gooch was apparently sympathetic
to the development of the pottery industry in Yorktown, a posi-
tion clearly against the English policy of mercantilism. Apparently,
Gooch felt he had to mention the Yorktown industry in his reports
to England, but at the same time he tried to minimize this in-
dustry by diverting attention from it through the use of the term
"poor potter." The word poor was probably meant to denote
inferior, thus implying that inferior production at Yorktown was
not competitive with the British ceramic industry.

The individual most closely associated with the poor potter
is William Rogers, who acquired lots 51 and 55 in Yorktown in
1711. The present kiln site is situated on lot 51, located on
the southwest edge of the town approximately twelve hundred
feet from the York River. Rogers was a fairly wealthy brewer,
surveyor, and merchant. He died on December 17, 1739, and
his will seems to link him with the poor potter. The will lists
a quantity of different kinds of pottery that only someone con-
nected with the pottery business would be likely to possess.[4]
It seems very likely that William Rogers was not the actual
potter, but was the entrepreneur who financed a successful
pottery business in Yorktown.

As to the dates of operation of the Yorktown factory, John
Mercer of Marlborough Plantation, in a ledger of the 1728 to
1732 period, lists a pottery account with William Rogers of
Yorktown. Governor Gooch first mentions the poor potter in
1732, and mentions him for the last time in 1741.[5]

Although the pottery factory may have been in operation as
early as 1711, the year Rogers purchased lot 51, probably the

factory was a reality by 1720, as evidenced by a remarkable
archaeological find at the kiln site. During the excavation of
the kiln in 1970, two very significant pots were found imme-
diately outside of the south kiln wall buried in a shallow pit
in the ground. One pot, a beautiful redware porringer, orange
in color with a brilliant lead glaze, was found upside down
covering an exquisitely potted and decorated delft cup with
blue floral decoration on a white background. Incised on the
exterior porringer wall are the initials "A G," below which is
incised the date "1720," making this pot perhaps the earliest
dated American-made piece in existence. The delft cup is
similar to one illustrated in English Delftware by F. H. Garner
and dated to about 1700.[6]

The burial of these two fine pots in a pit at the back of the
kiln probably represents the material remnants of some sort of
dedicatory rite. Perhaps the 1720 pot, which is definitely of
local manufacture, was one of the first products of the York-
town factory. This would indicate that the beginning date of
operation was probably in the 1711-20 period. Rogers died in
1739, but the business apparently was carried on by his family
at least until 1745 and perhaps later than this date.[7]

The archaeology of lot 51 began with the accidental discovery
of a waster heap in 1967. A pit five feet in diameter and three
feet in vertical depth was found to contain thousands of earthen-
ware and stoneware fragments, as well as almost fifty complete
to partially complete vessels. From this evidence it was
deduced a kiln had once been located in the vicinity. In July
of 1970, the kiln was found partially beneath a modern garage,
located about sixty feet from the waster heap. During the next
year, the kiln was completely excavated.

The kiln complex is made up of the kiln proper and an adjoin-
ing building that articulates with the kiln on the latter's north
side (Fig. 1). The kiln has been fully excavated (with the
exception of portions of the east wall), and the adjoining
building has been only partially investigated, but its size and
general characteristics are known.

The entire complex had originally been built into a large
excavated hole, the bottom of which is nearly 3.5 to 4 feet
below present ground level, which is approximately the same

Fig. 1. Plan of pottery kiln and portions of adjoining building, Yorktown, Va., 1720-45. (Colonial National Historical Park: Drawing, author.)

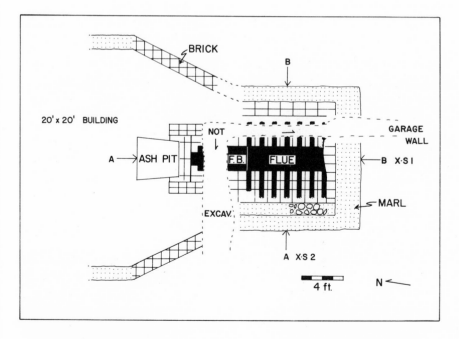

Fig. 2. Plan of pottery factory site, Yorktown, Va., ca. 1720-45. (Colonial National Historical Park: Drawing, author.)

as the eighteenth-century ground level. The dimensions of the
hole are slightly larger than the buildings within it. Thus, it
is estimated that the lower one-third or so of the kiln complex
was below ground level.

The kiln is rectangular in shape and measures twenty-one
by fourteen feet, and has survived to a maximum vertical
height of four feet (Figs. 2, 3). The kiln is well built of brick
and marl, and originally consisted of two chambers: a lower
heat chamber that contained arches and flues and connected
with the firebox at one end; and an upper chamber or room in
which the pottery was stacked, probably on a perforated brick
floor. The kiln was of the updraft type, and the upper pot
chamber may have had an arched roof with scattered roof holes
for heat-gas-smoke escape. The roof holes also would have
served to control or regulate draft and temperature distribution
within the kiln. It is believed that the surviving remains rep-
resent the majority of the lower heat chamber of the original
kiln structure, with pots having been placed on a perforated
brick floor situated about one foot above the present upper-
most level. The kiln was probably used for the manufacture
of salt-glazed stoneware, as is suggested by the heavy glazing
present on the kiln interior as well as by numerous salt-glazed
stoneware pottery fragments found in various parts of the kiln.
But earthenwares may also have been fired in the kiln at lower
temperatures.

For discussion purposes, the kiln remains can be divided
into four parts: (1) a central brick area, containing flues and
arches; (2) the firebox; (3) the ashpit; (4) a marl wall-
corridor area connected to the brick area on three sides (Fig. 3).

A central brick stucture contains the flues and formed the
foundation for the upper or pot chamber of the kiln. Vertical
brick walls originally extended upwards from this structure to
envelope or contain the heat generated in the firebox, which
connects with the northern end of the main flue. A back or
south wall of the brick structure is one half brick in width,
and has partially collapsed toward the center of the kiln.

The structure is 8.3 feet long (north-south) and about 8 feet
in maximum width (portions of the east side were destroyed in
the construction of the modern garage). It survives to a

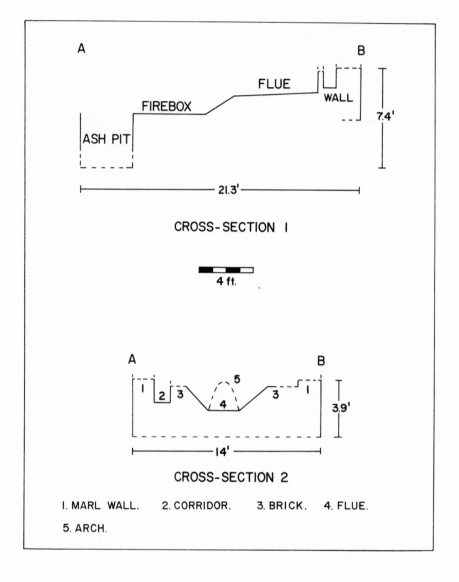

CROSS-SECTION I

4 ft.

CROSS-SECTION 2

I. MARL WALL. 2. CORRIDOR. 3. BRICK. 4. FLUE.

5. ARCH.

Fig. 3. Sectional diagrams of pottery kiln, Yorktown, Va., ca. 1720-45. (Colonial National Historical Park: Drawing, author.)

maximum height of thirteen brick courses (3.6 feet above sterile
soil or 1.8 feet above the floor of the main flue). The brick-
work is set in mortar, with an additional layer of mortar having
been placed on the exterior walls, presumably to prevent heat
leakage. The main flue is 2.2 feet wide and 6 feet in length,
and slopes gently from south to north, where it connects with
a short, steeper slope of about thirty-seven degrees, and the
horizontally floored but lower firebox. The total main flue-
firebox length is 11.7 feet.

The main flue passage was formed by a series of six paral-
lel brick arches, each separated from one another by a space
of four inches. The arches survive to various elevations, the
highest being 1.8 feet above the main flue floor. The arches
slope inward and originally met over the center of the main
flue. The arch angle is presently about nineteen degrees in-
ward from the vertical. Whether or not this represents the
original arch angle is not known, as arches often became dis-
torted due to repeated firing and cooling stresses.

Seven smaller or minor brick flues (each four inches in
width) connect at right angles to the main flue on both sides
of the latter, thus being directly opposed to one another.
The flues curve outward and upward toward the east and west.
The lowest level of the flues is at the same level as the main
flue floor, while the uppermost level is about 1.6 feet above
the same floor, although these minor flues originally extended
possibly a foot or so higher into the pot chamber. The maxi-
mum surviving horizontal length of the flues is 1.8 feet (east-
west). The six arches are thus separated by seven flues. The
northernmost minor flue is situated immediately above the south
edge of the firebox and seems to have originally been shorter
in length than the other minor flues.

The interior of the kiln is literally one continuous sheet of
glaze, since all flue surfaces are coated by a thick (one to
two inches) accumulation of a lustrous light to dark green
smooth and glasslike glaze. This type of glazing, possibly
due to repeated salting within the kiln, is identical to the
glazing present on the recovered kiln furniture, yet differs from
the glazing on the firebox walls. The latter glazing seems to
be due to actual melting of the firebox brick. From this evi-
dence one can infer that if the flue glazing is due to salt, then

the salt had been thrown into the kiln from the sides of the
kiln and not into the firebox.

The main flue connects with the brick firebox, both of which
are 2.2 feet in maximum width. The firebox is 4 feet in length,
and the brick floor of the firebox is 1.6 feet below the maximum
elevation of the main flue floor (Fig. 4). The firebox walls
survive to a height of 1.8 feet. The arched firemouth, or
opening of the firebox, measures 1.2 feet in width and was
originally about 1.5 feet in height. Possibly this rather small
opening served mainly as a stokehole with another larger
leading hole above.

The firebox is flanked on both sides by brick retaining walls,
each 1.1 feet in width (1 1/2 brick), and laid in Flemish bond.
The brick is yellow in color, in contrast to the redness of the
firebox bricks. The west retaining wall survives to a height of
2.4 feet (ten courses), and both walls extend 2 feet beyond
(to the north of) the firemouth.

Immediately in front of the firebox, i.e. to the north of it,
separated from it by a distance of slightly over one foot, is a
brick-walled box, here referred to as an ashpit. The ashpit is
slightly trapezoidal in shape, the end nearest the firebox being
narrower than the opposite or north end, which measures 4 feet
in width. The pit is 4 feet in length and presently measures
2.7 feet in maximum vertical extent. Ash deposits extend for
another foot beneath the lowest brick, giving a maximum depth
of 3.7 feet for the ashpit (Fig. 4). The ashpit was filled with
ash, charcoal, dirt, cinders, clinkers, pottery, and kiln fur-
niture fragments. Nineteen strata could be discerned on the
basis of color, texture, and content. The pottery found in the
ashpit as well as in the firebox was salt-glazed stoneware.

The ashpit had undoubtedly been used as a repository for
the hot coals and ash raked out from the firebox. The absence
of a brick floor in the ashpit leads to the inference that water
was thrown onto the porous sand subsoil. A portion of the
firebox and the entire ashpit were situated in a building adjoin-
ing the kiln, and the possibility of fire from coals was lessened
by the presence of the ashpit. The ashpit probably served
another function as well. When on occasion the temperature
in the kiln was too high and so was likely to overfire the ware,

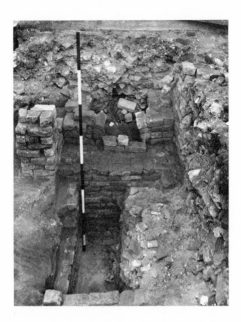

Fig. 4. Pottery kiln, portion outside of modern garage, looking south, Yorktown, Va., ca. 1720-45. Firebox and firemouth flanked by two retaining walls, with partially excavated ashpit below. (Colonial National Historical Park: Photo, author.)

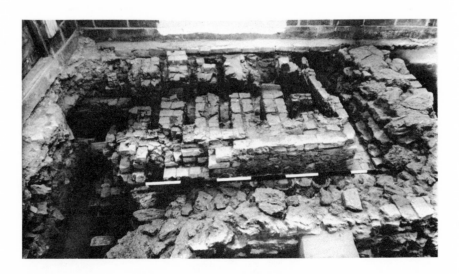

Fig. 5. Pottery kiln, portion inside modern garage, looking east, Yorktown, Va., ca. 1720-1745. (Colonial National Historical Park: Photo, author.)

the fire could be drawn or raked out into the ashpit, thus re-
ducing the temperature.

After ash and debris had accumulated to a sufficient depth,
the ashpit was apparently emptied by shoveling the contents
out. This may account for the presence of ash below the level
of and under the brick walls of the pit, as shoveling would,
over a period of time, tend to remove not only the ash contents
but also portions of the sand floor as well.

When not in use, the ashpit may have been covered by an
iron grate, which would have been situated at the level of the
firebox floor. Workers could stand on this grate to load and
fire the flue chamber or firebox.

Adjacent to three sides (west, east, and south) of the brick
arch-flue structure is a wall of marl, a material that was easily
obtainable along the shores of the York River. The straight-
sided wall is well built of irregular blocks of marl, the largest
measuring 2 square feet. The wall survives to a height of
nearly 4 feet, and varies from 1.5 feet to 2.5 feet in width
and from 8.8 feet to 13.8 feet in length.[8] No evidence of
mortar is present, although clay or mud seems to have been
packed between and around the stones.

Separating the west marl wall from the brick arch-flue area
is a corridor 1.2 feet in width, and 1.6 feet lower than the
present marl wall (Fig. 5). The floor of the corridor is composed
of uneven marl chunks. In order to level the rough flooring,
saggar lids, bases, and body fragments had been placed on
portions of this floor. This corridor evidently served as a
walkway along the west side of the kiln, into which a potter
could go in order to view his pottery through peep holes that
were undoubtedly located within the immediately adjacent brick
wall.

A comparable corridor is not present on the south and east
sides of the kiln. Instead, brickwork (one brick wide) separates
the marl wall from the brick arch-flue structure. On the east
side, the brickwork survives to the present height of the marl
wall, while on the south side the upper surface is at a much
lower level. However, traces of mortar on top of the brick, in
addition to the fact that the back wall of the main flue would
seemingly have been much too weak without added support,

suggest the south side brickwork was once as high as that
of the east wall.

Whether or not a marl foundation underlies the entire kiln
has not been determined as of yet. The function of the marl
walls themselves is not entirely clear at this point. In sev-
eral places, bricks are in place upon the marl wall. Perhaps
the walls were foundations for a structure that itself covered
the brick arch-flue structure.

Connected with the kiln on its north or firebox side is an-
other structure, as yet only partially excavated (Fig. 1). Two
brick walls, one of which survives to a height of 3 feet (twelve
courses), are both 1.1 feet in width (a brick and a half) and
7 feet in length. Both walls diverge at opposite but identical
angles to join north-south oriented marl foundation walls. The
latter, also 1.1 feet in width, are at least 20 feet in north-
south length. The exact nature of the angling walls-kiln junc-
ture is presently uncertain, as this point occurs beneath the
modern garage walls, an area not yet excavated. The maximum
interior dimensions of this structure are 20 feet in width by
approximately 20 feet in length.[9] As with the kiln, this structure
was also built below ground level, so that the sand floor of
the structure is presently nearly 4 feet below ground surface.

In this case the marl walls definitely served as foundations
for brick walls, since many well-mortared bricks have been
found in place on the marl walls. The building evidently was
the kiln workshop area, where a variety of activities connected
with the operation of the kiln took place. Surface remains
indicate other buildings once existed to the north of this structure.

The following summary description will serve to indicate the
types of earthenwares and stonewares that were made in Yorktown,
as presently known (Fig. 6). Whether or not the wares described
were all manufactured contemporaneously within the 1720 to
1745 period will hopefully be apparent in future stratigraphical
studies.

All vessels were made on the wheel, with paste or body
light in color--yellow, orange, or reddish-orange, and usually
containing small red hematite inclusions. Many of the wares
recovered are in a biscuit state, which indicates that earthen-
wares were fired twice--fired to biscuit; glazed, and then fired

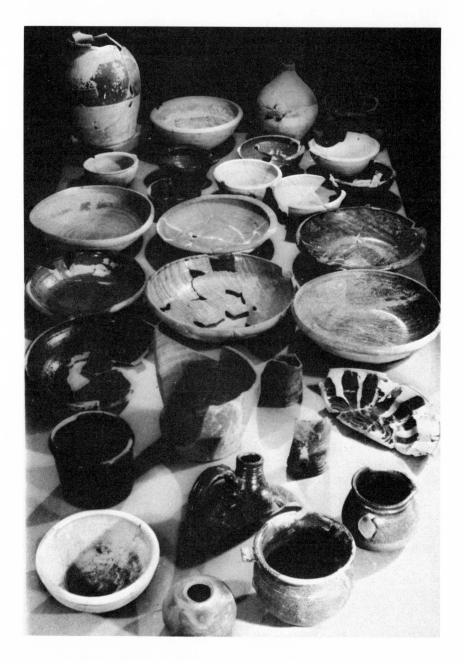

Fig. 6. Pottery vessels from the kiln site, Yorktown, Va., ca. 1720-45. (Department of Anthropology, College of William and Mary: Photo, author.)

again. The lead-glazed earthenwares generally reflect the
paste color; browns, often with darker fleckings, and green
glazes also occur although the green rarely occurs. A major-
ity of cream pans were glazed on the interior only, while
other shapes tended to be glazed on all surfaces, including
the base.

A minimum of sixteen earthenware shapes, distinguished by
rim, body, and base characteristics, have been discerned
thus far:

1. Crock. Flat base; vertical to slightly outsloping walls;
thickened rim with flattened to slightly concave lip, insloping
toward interior, with thickened exterior flange or overhang.
All surfaces lead glazed. Two parallel decorative grooves
on exterior wall near middle. Height 6 1/2"; Diameter (rim)
7 1/4", (base) 6 1/4" (Fig. 7A).

2. Crock. As above, but rim characteristics and size
differ. Rim thickened and rolled. Height 5"; Diameter (rim)
6 1/2", (base) 5 1/2" (Fig. 7B).

3. Dish. Flat base; slightly outsloping low walls; no
distinct rim, but rounded lip with V-groove immediately below
lip on exterior. All surfaces lead glazed. Height 2 1/4";
Diameter (rim) 6 1/2", (base) 5 1/2" (Fig. 7C).

4. Basin or bowl. Flat base; outsloping curved wall;
rounded broadened rim with overhang on exterior, and curving
inward on interior. Larger sizes have fairly thick walls (13/16").
Lead glazed on all surfaces. Many biscuit, unglazed sherds.
Height 3 3/4", 5 1/4"; Diameters (rim) 8 1/2", 12 1/4", about 14",
(base) 3 1/4", 5" (Fig. 7D, K).

5. Basin or bowl. Rim sherds only, possibly from a large
basinlike container. Thick walls (1/2") with wide, nearly flat
rim, with single grooves on rim top near lip and at rim-body
juncture. Lead glazed on interior and exterior. Diameter at
exterior rim 10" (Fig. 7L).

6. Bowl. Flat base, curved outsloping walls; flattened,
downsloping (toward interior) rim, with rounded exterior over-
hang with groove below. One C-shaped handle attached to
rim, circular in section. Lead glazed on all surfaces, or
biscuit unglazed. Height 3 - 3 1/2"; Diameter (rim) 7", (base)
3 1/2" (Fig. 7E).

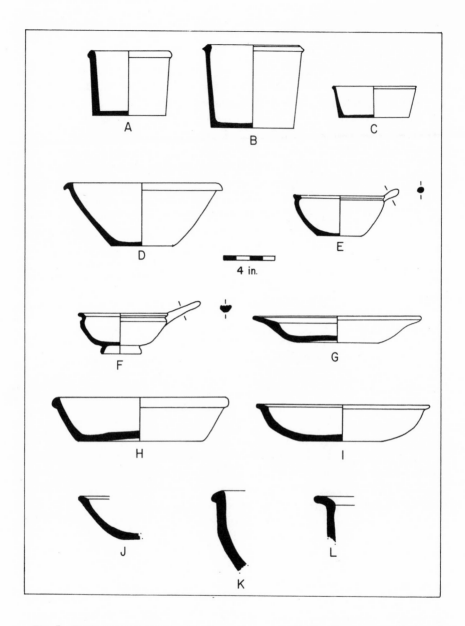

Fig. 7. Earthenware shapes from Yorktown, Va., ca. 1720-45. (Department of Anthropology, College of William and Mary: Drawing, author.)

7. Jar. Rim sherds only. Large storage-jar-like containers (see description of stoneware jars). Thickened outflaring rim with rounded lip, inner portion of rim curved to accommodate lid. A variant has a flattened, outflaring rim with no lid accommodation. Diameter (rim) 9". Lead glazed on interior and exterior.

8. Pan. Flat-based with center of base slightly raised; curved outsloping low walls; rim thickened and rolled, with slight overhang on interior. Flat pouring spout (2" wide, or width of two fingers) in rim. Lead glazed on interior only, with glaze runs usually on exterior. Numerous biscuit fragments found. Height 2 1/2 - 3 3/4"; Diameter (rim) 12 3/4 - 15", (base) 6 1/2 - 8" (Fig. 7H).

9. Pan. As above, but with flat, slightly insloping wide rim (about 1"). Pouring spout present on some specimens. Biscuit or lead glazed on all surfaces, including base (Fig. 7I).

10. Pan. As above, but rim narrower and more sharply downsloped toward interior. Lead glazed on rim only (Fig. 7J).

11. Platter. Flat based with center slightly raised; very low outcurving walls joined to very wide (about 2 1/4") insloping rim; V-groove on rim near slightly beveled lip. Maximum height 2 1/8"; Diameter (rim) 14 1/2". This represents the only decorated ware made at Yorktown--a multicolored slipware. Both slip glazed and slipped, but unglazed examples have been found. Interior: white slipped over body; two to four other slips applied over the white slip and smeared from rim toward center of vessel, or trailed and swirled. Biscuit slip colors include reds, black, brown, and a greenish-brown. Interior lead glazed, with background of one large sherd thus appearing yellow with red and dark brown to black decoration. Exterior: usually unslipped and undecorated; runs of glaze on surface. Vessel thickness 1/2" (Fig. 7G).

12. Porringer. Flaring foot ring, base flat and raised within; curved walls bend inward below rim; everted rim with slightly rounded inward sloping lip; triangular handle attached to rim and body, sloping inward; upper surface of handle flat with eight incised parallel grooves for decoration. All surfaces lead glazed, orange in color. Incised on exterior wall between handle and foot ring the initials "A G" over the date "1720," with

a series of grouped decorative punctates to the sides of the
initials. Maximum height (at handle) 3 3/4"; Diameter (rim)
6 1/2", (base) 3 1/8"; Dimensions of handle: length (to rim)
2 7/8"; maximum width: 2 1/8" (Figs. 7F, 9).

13. Mug. Several basal fragments of what appear to have
been glazed (interior and exterior) mugs appear in our sample.
Cordoned decoration on exterior above base. Diameter (base)
about 4".

14. Collander. Base and side wall sherds only. Probably
small pan-shaped collanders, lead glazed on all surfaces, with
holes punched through base and walls.

15. Birdhouse bottle. In the relatively small sample of
sherds studied for this paper, several biscuit fragments of
so-called bird bottles were noted.[10]

16. Funnel. Apparently the poor potter was also manu-
facturing earthenware funnels, a few sherds of which have
been found thus far.

The large quantities of salt-glazed stonewares manu-
factured at the Yorktown factory may represent the earliest
such wares produced in this country. Stonewares like the
earthenwares, went through two firings in the kiln, as numer-
ous biscuit earthenware examples of stoneware forms have
been found. The upper exterior portions of the majority of forms
were iron-oxide slipped, which appears red in color in the
biscuit state and generally a brown to purple-brown in the fin-
ished product. The biscuit body is a light earthenware color,
and the finished body is gray brown, or purplish brown in
color, with a mottled appearance due to salt-glazing.

A minimum of seven stoneware shapes have been discerned
thus far in the small sample studied for this report:

1. Mug. The finest stoneware product of Yorktown was
the tavern mug. This was probably the one ware that the potters
took the greatest care in producing, as is evidenced by the
many saggars found at the site, which presumably were used
to protect mugs in the kiln. Several saggars with mug frag-
ments stuck to them have been found.

The Yorktown mugs are vertical sided with a flat but slightly
raised base; one thin strap handle with top of curve of handle
below lip, and lower handle terminal folded back on itself and

impressed; ornamental cordoning on exterior near base;
slight groove on exterior just below lip. Upper half of
exterior iron-oxide slipped. Interiors generally light to
dark brown to purple in color. Several biscuit sherds
slipped in white on exterior before iron-oxide slipping.
A few other sherds exhibit an opaque white glaze on the
exterior, perhaps indicating an attempt to produce a white
delftlike glaze (Fig. 8A).

Mugs were stamped with the initials "W R" below a
crown, which appear in relief within a depressed rectangle
(1/2" x 7/16") a half inch below the lip on the exterior
wall opposite the handle. An identical but larger mark
appears on stoneware bottles. Since the marks appear
only on mugs and bottles, the purpose of the stamp was
probably to certify capacity, and the initials probably
stand for William III Rex, not William Rogers. If "W R"
served to denote the latter, one would expect other York-
town products to bear this stamp. Mugs were apparently
made in at least two sizes, small and large, possibly
pint and quart capacities: Size 1, diameter at base 2 1/2
to 3", height about 3 to 3 1/4"; Size 2, diameter at base
3 1/2 to 4", height 5 1/4 to 6".

2. Pipkin. Flat base slightly raised toward the center;
curving bag-shaped wall with pot wider at base than at
rim; rim slightly everted with slightly rounded lip; one
pouring spout in rim; raised cordon on exterior at juncture
of wall and rim. Tubular handle, pierced longitudinally,
with pestlelike terminal; handle attached at right angles
to side wall. Height 4 3/4"; Diameter (maximum) 5 1/2",
(rim) 4 1/2", (base) 4", (handle) 1 3/8"; length (handle)
4 1/4" (Fig. 8B).

3. Bottle. A tall form with small mouth, narrow
base, and bulging walls that reach their greatest width
at the center of the container; flat, slightly everted base;
cordoning beneath mouth; upper exterior slipped; broad
heavy strap handle attached below cordoning, with finger-
impressed rat-tail terminal. Stamp (3/4" square) on
upper exterior body opposite handle: in relief, a crown
above the initials "W R" within a depressed square. One

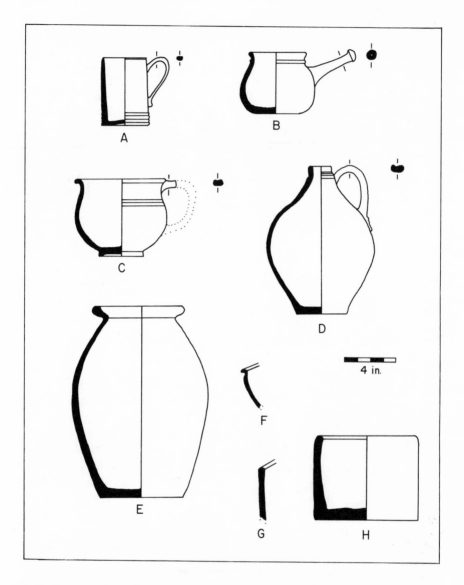

Fig. 8. Stoneware shapes from Yorktown, Va., ca. 1720-45. (Department of Anthropology, College of William and Mary: Drawing author.)

complete specimen has the following dimensions: Height
11 1/4"; Diameter (mouth opening) 1 1/8", (base) 3 3/4";
thickness (rim) 3/8". Larger sizes were also manufactured
(Fig. 8D).

4. Chamber Pot. Annular foot ring, base raised within;
curving walls; everted rim with strap handle attached at
rim; crude ornamental grooving one inch below rim on
exterior. Upper three-quarters of body and interior por-
tion of rim iron-oxide slipped, giving purplish-brown
appearance; lower salt-glazing greenish in color. Height
5 3/4"; Diameter (rim) 6 5/8", (base) 3 3/8" (Fig. 8C).

5. Storage Jar. Heavy, tall container with thick
(5/8") outsloping walls and flat base; outflaring rim with
rounded lip, inner portion of rim curved to accommodate
lid. Interior rim and upper half of exterior body red-
slipped (biscuit). Height 15"; Diameter 6". Smaller
jars of similar form are also present in our sample (Fig. 8E).

6. Bowl. Rim sherds only. Outcurving walls with
flat, overhanging rim. Diameter (rim) about 9"; Width (rim)
1/2" (Fig. 8F).

7. Crock. Crocklike containers are represented by
several biscuit and salt-glazed sherds. Vertical walls,
no distinct rim, slightly thickened, flat lip; ornamental
grooving one to two inches below lip on exterior wall.
Base type not known. Diameter (rim) about 6"; Thickness
(wall) 3/8" (Fig. 8G).

Saggars, saggar lids, props, and pads were used as
kiln furniture in the salt-glaze kiln. Saggars are essen-
tially containers designed to protect the wares placed
within them from too much fire or glaze. Saggars can be
of any size and are usually heavy and strong so as to
withstand repeated usage. Judging by the large quantities
found, saggars must have been one of the major items
produced at the factory, which in turn testifies to the
importance of stoneware manufacture in Yorktown. Com-
paring saggar sizes with stoneware pot shapes and sizes,
it is highly probable that only mugs were fired in saggars.

The Yorktown saggars, made of a uniform clay with no
grog or temper added, are flat based, straight sided, heavy,

thick walled, and thickly glazed (greenish in color), with
four openings in the walls so as to permit the entrance of
heated air, and so forth. Three of the openings cut into
the walls are teardrop shaped, while the fourth opening
is a rectangular fairly wide slit cut through the rim and
extending downward to the inner basal surface. In addi-
tion to these openings, several rounded, shallow, open
gouges were often cut out of the rim. The latter were to
facilitate air movement when one saggar was placed on top
of another in the kiln. All openings vary in dimensions
with the size of the saggar (Figs. 8H, 10).

At least three sizes of saggars were manufactured at
Yorktown:

	Exterior rim-basal diameter	Height	Wall thickness
Size 1	about 5"	--	3/8 - 1/2"
Size 2	7 - 8"	6 1/2"	1/2 - 1"
Size 3	10"	--	1/2 - 1"

One Size 2 specimen is complete and weighs nearly eight
pounds. Size 2 seems to be the most common; Size 3 is
relatively rare in our sample.

It is interesting to speculate on how many mugs each
saggar could have held. Size 1 saggar could have held
only one mug measuring 2 1/2 to 3 inches in diameter.
Size 2 saggar could have held one to four mugs each
2 1/2 inches in diameter; one to two 3-inch mugs; one
3 1/2-inch mug, or one 4-inch mug. However, from the
position of clay support pads still present in some saggars,
it seems likely that Size 2 saggars often or usually con-
tained only one mug at a time. Size 3 saggar could have
held one to five mugs each 2 1/2 inches in diameter; or
one to three 3-inch mugs; or one to three 3 1/2-inch mugs,
or one to two 4-inch mugs.

Different sizes of mugs could have been mixed in the
same saggar, of course, but it seems that both Sizes 1
and 2 were made to contain only one mug each, which
seems uneconomical, but this placement may have given
the best results.

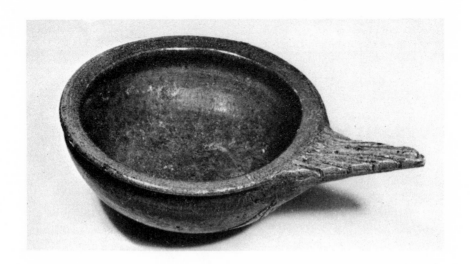

Fig. 9. Earthenware porringer, with initials "AG" and date "1720" incised on exterior below handle; Diam. (rim) 6 1/2". (Department of Anthropology, College of William and Mary: Photo, author.)

Fig. 10. A complete sagger, Yorktown, Va., ca. 1720-45; Diam. (rim) 8 1/4". (Department of Anthropology, College of William and Mary: Photo, author.)

The inside and exterior bases of saggars usually have
three or more small clay pads adhering to them. These
pads separated the mug from the saggar and the saggar
from the kiln or other surface, thus insuring that two sur-
faces would not stick and also aiding heat circulation
beneath the pot or saggar. Saggar lids are circular in
shape, flat on both surfaces, and also heavily glazed.
Lid sizes match the three saggar sizes. Lids average
about three-quarters of an inch in thickness.

Several hundred kiln props and many thousands of clay
wedges have been found thus far. They were scattered
throughout the excavations, but were especially prevalent
in the flues of the kiln, apparently having fallen through
the perforated potstacking floor of the upper kiln chamber.
Kiln props are solid tubes of clay, measuring an average
of 3 inches in length and 2 inches in diameter. Due to
repeated usage, all are heavily glazed, the glaze being
identical with that of the kiln interior. Clay pads gen-
erally adhere to both ends of the props. Props were used
in the kiln to separate pots or saggars from one another,
thus allowing better heat circulation, or were placed between
stacked wares to stabilize them.

Wedges and pads were made of very sandy clay, which
presumably lessened the sticking qualities of the clay.
Wedges average about 2 1/2 by 2 by 1 inch in size,
although many are larger. All show finger impressions.
Clay pads or squares are lumps of sandy clay, some of
which are not larger than one's thumbnail. Wedges and
pads served the same functions as the props previously
described.

A kiln is essentially a box in which to accumulate heat,
and any kiln must have at least four main components: (1)
a base on which to place the pottery; (2) a source of heat,
or fuel; (3) a means of transferring the heat from the source
to the ware through a firebox and flues; (4) an envelope
or chamber to confine the heat to the ware. Kilns can be
of numerous shapes, among them circular and rectangular.[11]

Circular kilns, usually bottle shaped, with numerous
fireboxes around the sides, were especially common in

England for the manufacture of lead-glazed earthenwares,
stonewares, and porcelain. Because of their long and
widespread use, we have a fair amount of information on
this type of kiln through historical documentation, archaeo-
logical examples,[12] and the fact that some are still in
existence today.

Much less information is available on rectangular kilns,
so at this point it is very difficult to trace the origins of
the Yorktown kiln. In the Old World, rectangular kilns
seem to have been associated with the tin-glazed earthen-
ware (delft, faience, majolica) industry. Eighteenth-
century English, Dutch, French, and Italian kilns were
based on the rectilinear plan.[13] Detailed information
concerning the architecture of these kilns is presently
lacking and will have to await archaeological excavations
of the kind now being carried out in Lambeth.[14]

One very important sixteenth-century documentary source
reaffirms the seeming similarity of the Yorktown-type kiln
to delft kilns. Cipriano Piccolpasso, an Italian potter,
wrote a treatise on the potter's art in about 1560.[15] In
this work he describes and illustrates a rectangular tin-
enameling kiln similar in shape and arch-flue construction
to the Yorktown kiln. Piccolpasso's kiln was composed of
two chambers, a firebox or combustion area below, and a
pottery chamber above, which was entered by a doorway
above the firebox. Several arches supported the perforated
floor of the pottery chamber. The updraft arrangement
enabled heat and flames to pass upward through the floor
into the upper chamber and out through holes in the arched
ceiling above.

Although similarities exist between the Yorktown kiln
and tin-glazing kilns, delftware was not produced at York-
town. As previously discussed, the Yorktown kiln was
probably a stoneware kiln, and until more detailed informa-
tion is available on the characteristics of German stoneware
kilns, no definite statements concerning the origins and
relationships of the Yorktown kiln can be made, although
the latter definitely does not relate to the circular English
kiln.

The lack of evidence for North American kiln sites makes
any intracontinental comparative discussion virtually impos-
sible. With the exception of the supposed seventeenth-
century kilns found at Jamestown and Green Spring, Virginia,
the majority of information we have from the United States
and Canada comes from kiln waster dumps, which yield
little or no evidence of the kilns themselves.[16]

One of the conclusions reached as a result of the
archaeological identification of the factory and products
was that the poor potter was not as poor as historical
documents would have us believe. In Yorktown a more or
less "complete potter" was at work in the second quarter
of the eighteenth century, capable of making a wide variety
of ceramics to meet the needs of an eighteenth-century
community. Here were no fumbling beginners in the pottery
craft, but experienced and competent potters making wares
in a well-built and well-designed kiln or kilns. The origin
of the potters, be it England, Holland, or Germany, has
yet to be determined.

Many types of earthenwares were manufactured, as well
as salt-glazed stoneware. The revelation that the latter
was also definitely being produced, perhaps as early as
1720 (or earlier) gives added significance to the Yorktown
industry, and elevates the poor potter to a higher position
among American potters. The stoneware made at Yorktown
was of relatively high quality, mugs for example being
indistinguishable from English-made mugs of the same period.
For certain types of stoneware, the poor potter was in
direct competition with English potters.

The pottery factory in Yorktown was much more developed
and productive than one would have expected, a factor
that may lead to eventual reevaluation not only of mercan-
tilism but also of the industrial development of the colonial
South. The poor potter and his pioneering industrial efforts
testify to the increasing independence of American industry
in the early eighteenth century.

The full extent of the poor potter's factory complex and
his ceramic production will hopefully be known in the near
future upon completion of the archaeological excavations

and detailed analyses of the buildings, pottery types, glazes, clays, and so on. It is hoped the present report has served to indicate the scope of this important American pottery factory.

316 Norman F. Barka

NOTES

1. Laura W. Watkins, Early New England Potters and Their Wares (Cambridge: Harvard University Press, 1950), p. 2.

2. The author wishes to acknowledge the assistance of the following individuals: Nathan Altshuler, Chairman, Department of Anthropology, College of William and Mary; Dean Bailey; Anne Barka; Mr. and Mrs. W. A. Childrey; James Corson, Superintendent, Colonial National Historical Park; Leverette Gregory; Ben McCary; Mr. and Mrs. C. Malcolm Watkins; numerous students of the College of William and Mary; and especially Mr. J. Palin Thorley, master potter, who has been kind enough to share with me his vast knowledge of the pottery industry.

3. C. Malcolm Watkins and Ivor Noël Hume, "The 'Poor Potter' of Yorktown," U.S. National Museum Bulletin 249, Contributions from the Museum of History and Technology, Paper 54 (Washington, D.C.: Smithsonian Institution, 1967), pp. 73-112. The historical summary of the present paper is taken from this source.

4. Watkins and Noël Hume, "The 'Poor Potter' of Yorktown," pp. 88-90.

5. Watkins and Noël Hume, "The 'Poor Potter' of Yorktown," pp. 79-80.

6. F. H. Garner, English Delftware (New York: D. Van Nostrand Co., 1948), pl. 23A. The Yorktown specimen, possibly from Lambeth, has the following dimensions: Diameter (rim) 2 1/2", (base) 1 1/4"; Height 3"; Minimum thickness near base 1 mm.

7. Watkins and Noël Hume, "The 'Poor Potter' of Yorktown," p. 83. A date based on documentary records, p. 110. Noël Hume found supposed Yorktown sherds in contexts dating to the 1750-70 period in Williamsburg. Until these specimens can be reexamined in light of the recent factory excavations, the date of ca. 1745 is currently accepted as the terminal date of the pottery factory operation.

8. The upper portion of the south wall overhangs the lower portion and is 2.6 feet in length. The east and west marl walls (oriented north-south) are seemingly disrupted

at their northern end and presently measure 8.8 feet and
10 feet in length.

9. The northern half of the building has not been
excavated, but the northeast corner has been tentatively
identified.

10. Watkins and Noël Hume, "The 'Poor Potter' of
Yorktown," Figs. 19 and 20, illustrate two nearly complete
birdhouse bottles.

11. Paul Soldner, Kiln Construction (New York:
American Craftsmen's Council, 1965), p. 6; F. H. Norton,
Elements of Ceramics (Cambridge, Mass.: Addison-Wesley
Press, 1952), p. 136; Daniel Rhodes, Kilns--Design,
Construction, and Operation (Philadelphia: Chilton Book
Co., 1968).

12. Peter Brears, "Excavations at Potovens, near Wake-
field," Post-Medieval Archaeology 1 (1967): 9; D. Gillian
Hurst, "Post-Medieval Britain in 1966," Post-Medieval
Archaeology 1 (1967): 116; Hurst, "Post-Medieval Britain
in 1967," Post-Medieval Archaeology 2 (1968): 187-89;
Hurst, "Post-Medieval Britain in 1968," Post-Medieval
Archaeology 3 (1969): 198-99; Philip Mayes, "A Seven-
teenth-Century Kiln Site at Potterspury, Northhamptonshire,"
Post-Medieval Archaeology 2 (1968): 67.

13. See Brian Bloice and James Thorn, "London Tin-
Glazed Pottery--2: Excavation of an 18th-Century Delftware
Kiln in Lambeth," The London Archaeologist 1, no. 4
(Autumn 1969): 85-86, for a discussion of this point.

14. Bloice and Thorn, "London Tin-Glazed Pottery--2";
Bloice and Thorn, "London Tin-Glazed Pottery," The Lon-
don Archaeologist 1, no. 3 (Summer 1969): 57-59; Graham
Dawson, "Excavations at Montague Close 1970," South-
wark and Lambeth Archaeological Society Newsletter, no. 26
(Nov.-Dec. 1970): 3-5; Dawson, "Two Delftware Kilns at
Montague Close, Southwark: Part 1," The London Archae-
ologist 1, no. 10 (Spring 1971): 228-31; Dawson,
"Montague Close, Part 2," The London Archaeologist 1, no.
11 (Summer 1971): 250-52; Hurst, "Post-Medieval Britain
in 1968," pp. 199-200.

15. Cipriano Piccolpasso, The Three Books of the Potters Art, eds. and trans. Bernard Rackham and Albert Van de Putl (ca. 1560; reprint ed., London: The Victoria and Albert Museum, 1934).

16. John L. Cotter, "Archaeological Excavations at Jamestown, Virginia," Archaeological Research Series, no.4 (Washington, D.C.: National Park Service, 1958); Louis R. Caywood, Green Spring Plantation Archaeological Report (Yorktown, Va.: Colonial National Historical Park, 1955). For examples of kiln waster dumps, see the following: Daniel M. Barber and George R. Hamell, "The Redware Pottery Factory of Alvin Wilson--At Mid-Nineteenth Century," Historical Archaeology 1971 5 (1971): 18-37; Ivor Noël Hume, Here Lies Virginia (New York: Alfred A. Knopf, 1963), pp. 215-20; Stanley South, "The Ceramic Forms of the Potter Gottfried Aust at Bethabara, North Carolina, 1755-1771," The Conference on Historic Site Archaeology Papers 1965-1966 1 (1967): 33-52; South, "The Ceramic Ware of the Potter Rudolph Christ at Bethabara and Salem, North Carolina, 1786-1821," The Conference on Historic Site Archaeology Papers 1968 3 (1970): 70-72; D. B. Webster, "The Brantford Pottery 1849-1907," Royal Ontario Museum, Art and Archaeology, Occasional Paper, no. 13 (1968).

THE POTTERS OF CHEESEQUAKE, NEW JERSEY

James R. Mitchell

SALT-GLAZED stoneware was made in Middlesex County, New Jersey, from the end of the eighteenth through the first half of the nineteenth century. The abundance of clay, sand, and allied raw materials in this area enabled potters to fill the needs of residents on a continuing basis. Clay was also exported to such distant markets as Charlestown, Massachusetts; Bennington, Vermont; Philadelphia, Pennsylvania; and New York State.[1] Cheesequake, located on Cheesequake Creek in Middlesex County (now Madison Township), is south of South Amboy situated on Raritan Bay. At the time, Cheesequake was not the only potting location in the area. Pottery was also made in South Amboy, Perth Amboy, Old Bridge, Matawan, Woodbridge, South River, and Sayreville, and because of the close proximity it is possible that potters working in Cheesequake considered they were working in South Amboy.

The stoneware objects were made on a potter's wheel, and decoration was incised, impressed, or painted cobalt blue. The unfired objects were placed in the kiln without glaze, and glazing was accomplished with ordinary salt (sodium chloride). When the temperature in the kiln was correct, salt dampened with a slight amount of water was thrown into the fire where it sublimed. At the same instant a chemical reaction occurred: salt and water became soda and hydrochloric acid. The hydrochloric acid was exhausted through the flue, and the soda reacted with silica and alumina in the clay body of the objects to form a thin layer of several sodium alumina silicates on the surface of the ware. Although the exact formulas of these chemical compounds are known, the proportions of the varieties in the glaze are unknown because of variations in kiln

Fig. 1. a, Capt. James Morgan, Fragmentary jar with indication of horizontal loop handles.
South Amboy, N. J., dated 1775. Salt-glazed stoneware; H. 13 1/2", Diam. 12". Inscribed
in glaze: ". . . Danniel Holmes/ . . . September 23, 1775/ . . . mboy James Morgan/
&. . . ." (New Jersey State Museum; ex coll. Sim.) b, Attributed to Capt. James Morgan,
Mug with blue decoration. South Amboy, N. J., dated 1773. Salt-glazed stoneware; H. 6",
Diam. 4 1/8". (Collection of John Paul Remensnyder.) c, Attributed to James Morgan, Jr.,
Barrel with blue decoration. South Amboy, N. J., dated 1788. Salt-glazed stoneware: H.
13 3/4", Diam. 10 1/4". Incised initials "AK" and date "1788." (The Newark Museum.)
d, Attributed to Capt. James Morgan, Jar with blue decoration. South Amboy, N. J., 1754-
76. Salt-glazed stoneware; H. 11", Diam. 9 7/8". The number "2" brushed in blue under
each handle. (Collection James S. Brown.) (Photo, Joseph Crilley.)

conditions and in the salt and body materials. Salting
usually was not a one-step process and could be repeated
a number of times to glaze the ware with a desired thickness
of glaze.[2]

Emphasis on Cheesequake as a pottery site has evolved
because of excavations at the Morgan pottery and the Warne
and Letts pottery refuse heaps by the late Robert J. Sim.[3]
There were many potters working in the South Amboy-
Cheesequake vicinity, but the accent here is on members
of the Morgan family, men who married into the family,
and other potters who worked in the area, as illustrated by
surviving ware.

The first member of the Morgan family in America was
Charles, who came to the New World in 1640 with the Dutch
West India Company and settled in New Amsterdam. Among
his offspring was a son, Charles, who was born in New
Amsterdam and died in Perth Amboy in 1719.[4] The second
Charles had eight children including a son named Charles
(1683-1750). The third Charles was an innkeeper at
Cheesequake and served in the provincial assembly. He
had nine children including a son named James (1734-84).
James was a potter at Cheesequake and a captain in the
Revolutionary Army. He could have begun potting in the
mid-1750s, and he probably operated his pottery throughout
the war. In 1776 he requested reimbursement for damages
resulting from the destruction of a kiln of his pottery by the
British; soldiers from a British outpost on Sandy Hook
regularly raided the Raritan Bay vicinity.[5]

There is only one known marked piece of Captain James
Morgan's pottery--half of a large salt-glazed stoneware jar
assembled from fragments excavated by Sim in the refuse
heap.[6] The jar was made for Daniel Holmes, a wealthy
landowner of South Amboy, in celebration of an occasion on
September 23, 1775 (Fig. 1a).[7] It was made by James Morgan
and is marked as part of the inscription. Morgan put an
extra n in Daniel, and it is assumed that the piece was
discarded because of the error.

The pottery refuse heap provides a wealth of fragments
that are the basis for all attributions to Captain James

Fig. 2. a, Attributed to Capt. James Morgan, Jug with blue decoration, South Amboy, N. J.,
1754-76. Salt-glazed stoneware; H. 12", Diam. 8". (Collection of John Paul Remensnyder.)
b, B. Lent, Jug with blue decoration. Caldwell, N. J., 1820-30. Salt-glazed stoneware; H.
13 5/8", Diam. 10 1/4". Mark: "B.LENT/CALDWELL" impressed as a circle on shoulder
beneath number "2." (The Newark Museum; ex coll.Connor.) c, Attributed to Capt. James
Morgan, Jar with grooved vertical loop handles, blue decoration. South Amboy, N. J., 1754-
76. Salt-glazed stoneware; H. 10", Diam. 8 1/4". (Collection of John Paul Remensnyder.)
d, Attributed to Capt. James Morgan, Jug with blue decoration. South Amboy, N. J. 1754-
76. Salt-glazed stoneware; H. 12 1/2", Diam. 8 1/2". (Collection of James S. Brown.)
(Photo, Joseph Crilley.)

Morgan's pottery. He employed a characteristic cobalt-blue
spiral or watch-spring motif that appears continually on
sherds from the dump and often on surviving objects
(Figs. 1a, d; 2a, c).[8]

The products of Captain James Morgan's pottery were
jugs, mugs, jars, and chamber pots (Figs. 1a, b, d;
2a, c, d). Some of the jars have horizontal loop handles
(Fig. 1d), and others have handles that are vertical loops
like jug handles, applied at opposite extremes of the wide
mouth (Fig. 2c). The jug necks were made in two styles.
The flaired necks of one probably facilitated pouring, and
perhaps secured a cover in the single circumferential groove
(Fig. 2d). The other neck style does not flair out but is
virtually cylindrical with a series of ridges and grooves
(Fig. 2a).

After Captain James Morgan's death in 1784, the pottery
was operated by James Morgan, Jr., for an unknown length
of time. A salt-glazed stoneware barrel, inscribed with the
initials "AK" and the date "1788," is attributed to the Morgan
pottery when it was operating under the aegis of James
Morgan, Jr. (Fig. 1c). He had three brothers and five sisters.
As far as is now known, none of his brothers were potters,
but four of his sisters married men whose surnames are
familiar. Abigail married Joseph Rue, whose occupation is
unknown, although John L. Rue, a member of a later genera-
tion, bought the Swan Hill Pottery in South Amboy in 1860
and moved it to Matawan in 1880. Margaret married Amos
Stout, who may have been related to Samuel Stout, the potter
at Washington, now called South River, in the 1830s.[9]

Sarah, born in 1772, married Jacob Van Wickle, who went
into business with his brother-in-law, James Morgan, Jr., at
Old Bridge. The pottery partnership included Branch Green
and was formed prior to 1805 when one of their advertisements
appeared in Trenton's newspaper, The True American.[10] The
partnership apparently ended in 1822 when James Morgan, Jr.,
died.[11] The quantity of pottery made by each of the three
men is unknown, and it is assumed other men were employed
in the pottery because there is evidence Van Wickle and
Morgan each had outside interests. Jacob Van Wickle was

Fig. 3. Attributed to Jacob Van Wickle and James Morgan, Jr., Jugs, salt-glazed stoneware with blue decoration. Old Bridge, N. J., 1805-22. a, H. 16", Diam. 10 3/4". Inscribed with initials "LxJ" and the date "1807." (New Jersey State Museum, Gift of Genevieve Donnell.) b, H. 16", Diam. 10 3/4". (New Jersey State Museum; ex coll. Sim.) c, H. 15 1/2", Diam. 11 1/4". (Collection of James S. Brown.) (Photo, Joseph Crilley.)

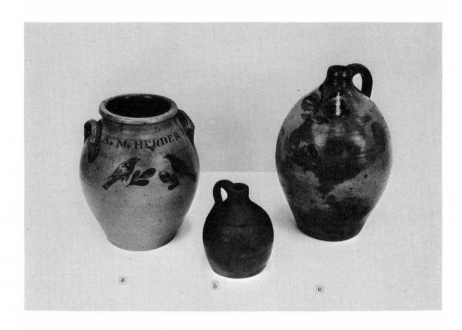

Fig. 4. a, Attributed to Nicholas Van Wickle, Jar with ear handles, blue decoration. Manasquan (now Herbertsville), N. J., 1823-38. Salt-glazed stoneware; H. 11 1/2", Diam. 10". Incised inscription "A.M. HERBERT." (Collection of John Paul Remensnyder.) b, Asher Applegate, Jug with blue decoration. Manasquan (now Herbertsville), N.J., 1823-38. Salt-glazed stoneware; H. 6 3/4", Diam. 5 1/2". Inscribed "Rum" at bottom of handle and "Asher Applegate/Maker Manasquan/Monmouth County/N.J." (New Jersey State Museum; ex coll. Sim.) c, Attributed to Nicholas Van Wickle, Jug with blue decoration. Manasquan (now Herbertsville), N. J., 1823-38. Salt-glazed stoneware; H. 15 1/4", Diam. 9 7/8". (New Jersey State Museum; ex coll. Brown.) (Photo, Joseph Crilley.)

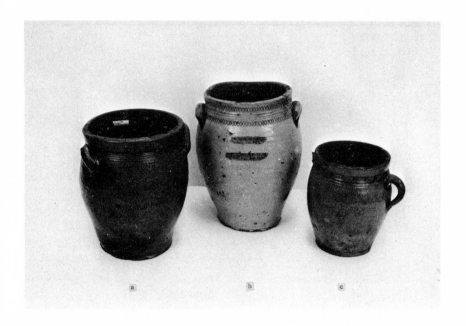

Fig. 5. a, Thomas Warne, Jar with horizontal loop handles (one missing), blue decoration, South Amboy, N. J., ca. 1780-1805. Salt-glazed stoneware; H. 11 3/4", Diam. 10". Mark: "WARNE" (above impressed holly leaves) and "S.AMBOY.N.JERSY" (inverted beneath leaves). (New Jersey State Museum, Gift of Mrs. Thomas Haight.) b, Thomas Warne Company, Jar with ear handles. South Amboy, N. J., ca. 1780-1805. Salt-glazed stoneware; H. 13 3/4", Diam. 10 1/4". Mark: "T.WARNE.C./SOUTH AMBOY." (New Jersey State Museum.) c, Attributed to Thomas Warne, Jar with vertical loop handles, blue decoration. South Amboy, N. J., ca. 1780-1805. Salt-glazed stoneware; H. 9", Diam. 8". Inscription: "Melinay Warne" incised on front above incised drawing of a bust of a man smoking a pipe. (Collection of John Paul Remensnyder.) (Photo, Joseph Crilley.)

a judge, and James Morgan, Jr., served in the House of
Representatives and rose to the rank of major general in
the state militia.

Stoneware marked "Van Wickle and Morgan" has not
survived except for two small groups of sherds with
sufficient letters to strongly suggest a two-line mark:
"VAN WICKLE/& MORGAN."[12] There is also an incised
circular mark or decoration with the profile of a man in a
circle with a wavy line around the outside of the circle.
This "man-in-the-moon" mark was often excavated at the
Van Wickle and Morgan refuse heap in Old Bridge and has
been employed to attribute surviving objects to Van Wickle
and Morgan's pottery.[13] The pottery produced salt-glazed
stoneware inkwells, jars, and jugs, with incised and cobalt-
blue decoration. The jars and jugs are ovoid and similar
in shape. The jugs have single handles at the neck. The
jars look like jugs with the neck and handle portion cut off
and replaced with a boldly molded rim and two closely set
ear handles. One surviving jug is decorated with an incised
sailing vessel partly colored with cobalt blue. It is attributed
to the pottery on the basis of an identical excavated
decoration fragment (Fig. 3c). Other incised decorative
motifs include a circle with four hearts in it, a circle with a
cross of loops, and flowers and leaves.[14] The incised
areas are always filled with cobalt blue (Fig. 3).

Jacob and Sarah Van Wickle had ten children, including
a son named Nicholas, who was in the pottery business
from the 1820s to the 1840s, first at Old Bridge in Middlesex
County and then at Herbertsville in Ocean County (Fig. 4a).[15]
Sim's excavations at the Herbertsville site exposed sherds
indicating that Asher Applegate had worked there with or for
Nicholas Van Wickle even though the only complete marked
example with Applegate's name on it says: "Asher Applegate/
Maker/Manasquan/Monmouth County/N.J." (Fig. 4b).[16]
Herbertsville, Ocean County, and Manasquan, Monmouth
County, are one and the same place. Ocean County was not
formed until 1850 and Applegate worked prior to 1840. At
that time the entire area around Manasquan Inlet was known
as Manasquan.[17] As a result, Applegate made the jug in

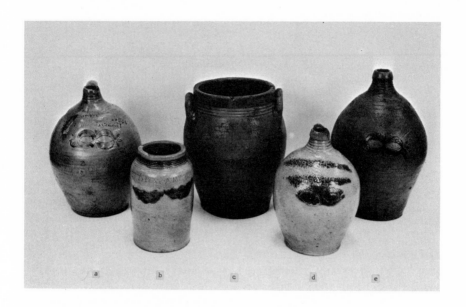

Fig. 6. Thomas Warne and Joshua Letts, Salt-glazed stoneware. South Amboy, N.J., dated 1806. a, Jug with blue decoration. H. 12 3/4", Diam. 9 1/2". Mark: "WARNE&LETTs1806/S.AMBOY.N.JERSY." (Collection of Mr. and Mrs. David B. McGrail.) b, Jar with blue decoration. H. 8 7/8", Diam. 5 7/8". Mark: "WARNE&LETTs1806 S.AMBOY.N.JERSY." (New Jersey State Museum; ex coll. McKearin.) c, Jar with horizontal loop handles, green decoration. H. 12 1/2", Diam. 10 1/2". Mark: "WARNE&LETTs 1806/S.AMBOY.N.JERSY." (The Newark Museum.) d, Jug with blue-green decoration. H. 11", Diam. 7 3/4". Mark: "WARNE&LETTs 1806/S.AMBOY.N.JERSY." (Collection of James S. Brown.) e, Jug with dark blue-green decoration. H. 14 3/8", Diam. 9 3/4". Mark: "WARNE&LETTs1806/S.AMBOY.N.JERSY." (New Jersey State Museum; ex coll. Sim.) (Photo, Joseph Crilley.)

Manasquan, Monmouth County, but the evidence has been
excavated in Herbertsville, Ocean County. One bottle-
bottom sherd excavated at Herbertsville was marked "A.A./
Maker" and covered with Albany slip in a manner identical
to the decoration on the above jug.[18] A characteristic
cobalt-blue floral decoration was excavated and appears on
surviving ware (Fig. 4c).

Captain James Morgan's daughter, Mary, married Thomas
Warne in 1786. Warne had a pottery located a quarter of a
mile from Morgan, on the Matawan-South Amboy Road.[19]
He probably began working at the end of the war, but the
exact date is unknown. In 1805 Thomas and Mary's daughter,
Melinay, married Joshua Letts, a potter who became Thomas
Warne's partner in 1806 and who probably worked with him
prior to the marriage. The partnership lasted until Warne's
death in 1813.[20] Letts continued to pot until his death in
1815 when the pottery was inherited by Catherine Bowne, a
granddaughter of Captain James Morgan.[21]

Salt-glazed stoneware was made at this pottery, and it
has survived in larger quantities than the wares from any
other pottery operating in New Jersey at that time. Sim
excavated the refuse heap, and it yielded a wealth of
decorative details corresponding to the large amount of
surviving wares. The pottery made jugs, jars, pots, and
pitchers decorated with coggle wheels and color in all three
periods of manufacture (Figs. 5, 6, 7, 8).

Impressed holly leaves were first used by Thomas Warne
but they were not filled with color (Fig. 5a).[22] The only
coggle wheel attributed to Warne prior to 1806 impressed a
series of lens or pointed ovals. In addition he used
impressed circumferential lines. Marks include "WARNE"
and the ubiquitous "S.AMBOY.N.JERSY" as well as the rare
"T.WARNE.C." (Fig. 5b). There is a surviving jar with a
crudely incised picture of a man with a pipe in his mouth
and the name "MELINAY WARNE" above. It is attributed to
the Warne pottery prior to 1805 when Melinay and Joshua
were married (Fig. 5c).

The terminal date of Warne's sole proprietorship has
always been 1805, but perhaps 1806 is a more accurate

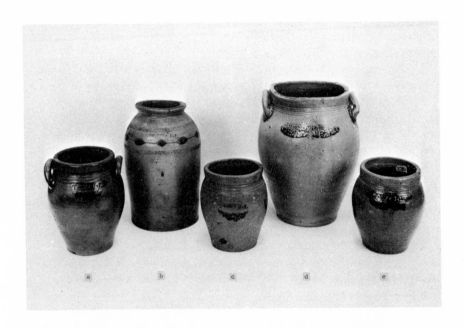

Fig. 7. Thomas Warne and Joshua Letts, Salt-glazed stoneware. South Amboy, N.J.,
1805-13. a, Jar with horizontal loop handles, blue decoration. H. 8", Diam. 6 1/2".
Mark: "T.W.J.L." (The Newark Museum; ex coll. Connor.) b, Jar with brown
decoration. H. 12 1/4", Diam. 8". Mark: "T.W.J.L." (Collection of James S.
Brown.) c, Jar with blue decoration. H. 7 5/8", Diam. 6 1/2". Mark: "T.W.J.L."
(Collection of John Paul Remensnyder.) d, Jar with horizontal loop handles, green dec-
oration. H. 13 3/4", Diam. 10 3/8". Mark: "T.W.J.L." (New Jersey State Museum.)
e, Jar with purple decoration. H. 8", Diam. 6 1/2". Mark: "T.W.J.L." (Collection
of John Paul Remensnyder.) (Photo, Joseph Crilley.)

watershed. The dates 1806 and 1807 are found on Warne
and Letts ware marked with the long mark "WARNE&LETTs"
(Fig. 6). Those objects dated 1807 also have the impressed
slogan "LIBERTYFOREV." None of the objects marked
"T.W.J.L." are dated or have either the slogan or a
location on them (Fig. 7).[23]

Impressed stylized leaves are found on all Warne and
Letts ware as well as a motif that looks like ribbon tied in
a figure eight lying on its side. Impressed motifs are
filled with one of six colors: dark blue (Fig. 6e), blue
(Figs. 6a, b; 7a, c), green (Figs. 6c, 7d), purple (Fig. 7e),
and brown (Fig. 7d). Coggle wheels were employed much
more extensively than before, and the firm owned at least
six: parallel vertical lines (Fig. 7e), single vertical
rectangles with a triangle above and below each rectangle
(Fig. 7d), paired vertical rectangles with a triangle above
and below each pair (Fig. 7d), five rows of tiny triangles
(Fig. 7d), vertical pointed ovals similar to Warne's except
that each is narrower (Fig. 5b), and diamonds alternating
with ovals connected by a line (Fig. 7b).

After Warne's death Joshua Letts continued to make the
same type of ware that he and Warne had previously made
except that he employed one more coggle-wheel design:
ovals alternating with circles, both consisting of a line of
tiny triangles (Fig. 8b, d). When Catherine Bowne inherited
the pottery in 1815, she continued to operate it into the
1820s, but no distinguishable ware has survived.[24] She
apparently employed B. Lent, who later worked at Caldwell
(Fig. 2b), as well as Vale and Knowles, according to sherds
found with their marks in the refuse heap.

During the same years there were other potters working in
the South Amboy area. Their marked wares have survived,
and from them we know that they were there, what their last
names were, and what they made. There is much that is
unknown, such as first names, exact locations, and fairly
exact dates of operation.

H. Humiston was in business in South Amboy at various
times with a Cummings, a Stockwell, and a Warner and
there are ovoid jugs and jars known with these makers'

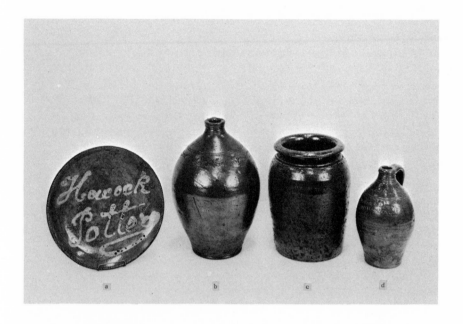

Fig. 8. a, John and William Hancock, Plate with coggle-wheel edge. South Amboy, N.J.,
1828-40. Lead-glazed redware; H. 1 1/2", Diam. 9 7/8". Inscription in trailed slip:
"Hancock Pottery." (Collection of John Paul Remensnyder.) b, Attributed to Joshua Letts,
Jug. South Amboy, N.J. , 1813-15. Salt-glazed stoneware; H. 11 1/4", Diam. 7 1/2".
(New Jersey State Museum; ex coll. Sim.) c, William H. Hancock, Jar. South Amboy,
N.J., 1828-40. Salt-glazed stoneware; H. 9 3/8", Diam. 7". Mark: "W.H. Hancock."
(Collection of John Paul Remensnyder.) d, Joshua Letts, Jug. South Amboy, N.J., 1813-
15. Salt-glazed stoneware; H. 8", Diam. 4 5/8". Mark: "MADE.BY.J.LETTs/SOUTH-
AMBOY." (New Jersey State Museum; ex coll. McKearin.) (Photo, Joseph Crilley.)

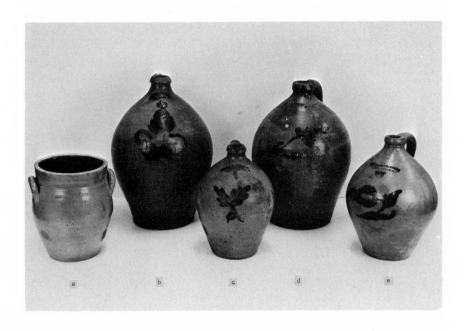

Fig. 9. a, H. Humiston and Warner, Jar with ear handles, blue decoration. New Jersey, prior to 1850. Salt-glazed stoneware; H. 9 1/4", Diam. 8 3/8". Mark: "HUMISTON & WARNER/SOUTH AMBOY." (The Newark Museum; ex coll. Connor.) b, H. Humiston and Stockwell, Jug with blue decoration. South Amboy, N.J., prior to 1850. Salt-glazed stoneware; H. 16", Diam. 11 3/8". Mark: "HUMISTON&/STOCKWELL/S.AMBOY,N.J." (The Newark Museum; ex coll. Connor.) c, H. Humiston and Stockwell, Jug with blue decoration. South Amboy, N.J., prior to 1850. Salt-glazed stoneware; H. 11", Diam. 7 7/8". Mark: "HUMISTON&/STOCKWELL/S.AMBOY, NJ." (New Jersey State Museum.) d, H. Humiston and Cummings, Jug with blue decoration. South Amboy, N.J., prior to 1850. Salt-glazed stoneware; H. 15 1/4", Diam. 11". Mark: "HUMISTON&/CUMMINGS-&S.AMB...J." above the number "3." (The Newark Museum; ex coll. Connor.) e, H. Humiston and Warner, Jug with blue decoration. South Amboy, N.J., prior to 1850. Salt-glazed stoneware; H. 11 1/4", Diam. 8 3/4". Mark: "HUMISTON & WARNER/SOUTH AMBOY, N.J." above the number "1." (The Newark Museum.) (Photo, Joseph Crilley.)

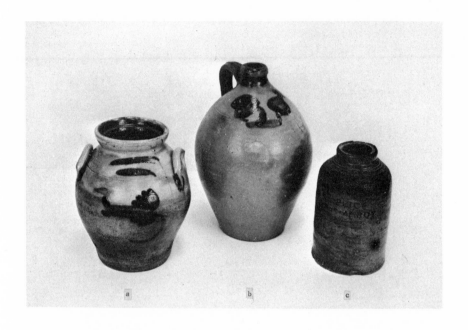

Fig. 10. a, John B. Pewtress, Jar with ear handles, blue decoration. Perth Amboy, N.J., prior to 1840. Salt-glazed stoneware; H. 9 1/4", Diam. 7 3/4". Mark: "JOHN B. PEWTRESS/PERTH AMBOY." (New Jersey State Museum, Gift of Mrs. Thomas Haight.) b, Henry French, Jug with blue decoration. Roundabout (now Sayreville), N.J., 1801-30. Salt-glazed stoneware; H. 12 3/8", Diam. 8 1/2". Mark: "HENRY FRENCH." (The Newark Museum.) c, Xerxes Price, Snuff bottle. Roundabout (now Sayreville), N.J., 1801-30. Salt-glazed stoneware; H. 8", Diam. 5 1/8". Mark: "MADE.BY.XERXES/ PRICE/AT.S.AMBOY." (Collection of James S. Brown.) (Photo, Joseph Crilley.)

marks. Most New Jersey stoneware has cobalt blue at the
ends of the handles, but these four potters did not follow
this practice. The only known Humiston and Cummings
object is a large jug (Fig. 9d). There are two known
Humiston and Stockwell jugs, one large and one small
(Figs. 9b, c). A small jug and a small jar are known with
the mark of Humiston and Warner on them (Figs. 9a, e).

Xerxes Price and his son-in-law, Henry French, operated
a pottery at Roundabout that Price built in 1801. Roundabout
is part of South Amboy, and Price marked his ware with the
latter location. The pottery was sold in 1830. Both Price
and French made salt-glazed stoneware decorated with
cobalt blue. Henry French's name appears on jugs (Fig. 10b),
and Price's mark is on both jugs and snuff bottles (Fig. 10c).

William H. Hancock opened the Congress Pottery in
South Amboy in 1828 and remained in business until 1840.
He made salt-glazed stoneware and lead-glazed redware.
The only known piece of stoneware made by him is an
undecorated jar marked with an impressed "W.H.HANCOCK"
(Fig. 8c). An example of Hancock's redware is a plate
marked "Hancock/Pottery" in trailed slip (Fig. 8a). In 1849
the Congress Pottery was acquired by Abraham Cadmus of
New York City who made molded earthenware at the pottery.

Across the Raritan River from South Amboy is Perth Amboy.
An important pottery manufacturing center in later years, it
was represented by one obscure potter, John B. Pewtress,
during the first half of the nineteenth century. Pewtress
made salt-glazed stoneware jugs and jars decorated with
cobalt blue (Fig. 10a). The blue decoration is on one side
of the illustrated jar only; the other side is undecorated.

A second pottery excavated by Sim in Old Bridge was
located on the opposite side of the South River from
Van Wickle and Morgan's pottery and belonged to the
Bissett family. They were in operation prior to 1815 when
Asher Bissett sold the pottery to Evert Bissett who continued
to pot into the 1840s.[25] The date "1832" is found on one
jar with Evert Bissett's impressed mark.

Between 1831 and 1845, Jacob Eaton and Samuel Stout
operated a pottery at Washington, now called South River.

Some ware is marked "J.EATON" alone and some is likewise
marked "SAM STOUT." Other pieces have both names as
well as the location. The dates "1831" and "1832" appear
in cobalt blue on some of their pieces.[26] That an earlier
potter, F. A. Kleine, was in Washington is known only by
a broadside of 1827 advertising his pottery.[27]

The study of Cheesequake pottery is far from complete,
and the era prior to 1840 is merely the prologue to a long
and exciting history of pottery manufacturing in New Jersey.

NOTES

1. Henry B. Kuemmel, The Clays and Clay Industry
of New Jersey (Trenton: Board of Managers of the Geological
Survey, 1904), pp. 165-66.
2. Cullen W. Parmelee, Ceramic Glazes (Chicago:
Industrial Publications, 1951), pp. 177-79.
3. Sim died in 1955 at the age of seventy-five. Trained
as an entomologist, he had worked for the New Jersey
Department of Agriculture in the Department of Plant
Industry since 1924. His interest in the excavating and
collecting of New Jersey pottery brought him recognition
in the state as an authority in his avocation. His articles
on pottery and several pamphlets on early New Jersey
industries were published by the New Jersey Agricultural
Society. Press Release Obituary, New Jersey Department
of Agriculture, Nov. 29, 1955.
4. Morgan Family ms. genealogy, Bureau of Archives
and History, New Jersey State Library, Trenton, N.J.
(hereafter NJSL).
5. "A Book of Register & Copy of Inventorys of the
Damages done by the Enemy and their Adherents to the
Inhabitants of the County of Middlesex," 1782, NJSL.
6. Sim Collection, 352.79, New Jersey State Museum,
Trenton, N.J. (hereafter NJSM).
7. Wills and Inventories, Bureau of Archives and
History, NJSL.
8. Sim Collection sherds, NJSM.
9. Morgan genealogy, NJSL.
10. Advertisement, July 22, 1805.
11. Inventory of the James Morgan, Jr., Estate, Joseph
Downs Manuscript and Microfilm Collection, Winterthur
Museum Libraries, 55.126.8 (hereafter WM).
12. Sim Collection, 352.110, 352.111, NJSM.
13. Sim Collection, 352.98, NJSM.
14. Sim Collection, 352.100, NJSM.
15. Morgan genealogy, NJSL.
16. Sim Collection, 353.75, NJSM.
17. Vivian Zinkin, "A Study of the Place-Names of

Ocean County, New Jersey, 1609-1849" (Ph.D. diss.,
Columbia University, 1968), p. 319.
 18. Sim Collection, 352.205, NJSM.
 19. Wills and Inventories, NJSL.
 20. Register of Marriages, Bureau of Archives and
History, NJSL.
 21. Wills and Inventories, NJSL.
 22. Sim Collection, 360.1, NJSM.
 23. New Jersey Pottery to 1840 (Trenton, N.J.: New
Jersey State Museum, 1972), nos. 88-92.
 24. Sim Collection sherds, NJSM.
 25. Early Arts of New Jersey: The Potter's Art c. 1680-
c. 1900 (Trenton, N.J.: New Jersey State Museum, 1956),
p. 25.
 26. New Jersey Pottery to 1840, nos. 113-16.
 27. WM, 58x30.2.

THE PRODUCTION OF TUCKER PORCELAIN, 1826-1838:
A REEVALUATION

Phillip H. Curtis

IN THE history of American ceramics, few manufactories provide as many possibilities for research and study as the Tucker porcelain factory of Philadelphia. The complete factory papers include account books, formula and price books, pattern books, letter books, and line drawings. The Tucker family and factory papers, presented to the Philadelphia Museum of Art in 1951 by a Tucker descendant, provide the essential primary materials for a reevaluation of the history and production of the Tucker factory.

William Ellis Tucker, the founder of the Tucker factory, was born in Philadelphia on June 11, 1800. His father, Benjamin Tucker, conducted a school at 206 Race Street, and in 1800 he opened a private school next to the Philadelphia Free Quaker Meeting House.[1] Not content with teaching, and in need of supplementing his income to support a family of twelve children, Benjamin Tucker became involved in other business interests. His letter books contain numerous real estate and mercantile transactions.[2] One such commercial interest was a china store at 324 High Street (now Market Street between Ninth and Tenth streets), which he operated from 1816 to 1823.

In Philadelphia William Tucker had many opportunities to gain knowledge, both practical and theoretical, about the manufacture of ceramics. Although he was listed in the 1825 Philadelphia City Directory as a teacher, William also worked in his father's china store, where he sometimes painted the undecorated European china. A small kiln for firing the painted china was erected behind the store. The use of this kiln and subsequent attempts at decoration helped to develop William Tucker's interest in ceramics. His father's lecture series on the application of the physical sciences to arts and manufactures

provided another source for William Tucker's interest and
education.[3] The Franklin Institute of Pennsylvania also offered
lectures on various branches of the arts and sciences including
pottery. Benjamin Tucker's charter membership in the Franklin
Institute qualified William for admittance to the institute's
lectures.[4]

In addition to the public lectures, William Tucker acquired
knowledge of chemistry and its role in ceramic production from
printed sources. Benjamin Tucker's memberships in the Frank-
lin Institute and the Apprentices' Library placed the libraries
of these institutions at William Tucker's disposal. The Franklin
Institute library contained a growing number of technical books
and pamphlets. The Apprentices' Library contained 6,185 books
with such catalog listings as Chambers' Dictionary of Arts and
Sciences, Artist's Manual, Bancroft on Colours, Bache's Chemistry,
Handmaid to the Arts, and Cabinet of Arts and Manufacturers.
Many of these books were concerned with the chemical prop-
erties and compositions of pottery and porcelain. A Grammar
of Chemistry, also in the library, was written by Benjamin
Tucker.[5]

In 1823 Benjamin Tucker closed his china store and estab-
lished the Philadelphia Select Academy at the southwest corner
of Fifth and Mulberry streets.[6] He provided William with the
necessary finances to open a dry goods business as well as
with unsolicited advice concerning store management.

W. E. Tucker
My son
 From a statement of thy affairs which thou hadst
lately shown me, it appears that thou hadst a stock
of goods now on hand which is greater than all the
debts thou hast contracted and in order to guard
thee against the rashness of giving notes, which
may and very probably will, bring thee to insolvency
and disgrace, I give thee this written caution (of
which I shall keep a copy) and inform thee, that
from the nature of my own private engagements, and
the expense of my own private engagements, and the
expense of my large family, thou must not expect me

> to advance thee one Dollar more than I have already
> done or in any way to become bound for thee.[7]

The threat of curtailed financial assistance was an idle one;
throughout the history of the Tucker factory, Benjamin Tucker
was the major investor and guiding influence. His dominant
personality and importance overshadowed William Tucker.
 While still engaged in his dry goods business, William
Tucker began the experiments in ceramic production that cul-
minated in the formation of creamware and porcelain. The
daybook of William Tucker provides invaluable information
pertaining to the early experiments of the Tucker factory. The
first recorded experiment appears under the heading:

> Trial 1st No. 1
> The preparation of B's [Bruerton, a Philadelphia
> potter] clay was nearly one fourth part silax to mix-
> ture was made in cups by measure the silax was
> dry and the clay was a thick slip. I afterwards
> added nearly another cup of clay whaich made
> ten cups of clay slip to nearly three cups of fleet.
> The ware is marked No. 1.[8]

The first dated experiment is also noted:

> Experiments made at Tucker and Birds China
> Factory July 10th, 1826
> Ware marked \int mixture passed through sive
> 4 Parts clay
> 1 Part Silax D & F's Clay[9]
> First made no. 12

The succeeding ware, marked number 2, was composed of the
same ingredients. The wares numbered 5 were composed of
frozen clay and silax. Wares numbered 6 to 10 consisted of the
same combinations of clay and silax. These experimental attempts
were directed toward producing queen's ware, the first product
of the Tucker factory.
 The first dated experiment for the production of porcelain
occurred in the same year.

Oct 10th 1826
Experiments on China
<u>No</u> 1
 2 oz caolin
 2 " Feldspar
 1 dram 2 simple Potash[10]

"Receipts," or formulas, two through six are also concerned
with the production of porcelain. Throughout these six for-
mulas the proportions of kaolin and feldspar remained constant.
The third ingredient, either potash or white lead, was varied.
A more elaborate recipe for porcelain was recorded in the day-
book on November 6, 1826. The composition of the formula was:

 c 3 Parts Clay from Flood Bank[11]
 c 2 Caolin
 c 1 Silax
 c 1/2 Bones
 c 1/2 Felt Spar[12]

The letters of Benjamin Tucker also reveal insights into the
early experiments and production of the factory. In a letter
to William Meredith, dated February 5, 1827, Benjamin Tucker
stated "that William is at present engaged with his resources
& my own in an laborious & expensive experiment upon the
formation of Porcelain and the finer specimens of earthenware."
On February 16, 1827, Benjamin Tucker sent a specimen of
Tucker porcelain to his friends, Isaac and Hannah Jones. The
postscript to the letter reported that the sample was from the
first kiln of chinaware manufactured:

By my son William Ellis, who built his first kiln,
made his first mould and formed and burnt his
first pitcher. . . . The difficulties he has since
met with, from the detection of foreign substances
in our American materials that at a high temper-
ature form new chemical combinations, which
destroy either the beauty or the texture of the ware
has greatly obstructed his progress.[13]

The problem of financing the experiments and later the
production of porcelain was a recurrent one for William and
Benjamin Tucker. On April 24, 1828, Benjamin Tucker wrote
to his friend, Robert Welch, that from the beginning of the
experiments to 1828, a total of "more than fifteen thousand
Dollars have been expended in bringing it [porcelain] to its
present perfection." By 1830 another two thousand dollars
had been spent on the porcelain factory and production. [14]

The apparent answer to the factory's financial difficulties
was the acquisition of partners. William Tucker acquired a
succession of three partners. All three were sons of wealthy
Quaker fathers who purchased the partnerships for their sons
in much the same way that Benjamin Tucker financed his
son's enterprise.

John N. Bird of Philadelphia was the first partner in the
Tucker factory. John Bird's father, Charles Bird, invested
money in the Tucker factory in the belief that his son would
actually enter the business, but the partnership between
William Tucker and John Bird was a brief one. It began shortly
before April 13, 1826, and was dissolved prior to January 5,
1827. On April 13, 1826, William Tucker and John Bird pur-
chased a tract of land in Middlesex County, New Jersey, from
John Flood. [15] A news article in the United States Gazette
(Philadelphia) of November 16, 1826, refers to the Tucker and
Bird entry in the Franklin Institute competition, but by 1827
Benjamin Tucker wrote to his friend and Delaware agent, Ben-
jamin Ferris, to have John Bird's name removed from the deed
to the Tucker factory's feldspar quarry near Wilmington. [16]
Once again Benjamin Tucker was attempting to protect his own
and William Tucker's investment in the business.

One possible reason for John Bird's leaving the partnership
was ill health. Another more plausible explanation could be
that the great financial requirements of the business outweighed
the profits. By February 5, 1827, the dissolution of partner-
ship was effected. Benjamin Tucker wrote to Benjamin Ferris
that "A dissolution of partnership between him Bird and my son
has taken place and his father has engaged under a penalty of
Ten thousand Dollars that his son shall make a title upon his
coming of age to my son William of the Real Estate which they
hold." [17]

In an attempt to bolster the factory's finances after the
dissolution of the Bird partnership, Benjamin Tucker thought
of entering the firm himself as a legal partner. He offered
William Tucker "the whole direction of mixture and of decor-
ating," in exchange for Bird's interest in the firm.[18] His
father's suggestion did not meet with William Tucker's approval.
In answer to William's negative reply, Benjamin Tucker wrote:
"From thy communication of yesterday I perceive it is thy
wish to stand at the head of an establishment . . . and to
take no partners."[19]

William Tucker's independent ownership was of short
duration. Economic pressures forced him to acquire a second
partner, John Hulme, who joined the firm in the spring of 1828.
A note in Poulson's American Daily Advertiser of April 9, 1828,
reported that William Tucker had recently "taken to partner-
ship a young gentleman of talent and enterprise."[20] John
Hulme's father, Thomas Hulme, a wealthy Philadelphian,
bought a partnership for his son by investing money in the
Tucker factory.[21]

The Tucker and Hulme partnership was of even shorter dura-
tion than the association with Bird. The new partnership was
dissolved by the summer of 1828. A newspaper notice dated
June 10, 1828, reported the "co-partnership between the Sub-
scribers under the firm of Tucker & Hulme is dissolved by
agreement."[22] There is no recorded explanation for the dis-
solution of the Tucker-Hulme partnership.

Shortly before the partnership was dissolved, William Tucker
entered specimens of his porcelain in the Franklin Institute
competition of 1827. In the pottery and porcelain category,
the judges awarded the silver medal to Tucker for "The best
specimen of porcelain to be made in Pennsylvania, either
plain white or gilt. . . . The samples (No. 174) of this ware
appeared to be strong, and sufficiently well fired, the glaze,
generally very good, the gilding executed in a neat and
workmanlike manner."[23]

A year earlier in 1826, William Tucker had also entered a
specimen in the Franklin Institute competition, but the award
was presented to the New Jersey Porcelain and Earthenware
Company.

While the silver medal was the major achievement of the
Tucker factory during 1827, the major change in factory oper-
ation occurred in 1828. In that year Thomas Tucker joined
the factory as an apprentice; he later became chief decorator
and manager. Thomas, born in 1812, was the seventh child
and third son of Benjamin Tucker. In 1879 Thomas reminisced
about his entrance into the Tucker factory. "In the year
1828 I commenced to learn the different branches of the busi-
ness, which I did by serving several years apprenticeship to
the same."[24] In 1828, the year Thomas Tucker joined the
firm, the factory received another award from the Franklin
Institute for "the best Porcelain made in the U.S. gilt,
painted, and plain--one hundred pieces must be exhibited,
. . . The judges report that they compared the sample . . .
with the best specimen of French china, and found it [Tucker]
superior in whiteness, and the gilding well done."[25]

Thomas Tucker's entrance into the firm was not greeted
enthusiastically. William Tucker did not want his brother to
enter the business, and it was only after his father paid William
an unspecified sum of money that Thomas Tucker was allowed
to join the firm as an apprentice.[26] By 1830 Thomas Tucker
was no longer content with the menial position of apprentice
and wanted to learn the "secrets" of the factory. William
Tucker did not agree, and again Benjamin Tucker interceded
on Thomas's behalf. Benjamin Tucker informed William that
Thomas Tucker was a talented asset to the business and that
it was necessary to impart the factory secrets to Thomas lest
an accident or William's death leave Thomas Tucker with no
security of livelihood.[27] William Tucker reluctantly accepted
his father's request.

In 1830 William Tucker received an invitation to move his
operations from Philadelphia to Louisville, Kentucky. After
weighing the consequences of the move, William declined the
invitation but offered to aid the Louisville group in establishing
their own factory in exchange for five thousand dollars.[28]
The counter offer was an attempt to bolster the ever-present
difficulties of financing the Tucker factory. The financial
plight reached such an extreme that in 1831 William Tucker
sought aid from the United States government. William Tucker

wrote President Andrew Jackson, offering to share "a complete and perfect knowledge of every branch of my business in the formation of American Porcelain, so that the discovery shall for ever be secured to the country." William Tucker's price for this information was twenty thousand dollars. President Jackson declined the offer on the grounds that it was constitutionally impossible to aid a private business.[29]

On January 31, 1831, both William and Benjamin Tucker wrote letters to generals Mark and Bernard of the United States Senate, from Pennsylvania, and to Judge Joseph Hemphill and Joseph B. Sutherland of the House of Representatives. In these offers William Tucker was to convey to the United States "a complete description of the art of making porcelain in exchange for $40,000 to erect a new factory and increase production."[30] This offer was also declined.

The letter to Joseph Hemphill produced the only profitable result. Hemphill became interested in the firm and bought a partnership for his son, Alexander Wills Hemphill, on May 21, 1831. A notation in the letter book of Benjamin Tucker reports, "William Ellis Tucker informed me he has entered into partnership with Alexander Hemphill with the consent of Judge Hemphill."[31] Alexander Hemphill was a partner in name only; Judge Hemphill had actual control.

Of the three Tucker partners, Joseph Hemphill was the most influential. His investment of seven thousand dollars provided the means to relocate the factory and increase the quality of production.[32] For the first time in the history of the Tucker factory, it appeared that financial success was possible. The possibility was short-lived, for on August 22, 1832, William Tucker died. Poulson's American Daily Advertiser printed a short obituary: "DIED, on the 22nd inst at 4 o'clock A.M. of Remitting Fever,[33] in the 33rd year of his age WILLIAM ELLIS TUCKER, Porcelain Manufacturer. His friends and those of his father's family are particularly invited to attend his funeral from the residence of his father No. 44 north Fifth Street, this afternoon, at 4 o'clock." Shortly after William Tucker's death the Franklin Institute awarded an honorable mention "to Joseph Hemphill of Philadelphia for No. 76, various samples of American porcelain, in the molding and glazing of which great improvement has been made."[34]

While the Franklin Institute acknowledged the new sole
ownership it was not until 1833 that Judge Hemphill assumed
complete legal control of the factory. On that date Joseph
Hemphill paid ten thousand dollars to the estate of William
Tucker for William's share of the factory.[35] Thomas Tucker
was retained by Joseph Hemphill as superintendent of the
porcelain factory. After the death of Alexander Hemphill in
1833, Judge Hemphill brought his second son, Robert Coleman
Hemphill, into the business, but since he lacked an interest
in the operation of the factory, the younger Hemphill was a
partner in name only. The factory continued in operation
under Thomas Tucker's supervision until 1837 and entered
porcelain in the Franklin Institute competitions of 1835 and
1836.[36]

In 1835 the Tucker porcelain factory, by an act of the
Pennsylvania Assembly, was incorporated as the American
Porcelain Company.[37] Thomas Tucker was still the factory
manager of the new concern, and for a sum of five thousand
dollars he contracted to disclose the "secrets" as to the
materials, proportions, and mixtures for the manufacture of
porcelain. He further contracted that for a period of five years
he would not divulge the secret information to any other indi-
viduals or factories.[38] Personal financial demands of the
varied stockholders prohibited the initial formation of the new
company, and Joseph Hemphill's growing financial problems
forced him to dispose of the expensive porcelain factory.

In October 1837, the factory was leased for a period of six
months to Thomas Tucker, who sold the wares in his new china
store at 100 Chestnut Street.[39] Actual porcelain production
continued for a year, but in 1838 Thomas Tucker was also
selling imported European china.[40] In 1841 Thomas Tucker sold
the contents of the china store at public auction and entered the
cotton business at the insistence of his new wife.

The failure of the Tucker factory can be traced to the tariff
controversies of 1825 to 1833 and the personal failure of Joseph
Hemphill. Tucker porcelain could not compete with the beauty
or the price of European porcelain, which could be imported
into the United States and sold for a lower price than the Tucker
porcelain produced in Philadelphia. Pennsylvania newspaper

editorials proposed that it was the patriotic duty of Americans to patronize this American manufacturer. One newspaper editor suggested "it should be rendered fashionable for every new married lady to get a tea set--from Tucker. . . . Tucker we think would find it for his interest to send, at least to every Country town, a few sets, and let them be known as his--seen and admired. Families of fortune should order sets with their names on each piece."[41] William and Benjamin Tucker tried in vain to persuade Congress to include porcelain on the list of protected commodities through a protective tariff.

With the failure of the rechartering of the United States Bank and the eventual bank debacles of 1833 and 1835, Joseph Hemphill was financially ruined. The porcelain factory had become an expensive hobby instead of a lucrative investment and had to be sold. Begun on a shaky financial foundation, the Tucker factory ended in financial disaster. It is surprising that a company so overwhelmed with financial crises during its twelve-year history could have produced such a sizable quantity of high-quality porcelain.

The successful production of Tucker porcelain required the availability of the two necessary ingredients--kaolin and feldspar. Attempts to locate and acquire the best quality and least expensive raw materials for the Tucker factory were limited to the four most convenient states--Pennsylvania, Delaware, New Jersey, and New York.

Pennsylvania was the major source of the kaolin used in the production of Tucker porcelain. In the early 1820s, while digging postholes on his farm, Israel Hoopes, a West Chester farmer, discovered a white clay that proved to be a good quality china clay.[42] William Tucker leased a section of Hoopes's farm containing the kaolin. The agreement between Hoopes and Tucker, executed in 1831, provided for a fifteen-year lease at a cost of two hundred dollars.[43] Prior to 1831, the Tucker factory had purchased the clay from Hoopes, but increased production made a simple sales agreement unacceptable. An undated note in William Tucker's daybook, written prior to 1831, states that a sample of West Chester kaolin was "handed us by Mr. Bird Belongs to Mr. Hoopes Chester County 12 miles from Wilmington near Delaware line price $125 for five wagon load."[44]

Purchase or lease of kaolin beds was more convenient and less expensive than the purchase of kaolin by the wagonload.

While the majority of the kaolin utilized in the production of Tucker porcelain came from the Hoopes's farm, other entries in the daybooks of both William and Thomas Tucker reveal that the factory considered other areas in Pennsylvania as possible sources for raw materials. The search for raw materials also brought William into contact with other potters. His daybook records a possible contact with John Vickers, the potter. Whether the two men actually met or exchanged ideas is only speculative, but Tucker was aware of the Vickers production and the quality of his raw materials. William Tucker wrote: "Charles Lawrence told Mr. Matters that Mr. Vickers a potter near Downingtown on the Lancaster Road that knew of a clay or sand that would fuse in a common Potter's kiln."[45]

While kaolin, the first major ingredient of Tucker porcelain, was obtained principally in Pennsylvania, the second major ingredient, feldspar, was obtained in Delaware. William Tucker purchased a feldspar quarry located on the farm of Jacob Way near Wilmington. The deed or lease was executed in 1827. For a sum of $270, William Tucker acquired "four acres one quarter and two perches of Land."[46]

The major source of New Jersey raw materials was located near Perth Amboy. A blue clay, or fire clay, was purchased through a lease agreement from the farm of John Flood in Mutton Hollow, Middlesex County. The daybook of William Tucker mentions the possibility of other clay being obtained near Amboy and Bordentown, New Jersey.[47]

New York provided the last source of raw materials for the Tucker factory. Heavy flooding in the West Chester area in 1830 forced William Tucker to obtain kaolin from the Salamander Works in New York City. The letter book of Benjamin Tucker contains numerous correspondence between himself and the Salamander Works throughout the year 1830.[48]

William Tucker's records also contain numerous suggestions for possible "receipts." These suggestions contained advice on ceramic bodies, glazes, and enamels. In 1827 William Tucker received a letter from William Boyd, a Philadelphia merchant. The letter contained recipes for enamels and creamware.[49] Continued discussion of creamware, the first

product of the Tucker factory, is found in William Tucker's
daybook in a memorandum entitled "Some remarks made by
Wedgwood as copied from Wm Rotches letter."[50] The letter
gave complete instructions for making creamware.

The formula books of William and Thomas Tucker contain
hundreds of recipes for ceramic bodies, glazes, and enamels.
The daybook of William Tucker begins with his recipe for
creamware. The preferred creamware formula was taken "from
Wm Shufflebottom's Book." The formula consisted of

 2 lb blue Clay
 2 lb Fine white clay
 2 do Flint
 4 do Composition stone
 4 do Bones

and

 No 2
 1 lb Blue Clay
 1 lb Fine White Clay
 6 lb Composition stone
 4 lb Bones calcined

The recipes for creamware appear to be confined to the factory's
earlier period of experimentation and production, 1825 and 1826,
for by September 1826 William Tucker was directing his attention
to the production of porcelain. Tucker's earliest recorded formula
for porcelain was a combination of

 2 lbs Caolin
 2 " Felt spar
 1 " Bones[51]

After experimentation with approximately twenty porcelain
recipes, William Tucker selected one mixture as his "secret
formula" to be the basis of Tucker porcelain. The composition
of the porcelain body was

500 lbs dry Kaolin
65 " " Bone calcined
3 1/2 Buckets Feld Spar even full calcined
2 Buckets Silix even full calcined[52]

The porcelain glaze selected for use was composed of

2 bucket Feldspar
5 lbs Kaolin
10 lbs China
7 lbs Flint
4 lbs Borax[53]

The exact sources for the formulas of the body and the glaze
have not as yet been discovered. Information relating to the
sources of the enamel recipes indicates that the glaze and
porcelain body recipes were not entirely original to William
Tucker and his factory.

The Tucker factory's enamel colors and fluxes did not result
from experiments, but were copied exactly from Robert Wynn's
book On the Preparation of Enamel Colours, and Fluxes and the
Vehicle for laying them on With. Originally published in London
in 1816, the book was reprinted in Philadelphia in the 1820s
and was available in the library of the Franklin Institute.

Both William and Thomas Tucker took precautions to keep
their formulas secret, and yet the majority of their recipes were
available in books on chemistry and pottery. This desire for
secrecy extended to the invention of a secret code by Thomas
Tucker. The code consisted of a substitution of numbers for
letters and letters for numbers. The key to the code was as
follows:

A	1	H	8	O	14	V	21
B	2	I	9	P	15	W	22
C	3	J	0	Q	16	X	23
D	4	K	10	R	17	Y	24
E	5	L	11	S	18	Z	25
F	6	M	12	T	19		
G	7	N	13	U	20		

Before being deciphered, the secret formula for the Tucker
china body appeared as:

3.8.9.13.1.2.14.4.24 Octo. 20th 1830
Left to me by Wm Ellis Tucker dec
E.JJ. lb 10.1.14.11.9.13
FE. lb 2.14.13.5
Ca buckt 6.5.11.4.18.15.1.17. even full
B. do 6.11.9.13.19.

Translated the formula becomes

China Body Octo. 20th 1830
Left to me by Wm Ellis Tucker dec
500 lb Kaolin
 65 lb Bone
3 1/2 buckt Feldspar even full
2 do Flint.[54]

Analysis of the Tucker formula and recipes is by no means complete,
but the recipes do provide clues to the production of Tucker
porcelain.

Production of Tucker porcelain is divisible into two periods of
operation: 1826 to 1831 and 1831 to 1838. In the first period of
operation the factory was located in the old city waterworks at
Twenty-third and Chestnut streets, Philadelphia. William Tucker
had obtained the property, probably by lease early in 1826, from
the Philadelphia City Council.[55] In May 1831 the influx of
capital provided by the Hemphill partnership allowed the factory
to be relocated to a "piece of ground situate on the south side
of Chestnut Street and on the west side of Schuylkill 6th street
in the City of Philadelphia."[56] The new factory site provided
more space than the former site and permitted the construction
of new buildings, slip pans, and three new kilns.[57]

The types of equipment used and the arrangement and opera-
tion of the new factory can be ascertained from drawings by
Thomas Tucker. These drawings, both watercolor and pen and
ink, document the mechanical processes involved in the pro-
duction of porcelain at the Tucker factory.[58] When the raw clay was

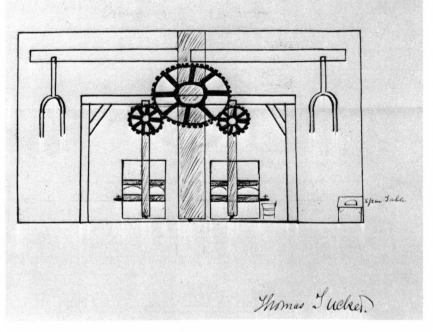

Fig. 1. Thomas Tucker, Drawing of a mill room, Philadelphia, 1832-38. Pen and ink. (Philadelphia Museum of Art: Photo, A. J. Wyatt.)

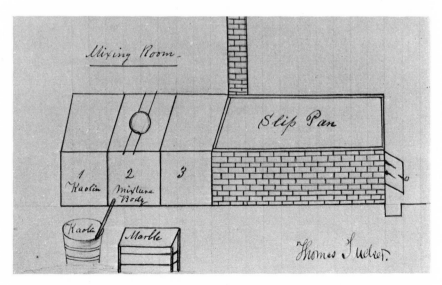

Fig. 2. Thomas Tucker, Drawing of a mixing room, Philadelphia, 1832-38. Pen and ink. (Philadelphia Museum of Art: Photo, A. J. Wyatt.)

delivered, it was placed in a clay mill, and, with the addition of
water, milled or mixed by blades or knives attached to a post
in the center of the mixing barrel until it had reached the
desired state of plasticity. Thomas Tucker's drawing of the
factory mill room (Fig. 1) illustrates this type of system.
The Tucker clay mill utilized two horses as power and made
use of double mixing barrels.

After the clay had been thoroughly mixed with water, it was
drained from the barrels and taken to the mixing room (Fig. 2)
where various ingredients, such as feldspar and bone ash,
necessary for the production of a porcelain body were added.
The liquid mixture was placed in the slip pan and slowly heated
until the water had evaporated and the clay had reached the
desired quality. The finished clay was kneaded on a marble
slab to work out the air bubbles that might have formed in the
clay.

Formation of the finished pieces by casting in molds or
throwing on a wheel was the next stage in the production of
porcelain. With the exception of one mold for a heart-shaped
perfume vial, none of the factory's molds survive. Once the
porcelain was shaped into finished products, it was ready to
be fired in the kilns. Several of Thomas Tucker's proposed
designs for kilns survive. The kiln design finally selected
(Fig. 3) was a common downdraft kiln divided into two sections,
a glaze kiln and a biscuit kiln. These designs for kilns were
not the result of Thomas Tucker's imagination or experimenta-
tion, but were copied from generally available books on the
chemical arts and manufacture. The kiln (Fig. 4), labeled
"French Plan of Glaze Kiln," closely resembles the kiln design
pictured in the 1771 edition of L'Art de la Porcelaine by the
Comte de Milly.[59] The procedure for firing the glaze kiln was
to "commence at 3 o'clock AM with a small fire increase
gradually until 2 o'clock PM when the fire holes are to be filled,
stopped up flues in the globe at 9 o'clock next morning--kiln
finished at 20 minutes before 2 o'clock PM."[60]

An important insight into the cost of producing one kilnload
of porcelain is provided by a note written by Thomas Tucker.
The note lists the costs as follows:

Cost of making ware in one glaze kiln	$67.00
10 cords of maple wood at $5 per cord	50.00
Sawing splitting and piling ditto	10.00
Setting up materials	10.00
Grinding and preparing ditto	12.00
Making saggars and ows	2.00
Grinding ditto	4.00
Preparing Glaze	6.00
Glazing Kiln	9.00
Setting and Burning Kiln	20.00
Drawing Kiln	5.00
Interest on buildings c&c	134.00[61]

After being fired and glazed, the wares were enameled by the decorators and placed in the enameling kiln (Fig. 5). The heat necessary for fixing the enamels to the porcelain body is less than the heat required for glazing, and as a result a more simple updraft, single-flue kiln is used. The directions for firing the enamel kiln were to "set fire at 8 o'clock AM red at 11 o'clock finish at 2 o'clock P M."[62]

The operation of the Tucker factory and the manufacture of porcelain necessitated the employment of a large number of workers. The letter books and business records of Benjamin, William, and Thomas Tucker contain no mention of factory workmen by name or occupation, but the United States census records for 1830 list seven male apprentices living at William Tucker's residence, 4 Clinton Court. The senior editor of the West Chester Republican and Democrat, after visiting the factory, related that "this establishment gives employment to about forty persons."[63]

Edwin Atlee Barber in his comprehensive Pottery and Porcelain of the United States records the first listing of many of the workers by name, supplied to him by George Morgan who turned a wheel for one of the Tucker potters and who was still alive in 1893. The list included Jacob Baker, John Basten, Charles J. Boulter, William Chamberlin, Charles Frederick, William Hand, Thomas B. Harned, George and Joseph Morgan, Isaac Spiegel, Andrew Craig Walker, and Vivien.[64]

Of the workmen mentioned in 1893, the identity of "Vivien"

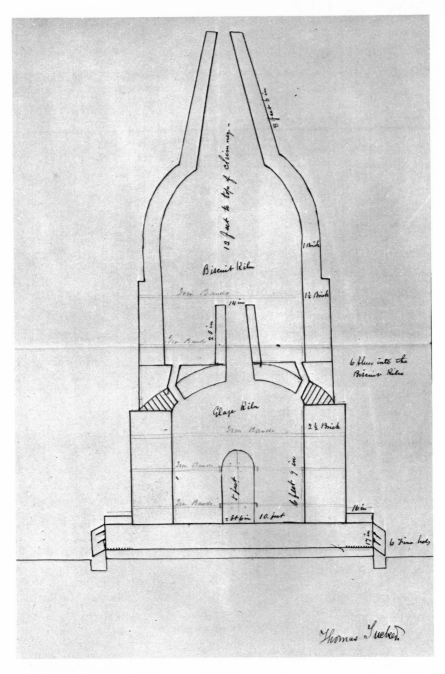

Fig. 3. Thomas Tucker, Drawing of a downdraft kiln, Philadelphia, 1832-38. Pen and ink. (Philadelphia Museum of Art: Photo, A. J. Wyatt.)

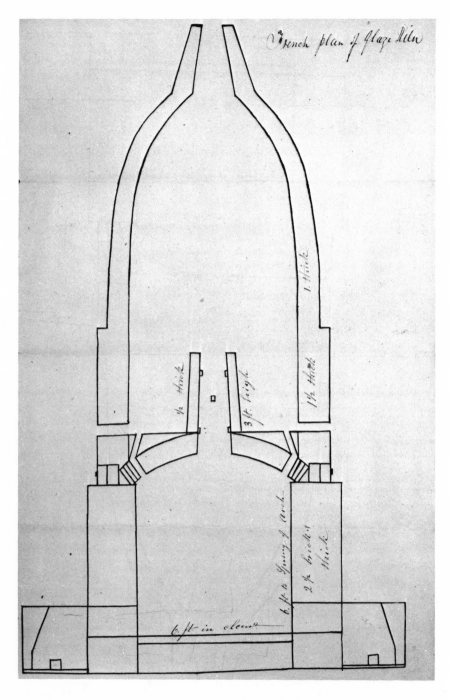

Fig. 4. Thomas Tucker, "French Plan of Glaze Kiln," Philadelphia, 1832-38. Pen and ink, after the design in Comte de Milly, <u>L'Art de la Porcelaine</u> (Paris: [L.F. Delatour], 1771), pls. 6, 7. (Philadelphia Museum of Art: Photo, A. J. Wyatt.)

has presented many unanswered questions. In an 1830 Phila-
delphia Municipal Court case, Lamontagne Vivien sued William
E. Tucker for three hundred dollars.[65] This entry provides
a partial answer concerning the Tucker firm's policy toward
employing foreign workmen. It has always been assumed that
when Judge Hemphill joined the firm, Vivien and other foreign
workers were imported from England, Germany, and France.
Since Hemphill did not become a partner until 1831, it seems
unlikely that Vivien could have been brought to America by
Hemphill. The most plausible explanation is that Tucker's
foreign workmen came from the Jersey Pottery and Porcelain
Company. The Jersey factory had imported foreign workers,
and when the company went out of business in 1827/28, it
seems reasonable to assume that some of the workers secured
employment in the Tucker factory.[66]

William E. Tucker preferred American workmen to those from
Europe. In a letter to Jacob Lewis of Louisville, Kentucky,
Benjamin Tucker stated: "You need not be concerned about
getting workmen to perform many of the other processes; the
enterprising genius of Americans, if they are called in at a
proper age will furnish you with equally excellent, and much
more confidential workmen than you can generally speaking
obtain from Europe--some of the apprentices that my son has
brought up under his own hand fully justify this statement."[67]
Tucker workmen were paid on a piecework basis. The records
of Thomas Tucker reveal the prices paid for turning, painting,
and burnishing.[68]

The arrangement, operation, and employment practices of
the Tucker factory are only as important as the explanation
they provide of the wares of products of the manufactory.
Detailed design books drawn by Thomas Tucker and the great
quantity of surviving Tucker porcelain in museum and private
collections provide ample documentation of the variety of forms
and decorations produced by the Tucker factory.[69]

The pattern books illustrate the designs used during the last
six years of the factory's history. Written on the title page of
both design books, in Thomas Tucker's handwriting, is the
notation "Pattern of china, made at the China Factory sw corner
of Schuykill 6th and Chestnut streets from the year 1832 until

the year 1838." No illustrations of designs employed prior
to 1832 remain, but an entry in William Tucker's daybook fur-
nishes an idea of the products of this early period. Under the
heading "Measure of Ware," the entry states the proportions
and measurements of various basins, pitchers, sugar dishes,
cream pitchers, mugs, washbasins, and chamber pots.[70]
Thomas Tucker's design books contain over 140 different
standard patterns (in both pen and ink and watercolor) for table
pieces and vases. The range of illustrated patterns consists
of teapots, creamers, sugar bowls, cups, plates, coffeepots,
fruit baskets, vases, butter coolers, bowls, covered vegetable
dishes, tureens, mugs, shell-shaped dishes, funnels, and
veilleuses.

Of all the Tucker designs, if we can judge by the quantity
surviving, pitchers and jugs seem to have been a specialty of
the factory. The design books list several pitchers by pattern
name. The patterns include "Grecian shape" (Fig. 6), "Walker
shape," named for the molder Andrew Craig Walker (Fig. 7),
"Fletcher shape," "New shape" (Fig. 8), and "Star shape"
(Fig. 9, left). The most characteristic Tucker pitcher design
is the "Vase shape" (Fig. 9, right), which features a high
arched handle and a corrugated molded band around the base.
The design appears to be peculiar to the Tucker factory. With
the exception of the vase-shaped pitcher, the shapes and forms
employed by the factory were close copies and interpretations
of English and Continental porcelain.

In addition to the patterns illustrated in the design books,
the Tucker factory produced many wares for which no manuscript
designs survive. This group of porcelain includes flowerpots,
covered powder and trinket boxes, toby jugs, inkstands, per-
fume bottles, oyster dishes, special commission vases with
gilt and ormolu handles, jewelry, and scent vials.

The pattern books not only provide documentation for the
forms of Tucker porcelain, but they also furnish an index of
the decoration applied to the Tucker products. Attempts have
been made to separate the Tucker decoration or motifs into
strict chronological periods of use by the factory. This cannot
be done. A continuity of decorative motifs utilized by the factory
exists from the beginning of operations in 1826 until the failure

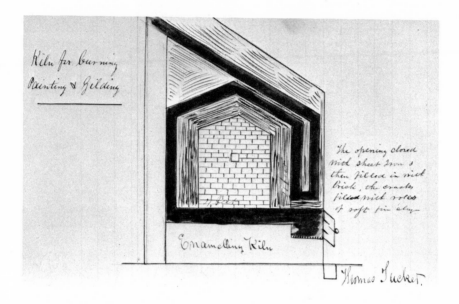

Fig. 5. Thomas Tucker, Drawing of enameling kiln, Philadelphia, 1832-38. Pen and ink.
(Philadelphia Museum of Art: Photo, A. J. Wyatt.)

of the firm in 1838. The only apparent development in Tucker
decoration is from a more simplified use of motifs in the early
years to a more elaborate use of gilt and polychrome details
during the Tucker and Hemphill period.

Designs in the hand-colored pattern book include combi-
nations of such motifs as sprig, polychrome floral, sepia and
charcoal landscapes, buff, and various gilt designs (Fig. 10,
left), including the characteristic spider pattern. Early factory
records seem to indicate that the first Tucker porcelains were
plain white or had only gilt decoration.[71]

While the production of the factory increased and the quality
of decoration improved, the factory's attempts at advertising
left something to be desired. A careful reading of three Phila-
delphia daily newspapers from 1826 until 1838 failed to produce
a single advertisement for the Tucker factory. The existing
bills of sale, receipts, and letters concerning the sale of Tucker
porcelain indicate that most Tucker porcelain was sold in the
Philadelphia area. Those pieces of Tucker porcelain sold out-
side the Philadelphia area appear to have been purchased by
individuals who were familiar with the Tucker family or factory.
The one documented exception occurred in Boston. The Boston
Commercial Gazette records an auction held by the Society for
the Promotion of Manufacturers and Mechanics Arts that in-
cluded an invoice of porcelain from the Tucker porcelain fac-
tory.[72]

Bills of sale exist for customers in Pennsylvania, Delaware,
New Jersey, New York, Maryland, and Virginia. W. H. Rich-
ardson, who was in charge of furnishing the Virginia governor's
mansion in 1830, made a buying trip to Philadelphia where he
ordered two pairs of Tucker pitchers. Tucker's most influential
customer was Andrew Jackson who ordered some porcelain from
the factory for use at his home in Tennessee.[73] The Tucker
daybooks also list the prices that customers were paying for
the undecorated wares and the prices for the various decora-
tions.[74]

It would appear from the great quantity of designs and in-
formation relating to the production of Tucker porcelain that the
identification of Tucker porcelain is a simple matter. Such is
not the case. Most Tucker porcelain is unmarked, and the

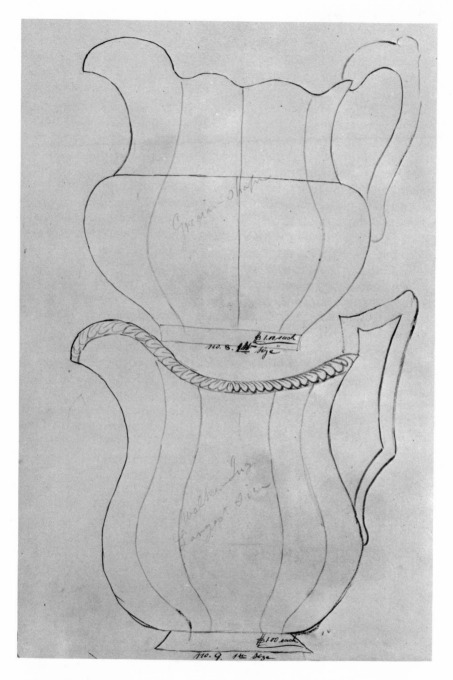

Fig. 6. Thomas Tucker, Drawing of Grecian and Walker pitcher shapes, nos. 8 and 9 in pattern book, Philadelphia, 1832-38. Pen and ink. (Philadelphia Museum of Art: Photo, A. J. Wyatt.)

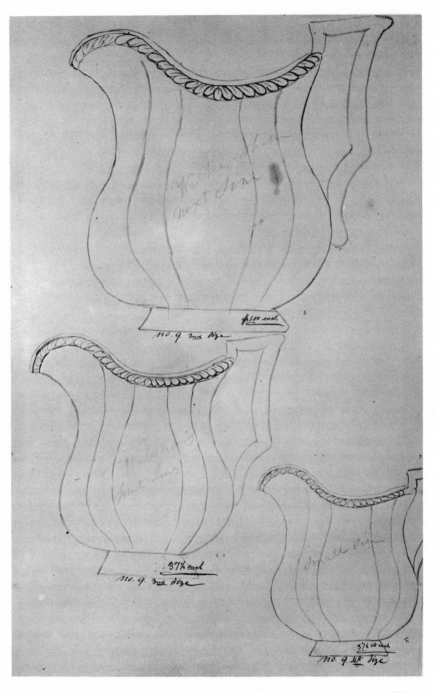

Fig. 7. Thomas Tucker, Drawing of Walker pitcher shapes, no. 9 in pattern book, Philadelphia, 1832-38. Pen and ink. (Philadelphia Museum of Art: Photo, A. J. Wyatt.)

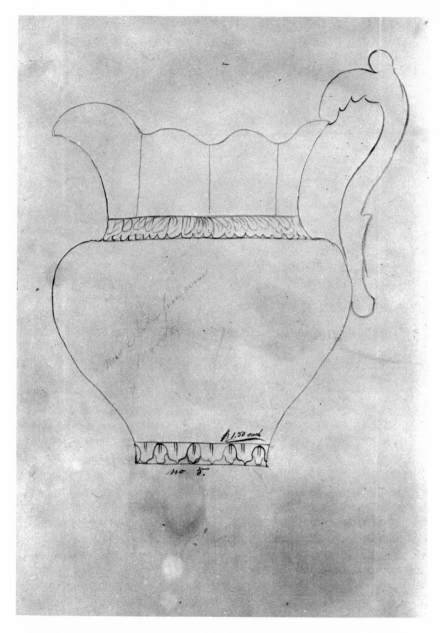

Fig. 8. Thomas Tucker, Drawing of new pitcher shape, no. 5 in pattern book, Philadelphia, 1832-38. Pen and ink. (Philadelphia Museum of Art: Photo, A. J. Wyatt.)

resemblance between Tucker porcelain and other porcelains of
the early nineteenth century is confusing. Traditionally Tucker
has been identified by examining its physical characteristics.
The physical characteristics of interest are the forms, bodies,
glazes, enamels, eccentricities of production, decorations,
marks, and color by transmitted light.

The forms can be easily understood by a careful study of
the Tucker pattern books, and by examining the Tucker porce-
lain in public and private collections. The body of Tucker
porcelain differs from both French and English bodies. The
inclusion of bone ash and other minor materials in Tucker por-
celain prevent it from being called hard paste or true porcelain.
By reflected light, earlier Tucker bodies possess a slight yel-
lowish color, but beginning in 1828 the porcelain has a hard
pure white color.

Another means of identifying Tucker porcelain is by examin-
ing the color of the body by transmitted light, under which
Tucker porcelain has a greenish color except in the few rare
instances when it appears orange.

The glaze of Tucker porcelain is clear and transparent, with
a bluish tinge where it accumulates in grooves and flutings.
Several pieces of Tucker porcelain in the Philadelphia Museum
of Art possess a glaze that is opaque white where it accumu-
lates in grooves, but the majority of pieces have the blue color.
The factory employed a standard palette of lead-based colors
or enamels. The enamel decoration is always executed over
the glaze, never under the glaze.

Two eccentricities of production have been used in identi-
fying Tucker porcelain. The bases of many Tucker urns and
vases turn slightly upward at the corners. The curling is a
result of excessive shrinkage during the initial firing process.
The other identifiable eccentricity is also concerned with urns
and vases. The characteristic caryatid handles have a small
ceramic brace between the caryatid and the body of the vase.
The brace was a device to keep the handles from sagging
during the initial biscuit firing.

Very few pieces of Tucker porcelain are marked, but the
factory employed several marks during its twelve-year history
of operation. The marks were executed in red and gold over

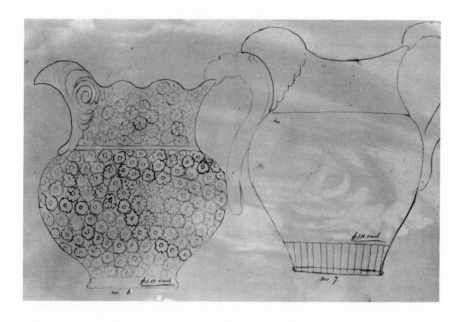

Fig. 9. Thomas Tucker Drawing of star and vase pitcher shapes, nos. 6 and 7 in
pattern book, Philadelphia, 1832-38. Pen and ink. (Philadelphia Museum of Art: Photo,
A. J. Wyatt.)

the glaze. The first factory mark was

William Ellis Tucker
Manufacturer
Philadelphia

Two marks from the period of the Tucker and Hulme partnership
are

Tucker & Hulme
China
Manufacturers
Philadelphia
1828

and

Tucker & Hulme
MANUFACTORERS
Philadelphia 1828

The final factory mark was limited to the period after 1832
when Joseph Hemphill was the sole owner of the factory. The
mark was

Manufactured
by Jos. Hemphill
Philad.

A series of marks incised on the bottoms of various porcelain
pieces were applied by molders employed by the factory. The
identified marks are B,F,H,M,V, and W, for Charles J. Boulter,
Charles Frederick, William Hand, Joseph Morgan, Vivien, and
Andrew Craig Walker.

These methods of identification are inaccurate and imprecise;
they have not provided a systematic method for reliable authen-
tication. With emphasis on scientific methods and technical
analysis, the field of the decorative arts is moving into a new
area of research. Two possible scientific methods of authenticating

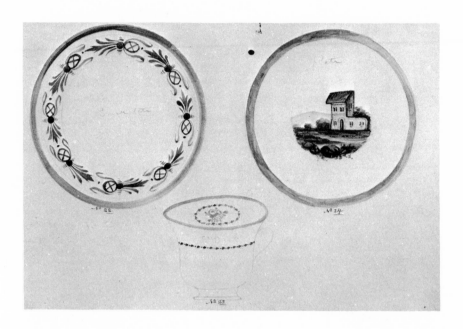

Fig. 10 Thomas Tucker, Drawing of cup and plate designs, nos. 22, 23, and 24 in hand-colored pattern book, Philadelphia, 1832-38. Watercolor. (Philadelphia Museum of Art: Photo, A. J. Wyatt.)

Tucker porcelain have been suggested. The first method
utilizes ultraviolet light, both short wave (2537 A) and long
wave (3660 A). Examined under the short wave, the Tucker gilt
decoration displays an unusual characteristic. A halo of white
outlines the gold decorations. It is believed that the mercury
used in the gilding process evaporates during the firing and
that the halo results from a contamination of the surrounding
area by this gold and mercury combination. Under the long-
wave ultraviolet light, Tucker possesses a characteristic pale,
blue-violet color. This is consistent in over three hundred
pieces of Tucker porcelain. The blue-violet fluorescence is
more characteristic of the early period of factory operation,
1826 to 1832.[75] Several of the examined pieces have a darker
matt pink fluorescence. This darker fluorescence is associated
with the 1833-38 period of operation.[76] These characteristics
were not seen on pieces of English, French, or German porce-
lain of the period, although they may be present on other speci-
mens. While the ultraviolet method is still in its early stages
of trial, it does provide the possibility of applying a new method
to the analysis of Tucker porcelain.

Another, as yet untried, method for the identification and
authentication of Tucker porcelain is the use of the nondis-
persive X-ray fluorescence analyzer. This instrument measures
percentages of different elements in tested objects. By using
the machine in connection with a computer, known Tucker recipes
can be compared with actual Tucker porcelain. The method
holds great possibilities for the study of all ceramics.

William E. Tucker and the Tucker factory produced porcelain
for the American market, although between 1826 and 1838 the
constant threat of financial insolvency, a result of nonpro-
tective tariffs, bank failures, national economic depressions,
strong European competition, and the personal financial prob-
lems of the individuals involved, doomed the Tucker factory
to certain failure. William Tucker, with the assistance of
his father, Benjamin Tucker, attempted unsuccessfully to
alleviate the factory's financial burden by acquiring partners.

By contemporary standards Tucker porcelain was highly
praised for its quality of decoration and novelty of design.
Yet the Tucker pattern books document the constancy of motifs

used instead of showing a chronological development of motifs.
The new appreciation of nineteenth-century design provides us
with an understanding of Tucker porcelain's intrinsic merits
rather than an apology for its antiutilitarian appearance and
overly romantic nature. At the same time newly explored tech-
niques of identification have enabled ceramic students to apply
a more systematic method of analysis to a very inaccurate area
of investigation.

While the study of Tucker porcelain is important in its his-
torical implications, a much larger cultural interpretation is
evident. Historically, the study of Tucker porcelain provides
not only insights into the history of American ceramic produc-
tion, but also into the history of the rise of American industry.
As the first commercially successful large-scale manufactory
of porcelain in the United States, the Tucker factory belongs
in the vanguard of American ceramic history. The establishment
of the Tucker factory supports a picture of the growing indus-
trialization of Philadelphia and the United States during the
period of rapid national growth and urban development in the
first half of the nineteenth century. The most important and
far-reaching contribution of a study of the Tucker factory is
its comment on nineteenth-century life. The story of the Tucker
factory presents a classic dichotomy between the rise of
American nationalism and the American dependence on European
precedents. While the factory was founded on the principle
of supplying an American market with American-made goods,
it was, nevertheless, totally dependent on Europe for its styles
and practices. The Tucker formulas and recipes were copied
from European books on the preparation of porcelain bodies,
glazes, and enamels; the shapes and decorations of the porce-
lain were approximations of the popular French and English
wares of the period. Given a choice, the public let the dollar
sign outweigh its feelings of nationalism, and most often
chose less expensive European wares. This popularity and
preference for European wares determined the nature of Tucker
wares and doomed the operation of the factory from its inception.

NOTES

1. The West Chester (Pennsylvania) Historical Society owns a group of papers relating to the establishment of Benjamin Tucker's school, subjects offered, and the assistant teachers employed in the school.

2. Letter Book of Benjamin Tucker, 1821-31, 3 vols., item 51-17-21 (6,7,8), Philadelphia Museum of Art (hereafter LB).

3. Benjamin Tucker's public lectures were given as a means of advertising his school. Benjamin Tucker to Benjamin Ferris, 1827, flat files, Philadelphia Museum of Art (hereafter FF).

4. Address of the Committee on Premiums and Exhibitions of the Franklin Institute of the State of Pennsylvania for the Promotion of the Mechanic Arts with a List of Premiums (Philadelphia: Franklin Institute, 1824), p. 51; Charter of Incorporation Constitution and By-Laws of the Franklin Institute of Philadelphia (Philadelphia: Franklin Institute, 1824), p. 26.

5. Catalogue of Books Belonging to the Apprentices' Library Company of Philadelphia (Philadelphia: Published for the Library, 1830), pp. 5-46; Benjamin Tucker, Grammar of Chemistry wherein The Principles of the Science are Familiarized by a Variety of Easy and Entertaining Experiments with Questions for Exercise and A Glossary of Terms in Common Use (Philadelphia: David Hogan, 1817).

6. Poulson's American Daily Advertiser (Philadelphia), Aug. 18, 1823, p. 2.

7. Benjamin Tucker to William Tucker, 51-17-21 (6), LB.

8. Daybook of William E. Tucker, n.d., 51-17-21 (4), Philadelphia Museum of Art (hereafter DB); DB, p. 15.

9. D and F refer to Dallie and Flood, two New Jersey farmers whose lands contained clay deposits used by Tucker.

10. DB, p. 31.

11. John Flood of Perth Amboy, New Jersey.

12. DB, p. 36.

13. Tucker to Meredith, LB; Tucker to Isaac and Hannah Jones, LB, p. 8.

14. Tucker to Welch, LB, p. 12; LB, p. 7.

15. Arthur W. Clement, Our Pioneer Potters (New York: Maple Press, 1947), p. 67.

16. Tucker to Ferris, 1827, FF.

17. LB, p. 5; Tucker to Ferris, LB, p. 5.

18. Benjamin Tucker to William Tucker, LB, p. 2.

19. Benjamin Tucker to William Tucker, LB, p. 4.

20. Clement, Our Pioneer Potters, p. 77.

21. Desilver's Philadelphia City Directory and Stranger's Guide (Philadelphia: Robert Desilver, 1833), p. 101.

22. Poulson's American Daily Advertiser (Philadelphia), p. 3.

23. Address of the Committee on Premiums and Exhibitions of the Franklin Institute (Philadelphia: Franklin Institute, 1827), p. 404.

24. Thomas Tucker to Professor Frazer, 1879, 51-17-21 (25), FF.

25. Address of the Committee on Premiums and Exhibitions of the Franklin Institute (Philadelphia: Franklin Institute, 1831), p. 7.

26. The event so angered Benjamin Tucker that he decided to deduct the money he had loaned William Tucker from William's share of Benjamin's estate upon Benjamin Tucker's death.

27. Benjamin Tucker to William Tucker, 1830, LB.

28. William Tucker to Louisville group, 1830, LB.

29. Tucker to Andrew Jackson, 1831, LB; Copy of letter from Jackson to William Tucker, 1831, LB.

30. 1830-31, LB.

31. John Ramsay, American Potters and Pottery (New York: Tudor Publishing Co., 1947), p. 102; 1830-31, LB.

32. Ramsay, American Potters, p. 102.

33. Possibly cholera; an epidemic swept Philadelphia during the summer of 1832, killing thousands of individuals.

34. Poulson's American Daily Advertiser (Philadelphia), Aug. 23, 1832; Address of Committee on Premiums and Exhibitions of the Franklin Institute (Philadelphia: Franklin Institute, 1832), p. 391.

35. Clement, Our Pioneer Potters, p. 80.

36. Neither entry received mention in the annual premium

list published by the Franklin Institute.

37. Pamphlet Laws of the State of Pennsylvania, 1835. Collection of the Historical Society of Pennsylvania, p. 338.

38. Article of Agreement between Joseph Hemphill and Thomas Tucker, 1835, Winterthur Museum Libraries, M-742 (hereafter WM).

39. Trade card of Thomas Tucker, 51-17-21 (11), FF.

40. Archibald M'Elroy, M'Elroy's Philadelphia Directory (Philadelphia, 1839), p. 102.

41. West Chester Village Record (Pennsylvania), Jan. 19, 1831.

42. Arthur E. James, The Potters and Potteries of Chester County, Pennsylvania (West Chester, Pa.: Chester County Historical Society, 1945), p. 102.

43. Chester County Pennsylvania Deeds, Miscellaneous Deed Book, no. 2, pp. 252-54, Chester County Courthouse, West Chester, Pa.

44. DB, n.d., n.p.

45. DB, p. 31.

46. New Castle County Deed Book, 1827, General Deed Book, pp. 497-99.

47. Last Will and Testament of William Tucker, 1832, Philadelphia Municipal Will Book, no. 10, p. 378, Philadelphia City Archives, City Hall, Philadelphia; DB, n.d., pp. 14-19.

48. 1830-31, LB, pp. 10-12.

49. Letter to William Tucker, Mar. 14, 1827, 51-17-21 (19), FF; Boyd to Tucker, Mar. 14, 1827, 51-17-21 (19), FF.

50. DB, n.d., pp. 19-20.

51. DB, n.d., p. 11; DB, n.d., n.p.; DB, n.d., n.p.; DB, p. 33.

52. Individual sheet in the handwriting of Thomas Tucker, FF.

53. Formula and price book of Thomas Tucker, 51-17-21 (2).

54. Thomas Tucker, price book, p. 38; Thomas Tucker, price book, p. 5. It was assumed that if a whole letter represented a whole number, then a small letter represented half the number.

55. The Philadelphia City Records Office can find no record

of the transaction, but all leases were not filed during the
early nineteenth century.

56. ,Agreement between William Tucker and Joseph Hemphill,
May, 1831, FF.

57. Individual sheet listing the value of William Tucker's
estate, Aug., 1832, FF.

58. Drawings, 51-17-21, figs. h,j,k.

59. Nicholas Christiern de Thy, Comte de Milly, L'Art de
la Porcelaine (Paris: [L. F. Delatour], 1771), pls. 6,7.

60. Information concerning the burning of the glaze kiln on
an individual sheet signed by Thomas Tucker, FF.

61. Ows are round doughnut-shaped saggars; information
on the cost of firing ware in one glaze kiln, individual sheet,
WM, M-742.

62. WM, M-742.

63. United States Census of Population, Philadelphia,
1830, Chestnut Ward, sheet no. 386; West Chester Republican
and Democrat (Pennsylvania), July 9, 1833.

64. Edwin Atlee Barber, Pottery and Porcelain of the United
States (New York: G. P. Putnam's Sons, 1893), p. 151.

65. Appearance Docket Philadelphia Municipal Court, Mar.
1830, p. 595, no. 455, Philadelphia City Archives 1825-35,
City Hall, Philadelphia.

66. Clement, Our Pioneer Potters, p. 67.

67. Tucker to Lewis, 1830-31, LB; WM, M-742.

68. Formula and price book of Thomas Tucker, p. 34, WM,
M-741.

69. Tucker pattern books (preserved in the Philadelphia
Museum of Art), 14-66.

70. Tucker pattern books, 14-66; DB, p. 26.

71. Franklin Institute Exhibition Catalog (Philadelphia:
Franklin Institute, 1827), p. 404.

72. Boston Commercial Gazette, Apr. 15, 1835.

73. 1830-31, LB, p. 16.

74. Individual sheet entitled "Prices for Making Wares
and Prices for Which They are Sold," FF.

75. Signed pieces were used as control samples.

76. Signed and Tucker family documented pieces were used
as control samples.